Mies van der Rohe: The Villas and Country Houses

Wolf Tegethoff

MIES VAN DER ROHE

The Villas and Country Houses

The Museum of Modern Art, New York

Distributed by The MIT Press, Cambridge, Massachusetts, and London, England

English edition copyright ©1985
by The Museum of Modern Art

Original German edition copyright ©1981
by Wolf Tegethoff and the Kaiser Wilhelm
Museum der Stadt Krefeld

All rights reserved
Library of Congress Catalog Card Number:
84-62541

Distributed by The MIT Press
Cambridge, Massachusetts
London, England
ISBN 0-262-20050-3 (MIT)
TEGMH

The Museum of Modern Art
11 West 53 Street
New York, New York 10019
ISBN 0-87070-558-X
(The Museum of Modern Art)

Printed in Germany

Translated by Russell M. Stockman
Edited by William Dyckes
German catalog designed by
Tunn Konerding, Essen
English edition adapted by
Abby Goldstein, New York

Type set by MJ Baumwell Typography
Printed and bound by Richard Bacht,
Grafische Betriebe und Verlag GmbH,
Essen, Germany

Contents

The art of the twenties—that is to say the period between the wars—is today regarded as if it were something that fell from another planet. It is also increasingly viewed as a Trojan horse, for which it was hardly worth tearing down the protective walls of tradition. The openness that characterized this art was all too soon felt to be an unpleasant draft. And so there has never been a time since the early thirties when people have not tried by one means or another to rebuild the walls of tradition.

Though the end of modern art as it originated in the late nineteenth century is everywhere regularly proclaimed, out of some need to blast open old and encrusted perceptions of having and being, one can easily overlook the fact that its development only occurred, after all, within very narrow limits. It would be quite possible to view artistic developments after the Second World War as a rearguard action on various levels, in spite of a number of significant individual achievements here and there in the world—and in spite of the fact that it was not until the fifties that a general breakthrough of the new style was accomplished in the specialized discipline of architecture. But what at that time spread around the entire world like wildfire had absolutely nothing to do with the earlier "New Era" that some seriously believed would be realized through architecture in the twenties. What spread was ultimately nothing but the simple method of producing buildings wholesale, without any careful reflection or consideration, but solely out of commercial interest.

Holding architects like Mies van der Rohe in part responsible for this kind of architecture is legitimate only if one separates this master builder's methodology from his artistic intention and from the buildings he in fact constructed—in other words, if one transforms what was merely a working method into a productive style of its own. However, if one consults the works themselves, it is no longer possible to speak of a common language between the two—as though Mies's style were some sort of blank check that would cover the ubiquitous building of the postwar period as well. Doubtless we will have to get used to the idea that there has been no such thing as a

"modern style" in our century, not even in architecture; nothing capable of elevating the mediocre, nothing that made sense except in important individual accomplishments. If one agrees to such a lack of a stylistic idiom that would also characterize the mediocre, then it is doubtless true, as Adorno put it, that "actually only works of the highest formal level still have any claim to existence; the mediocre, avoiding all care even in its smallest details, has immediately become worthless."

In the architecture of our century this highest formal level has only too seldom been attempted and attained; it is for this reason that the mediocre has been able to distort our present-day scene to the extent it has. And thus it happens that when we enter a recent building that rises above the usual standard we always feel as though transported into another world. We seem suddenly to stand outside our own time.

The sense of being somewhere else is surely present when one enters the Lange and Esters houses on Wilhelmshofallee in Krefeld. Designed by Mies van der Rohe in 1927 for two close friends, the silk manufacturers Hermann Lange and Josef Esters, these houses comprise a province remote from our time, or rather between the times. The austere lines of these brick buildings, their discreet spaciousness and sober integrity, place them at one and the same time in close proximity to notable buildings from the past and to industrial architecture in our own century. Here an aesthetic tradition that had never been wholly lost is once more brought into play; a unique sense of grandeur has here bridged the chasm that otherwise yawns irreconcilably between tradition and progressive thought. These houses are like an open secret that reveals itself to all who enter and find themselves transported into another world—which could in fact be the real one. The framed views out into undisturbed Nature, the rhythmic alternation of darker and lighter areas, the variety of spatial forms and their juxtaposition—all these calmly appeal to our sense of proportion; clarity becomes manifest. On the other hand, one notes the lack of that kind of coziness that would allow one to recognize, aside from all externals, that these spaces could be lived

in. The question is how to accomplish this today without unavoidably paying tribute to the banality of the everyday.

It is a rare piece of good fortune that houses of this kind, of which only a very few exist, can not only be seen from without, but are regularly open to the public. Yet since as long ago as 1955 the Hermann Lange House has been used as a museum for contemporary art. The city of Krefeld is indebted for this to Ulrich Lange, who ultimately gave the house to the city in memory of his father in 1968, with the welcome provision that the newest in art was to be exhibited in it for the following ninety-nine years.

In 1976 the city of Krefeld took possession of the neighboring Josef Esters House as well, purchasing it from the heirs of the original owner. The main intention was to be able to place both structures in this unique architectural ensemble under effective protection. In that same year the Krefelder Kunstmuseen, at whose disposal the house was placed as an additional exhibition institute, conceived the plan of opening the new double museum on the Wilhelmshofallee with a comprehensive exhibition featuring the villas and country house projects of Mies van der Rohe.

The plan for an exhibition then began a maverick course of five years' duration, leading as it were between Scylla and Charybdis. At first it was feared that the renovation of the Esters House would be completed too early; then it appeared it would be too late. We first worried whether the preparation and loan of the drawings could be accomplished at all; then whether it could be done in time. It was brash indeed to approach such an important repository of drawings as The Museum of Modern Art with such a loan request, especially since it developed that the major portion of the material was still completely unsorted and inaccessible in the Mies van der Rohe Archive. How was this treasure to be unearthed? And how could one deal with all the psychological, curatorial, and financial problems that would necessarily arise during the planning of the exhibition? It is scarcely possible to retrace in detail how all of these problems were happily resolved. Most important from the beginning, how-

ever, was generous assistance given by The Museum of Modern Art to the Krefelder Kunstmuseen, which began with nothing but the pipe dream of an exhibition in two of the architect's houses.

It was Dr. Ludwig Glaeser, director of the Mies van der Rohe Archive until the summer of 1980, who first fully supported and helped develop a plan for the exhibition; then it was Arthur Drexler, the director of the Department of Architecture and Design in The Museum of Modern Art, whose personal involvement made an essential contribution toward the final realization of our long-held plan. Special thanks are therefore owed to both Dr. Glaeser and Mr. Drexler; without their support the exhibition would never have taken place.

It was an additional stroke of luck that Wolf Tegethoff, who intended to write a dissertation on the villas and country house projects of Mies van der Rohe, could be given the job of sorting through all of the material in New York in 1979; only in this way was it possible to ensure the necessary research over an extended period of time.

Wolf Tegethoff also expanded his preliminary research project to the point that his present investigation, as an accompanying publication, more than takes the place of the customary exhibition catalog. The extent of his study and its scholarly style may represent something of a barrier to some readers uninterested in penetrating so fully into the material; still it was essential to provide considerably more than the usual picture book with its customary descriptions. After such intensive research it seemed necessary to allow the available source material to speak for itself in the context of a full-scale scholarly analysis. Unfortunately, writing on architectural history with regard to building in this century has tended to be all too often propaganda—either for or against the New Architecture (*Neues Bauen*). Genuine critical approaches or even the attempt to develop a set of workable concepts appropriate to it have been far too rare. It was time to do away with the usual array of images that display everything in a unified style—not to keep this tradition alive with yet another collection of photos and general pronouncements. To demonstrate this need, one has but to step inside the Lange and Esters houses and experience for oneself that some things are quite different from what we have been led to believe.

Special thanks are owed finally to all the assistants at the Mies van der Rohe Archive and the Krefelder Kunstmuseen who contributed to the success of the exhibition and this publication; also to the state of Nordrhein-Westfalen for financial support; and also to the Verlag Richard Bacht in Essen, which was willing to risk publishing the German-language edition of this book in such an imposing form—for which form Professor Tünn Konerding is largely responsible, as the supervisor of its design.

Gerhard Storck
Director of the Krefelder Kunstmuseen

The Mies van der Rohe Archive was established in 1968 as a division of The Museum of Modern Art's Department of Architecture and Design, and was the logical outcome of a long and cordial relation between Mies and the Museum. Alfred Barr, the Museum's first director, admired Mies's architecture and in the mid-thirties recommended to the Trustees that Mies be appointed architect for the Museum's building. Some 45 architectural drawings originally assembled by Philip Johnson for his 1947 exhibition of Mies's work had remained at the Museum, on extended loan, for sixteen years. In 1963, as Director of Museum Collections, Barr wrote to Mies at my request to ask that the drawings be donated to the Museum. Mies replied in a letter of July 19, 1963, giving the drawings to the Architecture and Design Collection and adding: "If in the future there is some interesting material you wish to have, please let me know. I will be delighted to give it to the Museum."

This response led immediately to a series of work sessions in which Mies, his grandson and associate Dirk Lohan, and I reviewed the drawings with the intention of selecting the most important for immediate transfer to the Museum. But as the sessions continued it became apparent that Mies himself wanted the entire body of work to be preserved intact. This in turn required more complicated arrangements.

Ludwig Glaeser had become the department's curator of architecture in December 1963, and was soon actively involved in these negotiations. His studies in Berlin had included work with the architect Eduard Ludwig, who was responsible for the survival of those drawings which remained in Germany after Mies came to the United States, and which now constitute a major part of the Archive's holdings. At Dr. Glaeser's suggestion, and in view of the enormous quantity of drawings involved, the Museum formally established the Ludwig Mies van der Rohe Archive.

Between 1963 and 1969 all materials still in Mies's possession were transferred to The Museum of Modern Art. The gift comprises all sketches, presentation drawings, working drawings, blueprints, architectural models, furniture designs by Mies and Lilly Reich, drawings by other architects for the Weissenhofsiedlung, and all work-related correspondence. (Personal correspondence was given to the Library of Congress.)

Dr. Glaeser, curator of the Mies Archive from 1968 to 1980, began the complicated task of cataloging and storing more than 20,000 items. Mrs. Phyllis Lambert provided generous financial support, as did Philip Johnson and many others, enabling the Archive to establish itself as a working entity. In recent years decisive financial assistance has been given by the Fritz Thyssen Stiftung and the National Endowment for the Humanities; it is a pleasure to acknowledge here the support of these benefactors as well as of the informal group called Friends of the Mies van der Rohe Archive.

The most important part of the Archive's holdings are those drawings from Mies's European career, dating from 1911 to 1938. Numbering some 2,700 original drawings and blueprints, this European work is especially fascinating because it includes unpublished variants of such well-known masterpieces as the Barcelona Pavilion, as well as studies for projects either never published in detail (the Krefeld Golf Club) or never published at all (the Emil Nolde House).

From this material Wolf Tegethoff has selected 135 drawings in which can be seen the development of Mies van der Rohe's ideas about architecture of domestic scale. The exhibition and this publication constitute the first major research project undertaken by an independent scholar working at the Mies Archive, and I believe Mr. Tegethoff has added significantly to the understanding of Mies's work.

It is particularly appropriate that the exhibition should have been presented first in Mies's Lange and Esters houses, rehabilitated under the aegis of the Krefelder Kunstmuseen; and I wish to thank the director, Dr. Gerhard Storck, for proposing the exhibition, persuading The Museum of Modern Art to make the loans, and having the patience to bring the project to a conclusion gratifying to both institutions.

Arthur Drexler
Director, Department of
Architecture and Design
The Museum of Modern Art

Response to modern architecture, the fundamental principles of which were developed in the 1920s and established around the world following the Second World War, was and continues to be largely emotional. The very misunderstandings and misinterpretations that helped secure its popularity in the 1950s are now used as arguments against the aims and attitudes of its former protagonists. All too easily overlooked is the fact that in addition to purely commercial interests and an unbounded faith in progress it was above all the formalistic approach of the second generation that won over its eager imitators. The founders of modern architecture, however, were distinctly opposed to such an attitude. The renunciation of decor, a preference for smooth, uninterrupted wall and window surfaces, asymmetry and repetitious accumulation, free-standing columns, and a disengagement from the ground do not alone make up the essence of modern architecture. What is essential is how and to what end these motifs are utilized, or, as Mies expressed it at the Werkbund conference in Vienna in 1930:

"It is not the 'what' that is important, but solely the 'how.' That we produce goods, and by what means we manufacture them — these tell us nothing intellectually. Whether we build tall or flat, with steel or glass, says nothing about the value of our building. Whether we aim for centralization or decentralization in our city planning is a practical question, not a question of value. Yet it is precisely the question of value that is essential."(*Die Form*, Vol. 7, No. 10, 1932, p. 306.)

An abhorrence of tradition, insufficient regard for surroundings, lack of standards, ubiquity, or an increasing uniformity of building tasks are by no means inherent characteristics of modern architecture, but rather the results of the one-sided and clearly mistaken manner in which it has been perceived — doubtless aggravated by the break in continuity after 1933. The postwar period of reconstruction and economic expansion eagerly snatched up its superficial attributes without having understood the logic behind its forms. Faith in an increasing sensitivity and refinement of the newly won architectural idiom as it was expressed by Walter Riezler in 1928 was hopelessly corrupted into its precise opposite, so that a widespread superficiality resulted. Riezler wrote:

"Surely change implies that beautiful old things will be destroyed, or at least that their calm and peaceful survival will be disturbed, and I share with Pindar a sense of regret that this is so. But this is the way of the world, and none of us can stay its progress. Nevertheless, I believe that the very least is lost when the modern architect attempts to solve a task with utmost seriousness and a most passionate involvement in his work — which is, after all, a matter of his building! A certain 'humility' is required as well, and many an architect today has need of this — even where nothing old and beautiful is endangered. But it is a different sort of humility than that of the nineteenth century, which sought to spare the old by imitating it, and thereby ruined many of our loveliest old cityscapes. By comparison, the present, with its ahistorical attitude, is truly anything but humble, for it has faith in itself once more, and dares to speak its own language. That seems to me to be a good sign, and I feel that we must only see to it that this language grows more and more refined, that what is expressed by this language becomes more and more profound. Then perhaps we may yet come to the point where we can occasionally sacrifice something old and beautiful in good conscience, because, as was the case in earlier times, we trust ourselves to be able to replace it with something new and different that we can feel is not inferior to it!" (*Die Form*, Vol. 7, No. 10, 1932, p. 306.)

This hope, and the commitment to a better future it expresses, must be preserved. The founders of modern architecture did not presume to be able to change the world. But they were filled with the firm determination to contribute with all the means at their command to finding new ways for human beings to live together.

To demonstrate this requires more than a few memorable slogans and a superficial tour through the architectural history of the twentieth century. On the one hand, a precise knowledge of the sources and facts is required, one such as has been present in only the rarest instances and is still largely lacking even for the works of the more important architects. But above all it is necessary to analyze in depth the buildings themselves, for they alone can give adequate answers to our questions about the goals and attitudes of modern architecture. Despite important beginnings in this direction — let me mention only the pioneering essays of Colin Rowe — such a method has hardly found a large following to date. I hope that the present investigation will make a contribution, above and beyond the necessarily narrow limits of its topic, toward better understanding of the most important architectural movement of the first half of the twentieth century.

A number of problems arose that made a comprehensive approach unadvisable, suggesting instead a serial treatment of the individual buildings. Frequent interruptions in the flow of the argument were bound to result, but I have sought to compensate for these by means of frequent cross-references. Thanks to the relatively continuous development of Mies's work, major gaps could by and large be avoided.

The greatest difficulty proved to be the fact that, in contrast to classical or medieval architecture, a reliable terminology for the discussion of these buildings is for all practical purposes nonexistent, and had to be laboriously created in each individual case. The few available technical terms — for example, *universal space* — turned out to be either misleading or so laden with inappropriate connotations that they proved unusable. Wary of the inadequacy of such terms, I have avoided introducing new ones wherever possible, preferring a descriptive approach instead.

Though the conditions for this research were far more favorable than is often the case, thanks to the fact that the architect's papers are concentrated in a few major collections, both the correspondence and the files of plans turned out to have serious gaps, especially with regard to the more important projects. In such cases contemporary journals and newspaper accounts have

been used as much as possible. At times more far-ranging analysis was unavoidable, either because of the need to refute prevailing opinions or to lay the groundwork for new understanding. A number of chronological revisions thus came to light (Concrete Country House, Brick Country House, Eliat House, Gericke House, Court House designs) as well as new attributions, on the basis of which the accepted view of the early country house projects and the Court House designs from the thirties as idealized projects has had to be challenged. New works included in this survey are, finally, the Dexel and Nolde projects, published here for the first time. Lack of documentation as well as the limited scope of this study precluded discussion of dwellings built by Mies van der Rohe before 1923.

Though my approach may have been fundamentally different, the monographs by Johnson, Drexler, and Glaeser nonetheless served as the matrix in which my research was rooted. Corrections became necessary at times, but one must bear in mind that these writers did not have access to the original documents against which to check their conclusions. Ludwig Hilberseimer's excellent book on Mies van der Rohe, with

whom he was long acquainted, provided invaluable stimulus in my interpretation of Mies's work. Ludwig Glaeser's publication on the architect's designs for furniture, which could not be discussed here for reasons of time, must be seen as an important supplement to any study of Mies's architecture.

The author is extremely indebted to Professor Christoph Luitpold Frommel for guiding this work, which in its essentials was submitted to the University of Bonn as a dissertation; he contributed countless suggestions and prevented me from making numerous mistakes. I would also like to thank here my other teachers at the university, especially Professors Tilmann Buddensieg and Reiner Haussherr, who were both involved, either directly or indirectly, in my work. And without the personal commitment of Gerhard Storck and Arthur Drexler, the directors of the Krefelder Kunstmuseen and of the Department of Architecture and Design at The Museum of Modern Art, respectively, neither the exhibit itself nor the present publication would have been possible. The beginnings of the project go back to the time when Ludwig Glaeser was curator of the Mies van der Rohe Archive. He graciously gave me unlimited access to

the sources themselves as well as to his own vast knowledge of them. Dorothea Schüten and Susan Evens not only bore most of the burden of coordinating between the two museums, but in addition provided me with valuable information. The support given me by numerous colleagues and former coworkers of Mies van der Rohe was especially appreciated, and their help has been acknowledged in the appropriate places. I am also grateful to the Fulbright Commission, whose generous grant made possible my extended stay in New York for the purpose of sorting through the documents. My family and friends have helped me in manifold ways during the two years I was engaged in this book. Above all I feel indebted to Veronika Darius, without whose productive criticism and untiring support the task could scarcely have been accomplished.

Tünn Konerding undertook the design of the book. My thanks to him, the publishers, and all concerned for their patience with me in the completion of the manuscript.

W. T.
Kiel, August 1981

This book is dedicated to the villa and country house projects of Mies van der Rohe, designs that constituted the greater part of his oeuvre until well into the 1950s. Their priority over all of his other endeavors was clearly expressed by Mies himself:

"It is true that it was with [the large utilitarian buildings] that a line of development based on function and necessity began that needs no further justification; it will not end there, however, but will find its fulfillment in the realm of residential building." (Contribution to a prospectus from March 1933; see Chapter 9.)

The problem that occupied Mies here was primarily one of space; how to organize it, open it, and relate it to the landscape so that, as he wrote in the same context, "the spatial needs of modern man" might be met. The continuing goal of his work was "to bring Nature, man, and architecture together into a higher unity" (Interview from 1958; see Chap. 21). Such an approach, as romantic as it is philosophical, places him in the tradition of the country house of antiquity as described by Pliny, its combination of architecture and landscape having stood as an ideal form of human dwelling in the thinking of architects for centuries, and been reproduced with varying success since the Renaissance. Ultimately, everything else appears to have been subordinated to this goal: the breakdown of room boundaries, the opening of the structure, the separation of supports and walls, the flat roof, projecting terraces and radiating lines of wall—all essentially serve the sole purpose of resolving the previous distinction between interior and exterior, and to create a situation in which both are perceived as portions of a "higher unity."

This study begins with the early country house projects, in which Mies explored the structural and design characteristics of various materials (concrete, brick, glass) and tested various ways of creating a transition from interior to exterior space. The following group of works, comprised of the completed Wolf, Esters, and Lange houses, did not allow him to realize his established intentions in every way, but nonetheless provided valuable new insights for future work. The later part of that phase was particularly marked by the attempt to reduce the massiveness of structures—clearly a problem with respect to his expressed goal—by relying on the effects of pure compositions of planes. But only the Barcelona Pavilion, with its free-standing columns, would provide the definitive basis for an open floor-plan arrangement in which large continuous glass surfaces could be substituted at will for walls that had been relieved of their bearing function. This in turn gave rise to a number of new problems, both practical ones and more all-encompassing ones. Undesirable views, for example, had to be screened, private areas protected from curious passersby and neighbors. Such huge openings demanded some sort of visual containment if the autonomy of the interior space was to be preserved. The Court House designs of the thirties represent an optimal solution in this sense, but one that sacrifices any ties to the surrounding landscape. The two American projects that bring this investigation to a close offer design possibilities pointing far beyond what had been achieved in this regard before. The seemingly limitless space available owing to the country's still largely undisturbed natural features, offered opportunities that he could hardly have found in more thickly settled, city-oriented Europe. Only in such a context can one begin to appreciate fully the cubical space of the Farnsworth House, enclosed as it was by nothing but glass. But

at the same time he had come to a more profound understanding of the meaning of the wall opening and its influence on the impression of interior space. The romantic approach to landscape that lay behind his desire to relate his structures to it, clearly evidenced in the earlier projects, had given way to a more reflective attitude toward Nature that was content to leave it untouched in its autonomy, and which sought to establish a link to it on a higher, purely aesthetic level.

With the exception of the Mosler and Lemcke houses, as well as the buildings and designs following immediately on the heels of the Farnsworth House (Caine House, "Fifty-by-Fifty" House, McCormick House), all of the residential projects from 1923 on have been discussed. The surviving documents relating to the Mosler House are preserved in the surveyor's office of the City of Potsdam, and were not readily accessible in the time available. Stylistically it quite obviously represents a compromise in any case, and it would have been difficult to incorporate it into the flow of my argument. The Lemcke House, though planned and constructed as a private house, is in terms of design more closely related to the apartment houses of Afrikanischestrasse and the Weissenhof Settlement: as a small, L-shaped-ground-plan type it belongs among the suggestions for mass-residential construction developed among others by Hilberseimer, and requires for that reason a separate investigation that would go well beyond the theme of the present one. The same can be said for the McCormick House, which was intended to be a prototype for later multiple construction. The two remaining projects are but variants on the theme of the Farnsworth House, and as such would have offered nothing essentially new toward the assertions I wished to make.

Preliminary Remarks

Mies van der Rohe's reputation as a founder of modern architecture (*Neues Bauen*) rests on a series of five projects, none of them actually constructed, that he presented to the public during the first half of the 1920s. The series includes two glass skyscrapers dating from 1921–22, a horizontally layered seven-story office building in reinforced concrete (early 1923 at the latest, but presumably conceived near the end of the previous year), and two designs for country houses from the years 1923 and 1924.[1] Heretofore it has been possible to place only the first of these in a specific context. The other four were thought to be idealized proposals, amounting almost to a manifesto for an architecture of the future, displaying its principles and design possibilities programmatically for the first time. Their prime purpose, to all appearances, was thus to foster the dissemination of new ideas simply by their exhibition and publication. This view has been chiefly supported by the revolutionary, almost utopian nature of the designs themselves, independent as they seem to be of historical models and implying a radical break with the traditional concept of architecture. One would, of course, be justified in making the same claim for the first design of the series, the skyscraper next to Friedrichstrasse Station (Illus. 1). Submitted for a competition in Berlin in December 1921, this proposal was given only scant attention at first for the very reasons suggested above, while Hans Scharoun's proposal for the site, considerably more "fantastic" from a formal point of view but strictly in line with the Expressionist taste of the period, nevertheless brought its creator praise from the jury.[2]

The extremely divergent character of the

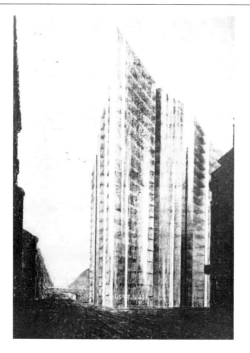

Illus. 1 Friedrichstrasse Skyscraper, Berlin (competition entry, 1921).

individual projects can be ascribed only in part to the diversity of the building assignments addressed. Aside from site-related factors, it is above all the choice of materials that has determined the structure and form of the buildings envisioned.[3]

From this point of view the following grouping can be made. First come the two skyscraper designs. In each of these we are presented with free-standing, sculptural structures, their steel skeletons partly hidden behind a glass-curtain facade. The close relationship between the two is quite apparent. It was already noted by contemporaries, and it was also stressed later by Mies himself.[4]

It is more difficult to compare the subsequent office building and the Concrete Country House (Illus. 2, Pl. 1.4), both of

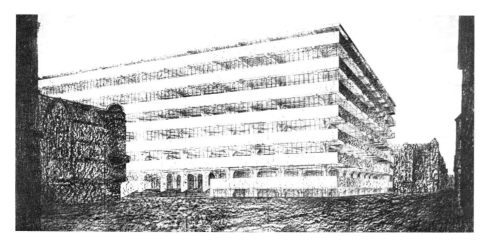

Illus. 2 Concrete Office Building (proposal, 1922/23).

Notes

Abbreviations frequently used:

MoMA—Mies Archive, The Museum of Modern Art, New York

LoC—Library of Congress, Washington, D.C.

1 With the exception of the prismatic skyscraper, which can be dated to the precise month inasmuch as it was submitted to a competition, the new chronology of the projects is based on the date of their first publication. All of them first appeared within the framework of the annual Great Berlin Art Exhibitions. In certain cases the extant correspondence provided additional points of reference that will be examined more closely in the proper context (see also Chap. 3).

The dates provided differ considerably from those in previous accounts. The available literature has taken its information primarily from the Johnson monograph (Philip Johnson, *Mies van der Rohe*, New York, 1947). Johnson was himself largely dependent in matters of chronology—at that time the original sources were not readily accessible—on the architect's own memory.

In the late 1960s Glaeser came to partially divergent conclusions on the basis of his own research, and these have been adopted in more recent publications. (Ludwig Glaeser, *Mies van der Rohe: Drawings in the Collection of The Museum of Modern Art*, New York, 1969. See also *Ludwig Mies van der Rohe, Ausstellung anlässlich der Berliner Bauwochen 1968*, Akademie der Künste, 1968. Text by Frederick Koeper, particulars accepted by Johnson, *op. cit.*, 3rd rev. ed., 1978.)

2 Mies had this to say about the competition in a recorded interview in October 1964:

"At that time a competition was exhibited in the old Berlin Rathaus. My design was placed somewhere in a dark corner because they had somehow taken it as a joke."

("Mies in Berlin," *Bauwelt Archiv I*, 1966; transcript: MoMA.) Concerning Scharoun's submission, which, though it won no prize, was acquired by the contractor, and the competition in general, see Friedrich Paulsen, "Ideenwettbewerb Hochhaus Friedrichstrasse," 2nd special issue of *Stadtbaukunst alter und neuer Zeit*, Berlin, 1922.

3 This last point corresponds with the goal expressed in various articles by Mies van der Rohe himself: "Hochhäuser," *Frühlicht*, Vol. I (New Series), No. 4, Summer 1922, pp. 122-24; "Bürohaus," *G*, No. 1, July 1923, p. 3; "Bauen," *G*, No. 2, September 1923, p. 1; "Industrielles Bauen," *G*, No. 3, June 10, 1924, pp. 8-10 (8-13?). The fact that Mies

which were first seen at the Great Berlin Art Exhibition in the spring of 1923.[5] Their similarities are limited most obviously to exploitation of the technical possibilities of an essentially identical construction method, namely a reinforced concrete shell resting on beams supported by free-standing columns. The high bearing strength of these beams here permits a wide, free-floating overhang of the ceiling slabs, while the distinction between supports and walls leads quite logically—for it is functionally justified—to the abandonment of all formal differentiation between horizontal and vertical surfaces. Walls are no longer weight-bearing elements; they now serve merely as space dividers, and combine with ceilings to form a homogenous outer skin. In all other respects the contrasts between the two designs outweigh their similarities. The compact rectangular block of the Concrete Office Building comprises a number of fundamentally identical unpartitioned floors surrounded by a continuous ribbon of windows. The country house, on the other hand, is made up of individual one- and two-story wings reaching out at angles, partially even at different levels, into space. Aside from the entryway and the large living room, which display a similarly open design, the whole is dominated by what is in effect a closed core area with what at first glance appears to be a more conventional scheme of walls and windows.

The differences detailed above are the direct result of radically differing sets of conditions for the two projects. While the urban context of the office building required maximum exploitation of the available site for economic reasons (and therefore suggested as compact and uniform a design as possible), the site of the country house permitted a free disposition of the structure in the landscape. In the first instance a relatively consistent approach was required, one recognizing the need to adapt to unanticipated changes in working methods and therefore providing large spaces with uniform illumination that could be flexibly partitioned. In the second, however, a specific set of requirements had to be met in the arrangement and individual treatment of the various parts of the building, namely those of a specific occupant with diverse needs. In the office building all other functions were subordinate to the one central objective of providing for the smooth performance of essentially identical tasks. The dwelling, on the other hand, had to meet a number of requirements at once, all of them

of more or less equal importance.

In this respect it might first appear more reasonable to treat the two country houses together. But any attempt to do so will reveal little basis for a stylistic comparison, for the architect's rigorous emphasis on the problem of construction led him to utterly different solutions. In this case an arrangement of projects by chronological development meets with particular difficulty: the somewhat earlier design for the Concrete House is unquestionably more progressive from the technical point of view, inasmuch as it anticipated the distinction between supports and (nonbearing) walls that became so characteristic of later buildings. On the other hand, the motif of straight lines of free-standing wall that gave Mies's architecture its individual stamp from 1929 on was already fully developed in the Brick Country House (Pls. 3.1, 3.2), conceived only a short time later. Study of the ground plan and the exterior views of the two-story complex reveals an openness in the ordering of space that is totally incompatible with the construction possibilities of traditional building in brick. It was only considerably later, in the Barcelona Pavilion, that these two ideas, originally developed quite independently of each other, were brought together—thus creating the necessary formula for resolving the conflict between a desired integral continuity of space and the structural demands that limited its realization.

The obviously radical difference between the concentric plan of the Brick House and the many-branched configuration of the Concrete House does not in itself provide an adequate basis for a discriminating critical evaluation of their styles. Both design schemes—one differentiated and thrusting out into space, the other integrated and concentric—continued to be employed side by side with equal justification well into the 1930s. As examples one need only mention the house at the Berlin Building Exposition of 1931 and the Gericke House designed in the following year (Pls. 14.1, 15.16).

The supposed uniqueness or independence of each of these five projects was pointed out quite early on by Johnson. Glaeser also expressed this conviction with absolute clarity: "Like many masterpieces, the drawings [of the five projects] defy biographical convention: they hardly reflect a continuous development or evidence major influences."[6] Nevertheless, both authors make much of the close affinity of the

drew upon the above-mentioned plans as illustrations for his theses as expressed in these articles may be seen as an indication of their programmatic intent.

See also a letter from Mies to Gropius from June 14, 1923; LoC:

"I would be delighted to be represented by the three projects [second skyscraper design, office building, concrete house], so that I could show how the same structural principle works out in three completely different assignments. Since I reject any and all formalism, and endeavor to develop the solution to an assignment out of its particular requirements, there will never be a formal relationship uniting the separate projects."

4 The polygonal curvature of the structure in the second skyscraper project resulted from an analysis of the effect of light on the model version. It therefore represents a further development of the previous competition project.

See in this connection the interview of October 1964 (note 2). The sentence "After that I tried to work with small glass areas *because I was not satisfied with the first results*" (italics mine) appears, by the way, only in the English translation, and is not found in the German transcript.

See also Carl Gotfrid, "Hochhäuser," *Qualität*, Vol. 3, Final Issue 5/12, August 1922/March 1923, pp. 63–66: "The possibilities in the use of glass as the exterior wall instead of a standard building material, demonstrated in this [first] design, led the architect to build a glass model. A study of the glass, its reflection and transparency, its varying degrees of brightness, the absence of the plastic effect of light and shadow—in short the absolute glassiness of it, was conducted in countless outside experiments with the model. The result of these experiments is shown in the second design reproduced here" (p. 65).

A further bit of evidence for the close connection between the two projects can be seen in the earliest surviving sketch for the second design. Here the ground plan still shows the central, circular lobby of the prismatic version, while the final solution calls for two separate elevator and service shafts (Pencil Drawing: MoMA, 21.5).

5 *Grosse Berliner Kunstausstellung 1923*, May 19–September 17, catalog of art works exhibited, cat. nos. 1270, 1271 and 1272, 1273.

Concerning the dating of the country houses as well as the resultant reversal in the sequence heretofore accepted, see also Chap. 3.

designs; after all, it was they who first treated them together as "five (early) projects." This apparent contradiction is explained by their choice of a point of comparison that is not merely a matter of style, but rather one of intent and meaning. The decisive criteria were already presented at the beginning of this essay: the programmatic nature of these designs, the apparent absence of specific commissions giving rise to them (characterizing them as idealized projects), and their somewhat unique, isolated position both within the totality of contemporary architecture and within the work of the architect himself (whose buildings constructed at around this time or immediately afterward display a comparatively continuous development and, most important of all, fall far short of the promise displayed here).[7] As a result, the more recent trend is to view the projects as belonging even closer together chronologically, and to deny by and large any stylistic development within the group.[8] Such a view would seem to be supported by the general mood of revolt during those years and by the decisive turning away from Expressionism to "objectivity" (*Sachlichkeit*), which expressed itself among other ways in experimentation with a variety of means of structural design. This attempted clarification has proven to be invalid, however, and must be corrected in light of the dating presented above and the results of the present investigation, which throw considerable doubt on the pertinence of previous interpretations. The assumption that all of these projects with the exception of the earliest of them are idealized solutions in the abstract sense is obviously incorrect in the case of the Brick Country House and also questionable in that of the concrete one.[9] Moreover, there is evidence of at least one additional Mies van der Rohe design from this period, generally unknown, that could be ranked with some justification along with the two just named. This is the commission—never executed—for the Lessing House from 1923, for which only a floor plan survives (Pl. 2.1).

Consequently, a new grouping of the early projects is indispensable. The present attempt to integrate them into the entire context of the residential designs is intended as a first step in this direction.

"The introduction of reinforced concrete as a building material in residential construction has been attempted repeatedly before this—generally, however, in an unsatisfactory manner. Neither have the good qualities of this material been exploited nor have its poor qualities been avoided. It was thought that by rounding the corners of the house and those of individual rooms one was adequately giving the material its due. Such round corners are utterly irrelevant so far as concrete is concerned, and by no means easy to construct. Naturally it is not enough merely to translate a brick house into reinforced concrete. The chief advantage in the use of reinforced concrete, as I see it, is the opportunity to save a great amount of material. In order to realize this in a dwelling it is necessary to concentrate the bearing and supporting forces on only a few points in the structure. The disadvantage of reinforced concrete is its inefficiency as an insulator and its being a great conductor of sound. Therefore it is necessary to provide special insulation as a barrier against outside temperatures. The simplest method of dealing with the nuisance of sound conduction seems to me to be the elimination of everything that generates noise; I am thinking here of rubberized flooring, sliding windows and doors, and other similar precautions, but also of spaciousness in the general layout. Reinforced concrete requires very precise calculation of all plumbing and wiring before it is cast; here the architect has everything to learn from the marine engineer. When building with brick it is possible, if not exactly logical, to turn loose the men installing the heating and plumbing as soon as the house has been roofed. In no time at all they transform the barely completed structure into a ruin. Such practice is naturally out of the question when working with concrete. Here only disciplined planning will lead to the attainment of one's goals.

The model depicted above shows an attempt to deal somewhat better with the problem of reinforced concrete in residential building. The main living area is supported by a four-post truss system. This structural system is enclosed in a thin skin of reinforced concrete, comprising both walls and roof. The roof slopes downward slightly from the exterior walls toward the

6 Glaeser, *op. cit.* (note 1), unpaginated.

The corresponding passage in Johnson, *op. cit.* (1978; note 1), p. 21, reads: "In the first few years after the war, Mies van der Rohe published a series of projects so remarkable and so different from one another that it seems as if he were trying each year to invent a new kind of architecture." And further: "Mies's position as a pioneer rests on these five projects" (p. 34).

7 An example is the Mosler House, which is not discussed here, a two-story structure from the years 1924 to 1926 with a plain exterior, hip roof, and symmetrical facade treatment. The Wolf House in Guben also fails in some respects to achieve the design quality of the preceding projects.

Concerning the Mosler project see Renate Petras, "Drei Arbeiten Mies van der Rohes in Potsdam-Babelsberg," *Deutsche Architektur*, Vol. 23, No. 2, February 1974, pp. 120 f. There one also finds the only published illustration of the house (illus. 3, p. 121).

8 Glaeser, *op. cit.*, the catalog of the Berlin exhibition of 1968, and Johnson, *op. cit.*, 1978, correctly date the skyscrapers to 1921 and 1922, respectively, but assign as the conception dates of the remaining three projects the years 1922 and 1923, respectively, thereby shrinking the critical period to from a year and a half to two years (i.e., December 1921 to the beginning of 1923).

9 It remains true, however, for the second skyscraper design and the Concrete Office Building, quite apart from the fact that in both cases a specific site—presumably in Berlin—could have served as a starting point.

Gotfrid, *op. cit.* (note 4), p. 65, confirms this assumption for the second glass tower: "The form of the building grew out of the restrictions *of a given site...*" (italics mine).

center. The trough formed by the inclination of the two halves of the roof provides the simplest possible drainage for it. All sheet-metal work is thereby eliminated. I have cut openings in the walls wherever I required them for outside vistas and illumination of spaces."

Mies van der Rohe, "Bauen" (1923)[10]

The Sources Available

The Concrete Country House was the first of Mies van der Rohe's residential designs to develop in the direction set by the two tower projects. It was also the first to bring about a radical break with traditional concepts in this field. For this reason it is only proper that it stand at the beginning of this chronological investigation.[11]

The Concrete House became known primarily in the form of the frequently published charcoal drawing, an image that has decisively shaped our understanding of the project to this day (Pl. 1.4). For all its artistic quality, it nonetheless presents only an incomplete picture of the original conception, since the corresponding model has not survived and is only preserved in the form of two photographs (Pls. 1.2, 1.3). A letter from Mies to Gropius at the time makes clear that the model was mostly made out of plaster, which may explain why it disintegrated so soon.[12] It is possible that it did not even survive the Great Berlin Art Exhibition, where it was displayed from May to September 1923.[13] Later reference to it is nowhere to be found, though the letters do refer to the whereabouts of the skyscraper model of the previous year that suffered a similar fate.[14]

Specific references lead one to suspect that the charcoal drawing is of a later date and was in fact based on the model—which would accord with common studio practice at that time.[15] The drawing differs from the model in the omission of one of the terrace levels and the addition of a roof over the door on the courtyard side, and also in the subsequent blacking out of the basement windows on the projecting wing to the right of the courtyard. As in the model, the windows originally continued as an unbroken band around the corner of the house. Moreover, the wooden base of the model is clearly suggested by the broad band across the foreground, tapered by perspective. Here it has been reinterpreted as a retaining wall, thus apparently triggering a further terracing of the site. Everything therefore seems to point to a subsequent reworking of the model design—which ultimately confirms the central importance of the model in the planning process.

Another, previously little-known charcoal drawing shows the basement windows but otherwise corresponds precisely to the sketch already discussed, save for a line of trees that appears behind the structure.

10 Quoted from Ludwig Mies van der Rohe, "Bauen," *G*, No. 2, September 1923, p. 1.

11 The residences from the years 1907 to 1924 were doubtless of quality, still indebted as they were to the Berlin neoclassicism revived by Behrens. They must be left out of this discussion primarily for lack of space, but also because of the mostly fragmentary source material.

12 Mies to Gropius, June 14, 1923; LoC.

13 *Grosse Berliner Kunstausstellung 1923, op. cit.* (note 5), cat. nos. 1272 (drawing) and 1273 (model).

The model was not included at any of the later exhibits (as far as can be determined on the basis of extant catalogs), which argues for this assumption.

14 Gera Art Association to Mies, February 13, 1925; LoC: "The plaster facades that were supposed to be placed around the glass building have suffered the most; to a great extent these were broken on arrival. Please let us know whether we are to send the surviving pieces back to Berlin along with the models."

A surviving invoice from the model builder, Albert Lugino, dated March 8, 1923 (MoMA), may indicate that these had already been replaced once. The bill includes: "1 model constructed in a curve with 2 endpieces. 1 model constructed with a straight front with 2 endpieces. Material: ¼ sack of plaster." It cannot, of course, be proved from this alone that reference is to the model of the glass tower of 1922—unless one accepts my own opinion and replaces the confusing term *curve* with *angles.*

15 This has been confirmed by Sergius Ruegenberg, Mies van der Rohe's assistant from November 1925 to July 1926 and again from September 1928 to February 1931.

This would also explain why a remarkable number of the perspective views correspond to the completed structures or to the final versions of the projects. In contrast with the ground plan sketches, most of the projection drawings are thus not drafts in the narrowest sense, but often only views documenting the various planning stages.

Everything seems to indicate that this one is the original version exhibited in Berlin in the summer of 1923. Presumably the published version was created for display at the International Architecture Exhibition put together by Gropius at the Weimar Bauhaus a short time later. The preparation of an additional drawing may well have been necessary on that occasion, inasmuch as the two events overlapped by several weeks, and Mies saw no possibility of sending his designs to Weimar before the close of the Berlin exhibition.[16]

It is by no means clear, however, for what purpose the two unpublished pastel renderings were made (Pl. 1.1). They too are based on the above-mentioned view; perspective, field of vision, and scale in both cases have been carried over unchanged. The unretouched band of windows and the line of trees in the background place them in direct proximity to the earlier charcoal version, so that now a relatively certain chronology can be produced for the various plans. Working from the model, Mies must have first made the lesser-known charcoal drawing, which is distinguished from the other three by its somewhat firmer lines. He then experimented for a time with the coloration of the building before finally returning to his more familiar medium in the fourth and last version, which was the only one published.

As is the case for nearly all of Mies van der Rohe's early projects, there are no surviving sketches or preliminary studies for the Concrete Country House. It is actually because of the extremely fragmentary nature of the sources that we now, looking back, tend to submit to the impression that here, as though with one stroke, the breakthrough into the "modern" was made. What is today presented as the work of only half a decade (1919-24) is in fact the end product of a radical change in the architect himself, supported by a general cultural upheaval. The route that led him to this point—his still-groping search for new means of expression—cannot be retraced in detail. The equation of spontaneity with creativity that is frequently met with in the popular view of modern art, that widespread and often consciously encouraged notion of the instantaneous realization of an artistic idea, most certainly does not apply to Mies, as the model of the Concrete House amply demonstrates.[17] Exhibition or presentation models designed primarily for a lay public, in contrast to simple working models for use within the studio, were not produced in the studio itself at that time, but contracted out to shops set up especially for their manufacture. For this purpose detailed plans and specifications were required; as a rule, the architect or his colleagues had to make elevation drawings and cross sections in addition to floor plans.[18] It is obvious that none of this could be accomplished without painstaking preparatory planning.

The countless drawings that have survived from certain later projects provide an approximate notion of Mies van der Rohe's working method. These sketches on simple tracing paper, generally in his own hand, registered—with at times only the tiniest changes—all conceivable variants of a floorplan scheme before a solution to which he was committed began to evolve.[19] The same compulsive striving for perfection is also evident in the manuscripts of some of his aphoristic statements on architecture published in the twenties.[20] This tendency toward perfectionism may be seen as a consistent trait of Mies van der Rohe's character. Accordingly, the design of the Concrete Country House must be understood to be the end result of a painstaking process of planning, even if we are no longer able to reconstruct its course.

16 The International Architecture Exhibition was but one event within the framework of the first major Bauhaus exhibition held in Weimar between August 15 and September 30. The architecture portion was also shown later by itself in various German cities. No catalogs have survived, but the correspondence with Gropius from that time permits us to identify beyond any doubt the design that Mies placed at his disposal (correspondence between Mies and Gropius, June 4, 1923, to January 11, 1924; LoC).

Mies denied Gropius's request for the model because he would not be able to remove it from the Berlin exhibition (letter of June 14). But the large charcoal drawing was also being shown in that exhibition. Therefore it is tempting to assume that a second version was prepared specifically for Weimar.

17 This may, of course, be valid for certain "architectural" fantasies produced under the aegis of Expressionism. With some reservations, Bruno Taut might be mentioned as being a typical representative of this trend, in addition to Krayl, Finsterlin, and various figures on the margins of the Expressionist scene. This is especially true of the illustrations for his early writings (*Alpine Architektur*, Hagen, 1919, and *Die Auflösung der Städte*, Hagen, 1920), which must, however, be interpreted from a completely different point of view.

18 Just such a plan has survived for Mies's submission to the Krefeld Golf Club competition in 1930, since the model was never constructed. Werner Gräff, who had met Mies in 1922 and was on relatively intimate terms with him by virtue of their collaboration on the journal *G*, mentions that at one time the sculptor Oswald Herzog was employed in the construction of Mies's models. (Copy of a taped interview with Werner Gräff by Ludwig Glaeser on September 17, 1972; MoMA.)

19 For the Resor project, for example, the number of sketches runs to well over a thousand.

20 Manuscripts preserved among Mies's papers permit us to see how at times a single sentence was reworked again and again for page after page until being given its final form.

Dating

Traditional dating of the Concrete House to the year 1924 is clearly inaccurate since the model had been exhibited in Berlin in the previous year[21] and a drawing had been shown in the Weimar Bauhaus exhibition in the autumn of 1923.[22] Immediately afterward there was also an exhibition of the Dutch de Stijl movement organized by Theo van Doesburg in the Paris gallery L'Effort Moderne, which belonged to the art dealer Léonce Rosenberg. Van Doesburg, a co-founder and driving force of that group, had personally urged Mies to participate as the only nonmember.[23] Again Mies contributed a drawing of the country house.[24] In September his article "Bauen" (Building) appeared in the second number of the periodical *G*, dealing at length with the design and including a photograph of the model. A portion of this article appears earlier in this chapter.[25]

The earliest firm date, then, is the opening of the Great Berlin Art Exhibition on May 19, 1923. From the correspondence with Gropius and van Doesburg it becomes apparent, moreover, that Gropius first saw the project at that event, and that van Doesburg clearly did not know of it at all.[26] Yet van Doesburg and Mies were in relatively close contact before that time, so that the artist was generally well informed about his colleague's current endeavors. Therefore a date for the genesis of the project before the beginning of 1923 is unlikely.

In itself, the result of these researches would be of limited significance if this new dating did not at the same time provide a complete rearrangement in the previously accepted sequence of the projects. Though up to now the Concrete Country House has generally been placed at the end of the series, it belongs without question before the Brick Country House, which was not conceived until 1924. It was therefore closer to the period of the office building, with which, in spite of many differences, it shares a common principle of construction.

Prerequisites for an Analysis

The loss of the model might suggest that we are dealing with a design for which only fragmentary evidence survives. The photographs give only two views of the building, so that the wall arrangement on the sides turned away from the camera cannot be studied. The same applies to the interior arrangement, the spatial and functional aspects of which can only indirectly be deduced from the overall layout and the varying size and disposition of windows. No floor plan has been published, and we can be relatively certain that—aside from the lost sketches and working materials for the model builder—none ever existed.

The extraordinary quality of the design is, however, confirmed by the fact that we scarcely feel the need of additional material. The clarity of the organization of the building complex renders most other materials largely expendable, if not entirely superfluous. Mies's decision not to indicate separately the disposition of the interior space clearly shows, moreover, where the emphasis of an interpretation is to be placed: obviously he was concerned with a balanced grouping of volumes, but also just as much with the relationship between the structure and exterior space, here defined in a fundamentally new way.

For another thing, one must not focus too one-sidedly on the structural features that Mies himself stressed so exuberantly. To be sure, there is a close relationship between the method of construction and the exterior appearance of the house, but this is hardly paramount—unless of course one chooses to elevate construction to the status of an end in itself, thereby substituting a primacy of technique for the primacy of form. That, however, would be tantamount to granting technology a value per se, while strictly speaking it can always be only a basic element—a means, so to speak—in the service of other, higher goals. Mies pointed out that the chief advantage of reinforced concrete is the saving of material that can be achieved by concentrating bearing strength on a limited number of spots in the building (columns shifted inward). The design advantages of this principle are only mentioned in passing, however: in the exterior walls, now for the most part unburdened, one can place windows practically anywhere one wishes and make them of virtually any size desired, creating ideal conditions for views of the outside and the exploitation of sunlight.

Is this really to be thought of as nothing more than a welcome side effect? After all, the absolute prerequisite for the design of a free floor plan is here provided for the first time. Should we not then proceed conversely, recognizing that there was an unequivocal priority of the concept of space

21 See note 3.

The date of 1924 is to be found for example in Johnson, *op. cit.* (note 1); Arthur Drexler, *Ludwig Mies van der Rohe*, New York, 1960; Werner Blaser, *Mies van der Rohe: Die Kunst der Struktur*, Zurich/Stuttgart, 1965.

Glaeser, *op. cit.* (note 1), the Berlin exhibition catalog of 1968, and also Johnson, *op. cit.* (1978; note 1) shift the time of conception correctly to 1923, but retain the old sequence of the projects by dating the Brick House to 1922. The correct date appears frequently in the prewar literature, as for example in Walter Gropius, *Internationale Architektur* (Bauhaus Books, No. 1), Munich, 1925; Gustav Adolf Platz, *Die Baukunst der neuesten Zeit*, Berlin, 1927; Paul Westheim, "Mies van der Rohe: Entwicklung eines Architekten," *Das Kunstblatt*, Vol. 11, No. 2, February 1927, pp. 55-62.

22 Mies to Gropius, June 14, 1923, and also July 27, 1923; LoC.

23 The title of the exhibition: Les Architectes du Groupe "de Styl." Projets et maquettes par Theo van Doesburg, C. v. Esteren, Huszar, W. v. Leusden, J.-J. P. Oud, G. Rietfeld, Mies van der Rohe, Wils. Galerie "L'Effort Moderne." Paris, October 15 - November 15, 1923 (taken from the printed invitation to the opening of the exhibition; MoMA).

Van Doesburg's invitation to Mies was in the form of a letter written on July 28, 1923; LoC:

"At the beginning of October there is to be an extraordinary show of the very newest architecture in Paris (Galerie Rosenberg). Paintings will also be shown in immediate juxtaposition with the architecture. It is most important to begin making preparations right away for participation in this show. I would like to invite you most cordially to take part. Since there are many possibilities for actualization (construction) here, it is very important that you send some of your very best works to my address before the first of October. Models with explanatory drawings would be best. I have often shown people here your photograph of the glass skyscraper, and everyone is enthusiastic about it. Please let me know as soon as possible whether you would like to take part in this exhibition and how much space you would want. I enclose a sketch of the exhibition room. Eagerly, with friendly best wishes, Theo van Doesburg."

According to Hans Richter, van Doesburg and Mies had definitely met in 1921, for he himself had introduced them (see Hans Richter, *Begegnungen von Dada bis heute: Briefe, Dokumente, Erinnerungen*, Cologne, 1973, p. 53).

that suggested the use of new materials and new methods of construction in the Concrete Country House? Or, put another way, does technological development alone lead to new forms of dwellings or do changing personal and artistic needs require the exploitation of existing materials and methods and the application of new ones? Construction, no matter how deserving of attention as the medium in which a formal idea is expressed, can never itself become the sole focus of the design process. If it does, one risks the danger that that very process may degenerate into hollow formalism. And the two country houses are certainly far removed from that.

Inasmuch as Mies limited himself to only a few suggestions regarding the interior arrangement of the Concrete House, one might easily get the impression that he more or less neglected this central issue in favor of other considerations. As will be shown in detail, however, the project makes a distinct contribution in precisely this regard. Thus the idea that this design is merely a study must be rejected at the outset; we must instead consider the Concrete Country House to be a fully developed project, one that in every respect does full justice to the complex demands of residential design.

Siting and Entry Solution

The surviving drawings and photographs permit an approximate reconstruction of the overall site—some knowledge of which is essential for a correct understanding of the design. For the moment, at least, we must set aside the question of to what extent Mies had a specific property in mind. Neither the model nor the drawings give any indication of compass directions, but a hypothetical orientation of the building (Illus. 3) can be made from the location of the living area. This wing, with its windows on three sides, can be assumed to have a north-south axis, with the huge fireplace block at the closed north end of the large room. The front of the projecting main entryway would accordingly face west, while the two-story wing branching from the side of it first extends to the north parallel to the street, then turns toward the east.

The site has quite pronounced differences in level. However, the ground contours as we see them have been graded and replaced by terracelike stages. Within the given spatial boundaries, the surroundings

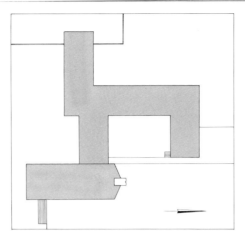

Illus. 3 Concrete Country House, floor plan (reconstruction).

have been subjected to the same strict creative control that dominates the structure itself. The property slopes downward from the higher southern edge toward the northeast and northwest. In between lies a narrow, elevated area with retaining walls on either side that divides the exterior space into two completely independent sections, a front court facing the street and the garden proper. There is no connection between them; the garden can only be reached from the living room.

The approach to the house consists of an elongated forecourt on the southwest corner of the property (Pl. 1.2, pictured on the right). A high wall here serves to screen off the backyard, while on the other side the retaining wall rising from the lower level of the front court forms only a low balustrade. Both the absence of a corresponding screen against possible views from the south and the requisite easy access of the service wing permit us to deduce the position of the street, which would accordingly have to run along the western boundary of the lot. A quite similar layout can be seen a few years later in the two Krefeld villas (the Lange House and the Esters House), and somewhat later still, though in altered form, even in the Tugendhat House in Brno.

Leading off from the forecourt is an entryway of considerable length, open on the sides, with a deeply projecting roof resting on four beams and supported on columns inside.[27] At the front end of this entryway, and extending across its entire width, are steps leading up to the higher level of the living area. The combination of the steps and the open vestibule creates an entryway of surprising monumentality—a solution

24 Mies to van Doesburg, November 8, 1923; LoC:
 "Considerable difficulties arose here in connection with the shipping of the models, so that to my regret I had to abandon the idea of sending them to you. I did send to your address in The Hague a perspective, a photograph, and a cross section of the office building, as well as a perspective of a country house in reinforced concrete and one of the glass skyscraper for Friedrichstrasse."
 (Owing to the tense situation following the French occupation of the Ruhr, the shipment to Paris had to be first sent to The Hague.)
25 See note 10.
26 Van Doesburg mentioned only the model of the Glass Skyscraper (postcard to Mies, August 20, 1923; LoC).
27 The columns that can still just barely be seen in the original negatives correspond to those of the large living room, but are clearly closer together. As in the Concrete Office Building they obviously support the ceiling beams enclosed in concrete (in one instance Mies calls them "railway cantilever beams"; see note 48).

that is virtually unique for this phase of modern architecture. Neither Frank Lloyd Wright nor Le Corbusier, nor least of all Gropius, ever created anything comparable for a residence; presumably they never attempted to.[28] Such a thing would have seemed almost grotesque to the later "Functionalists."[29] One comparable solution, however, is the entryway of Mies's own Concrete Office Building, conceived at about the same time or perhaps a bit earlier (Illus. 2). Since an analysis of this last building can provide important insights for the further interpretation of the country house project, let me interpolate a brief discussion of it here.

Excursus
— The Entry Solution in the Concrete Office Building

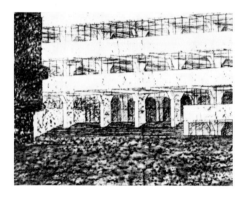

Illus. 4 Concrete Office Building, entryway (detail).

The entry of the office building (Illus. 4) is situated slightly off center on one of the structure's long sides. It extends across more than four axes of the first floor, the parapet of which has been cut out, or more precisely, bent inward here to serve at the same time as facing for the stairs. There is no demarcation against exterior space until the upper stair landing, and there it is scarcely visible because of the utter transparency of the partition wall made entirely of glass. This, together with the uninterrupted positioning of the pillars and the unifying element of the ceiling continuing over the entire area, marks the entry as merely a subordinate portion of the first-floor space. Even at first glance we relate the entry to the interior of the building, yet in fact it stands outside (a situation clearly underscored by the use of the parapet as its lateral boundary). The entry thus provides an uninterrupted, "flowing" transition between inside and out.

The deep displacement of the transition zone and the absence of demarcation from the interior space produce a kind of vacuum effect that threatens—intensified as it is by the sense of depth created by the steps themselves, their lateral facings, and the longitudinal orientation of the columns—to destroy the spatial equilibrium of this floor of the building. This negative aspect of the opening toward the outside is only checked by the total, homogenous effect of the structure's sharply outlined, blocklike bulk. This homogeneity derives in turn from the regular superimposition of one floor upon the next, or, to be exact, on the sixfold repetition of the motif of the concrete parapet of more than a man's height, which acts as a horizontal barrier against the undermining of the entryway and restores the visual balance.

The posture of the architecture in this encounter between interior and exterior space thus remains essentially passive—a fact given almost symbolic expression in the "retreat" of the entryway. The increased pressure of exterior space exerted on this spot is not intercepted and diverted by means of projecting structures, but is, instead, counterbalanced almost exclusively by sheer mass. For this reason, the effect of mass is further enhanced by the increasing projection of each floor beyond the one below.

28 More imposing entry solutions, often with a round-headed portal, can be found here and there in the early work of Frank Lloyd Wright. Perfectly convenient axial referents are here consciously ignored or checked by means of porches or projecting terraces screened by balustrades and with the ascent on the side (Heurtley House, 1902). Here the monumental effect appears markedly softened. In the later Prairie Houses the main entry is predominantly understated, at times almost hidden (Robie House, 1908).

29 The term *functionalism* is here used exclusively in the narrower sense, and is by no means to be applied to the modern movement as a whole. Basically only those who were hostile to any aesthetic approach to architecture, such as Hannes Meyer, the second director of the Bauhaus, and Ernst May, municipal building commissioner in Frankfurt, may be properly labeled as "functionalists." These men were exceedingly committed to social concerns and tended to scorn all aesthetic considerations, therefore all traces of *art* in architecture.

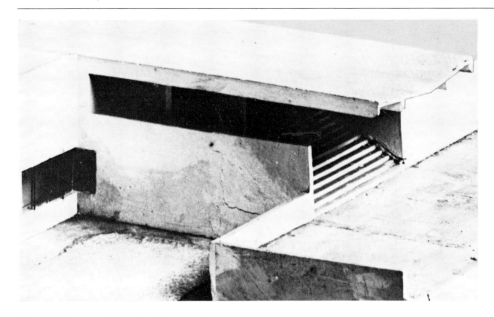

Illus. 5 Concrete Country House, entryway (detail).

The Concrete Country House presents a different picture, however. The totally different nature of the assignment precluded any direct adoption of the solution worked out immediately before. In contrast to the office building, its entryway is clearly marked as an independent structure only casually attached to the dwelling itself. The end facing the yard appears to be completely closed, and there the roof lies flush with the exterior wall, without overhang or transition of any kind. In defiance of traditional practice, then, all formal distinction between horizontal and vertical surfaces has been expressly omitted. This basically equal treatment of roof and wall produces an impression of blockiness in the exterior, one that becomes even more pronounced in the core structure branching off from the side.

To a degree, the same can be said of the open front portion of the entryway (Illus. 5). Thanks to the inside system of support, the exterior walls were relieved of their bearing function and could be cut away back as far as the beginning of the perpendicular wing, so that they rise only to the height of a balustrade.[30] The roof slab projecting freely above them rests on four concrete-enclosed steel beams. While embracing the outer beams, it provides a more solid spatial definition to the sheltered area than it could possibly have had it ended as in a simple cross section. The apron thus suspended from its sides lies on a plane with the balustrade below. Both are further connected by means of a narrow strip of wall left in the corner between the two adjacent wings. The balustrades and aprons must accordingly be read as being residual portions of what was the exterior wall before the openings were cut. In spite of a distinct tendency to break apart into its separate components, the unity of the concrete shell—the "skin" as Mies called it—is thus for the time being preserved.

On the front end of the entryway, however, the situation is fundamentally different. The roof here disengages itself from any attachment to the structure and thrusts forward, floating freely over the forecourt. Since there is no marked ending comparable to the aprons along the side, and since the bearing structure is clearly visible, the roof slab acts as though it were arbitrarily cut off. The same applies to the left side wall, which projects like a slender flange above the abutting, but considerably shorter, forecourt balustrade. Its southern counterpart, however, bends at a right angle just at the beginning of the steps and continues at the same height as a freestanding wall dividing the forecourt from the yard. This abrupt extension of the south wall out to the side ushers in the total dissolution of the formerly integral concrete shell. Inasmuch as the shell here breaks up into its separate components, the effect of blockiness in the structure we noted at the beginning is also destroyed. The roof slab and the exterior walls now appear as self-contained elements independent of each other and reaching out freely into the exterior space, thereby pointing to future solutions (the Brick Country House; the House at the Berlin Building Exposition).

The entryway effects a gradual differenti-

30 This "sculptural" approach is confirmed by Mies's own words: "I have cut openings in the walls wherever I required them for outside vistas and illumination of spaces." (See note 10.)

This pronouncement is doubtless to be taken largely in a metaphorical sense, but it sheds considerable light on the planning process nonetheless. Like a sculptor, the architect proceeds from the concept of a solid block (here the structure), giving it its final form by a process of removal of individual pieces of it (here sections of wall).

The possible alternative to this would be a process of addition, attaching independent wall and ceiling elements. Such a change in method, or better in conceptual approach, is evident in the outer end of the entryway, and is consistently carried out for the first time in the ground plan of the brick project of the following year.

ation of spatial contexts between the two extremes of the solidly enclosed interior space that is complete in itself and the undefined and therefore seemingly limitless exterior space. First there is the covered portion of the forecourt, which is not otherwise set off from the remainder of that space, then the open yet separate vestibule marked off by the steps and the defining walls on either side, and finally the inner foyer, presumably separated from the preceding spaces by a glass door. While the structure of the entryway cuts into the U-shaped living area and is thus firmly anchored in it, the wall flung out to the side and the deeply projecting roof slab tie the front of it to the surrounding space.

Between those linking parts, which serve as what might be called transitional zones, extends the vestibule proper, which occupies nearly two-thirds of the entire structure. Although its sides are completely open, a certain spatial self-containment is maintained thanks to the fragment of wall that has been left to suggest the original inclusiveness of the concrete shell. Demarcation from the street on the forecourt end is achieved by the higher elevation of the vestibule. To what degree the windowless area lying behind it that is here called the foyer is provided with a similar demarcation can be answered only hypothetically, given the fragmentary materials available for study. One might argue, however, for the presumption expressed above, namely that it was set off by a glass dividing wall at the point of the intersection of the living wing. For one thing, the office building reveals a quite similar arrangement, which at least suggests that the thought of such a solution was by no means remote to Mies. And for another, the vestibule's being open on three sides, and therefore drafty, would make a protecting wind screen a virtual necessity. A dividing glass door would therefore seem to reflect the architect's intentions most closely. The alternative of a massive partition wall is improbable since this structure is clearly conceived to be a single unit.

The principle of the entryway, to which is accorded the function of mediating between the interior and exterior space, is taken up again in miniature in the two transition zones. On the street end, the roof projection beyond the steps defines a portion of the forecourt. There results an ambivalent area that on the one hand must clearly be considered a part of the exterior space, but on the other hand already suggests the beginning of a demarcation. This ambiguity expresses itself as an indistinct boundary, and is heightened by the manner in which the roof slab ends in simple cross section with no specific termination.

Conversely, the inner foyer is scarcely distinguished in essence from the adjacent interior rooms. Indeed, it is quite possible that there as well the spatial distinctions are similarly slurred, and that a corresponding unbroken transition has been designed, perhaps suggested only by projecting walls.

In contrast to the rather indistinct areas at either end, the vestibule is set off from the two transition zones by clearly recognizable boundaries: the top of the steps on one end and the glass wall on the other (especially if the latter is placed between the innermost pair of pillars, as one must assume it is). The vestibule thus assumes the character of a virtually independent spatial configuration, one whose relationship to exterior space would seem to be most easily compared to that of a free-standing loggia.

So far only the features that serve to set off the vestibule by itself have been discussed. But there are other elements that serve to tie it to the transition zones at either end. The (presumed) glass dividing wall, being transparent, preserves the visual continuity of space though in fact separating it into two sections. The floor level of the vestibule doubtless corresponds to that of the inner rooms. While the steps at the front clearly express the difference in elevation from that of the street, they at the same time provide a means of surmounting it. Moreover, the continuous roof slab, like the continuous ceiling in the design of the Concrete Office Building, serves as a unifying element blurring the boundaries. Nor must one forget the continuous side walls, or balustrades, which extend as freestanding walls into the exterior space. These function as visual guidelines that first serve to locate the entryway, then bend at right angles so as to lead one through to the foyer.

Though these have been dealt with separately for purposes of better understanding, it appears that in fact the two tendencies that relate the entryway to the exterior space, the one toward isolation and the other toward integration, are most closely intertwined. The ambivalent, but by no means discordant, character of the entryway as both transition area and autonomous space must be kept firmly in mind as the essential result of the foregoing analysis. It is only thanks to Mies van der Rohe's extreme consistency as a designer that the contrasting impulses here described were preserved without becoming contradictory.

The Living Room

The southeast wing, which contains the living room and opens onto the backyard (Pls. 1.3, 1.4), modifies the theme introduced in the entryway but places it in a fundamentally different context. Once again the attached end of the structure is closed off and the projecting portion, open to the exterior space on all sides, is overhung with a free-floating roof slab. The openings are here filled with a continuous band of glass, however, and in contrast to the traditional recessed placement of windows, the glass is here flush with the outside of the walls. The shadow area that results from the earlier practice, causing the openings to appear as sculptural depressions and as breaks in the wall when viewed from outside, is thereby totally eliminated. This in turn ensures that the concrete shell enclosing an inner skeleton of steel does not appear to break apart into its components, but seems merely to have been partially replaced by another medium that happens to be transparent. Consequently, the unity and integrity of the interior space are more distinct than in the unglazed entryway, even though the lateral openings, exposing large surfaces to the expansive pressures of exterior space, have been equally generous in both cases. To all appearances, this elongated wing comprises a single large room. It ends roughly at a line indicated by the outermost pair of pillars, beyond which is an open veranda.[31] The sole spatial demarcation between these is once more a transparent dividing wall, while the roof and the side walls continue without a break and underscore the homogeneity of the whole. Differentiating and unifying elements do not balance each other by any means, however. Depending upon one's location and viewing angle, they at times permit the structure to appear to be a complex formation of isolated compartments, while at other times the impression of a unified and

continuous space predominates.

A platform only one step high projects as a terrace beyond the veranda itself, its outer edge conforming precisely to that of the cantilevered roof slab. The balustrade of the veranda may well be interrupted at this point so as to permit access to the yard from the living room.

The spatial sequence of living room, veranda, and projecting terrace just described corresponds in its threefold division to that of the entryway (reading in reverse order, foyer, vestibule, and covered forecourt). A considerable displacement has occurred within the sequence, however. What was formerly the foyer, and limited to a relatively small segment of the whole, has been considerably enlarged, so that now, reinterpreted as a living room, it occupies almost the entire length of the structure. Conversely, what was the spatial center of the entryway, the vestibule, has been reduced to only a narrow strip of veranda. The outermost transition zone has been visibly upgraded by the addition of a floor slab.

The motif of a flight of steps that is so important in the entryway is not repeated here in the same form, since the southern end of this wing lies at ground level as the result of a terracelike elevation of the terrain. Thus the interior floor level presumably extends clear through to the projecting platform. By no means does this platform appear to be only loosely attached, for it is as though the foundation slab of the structure here became visible. The covered terrace is tied considerably more closely to the remainder of the wing thanks to this platform, and is contrasted more distinctly with the exterior space. The steps, however, another important feature of the vestibule, have not been completely sacrificed. Separated from their original context, and rotated 180 degrees, they now run parallel to the eastern outside wall of the living room. In the photograph of the model they form the sole access to the sunken level of the yard that extends over the entire northeast portion of the site. (Since one terrace level has been omitted in the drawings, there happens to be a second access to this area via the three-sided interior courtyard.)

In this arrangement of the flight of steps one cannot fail to notice once more a suggestion of later buildings by Mies van der Rohe. In both the Barcelona Pavilion and Tugendhat House he once again had recourse to this motif. In each case it is char-acteristic that one ascends the steps alongside the building and changes direction on the upper landing. Only then, having reversed one's original direction, does one enter the structure.

Up to now the comparison has been limited to the spatial disposition of the two wings set at an angle opposite each other. Other differences can, however, be pointed out. While the height of the entryway corresponds to that of the central structure, the living room wing juts somewhat above the rest of the complex. Also, this latter wing is attached to the house at the side, and not at the end of this large room, so that a smooth connection is obtained and dovetailing with adjacent rooms is avoided. The inner end of the entryway, by contrast, is firmly anchored in the core of the building. Thus the self-contained living room wing is set off from the whole complex even more than the entryway is, and is thereby plainly emphasized.

Remarkable, moreover, is the continuous ribbon of basement windows that is visible even behind the projecting fireplace block, runs around the structure roughly a foot and a half above the ground, and ends flush with the bottom landing of the steps. In combination with the prow-shaped, pointed "apse"[32] of the living room, this line of windows counterbalances the south-facing openings above. What at first glance appears to be a one-sided orientation of the structure is thus considerably weakened, giving way to a more balanced relationship of tension in which the forces leading in opposing directions are held in check.

In contrast to that of the upper window openings, the glass of the basement windows is set well back from the outer surface of the exterior walls. A narrow, deeply shadowed indentation is thereby produced that separates the foundation from the main floor, depriving the latter of its footing, as it were. On the other hand, the actual structural framework of the building (the concrete columns only faintly visible from the outside) has essentially no effect on the viewer's sense of the structure's support. It therefore appears as if the living room were supported only at its narrow ends, floating like a bridge above its foundation. The fireplace block that serves as one of these two visual supports even heightens this effect in a certain respect: like a clamp, it grasps the seemingly weightless structure, thereby fixing it in its architecturally unsteady position.

31 In the model there appears to be only a narrow platform little more than a meter in width. Only in the drawings is this expanded into a proper veranda.

32 Here again there is a discrepancy between the model and the drawings. In the latter the back end is closed with a straight wall.

This bridgelike wing is a logical consequence of the entryway solution. There too a clear prominence of the central section was attained by means of the insertion of intermediary transition zones, so that within the entire spatial context it enjoys a rather independent status. The forecourt and foyer were the linking elements, between which the vestibule extends without incursions. This is true there only with regard to the inner spatial relationship; here it begins to make itself visible on the exterior structure as well. The building seems to hover above the ground, but since it is anchored on either end it nonetheless remains firmly rooted to the site. The expansion, through the use of reinforced concrete, of the narrow limitations heretofore placed on architecture by the laws of gravity is immediately visible in this deep undercutting of the southeast wing, demanding that we revise the tectonic rules previously thought to be binding. Nevertheless, this liberation by no means occurs merely for its own sake, out of purely formalistic delight in the virtually limitless possibilities presented by the new materials of steel, glass, and concrete. A design such as Lissitzky's *Cloud Props* of 1924, for example, would hardly have met with Mies van der Rohe's approval. By the same token, it is not based on any metaphysical or cosmological claim of the sort that Sedlmayr ascribes to modern architecture in his book *Loss of the Center.* Rather, this is a necessary prerequisite for the opening up of the main floor, the spatial unity of which can only be maintained with the aid of this additional detachment of the structure itself. The ideal of a space open on all sides and yet strictly set off from its surroundings, subliminally attempted already in the entryway, is thereby logically realized here for the first time.

The fundamental impact of the solution worked out in this living room is apparent if one takes a brief look at later buildings of Mies van der Rohe's. For comparison let me refer above all to the Farnsworth House from the late forties (Pl. 21.10). Setting aside all the superficial differences relating to construction and materials, one can clearly recognize in the relationship between the structure and exterior space the decisive similarities between the two designs, and therewith at the same time their very essence. In this respect the Farnsworth House proves to be a restatement, translated into steel and somewhat refined, of

the living room of the Concrete Country House from more than two decades earlier. The two projects thus represent the beginning and the end of the development of an idea that was to experience its ultimate formulation—albeit necessarily a seemingly abstract one—in the years around 1950.

The Central Structure

At first glance, the central part of the building appears to be rather severely closed, compared to the entryway and the living room. In part this is surely explained by the fact that there is no corresponding system of interior supports, so that the exterior walls are forced to bear the entire weight of the roof.[33] This is doubtless a reflection of its function, however; for this area, reserved primarily for the private life of the occupants, a comparable openness to the rooms would scarcely seem appropriate.

The southern arm, which abuts the entryway off center, functions as an anteroom for the large living room, which can be entered only through this part of the house. Given its central location, it is conceivable that it might serve as a dining room, for guests could then be led directly into the imposing living room without having to pass through other areas. With the exception of one side door that opens onto the narrow walkway of the middle terrace level, the southern arm reveals itself to be fully closed on the courtyard side. Accordingly, both this area and the entire northwest wing are protected from undesirable cross views. This expresses quite clearly the careful division made between the social sphere and the private one, and supports the assumption expressed above—namely that one of the main reasons for the considerable difference in external design of the various areas is their widely divergent functions.

The middle section of the U-shaped structure is two stories high on the street side (Pl. 1.2). Long bands of windows open it on the main floor toward the east and west. Judging from the way the light falls through these windows, this floor is divided in two longitudinally.[34] The corridor on the front side, running parallel to the street, connects the perpendicular north wing with the foyer of the entryway. The location of the corridor, its almost completely glazed exterior wall, and its generous proportions

give it an uncommonly public character, so that the term *gallery* might seem more appropriate in this case.

Next to this gallery and facing the courtyard there is a long room (Pl. 1.3) that obviously runs the full length of this middle section. Its distinct function cannot be determined precisely. It is possible that it serves as the workroom of the master of the house, though it might well be a children's room. An all-glass door stands flush against the exterior wall of the southern arm and opens onto the courtyard. In the drawings it is provided with a simple concrete slab roof. In one of two photographs of the model, one can see, to the right of a band of windows extending across the middle of the wall, the top corner of an opening largely hidden by the projecting north wing of the building. The opening may reach around the inner edge of the latter wing and extend along its southern wall. A similar solution has been noted in the corner on the west side just below the entryway. It is equally possible, however, that this is a second door opening, a mirror-image counterpart to the courtyard door at the other end.

If the latter is the case, the exterior of this wall then displays a perfectly symmetrical treatment, an A-B-A scheme (door-window-door). Though this point cannot be definitely confirmed, a solution of this sort does not appear to be farfetched, especially inasmuch as the western facade shows a certain tendency toward a symmetrical arrangement of window surfaces as well. A wall division of such regularity would necessarily lead to a kind of hierarchical upgrading of the U-shaped core of the building, however, lending additional weight to the pattern of a "three-wing layout" that is subliminally suggested by this configuration. The imposing formality that adheres to such a pattern is considerably compromised, on the other hand, by the projection of the living room cutting asymmetrically into the courtyard and checking the full evolution of such a dignified effect.[35] A desire for intimacy and enclosure, apparent after all in the orientation of the building toward the backyard in the first place, was thus unmistakably more important than any need for self-aggrandizement.

The wing that closes the courtyard to the north is fully closed on the two outside walls facing the street except for a single window opening of relatively modest proportions. The space derives its light primar-

ily from the southeast, where the deeply cut and unsupported corner of the house is replaced by a right-angle window. This window provides a panoramic view of the courtyard and the garden area beyond, but at the same time the interior space is screened as completely as possible. Specifically, it is impossible to see into this space from the workroom or children's room diagonally across from it. Since this is surely not coincidental, we may assume that the owners' bedrooms are located here. It follows that the bathroom must be adjacent to them, an observation that completes the complement of the rooms on this level. The lower floor remains for the accommodation of service rooms and staff quarters.

The ground along the lower length of the street has been graded at a level below it, and is marked off from the forecourt above and the adjacent garden terrace by retaining walls. The low level of this front portion of the site permitted the development of a proper ground floor. There are three windows on this floor, one to the north and two to the west. In addition to the kitchen, it would seem that this level also contains a caretaker's apartment, or at the very least a maid's room or two.

The service rooms have their own entrance at the northwest corner of the building, which is deeply recessed for this purpose. This entry is further protected by a cantilevered concrete slab that serves as a visual counterweight to the setback undermining the structure below. Such a display may seem somewhat unusual for a secondary entry, but it is relatively modest compared to the considerably more imposing main entry above. The hierarchy between these two entries reflects on the interior arrangement of floors, maintaining a certain distinction between the relative importance of their respective functions. This is in sharp contrast to the entry solution in the Lange House (Illus. 29), where the service entrance and the front door stand side by side, hardly distinguishable in appearance.

The placement of the kitchen and the servants' rooms in the basement ultimately goes back at least to the scheme of the classical villa, if indeed it was not a feature of Italian palace architecture of the High Renaissance or its medieval antecedents.[36] Since the Wilhelminian era such an arrangement had been the general rule in Germany even in the homes of the upper-middle class.

In spite of all of its undeniable modernity,

the Concrete Country House thus remains closely tied to traditional practices. Subliminally suggested in it is the opposition of a concept of form and space that aims at radical change and an upper-middle-class life style still deeply rooted in the nineteenth century — in other words, the collision of artistic aspiration with the social realities that impose limits on architecture. Unlike many of his contemporaries, Mies not only recognized the difficulties arising from this conflict, but accepted them as presumably unalterable facts and sought to manipulate them accordingly:[37]

"I talked about how we tried to reduce the size of apartments in Berlin and the bankers got twice as much, leaving it still too expensive for the people. It is an economical problem, not an architectural problem. ...You know, there are, in the whole structure of civilization, some facts which are given which cannot be changed. Facts which come from the past. Some have done something and it has influence. We [architects] can lead and guide these factors of reality but we cannot change them."

There are traces of this latent conflict between a desire for unlimited personal freedom and the social restraints that prevent its full realization in all of the country house designs that Mies van der Rohe developed during the twenties and thirties. It can be seen immediately in the predominance given in every case to living areas at the expense of areas obviously subordinate to them. Increasingly, however, Mies understood how to resolve these inner contradictions and integrate them into a single viable organism. One proof of this is seen in his decreasing reliance on typological models as his growing self-confidence asserted itself against the rigid conventions of inherited living habits.

It matters not how one personally responds to this basic attitude in Mies — some are convinced that he is guilty of crass opportunism, others that he is a hardened realist — for the quality of his designs remains unaffected by any consideration of this sort. The fact remains that he influenced the development of residential architecture as decisively as few other people in his time.

The foregoing reconstruction of the floor-plan arrangement can admittedly lay no claim to absolute accuracy. One might well have

33 The drawings and the photographs do not give precise information about the construction of the central structure. The architect's own statement, however, appears to leave little room for doubt: "The main living area [not the entire structure, then] is supported by a four-post truss system." (See note 10.)

34 In the photographs of the model the light entering from the west falls on a wall, while on the opposite side only the floor is illuminated. Accordingly, the room on the east side must be considerably wider than the corridorlike space facing the street.

35 The same principle can be observed without exception in all of the Prairie Houses of Frank Lloyd Wright. Take as an arbitrary example the Thomas H. Gale House of 1909; its front section is arranged with strict symmetry, a fact that is apparent only when it is viewed from the front, which is to say in detail, for by contrast the complex as a whole is made up of freely interlocking pieces.

36 The kitchen of the Farnesina, for example, was located in the raised cellar floor of the villa. See also Christoph Luitpold Frommel, *Der Römische Palastbau der Hochrenaissance*, Vol. I, Tübingen, 1973, pp. 81 f.

37 "6 Students Talk with Mies" (interview with Mies van der Rohe on February 13, 1952), *Master Builder* (student publication of the School of Design, North Carolina State College), Vol. 2, No. 3, Spring 1952, pp. 21–28, quote p. 24.

basic reservations about the advisability of such an endeavor in the first place, inasmuch as it is clear that Mies himself deliberately refrained from providing detailed drawings. I have attempted a clarification nevertheless, because I am firmly convinced that the design is the result of a program thought out to the smallest detail. If this is the case—and all the evidence suggests that it is—then the deciphering of such a program represents a prerequisite without which a true understanding of the project is scarcely possible.[38]

Tradition and Progress

"The trouble now-a-days is that there is no tradition whatsoever."

Mies van der Rohe[39]

Any analytic procedure necessarily entails the breaking down of the object under investigation into its separate parts. But to do that and nothing more would mean not only that one is left with a more or less fragmentary sense of the whole, but also that one runs the risk of providing a false interpretation. With respect to the Concrete House project one might for example have the impression, seeing various reminders—at times quite obvious ones—of building types from previous epochs, that Mies was here employing a subtle kind of "historicism," though it is one, to be sure, that recalls not so much the forms as the arrangements of older models from the most varied of sources. Since the most important of these have already been discussed in detail, a brief summation should suffice here.

Both the entryway and the living room derive from the portico and loggia, two elements of classical palace and villa architecture. The same tradition has influenced the arrangement of the front of the house along the street, the main floor of which, placed above the domestic functions as it is, has distant traces of the *piano nobile.* The light-flooded corridor as a specific type of space made its first appearance in French palace architecture, from which the designation *gallery* used here is ultimately derived. And this is also the source of the three-wing layout evoked in the central structure of the building, a motif that was given its ultimate formulation, thanks to the assimilation of Italian influences, in the Baroque era in France.

The reason this analysis was so detailed

was to show that none of these motifs that developed over the course of centuries has been taken over for its own sake, but rather because it offered itself as the most practical solution in the specific instance. Therein, and this must be particularly stressed, lies the fundamental difference between Mies's manner and a mere imitation of styles so typical of countless buildings of the late nineteenth century. Such historicism, decadent and vulgar, and against which the representatives of modern architecture were to take a stand, employed inherited forms primarily as mere stage sets, or at most for their civic connotations (columns and pediments) or emotional ones (Gothic oriels, miniature towers, etc.). In this sense the best-trained architects of the Wilhelminian era compiled their structures out of assimilated textbook knowledge almost exclusively, having virtually lost any ability to function creatively. On the other hand, it is true that architects of every age have been inspired by buildings in earlier styles, a fact historians of modern architecture have frequently failed to take into account.

None of the motifs that Mies has incorporated here are in themselves free of connotations, to be sure. All of them derive from a specific order of buildings that could be classified roughly as "seigneurial architecture," including palaces, villas, and manor house complexes. Wherever these motifs are used, they unavoidably bring with them evocations of that sphere. As has been demonstrated above, the Concrete Country House is in this respect no exception. But it is a question how much these evocations, which surfaced only gradually in the course of this investigation, are subordinate to more important impressions. In analyzing details one always runs the risk of placing them excessively in the foreground; a balanced interpretation must always proceed from the total effect of the building. Quite a different picture results if we do so here.

As far as the U-shaped central section is concerned, it was clear at the outset that the connotative character of such an arrangement is drastically curtailed by the fact that the asymmetrical living room juts out in front of it. But for that matter, asymmetry as a law of composition dominates the entire building. The free play of forces prevails, a free relationship between the structures and exterior space. The arrangement and subdivision of the building's parts were not determined in accordance with a preexistent scheme, but rather out

of consideration of their function. Thus it is significant that the entryway is placed eccentrically rather than axially, with the result that it provides optimal access to the separate wings with a considerable saving of space. It must be noted as well that in spite of its prominence, the living room does not in fact occupy a central position; rather it is placed so as to offer the most favorable conditions for "vistas and illumination of spaces," and also in such a way that it screens the view into the sleeping wing across from it by being closed on the north end.

If the design gives the impression of monumentality, then, it is not because of the introduction of formal echoes from without, but rather because of the integrity of the building itself. The entryway creates its effect only secondarily by evoking recollections of a portico; it is instead the design principle common to both that succeeds in arresting the viewer's attention—the immanent conflict between dividing and unifying elements, the quality of being an enclosed space and at the same time largely open to the outside. Inasmuch as this effect is attained in each case by totally different means, the originality of Mies's design is in every respect unquestioned, even though as a student of Peter Behrens he was doubtless intimately familiar with the possible prototypes. It was certainly Behrens who managed to direct the attention of his erstwhile collaborator toward the essence of classical—or, more precisely, neoclassicial—architecture. Mies later confirmed that it was thanks to him that he finally developed a feeling for the "grand form," a sense of the monumental.[40]

One thing seems worth noting in this regard. Contrary to widespread opinion, in part deliberately promoted for purposes of propaganda, modern architecture did not make a break with history, but consciously adopted its achievements and sought to build upon them. Behind the presumed fundamentally new beginning that took place in the years just before and immediately after the First World War there run uninterrupted strands of development that clearly exhibit this historical continuity. Colin Rowe was one of the first to succeed in demonstrating this in the case of Le Corbusier.[41]

On closer inspection, furthermore, the origins of Mies's concept of architecture can be narrowed down considerably more than the recital of his historical sources would lead one to think they could. All of

the forms referred to—portico, loggia, gallery, three-wing layout—were present in Berlin in the first half of the nineteenth century, where they were taken up by Schinkel and his students and subjected to a new synthesis in the open villa complexes of the immediate vicinity, such as the Charlottenhof and the Gärtnervilla near Potsdam (Illus. 6, 7). As Eva Börsch-Supan was able to demonstrate most convincingly, these reveal a direct connection to the reawakening of interest in the country house of antiquity.[42] In both of these we are struck by the free, asymmetrical grouping of structural masses, a kind of planning that was elevated to the level of dogma during the twenties, and which gave the residences of Mies van der Rohe their characteristic stamp. The concept of the "country house" that has since become quite common, and was also chosen by Mies, found unreserved acceptance in the terminology of New Architecture, while the more imposing term "villa," with its more specific connotations of symmetry and a preponderance of columns and pediments, was generally rejected in Germany. Both, however, serve to illuminate the connection between Berlin modernism and Prussian classicism. And it is there, in the neoclassical tradition of Berlin as revived by Behrens (the Kröller-Müller project, the Wiegand House; Illus. 8, 9), that one ultimately finds the point of departure for Mies van der Rohe. In this respect he stands squarely among the successors of Schinkel.[43]

The Composition Scheme

The picture of the Concrete Country House presented here requires one final correction. This analysis began with the assumption that the entire complex is made up of three relatively independent structures: entryway, central section, and living room. This view is encouraged by the differences in construction of the separate wings and their varying degrees of openness to exterior space. On closer inspection, however, this perfectly logical breakdown appears to have only limited validity. The entryway and central section, for example, are tied quite closely together, and from a normal viewpoint—unlike the elevated one from which the photographs of the model were taken—they might well be perceived as a single unit. Furthermore, the division of the com-

Illus. 8 P. Behrens: Villa Kröller-Müller, inner courtyard (proposal, 1911/12).

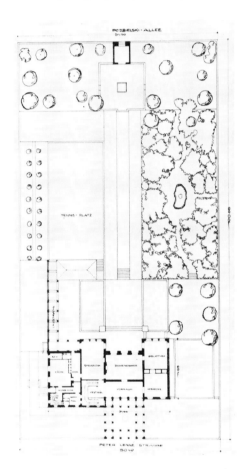

Illus. 9 P. Behrens: Wiegand House, floor plan and garden layout (1911/12).

plex into two strictly separate sections in terms of function seems to correspond in crucial aspects to the visual impression the building makes—and to contradict the initial assumption. The southern arm of the central section must then be taken out of its previous context and seen as being aligned instead with the living room. The result is a configuration of two main structures, each broken at right angles,

38 Johnson also points out the division of the house into strictly separate functional areas, but fails to provide any more detailed identification:

"The different areas, i.e. living area, sleeping area and service area, are isolated from each other in an admirably balanced swastika-like plan that combines the maximum of indoor and outdoor privacy with the minimum dispersal of architectural units."
(Johnson, *op. cit.*, note 1, p. 30.)

39 "6 Students Talk with Mies," *op. cit.* (note 37), p. 22.

40 "Mies in Berlin," *op. cit.* (note 2).

41 Colin Rowe, "The Mathematics of the Ideal Villa" (first published in 1947), *The Mathematics of the Ideal Villa and Other Essays*, Cambridge, Mass./London, 1976, pp. 1-27.

42 Eva Börsch-Supan, *Berliner Baukunst nach Schinkel: 1840–1870*, Munich, 1977, especially pp. 89-97.

43 See also Westheim, *op. cit.* (note 21).

Illus. 6 K. F. Schinkel: Charlottenhof near Potsdam (1826).

Illus. 7 K. F. Schinkel: Gärtnervilla in Charlottenhof (1827–33).

joined to a third, fragmentary wing. If one is willing to consider the northern extension of the forecourt, projecting as it does out into the front yard, to be part of the third wing, then this too creates a hook-shaped continuation and thereby repeats the basic form of the two fully developed areas. The geometric center of gravity and the spatial focus of the complex lies in the transition area between the foyer and the living quarters. From there the arms of the building diverge and radiate in all directions into the landscape. In the introductory section of this chapter this type of composition scheme was tentatively defined as a differentiated one, thrusting out into space.

The inherent dynamics of this three-limbed configuration are considerably softened by the fact of the right-angle extension onto each wing, and give way to a more balanced, contained degree of tension. Moreover, these extensions create small courtyards that can in certain circumstances assume an atriumlike quality. This is especially true of the courtyard lying between the living room and the sleeping wing, a space further set off from the surrounding yard by its higher elevation. The architectural manipulation of space is thus not confined merely to the interior, but reaches out into the surrounding areas as well.

Johnson found himself reminded of a swastika when viewing the configuration of the Concrete Country House, an impression expressed later as well by Koeper.[44] But this is a three-limbed figure, a basic form that is somewhat related to the swastika but by no means identical to it. The same motif served as the pattern for the Krefeld Golf Club (Pl. 13.8) and the Gericke House (Pl. 15.16) from 1930 and 1932, respectively, and they conform to the Concrete House in their floor-plan arrangement except for only the most trivial details. This is further proof of the overwhelming importance of this project in the work of Mies van der Rohe, whose development through the next two decades took this design as its starting point. Moreover, the Concrete House was to influence another major exponent of the New Architecture decisively, as the following section will show.

The Dissemination of an Idea

The project obviously left a lasting impression on Gropius. In the arrangement of its

Illus. 10 W. Gropius: Bauhaus Building in Dessau, ground plan (1925/26).

major elements, his Bauhaus Building in Dessau, constructed in cooperation with Adolf Meyer beginning in 1925, clearly relies on Mies's 1923 design. The ground plans of the two buildings are mirror images of each other, and reveal similarities even in details (Illus. 3, 10). Even Mies's alternation of completely open expanses of wall with walls that appear to be more closed is found here in only slightly different form. The studio wing, with its walls consisting entirely of glass (Illus. 12), may take its form from the Fagus Factory (Gropius and Meyer, 1911–14), but in its conception of space it unquestionably derives from the living room of the Concrete House, especially since its two additional floors are scarcely visible from the exterior. Even the effect of seeming weightlessness is common to both structures. While in the earlier design for the house a narrow band of deep-set windows served to separate the living room from its foundation and caused it to appear as if it were almost floating above the ground, a similar effect is achieved in the studio building by means of the dark tones of the recessed base. Like the northwest wing of the house, the classroom wing (Illus. 11) across from the studio building is enveloped in a homogenous outer shell, seemingly embracing both roof and walls. Once again natural light enters through elongated bands of windows, and once again these windows are placed flush with the outer surface of the walls.

A listing of points of comparison could doubtless be continued, but let these few suffice for our purposes. There is no question but that Gropius was intimately familiar with Mies's Concrete Country House project, since it is a matter of record that he had seen the model in the summer of 1923 and that one of the charcoal drawings was

44 Johnson, *op. cit.* (1978; note 1), p. 30; Koeper, Berlin Exhibition catalog 1968 (note 1), p. 52.

later shown at his own exhibition in Weimar. A passage from a letter of his to Mies from June 7, 1923, provides further interesting information. There he wrote:[45]

"Meanwhile, I have been in Berlin and had a look at your works with considerable pleasure. I find the flat factory or office building with its construction based on reinforced concrete beams to be by far the best. It represents a completely new type and has a vitality of design. The business building I find still too schematic; it lacks articulation."

The designation "factory or office building" is of course ambiguous, and it calls for some clarification. Gropius is clearly speaking about the Great Berlin Art Exhibition, which he must have visited during his stay in the city. Mies was represented in it that year by the Concrete House, the Concrete Office Building, and a sketch for a brick building not further identified.[46] The letter does not refer to the brick design, for it can hardly have exhibited a "reinforced concrete construction." The business building that Gropius found over schematic and insufficiently articulated is without question the Concrete Office Building, so he cannot be referring to this design either. Therefore it follows that he must be referring to the Concrete Country House, which he had interpreted as a factory or office building, confusingly enough. His use of the additional adjective "flat" would also appear to argue for this assumption. In his response dated June 14 of the same year Mies accordingly attempted to set him straight. This letter is important in the more general context as well, and deserves to be quoted in full:[47]

"Dear Herr Gropius, I received your letter and would like to say that I cannot remove the plaster model of the concrete residence (Eisenbahnkragträgerkonstruktion), so I can only place at your disposal a photograph of it and a charcoal drawing. The only models I could make available to you are the glass model of my tower and the wooden one of the large office building [Concrete Office Building], and indeed I had thought of combining these two models, placing them next to each other so as to suggest a square. I tried it out, and the effect is wonderful; I believe that you too would understand then why the business building has only the horizontal articulation. I am sending you two photos of these two buildings, and ask that

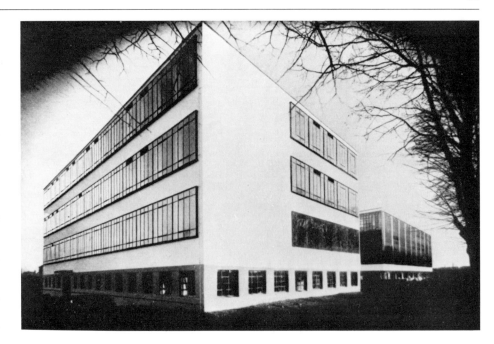

Illus. 11 Bauhaus Building, classroom wing.

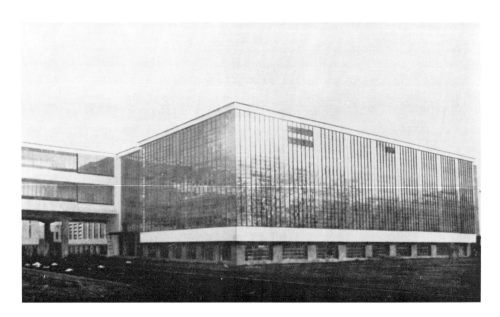

Illus. 12 Bauhaus Building, studio wing.

you return them to me sometime. I would be delighted to be represented by the three projects, so that I could show how the same structural principle works out in three completely different assignments."[48]

It is almost incomprehensible that Gropius, one of the most prominent representatives of the movement, could have committed the faux pas of interpreting a residential project as the design for a factory. On the surface it would appear that Gropius is here falling in with conservative, even reactionary critics, who insisted that the houses of modern architecture all looked like factories. The foregoing investigation has

proved, however, that in this case at least any accusations of vagueness or ambiguity are utterly unjustified. Looking back now, we can see in this misunderstanding the beginning of the substantial influence the Concrete Country House was to have two years later on the conception of the Bauhaus Building in Dessau. Its reinterpretation in that later project is already unconsciously anticipated here.

A Home for the Architect

One crucial question remains to be answered, one that has arisen repeatedly but

which it was necessary to leave until the end. Is it still conceivable after all this that a project so complete, so painstakingly thought out even to the smallest detail, could have been created without a specific commission, with only a vague notion of the personal requirements of a possible inhabitant and without precise knowledge of a possible building site? Or put another way: Is this really a design born solely and exclusively in fantasy as a kind of utopian ideal solution, or is there not a very concrete motive lurking behind these plans? Written documents from before the middle of the year 1923 are exceedingly fragmentary, as has been pointed out. From the crucial period two other residential projects by Mies van der Rohe are known, but these can hardly be related to the Concrete Country House. The Mosler House was begun in the late summer of 1924 and completed in 1925. Theoretically it is not impossible that there were previous sketches for it, for client and architect were in contact as early as 1923.[49] Given the fact that it is a conventional brick building with a high hip roof, however, any connection between the two would be improbable. The Lessing design dating from 1923 and never constructed (Pl. 2.1)—likewise a brick structure and, like the Mosler House, planned for Neubabelsberg—is significantly more advanced, and is therefore closer to the Concrete House than the Mosler design. On the other hand, it reveals considerable differences in the types of spaces required (among other things it provides for two children's rooms). Also, it is based on a concept seemingly designed for a completely different kind of site. Any direct connection to either of these two buildings can accordingly be dismissed with some certainty. Could there have been in the background still another client unknown up to now and no longer possible to trace today?

One last possibility, not yet considered, is that Mies planned this residence for himself. One might object that the unusually lavish layout of the project in all probability far exceeded the architect's resources. The economic situation in Germany since the end of the war had been extremely tense. A catastrophic devaluation was just then approaching its peak, and it struck the middle class most of all. The building market had been in a persistent state of crisis since 1913, one from which it recovered only very slowly even after the currency reform. The income from the few buildings that Mies had constructed up to this point (since

1919 only the Kempner and Eichstätt houses) may just have sufficed to meet his living expenses. They scarcely provided the basis of any considerable affluence.[50]

This idea would also have to be rejected if it were not for one isolated reference that appears to argue for it. On February 14, 1923, Mies wrote to a Herr Albrecht, a factory owner from Friedrichsrode, applying for a possible commission. In that letter he elaborates a bit:[51]

"Dear Herr Albrecht, I have learned that you have bought the property on Schwanenallee, corner of Hasengraben, in Potsdam, and that you intend to build there. Since I have negotiated with Herr Kohlhase over the purchase of that property for my own purposes and am fully aware of the advantages and disadvantages of the site, I would like to propose that I be permitted to provide the design for your house."

This reveals not only that Mies had definite intentions to build since the summer of 1922 at the latest, but also that he had already made an intensive study of the characteristics of the site in question. Even at that time he must have developed a specific idea of the arrangement of his house. He persisted even after these plans failed to materialize. On April 30 of the same year he wrote once more to Albrecht:[52]

"As I hear, you have given up your plan to build on the Schwanenallee property in Potsdam. In the event that you intend to divest yourself of the property, I would be grateful if you would let me know the particulars."

Whether Albrecht had meanwhile responded to the letter of February and asked Mies to submit a proposal remains uncertain, given the fragmentary nature of the surviving correspondence. In the case of a positive reply Mies would have presumably presented his already completed drawings. If we are in fact dealing here with the Concrete House, this could have been the reason for the preparation of the two pastels, which, unlike the charcoal sketches, were never displayed in any exhibition. The abrupt miscarriage of the plan might also explain why the version done in white was left unfinished.

One further consideration confirms the probability that the 1923 design does indeed represent a plan for Mies's own house. Even though the arrangement of the wings

45 Gropius to Mies, June 7, 1923; LoC.

46 See the catalog of the Berlin exhibition of 1923 (note 3), cat. no. 1275: "Brick residence, drawing."

47 Mies to Gropius, June 14, 1923; LoC.

48 In Gropius's letter of June 7 the word *beton* (concrete) in *Eisenbetonkragträgerkonstruktion* was inserted later by hand. Any reader accustomed to old-fashioned handwriting could easily misread this *beton* as *bahn* (railway) in a rapid scanning of the line. Obviously Mies made just such a mistake, for the parentheses indicate that he wished to quote Gropius here. Clearly what is meant is a beam in the form of a railroad track, or what modern usage would call an I-beam.

49 The earliest letter to survive is dated November 14, 1923 (MoMA). However, as early as February 14 Mies could say in applying for another commission that he "will soon be starting the house for Herr Georg Mosler, bank director" (Mies to Albrecht; MoMA).

 Further details regarding the Mosler House are to be found in Petras, *op. cit.* (note 7).

50 It is interesting, however, to note a comment of Hans Richter's *(op. cit.,* note 23, pp. 54 f.), who recalled an incident from the spring of 1924 (when Mies had financed the third number of the journal *G* out of his own pocket): "Between the library shelf and its supports Mies kept a hoard of dollar bills with which he could have easily purchased the whole fashionable street Am Karlsbad."

 We cannot know to what degree Richter was speaking in hyperbole. It is nonetheless apparent that Mies must have had a considerable amount of money at his disposal at that time, so that this assumption does not seem entirely farfetched.

51 Mies to Albrecht, February 14, 1923; MoMA.

52 Mies to Albrecht, April 30, 1923; MoMA.

53 Johnson, *op. cit.* (note 1), p. 20, and illus., p. 18. Westheim is not quite so unequivocal: *op. cit.* (note 21), illus., pp. 60-61 ("L. Mies van der Rohe: Werder House, Sketch, 1914"). Since Johnson was in close contact with Mies, there is no reason to doubt the accuracy of his attribution. Mies may well have made frequent mistakes in the dating of his projects, but it would seem improbable that he would wrongly identify a specific drawing as the design for his own house.

allows an alternate reading, it is undeniable that the entryway and the living room clearly differ from the core structure both with respect to their manner of construction and their openness to exterior space. They are in a certain degree the more advanced components of the design, while the rest of the house strikes one, in the division of its spaces at least, as being comparatively more traditional. From this "stylistic" point of view, the U-shaped center section thus stands out once again as the core of the complex. An arrangement of this kind can be found a second time in the work of Mies van der Rohe in an early drawing for a country house in Werder (Illus. 13)—a project which has come down to us as "Home of the Architect."[53]

Therefore the U-shaped center section of the Concrete Country House comprises the heart of the design in more than just a visual sense. It has been taken over virtually unchanged from the earlier project, with only the living room and entryway added. But the result of this process of transformation is immeasurably more advanced. From rather modest beginnings, all in all, there emerged in the Concrete Country House a conception that overshadowed practically everything that had been attempted up to that time in the field of residential architecture—with the exception of the Prairie Houses of Frank Lloyd Wright — and almost overnight secured for its creator a leading position in the European avant-garde.

Illus. 13 House in Werder (proposal, 1914).

There is another country house project by Mies van der Rohe from the first half of the twenties that is scarcely known, one that has been almost completely overlooked by earlier researchers. Johnson, to be sure, listed the Lessing House in the catalog of works in the recent third edition of his monograph, but he failed to make any more detailed mention of it in the text.[1] The general neglect of this project is certainly due in part to the extreme paucity of source material; as in the case of most of the architect's early works, the Lessing House is not documented in the surviving papers, so we must assume that all plans and written documents were lost. The sole reference to it is the ground plan (Pl. 2.1) reproduced in an early essay by Paul Westheim, which is obviously only a copy made for publication.[2] From this generally reliable source we also derive the location, Neubabelsberg, and the date of 1923. However, it is impossible to tell from the caption whether it was a proposal or was a completed project. The most recent supplementary inventory of architectural monuments in Potsdam provided by the East German Institute for the Preservation of Monuments lists for the suburb of Babelsberg, annexed in 1939, only three structures by Mies van der Rohe: the Riehl House (1907), the Urbig House (1915-17), and the Mosler House (1923/24-26).[3] Nor is the name Lessing included among the references Mies provided in various applications for commissions that have survived.[4] We may therefore assume that the project was prematurely scrapped and never progressed beyond the planning stage. Considering that they were executed at roughly the same time, it would be quite possible to identify this ground plan with the drawing of a "brick residence" exhibited in Berlin in 1923, but there can be no conclusive proof of this given the absence of appropriate illustrative material.[5]

Although the floor plan does not include any measurements, it is possible to form a rough idea of the dimensions of the building. Based on the width of the door openings, for which one can assume a minimum of 36 inches, a floor area of roughly 5400 square feet must be assumed — not including the two courtyards. A project of this magnitude suggests a well-to-do client. Judging from the extravagant number of rooms required, he belonged almost certainly to the upper class, like the majority of Mies van der Rohe's private clients,

though one must take into account the conditions of the time, which allowed even middle-income families (in today's terms) to employ household help.

The complex consists of three attached but irregularly placed sections: the parents' bedroom wing, the core structure with living room and library, and the L-shaped wing comprising service rooms and rooms for the children and the governess *(Fräulein)* with their own outside entry.

The centrally placed living room connects the well-defined sections and dominates the whole. Based on the above estimates this room alone measures some 50 x 20 feet, or roughly 1,000 square feet. From outside one enters a square vestibule that is labeled in the plan as a cloakroom *(Gard.)*. Adjacent to this entry on the left is the library. Presumably it was meant to be an office as well, since it can be entered only from the vestibule and not from the large living room adjacent to it. Across from it is a guest toilet and a second door leading to a narrow corridor connecting to the pantry. Off the side of this corridor, and accessible only from it, is a winding stair to the cellar and the attic. The direct connection between the vestibule and the service wing makes it possible to have the staff answer the door without having to pass through the living room. The last room in what is, strictly speaking, the living area is a sitting room with fireplace. Though placed as though it were an extension of the library, it is separated from it by a masonry fireplace wall extending across the entire width of the room. It is only partially closed off from the living room, however. Though to all appearances the ceiling of this room is at a different level, no drop is indicated at this point — as are, for example, the ones clearly marked by two parallel lines where the vestibule and dining room abut the living room on the other end. This area is, then, basically only an extension of the living room itself, a bay as it were, which explains the term *fireplace niche* in the floor plan.

From this part of the house a short hall leads to the parents' bedroom suite, a U-shaped wing surrounding a small courtyard and only casually attached to the central core. A door on the inner side of this hall, which is also lighted by a window on this side, provides the only access to the courtyard. All the other rooms — the adjacent dressing room, the spacious bedroom, and the bath lying opposite the hall — have windows opening to the outside. A straight

continuation of the outer wall on the fourth side of the unroofed courtyard screens it almost entirely from the yard and obscures the U-shaped arrangement of this wing. From its outline, one is more likely to think of this as another rectangular structure.

In contrast to the extension just described, the L-shaped wing on the opposite corner of the house is firmly interlocked with the core structure. The dining room is completely part of this side wing, whereas the pantry is a clear component of the central core, the massive exterior wall of which cuts here into the adjoining kitchen. The seeming inconsistency of this arrangement (the pantry should logically be aligned with the service rooms, the dining room with the living areas) was in part a result of the need to provide the staff with unobtrusive access to the vestibule and in part because the dining room provides the only connection to the childrens' rooms just beyond, which are otherwise accessible only from the outside.

The paved courtyard extending out from the kitchen is entirely surrounded by walls except for a small entrance at the lower corner. On the garden side there is a large square terrace in the angle formed by the center section and the side wing. It is bordered at the outermost end of the building by a kind of loggia, the precise nature of which (wholly or partially covered, open to the terrace or closed by a glass wall?) cannot be conclusively determined.[6]

Judging from the placement and designation of the various rooms, the side facing the garden is probably the south flank of the building, which would mean that the parents' bedroom lies to the east and that the large living room, as the center of the house, receives sunlight from midday all through the afternoon. Accordingly, the street must run along the north side, so that there is convenient access provided to the service courtyard, while the residents of the house are largely spared any disturbance from either noise or curious passersby. As the main approach to the front door, there would likely be a forecourt adjoining the house on the east and providing parking space well off the street. Any other solution would seem to be ruled out by the arrangement of the bedrooms, especially since no use was made of the opportunity to have the windows of these rooms face the inner courtyard.

The two courtyards enclosed by freestanding walls may remind one at first glance

Illus. 14 The Petermann House in Neubabelsberg (project, 1921).

of the country house projects of the thirties, in which the motif of walling off the outside so as to allow for as open a structure as possible became the dominant planning principle. One must, however, consider that in the present instance these roofless enclosures have no meaning for the interior arrangement of the building, but serve almost exclusively as utility areas. The reason for their inclusion was not to provide a visual extension of the living area, but to shut out specific border areas that were undesirable as part of the total effect. The designation "open floor plan" is similarly problematic in this instance, for although the fireplace niche, the vestibule, and the dining room are no longer closed off from the living room with actual doors, the last two at least are designed as separate, self-contained spaces clearly distinguished from it. Evidence of this is found not only in the lower ceilings, but in the manner in which the drop is prolonged through the full width of the wall, so that the sense of a wall closing the space is still there. All in all, however, the tendency toward an increasingly freer floor-plan arrangement is unmistakable.

The differing ceiling heights in the center section give rise to the question of what the house looked like from outside. Before attempting to answer this we must note that it seems odd that though a cook and a governess have been provided for, there is neither a guest room nor adequate provision for staff (for a dwelling of these dimensions would require two or three maids). It follows, then, that Mies had provided an upper floor, a supposition bolstered by the presence of the winding staircase mentioned earlier. The only space available for one is that above the rooms bordering on the living room, since the living room is probably higher than the rest of the ground floor. With the addition of this level the central structure is thus distinctly set off from the two side wings. A comparable hierarchial distinction between units can be found in the proposal for the Petermann House, which was designed two years earlier, and which was also to have been built in Neubabelsberg (Illus. 14). The single surviving illustration of this design[7] may well provide an impression of what the Lessing House might have looked like from the outside.

1 Philip Johnson, *Mies van der Rohe,* 3rd rev. ed., New York, 1978, p. 214.

2 Paul Westheim, "Mies van der Rohe: Entwicklung eines Architekten," *Das Kunstblatt,* Vol. 11, No. 2, February 1927, pp. 55-62; illus. at bottom of p. 59.

3 *Die Bau- und Kunstdenkmale der DDR: Bezirk Potsdam* (Art and Architectural Monuments of the German Democratic Republic: Potsdam and Environs), published by the East German Institute for the Preservation of Monuments, Berlin/Munich, 1978, pp. 344 f.

4 As, for example, in a letter from Mies to Herr Albrecht, a factory owner in Friedrichsrode, on February 14, 1923 (MoMA): "For your orientation let me inform you that among others I have built the house at 3 Bergstrasse in Neubabelsberg for Geheimrat Riehl, the one at 9 Luisenstrasse in Neubabelsberg for the bank director Franz Urbig, and the one at 5/7 Sophienstrasse in Charlottenburg for Justizrat M. Kempner, and that I will soon be starting the house for Herr Georg Mosler, the bank director, at 28/29 Kaiserstrasse in Neubabelsberg."

5 *Grosse Berliner Kunstausstellung 1923,* May 19-September 17, catalog of the art works exhibited, cat. no. 1275, "Brick residence, drawing."

6 The country house project depicted in Illus. 14 from 1921 likewise shows an open addition, and may serve as a point of comparison here.

7 Illustrated in Westheim, *op. cit.* (note 2), at the bottom of p. 61.

The Sources Available

Of the two drawings of the Brick Country House project frequently published — a perspective view and a ground plan — only a few photographs have survived, the originals having been lost. These photographs, relatively small ones at that, comprise the sole sources relating to this pioneering design whose influence on the development of Mies's residential work was only matched by that of the Concrete Country House.

The Museum of Modern Art in New York owns a contemporary photograph of the drawings that was among the architect's papers and that served as the original for all known reproductions of the Brick House to date.[1] It shows the plans in the order Mies preferred, namely the elongated perspective view on top, with the markedly smaller ground plan centered directly below it.[2] The latter contains as sole identifications the two legends *living area* and *service area* for the two main wings of the house. The perspective was obviously done primarily with a grease pencil (Conté crayon), while the ground plan is in pencil with charcoal shading (to bring out the lines of the walls). The negative was not uniformly sharp, and the photographer may have had to redraw some of the extremely fine lines before preparing the printing plate. Even so, a number of points remain unclear, and these have led to misunderstandings and incorrect interpretations. Fortunately, a second photograph has been found in the archives of the Mannheim Kunsthalle, one that is different from the one already discussed, and which was presumably made on the occasion of the 1925 exhibition *Typen neuer Baukunst* in which this project was displayed (Pls. 3.1, 3.2).[3]

Two additional ground plans executed in ink (Illus. 15, 16) have been in the New York collection since 1965. These are of a considerably more recent date and must accordingly be regarded with some reservations. In contrast to the original version mentioned above, these are highly detailed drawings that show the structure of the walls brick by brick.

Aside from a few trivial discrepancies, these newer drawings differ from each other first of all in the manner in which the bricks are laid in the massive fireplace wall. Another variation is to be seen in the stretcher course in the bond of the slightly indented right-hand wall of the service wing, which was indicated so as to correspond with the sections of wall parallel to it. In one version

(Illus. 15) the binder course interlocking it with the walls perpendicular to it was not. Obviously the draftsman made an error here that was corrected in the second version. The essential differences, meanwhile, are concentrated in the upper left corner of the structure. In one of the two plans (Illus. 16) the gutter line that surrounds the building has been omitted; there is also no indication of any glass between the two perpendicular radiating walls, and therefore no clear demarcation of the interior space. In this respect this drawing corresponds precisely to the original, which also leaves it an open question just how the interior is to be closed off at this point. The first of the more recent versions is much more explicit here, for it does close the gap in the wall (under what is now a slightly projecting roof) with a pane of glass — but, because it is a reconstruction, this is only a hypothetical solution.

Illustration 15 is the version reproduced in the first edition of Werner Blaser's 1965 monograph on Mies, while the paperbound edition of 1972 reproduced the second plan, which undeniably attempts to be a closer copy of the original. Both of these later ground plans are identifiable as drawings originating from Mies van der Rohe's own studio, but they can hardly have been made before the mid-sixties.[4]

Dating

Postwar literature is divided on the chronological placement of the Brick Country House, dating it variously as 1922 or 1923. In light of the revised dates for the two skyscraper designs there is a tendency once more to give it an earlier date, though there seem to be no specific reasons for doing so.[5] The only unanimity revealed by these writers is their placement of the Brick Country House before the concrete one. On the basis of the contemporary sources that were discussed in detail in the introductory chapter, however, the accuracy of this consensus must be questioned. According to those sources the two drawings of the project were not displayed at the Great Berlin Art Exhibition until 1924, a year after the Concrete House was shown there, which allows us to determine the sequence of the projects with relative certainty.[6]

In itself, of course, this would appear to be fairly insignificant. Since the Berlin Art Exhibition opened each year in the spring, it is certainly conceivable that Mies had

1 Inv. No. of the negative: MoMA 1811; reproduced in: Hans Richter, "Der neue Baumeister," *Qualität*, Vol. 4, No. 1/2, January/February 1925, pp. 3–9, illus. pp. 6, 7; Gustav Adolf Platz, *Die Baukunst der neuesten Zeit*, Berlin, 1927, illus. p. 386 (perspective); Walter Curt Behrendt, *Der Sieg des neuen Baustils*, Stuttgart, 1927, p. 52, illus. 70; Ludwig Hilberseimer, *Grosstadtarchitektur* (*Baubücher*, Vol. III). Stuttgart, 1927, p. 54, illus. 128 (perspective); Heinz and Bodo Rasch, *Wie bauen? Materialien und Konstruktionen für industrielle Produktion*, Stuttgart, 1928, p. 26, illus. 56; C. Z. [Christian Zervos], "Mies van der Rohe," *Cahiers d'Art*, Vol. 3, No. 1, 1928, pp. 34–38, illus. p. 34; idem, *L'Architecture Vivante*, Vol. 5, No. 21, 1928, p. 16.

2 Mies to Walter Dexel, October 29, 1924; LoC: In the exhibit the two drawings "are to be hung as in the enclosed photograph, one above the other."

3 Typen neuer Baukunst (New Types of Architecture), Mannheim Municipal Art Gallery, October 25, 1925 to January 3, 1926, catalog by G. A. Platz and E. Strübing (no illus.).

4 Werner Blaser, *Mies van der Rohe: Die Kunst der Struktur*, Zurich, 1965, illus. pp. 22–23; idem, *Mies van der Rohe* (rev. ed.), Zurich, 1972, illus. pp. 20–21.

 Herr Blaser confirmed in a letter to me that the ground plans were prepared specially for his book under the supervision of Mies himself in his Chicago office. This is also true of the structural patterns for the brick bond reproduced on pages 21 and 19 respectively.

5 See, for example, Philip Johnson, *Mies van der Rohe*, 3rd rev. ed., New York, 1978, p. 32. Following Ludwig Glaeser, Johnson here was inclined to believe that all the early projects (the two skyscrapers, the office building, and the two country house designs) were conceived in rapid succession, and therefore dates the drawings to 1922.

6 *Grosse Berliner Kunstausstellung 1924*, May 31–September 1, catalog of art works exhibited, section of the November Group, p. 102, cat. no. 963, "Landhaus" (no illus.). Conclusive identification is provided in Hans Soeder, "Architektur auf der Grossen Berliner Kunstausstellung 1924," *Der Neubau*, Vol. 6, No. 13, July 10, 1924, pp. 153–58, illus. p. 158. To be sure, Mies had already been represented the previous year by the ground plan for a "Brick Residence" (see *Grosse Berliner Kunstausstellung 1923*, cat. no. 1275), but it is inconceivable that he submitted the same design both times, especially since this was his sole contribution.

begun planning this second epoch-making contribution to residential architecture as early as the middle of the previous year. The opening dates of the Berlin exhibitions provide us with the outside dates of May 19, 1923, and May 31, 1924. The drawings must have been made during the intervening twelve months—a fairly imprecise conclusion when one considers how decisive this design was to be in the development of modern architecture. It was during this same period that two extremely important artistic currents of the twenties, basically opposed for all their similarities, confronted each other head-on. I refer to the Russian Constructivist movement led by Lissitzky, Malevich, Pevsner, and Gabo, and the Dutch de Stijl movement incorporated largely in the person of Theo van Doesburg. Since 1922, Berlin had been the focal point for these influential currents, and the latter appears to have played a specific role in the conception of the Brick Country House, a point to which we will return later. Given certain manifest stylistic similarities between de Stijl and the Brick House, it would certainly be desirable to be able to narrow down the period of Mies's conception of the project. But because the sources are so meager this can only be accomplished indirectly.

Two events that immediately followed the Berlin exhibit of the summer of 1923 have already been mentioned a number of times in another context, namely Gropius's International Architecture Exhibition at the Bauhaus in Weimar from August 15 to September 30 and van Doesburg's show *Les Architectes du Groupe* "de Stijl" at Léonce Rosenberg's gallery in Paris from October 15 to November 15. At both of these Mies was represented by works already shown in Berlin.[7] The Brick Country House was not included in either of them, nor is there any mention of the project in Mies's correspondence with his two colleagues relating to these exhibitions, even though he wrote at times in some detail about his recent plans and projects.[8] This would seem to confirm the supposition that no fully developed plan suitable for exhibition existed before late autumn 1923.

Since there is nothing that would indicate otherwise, it appears that the project dates from the beginning of 1924—although it is not impossible that work had already begun on the project in the final months of 1923. The design of the Brick Country House once again attests to a protracted period of planning. As in the case of the Concrete House, the final version must have

been preceded by numerous preliminary sketches, and indeed there is evidence of them lurking in the plans themselves.

The Planning Stages

Since there are a number of discrepancies between the two extant drawings, we are forced to suspect that they reflect different planning stages. In deciphering the plans particular difficulties arise with regard to the relative position of the two stories. The ground plan and the perspective do not agree at all on this point. Nor do exterior dimensions always correspond between the two. To be sure, certain distortions result in any perspective, but that certainly does not account for all of the differences here. The assumption that these are two separate versions of the same project can be confirmed by a simple comparison of the glass wall areas that appear to set off the closed front corner from the rest of the structure. Judging from the ground plan, the width of the larger opening should be roughly one and a half times that of the smaller. In the perspective, however, it appears to be nearly three times as wide. This impression is heightened by the disproportionate number of panes, which are, moreover, of quite different shapes in the two openings. In the one instance there is a regular sequence of six identical window elements; the other shows a group of three, a large pane in the middle with narrow ones on either side. We may therefore assume that this is not an optical illusion. Owing to this alteration, the whole section of the building between the chimney block and the garden wall appears considerably narrower and longer. Moreover, in the perspective view it is set back somewhat, whereas the ground plan calls for it to connect with the chimney block roughly in the center.

To be sure, these renderings are by no means construction drawings. They were obviously intended for exhibition purposes, to be seen primarily by laymen and, at best, potential clients. For such viewers it was necessary to provide an image of the project, and therefore it may be that in the preparation of the perspective it was not the intention to portray the ground plan disposition exactly so much as to produce a composition for a specific visual effect. If this was indeed the case, the argument for a change in the plan along the way is by no means compelling. If one maintains that Mies chose to create a freer sort of rendering for a deliberate effect, the differences

between the two drawings would be of no particular significance.

But one easily overlooked bit of evidence argues against this second possibility: the edge of the first-floor roof casts a shadow on the second chimney block visible behind the garden wall. This means that the roof and the chimney wall connect there, though in the ground plan they are quite clearly a considerable distance apart. Visually, the tiny black triangle of the shadow is far too insignificant for it to be explained solely in formal terms, as could the deviations in proportion mentioned above. Therefore it can only refer to a deliberate arrangement of structures in space, one that either does not yet match the arrangement illustrated in the ground plan or does so no longer.

A shift in the position of the secondary chimney wall in turn suggests a rearrangement of the kitchen wing of which it forms an integral part. An exposed placement of that area such as the one shown in the ground plan is therefore almost certainly precluded, and various hints suggest a closer tie between the service area and the living section. In any case, it is plain that two different planning stages are here represented—the sequence of which requires further clarification.

Aside from the numerous discrepancies already observed, the drawings differ markedly in the style of their execution. The perspective has been drawn with great care, with the bricks depicted layer by layer, while the ground plan gives much more the impression of a sketch. The strength of the individual lines in the latter varies considerably, and inasmuch as they frequently overlap where they meet, the effect is one of haste and imprecision.[9] Certain constant measurements such as the roof overhang (indicated by a boundary line surrounding the structure) are not kept consistent, appearing narrower in some spots than in others. This is particularly true of the spaces between double lines indicating walls of glass. The layout of walls and fireplaces was first outlined somewhat roughly in pencil, and the resulting areas then shaded in with charcoal or black chalk. The pebbly texture of the shading suggests a certain massiveness in the masonry and permits the walls to stand out in strong relief, but it decreases the linear quality of the plan in favor of a distinctly more graphic effect.

As was pointed out at the beginning, it is striking that the gutter line running around the whole building is missing only in the upper left section of the drawing. According to the perspective, the corner formed between the two radiating walls should also be

covered by a concrete slab, one that in fact extends well out over the front terrace. In that drawing the whole slab is roughly centered on top of the perpendicular garden wall, and on the end closest to us it cuts slightly into the chimney block for support. Presumably the other end of this projecting roof is likewise supported by a segment of wall, or at least by a pillar, for the even wider overhang on the side of the wall away from the viewer would preclude a cantilevered solution.

The ground plan, however, reveals neither the outline of this concrete slab nor the position of any kind of support required for it. In this corner of the building the plan is completely unclear, although in its detailing of the front terrace area it does correspond with the perspective. Of course it is possible that the missing roof line was merely overlooked. But it is more probable that Mies intended to make a further change, and in anticipation of a reworking of the corner solution simply chose not to make any definite indication of it for the time being. In any case, the drawing is incomplete in this respect.

It has been established that although the ground plan gives the appearance of a sketch, it is not a sketch in the traditional sense since it lacks a quality of spontaneity. At the same time, it by no means fulfills the demands of a construction drawing, which would have to be considerably more precise and informative in its details. It is rather a presentation drawing with artistic intent, one that relates to its corresponding perspective even in the medium in which it was done (charcoal or Conté crayon). This may indeed be responsible for some of the imprecision we have noted; we could view it as an inherent quality of the medium. But at the same time we have a distinct impression that a further reason for its inexactness could well be the degree of haste with which the ground plan seems to have been done. How else are we to interpret its omissions, especially since it would have required but two lines even at the last minute to at least indicate the solution presented in the perspective?

On the other hand, if there really had been a rush to meet a deadline, both drawings would have been affected surely, for without the accompanying perspective drawing, the ground plan would have been completely incomprehensible to an uninitiated observer. How can the difference in the quality of execution of the two drawings be explained other than by the fact that the perspective had already been (long since?) completed when work on the ground plan

was begun? Of course, it could be that the latter is an older trial design that Mies here appropriated for want of anything better. But if such were the case, the perspective would certainly have to represent the more recent version, which in turn gives rise to the question of why he did not simply prepare a second ground plan based on it. Considering the manner in which the present one was done, this could have been accomplished in a very few hours, while the creation of a revised perspective would certainly have required several days.

Further, it appears that the essential changes, such as the shifting of the chimney block, only affect the back side of the building. From the viewpoint selected for the perspective these changes are scarcely noticeable and can only be discerned after close analysis of the two drawings. Assuming that the perspective was made later, why should Mies have therefore gone to the bother of a revision? Not only would the changes in the design have escaped most viewers altogether, but even the more alert among them would have accepted the differences as only slight discrepancies, at most a matter of contradictory details. On the other hand, the effort might well have seemed justified. No matter how the original scheme might have looked, the spatial composition of the present ground plan is so very convincing at first glance that this alone may well have been the reason for departing from the arrangement of the building's elements as given in the perspective. Considering all of these arguments, there is no longer much doubt about the chronology of the two plans. The ground plan must represent the final version, while the perspective goes back to an earlier stage of planning.

The Genesis of the Project

The programmatic quality of Mies van der Rohe's early projects, among which the Brick Country House has generally been included, was recognized quite early on by Hans Richter, who devoted his 1925 essay "Der neue Baumeister" to them.[10] Mies encouraged critics to examine his works by using several of them himself (the Concrete Office Building, the Concrete Country House) as examples in his own writings on architecture.[11] It was thus perfectly natural to view all of these projects as idealized solutions — designs conceived without any concrete commission, free of all obligation to private or public clients, and unhampered by the particular conditions of a specific site. Of all

7 No catalog exists for the Weimar exhibition. Whether there was one for the Paris exhibition is questionable, although in a postcard on October 1, 1923 (LoC), van Doesburg asked Mies for catalog information for his contributions. Conclusive identification of the designs submitted by Mies is to be found in both cases in the correspondence.

8 The entire correspondence between Gropius and van Doesburg is in the Library of Congress; copies of portions of it are in the Mies van der Rohe Archive of The Museum of Modern Art.

9 In places the lines are very faint, and can just barely be seen in the original photograph. They would be completely lost in any further reproductions from the print. In order to make it easier for the reader to decipher the ground plan, all of the outlines in the copy reproduced here have therefore been retraced in ink.

10 Richter, *op. cit.* (note 1); see also Norbert Huse, *"Neues Bauen" 1918 bis 1933: Moderne Architektur in der Weimarer Republik*, Munich, 1975, p. 37.

11 Ludwig Mies van der Rohe, "Hochhäuser," *Frühlicht*, Vol. 1 (New Series), No. 4, Summer 1922, pp. 122-24; "Bürohaus," *G*, No. 1, July 1923, p. 3; "Bauen," *G*, No. 2, September 1923, p. 1.

of the early projects, the Brick Country House invites such an interpretation most of all. While the office projects of 1921/22 are ultimately only the logical consequence of recent technological development, despite their distinct modernity in terms of form, the Brick House, with its complete dissolution of customary spatial units, presupposes a radical revision of traditional living habits. One can only appreciate the full import of the breach implicit in this design by reflecting on the living style of the Wilhelminian bourgeoisie. Excessively oriented toward representation as it was, this living style had witnessed but few changes in principle even in the 1920s. The utopian nature of this pioneering design seems evident above all in the straight lines of wall radiating from the building itself. Cut off only by the edge of the drawing, these appear to extend outward to infinity. Seen as a whole, the design—particularly the ground plan—resembles something more like an architectural-philosophical manifesto than a product of any planning rooted in reality.

On the surface everything would suggest that this is an idealized proposal. But what could have served as its stimulus? What was Mies aiming at in these designs if there was never any thought of constructing them? One might presume that his intention was primarily to achieve recognition by using the November Group, an association of progressive Berlin artists, as a platform.[12] As was mentioned above, the Brick Country House was first presented to the public at the exhibition of 1924, and since the two drawings were probably made for it, as was shown, one can hardly resist the assumption that a review by his peers was part of the motivation for them. But even if the drawings were made specially for this exhibition, which is by no means certain, that still tells us nothing about the previous history of the project. In this regard one might recall the Concrete Country House exhibited the previous year. It too was thought to be an idealized project, but such a view was seriously challenged in the present investigation. Could it be that a specific commission provided the original stimulus in this instance as well, one that for one reason or another was not brought to completion? Is it not possible that the idealization—not entirely inopportune for Mies's own purposes—only came later, once he saw that the proposed building was not going to be constructed? Contemporary documents suggest that this might be the case.

The earliest reproduction of the Brick House design appeared in the journal *Der*

Neubau, as an illustration for a discussion of the Berlin exhibition by Hans Soeder.[13] Soeder identifies the project as a proposal for a country house in Neubabelsberg, and that location is repeated in the caption to the illustration:[14]

"Mies van der Rohe's design for a 'Country House in Neubabelsberg' is probably the boldest, most forward-looking achievement in the exhibition. The means of rational calculation have here been surpassed on a high level, mathematics filled with music—at least in the ground plan of the house. It is impossible for this reporter to convey in words the impact of this work. To see it is to be enchanted by it, to be set dreaming by it, to stand in awe of such a daring arrangement of spaces."

Caution is often appropriate when evaluating critiques of exhibitions. Owing to the conditions under which they are written, false attributions or other similar mistakes are by no means exceptional in such reviews. As a sobering example of this one could point to the review that appeared a short time later by Walter Curt Behrendt, who likewise speaks of a "country house in Babelsberg," but then proceeds with a description that can only refer to the Concrete Country House exhibited already in 1923.[15] Whatever it was that the author may have seen, the catalog entries for the two years prove conclusively that Behrendt was confused. Still, the mention in both articles of the suburb on the outskirts of Berlin is noteworthy. This was an area extending from the south shore of the Griebnitzsee to the Babelsberg Gardens that was ultimately incorporated into Potsdam in 1939. Before the First World War, and during the time that Mies was still employed there, the studio of Peter Behrens had been located there. There too were the Riehl house (1907), the Urbig House (1915-17), and the Mosler House (1923/24-26)—which is to say, half of the buildings Mies had constructed up to that time. Two further projects for Neubabelsberg, the Petermann and Lessing houses from 1921 and 1923, never got beyond the planning stage. Given all of this, Mies doubtless had an excellent knowledge of the area.

Soeder's article was conclusively confirmed by the discovery of the photographic negative in Mannheim. In it the lower drawing bears an inscription in the upper left corner: "Ground Plan for a Country House in Neubabelsberg." Although the New York

photograph is clearly based on the same original, it shows no trace of any writing in that spot. We know that the more familiar picture was definitely taken earlier, since it was published in *Der Neubau* in July 1924. By comparing the two we learn, moreover, that the perspective was obviously cropped before it was exhibited in Mannheim. In the negative made there a narrow strip is missing on either side, while the New York print reproduces its full original width.[16] Accordingly, this inscription can only be a later addition, but this by no means renders it less authentic. The project must have been given a similar designation even at the Berlin exhibition; either that or both Soeder and Behrendt were given their information directly by Mies—which amounts to the same thing.

Inasmuch as evidence of a specific location has already shaken the theory somewhat, the next step is to find out something about the client and thus prove beyond doubt that the Brick Country House was not an imaginary project. Theoretically, of course, it would be perfectly possible for it to have been a preliminary design for the Mosler House, since the commission for that building falls into the same time period (1923/24). But the differences between the Brick House and that relatively conventional design are altogether too obvious to permit us to conceive of any connection between the two.[17] On the other hand, comparison of the Brick House with the earlier Concrete Country House reveals surprising similarities. In order to make such a comparison one must turn the familiar plaster model in one's mind until the large living room is superimposed on the living area of the brick house. Once this is accomplished, the orientation of the two equal-sized rectangular building lots is identical, and certain analogies can no longer be overlooked.

In both cases a narrow strip of land has been set apart along the upper left edge of the site, following the lines of the ground plan, and marked off by walls. In the case of the Concrete House this open space served as the approach to the main entry. Rather compelling reasons suggest that it was given a similar function in the brick design—for one thing, this outside area adjoins the only windowless corner of the house. With the exception of a passage resulting from the offset placement of the walls, there are only closed wall surfaces on this corner. Even the one opening mentioned is placed in such a way as to prohibit views between inside and out. This gives rise to two possibilities:

either the garden walls enclose an open or partially open forecourt, from which the interior of the house is not supposed to be seen, or the other way around, namely that this section of the lot did not offer a very inviting vista because of its designated function and therefore needed to be screened off from the living spaces. The latter would have been likely only if the area were a vegetable garden or a service yard, but that would appear improbable since the kitchen wing is located at the other end of the building. Thus it can only be a forecourt, quite like the one in the same location in the Concrete Country House. It follows that the actual entry must be located on this corner of the building, which would in turn explain the deeply projecting concrete roof omitted from the ground plan, the outer corner of which is just barely visible in the perspective.

The two country house designs thus agree on the placement of the main entry, which permits us to assume that the location of the street is also the same in both. If one accepts these coordinates as given, a startling similarity in the arrangement and illumination of the living rooms and service areas becomes apparent. The situation of the two lots would therefore appear to be identical. Finally, it is worth noting the analogous placement of the secondary entrance. In each case it is placed at the outermost end of the service wing and marked by an indentation in the corner of the building. Since this wing happens to be only a single story in the Brick House, its basically square shape is preserved only by the line of the roof slab projecting above this indentation; in the Concrete House the indentation was covered by the projecting second story.

It is still questionable to what degree the property in the later design reveals the same dramatic changes in elevation that characterized the site of the Concrete House. The ground plan of the brick project would seem to suggest that it does not, but in the perspective there is evident terracing in the foreground that one could relate to the distinct changes of level in the 1923 model.

If the assumption that both projects were originally planned for the same site were to prove correct, this would mean once again that the architect and client were the same person. In its April 1925 issue the journal *Das Kunstblatt* published a reproduction of the two drawings with the caption: "Mies van der Rohe: Design of a House for Himself." The accompanying article, which is admittedly not directly related to the Brick Country House, was written by Paul West-

heim.[18] The same writer produced one of the first extensive appreciations of Mies van der Rohe two years later in the same journal.[19] The knowledge of his subject revealed there suggests intensive study of the architect's work. It is apparent that the two men were relatively well acquainted, for details and incidents from as long as fifteen years before are mentioned in the article. Westheim clearly had information at his disposal that could only have been obtained from Mies himself. All in all, he can be considered an extremely reliable reporter, a fact that lends added weight to the designation of this project as a house for Mies himself, for which presumably Westheim was responsible.

The correspondence of 1923 makes it quite clear that Mies had had definite plans to build since the summer of 1922 at the latest. Among other things, there are several passages that reveal his interest in the purchase of specific building lots. In one case it is the Schwanenallee, corner of Hasengraben, that is mentioned, in another a Höhenstrasse in Potsdam.[20] It is not at all unlikely that there was a direct connection between these purchase attempts and the first country house design.[21] Likewise, the brick project, labeled as a design for Neubabelsberg, must have been planned for one of the above-named properties. Each of these streets extends for a very few kilometers outside Neubabelsberg, though remaining in an area that is clearly part of Postdam. At that time Neubabelsberg was part of the suburb of Nowawes, which was independent until 1939. Thus on this point the earlier argument does not appear to be entirely conclusive. Either we must reexamine the connection of the earlier project with one of the designated parcels—which would mean that the Concrete House was likewise intended for Neubabelsberg from the beginning—or we can no longer hold that both country houses were designed for one and the same site. This apparent contradiction can be resolved by means of a further explanation that will dispel all doubt—but in order to reach it we must return once more to the separate planning stages.

Adapting the House to the Site

For the reasons given above we can no longer deny that only the perspective of the Brick House, demonstrably of an earlier date, was executed for a site in Potsdam, but that after plans there had fallen through, Mies then

12 Contrary to widespread opinion, Mies was not among the founders of the November Group. He first participated in an exhibition in the summer of 1922 (*Grosse Berliner Kunstausstellung 1922*, p. 64, cat. nos. 1385, 1386, 1387). From January 1923 at the latest he was treasurer and a member of the working committee. For the exhibition of 1923 (note 6) he sat on the commission with Luckardt. Only in 1924 and presumably also in 1925 (when he himself was no longer exhibiting) did he direct the architecture section.

13 Soeder, *op. cit.* (note 6).

14 *Ibid.*, p. 156.

15 Walter Curt Behrendt, "Die Architektur auf der Grossen Berliner Kunstausstellung 1924," *Kunst und Künstler*, Vol. 22, No. 11, August 1, 1924, pp. 347-52:
"Mies van der Rohe has similar intentions in his design for a country house in Babelsberg, but at the same time strives to express these intentions in a more stylized and impersonal form. Within a compact outline he collects a group of spaces, and he envelops this configuration with a thin skin of concrete and glass that serves both as wall and roof. With the most exquisite sense of proportion, the openings for doors and windows are cut out of this skin. The sharp-edged, elegant structure with its precise forms could best be compared to something made by a machine" (pp. 350 f.).

16 The Mannheim photograph was obviously made during the exhibition, for below the drawings the label can be seen with its precise information. On either side of the perspective a narrow strip of wall is visible, so that the trimming of the edges cannot possibly be explained as cropping of the negative.

17 The Mosler House has never been mentioned in any of the extant monographs. Mies could well have suppressed information about this relatively conventional structure, which is in complete contrast to the previous designs, in order to underscore the continuity of his development. An illustration and a brief history of the structure are provided by Renate Petras, "Drei Arbeiten Mies van der Rohes in Potsdam-Babelsberg," *Deutsche Architektur*, Vol. 23, No. 2, February 1974, pp. 120 f.

18 Paul Westheim, "Die tote Kunst der Gegenwart," *Das Kunstblatt*, Vol. 9, No. 4, April 1925, pp. 106-14, illus. p. 110.

19 Paul Westheim, "Mies van der Rohe. Entwicklung eines Architekten," *Das Kunstblatt*, Vol. 11, No. 2, February 1927, pp. 55-62.

20 Magistrat der Residenzstadt Potsdam (Potsdam City Council) to Mies, March 31, 1923; MoMA:
"In response to your letter of March 11 we

produced a very slightly modified design for a different property in Neubabelsberg. With such an explanation the divergence of the ground plan from the original conception would make more sense. All changes could thereby be interpreted as attempts to adapt the already existing scheme to the specific contours of a new site.[22]

Certain unique features of the brick design now take on quite a different aspect. If we accept that the perspective is in fact based on the same site conditions as those of the Concrete Country House (which is very probably the case), then with the exception of a narrow strip at the left edge of the drawing, the portion of the site closest to the viewer is lower than the general level of the property in both cases. Presumably this terracing in one form or the other was suggested by the natural conditions. This therefore becomes a solid piece of evidence that allows us to view the differing arrangement of the structural elements with relative ease.

Without question, the brick building is set back somewhat further than the concrete one, as well as being shifted noticeably to the right. Thus the available area is much more fully exploited, the garden area considerably increased at the expense of the service yard on the back side. This also explains why the kitchen wing occupies a different position from the one in the ground plan. An extended wing is unthinkable here if only because the yard space remaining would not have offered the depth required. Seen in this light, even the free-standing wall lines appear to be by no means so unusual as they did at first. They are basically garden walls in the traditional sense, only here they do not stand directly at the boundaries of the property but have been shifted slightly inward. The chimney block, still partially visible in the perspective, shows, however, that even at this planning stage the wall barrier has been breached, and the building pushes on into the open space to the back. The wall thus forms a distinct barrier that sets the service area apart from the living spaces and makes the inner disposition of the house visible from without. Its prime function is to mark off the garden and screen it from view from without, but at the same time it permits the opening of the living space. Now whole sections of the outside wall can be replaced by glass without loss of the sense of privacy. It also prevents a view of the kitchen wing from the garden. Here — though only here to be sure — one can speak of a radical separation of the different functional areas. The whole "service sector" is completely set off, and appears to be virtually hidden behind a screen. Although it constitutes a perfectly necessary part of the house, it appears as if it were completely closed off from the life of its inhabitants. Perhaps the side turned away from the viewer and the arrangement of the interior would give a somewhat different impression. The perspective provides no information on this point, but the ground plan, based on a different set of conditions, reveals essential modifications in precisely this regard. Still, there as well, there is a tendency to clearly separate the service wing.

In this project the multitude of activities that make up one's living routine and therefore determine the requirements of residential architecture are organized toward a single goal, one to which all other considerations are subordinate. This design promotes living in its purest and highest form for the sake of the self-realization of modern man. It is obvious, and a fact that needs no further comment, that this presupposes a spatial and material extravagance which can only be afforded by a thin upper stratum of society and which is inaccessible to the mass of the population.

In principle, the later solution of the ground plan is already evident here, the radiating walls its most distinctive feature. But in the reworking of the plan these walls are given still greater significance. Originally their main function was simply to screen off unwanted views, enclosing and delimiting the private area and separating it as much as possible from the public ones. Now they become the distinguishing design element of the entire composition. At the same time, the building complex disengages itself from the upper edge of the property and shifts from the periphery toward the center. In the earlier version recorded in the perspective, house and yard stood in more or less balanced opposition to each other, and between the projecting and receding structural volumes and outside space there was created a relationship of dynamic tension; now, however, the house stands as a static pole within the landscape, largely dominating its surroundings by virtue of occupying their geometric center.

The Brick Country House — 1924 and Four Decades Later

The 1965 ground plans mentioned above and first reproduced in Blaser (Illus. 15, 16) have definitely influenced understanding of this project. Since the lost original had only survived in small photographs, frequently only poorly reproduced, some essential differences remained at first undiscovered. In order to correct the prevailing view of the project, which is therefore inaccurate in many respects, a brief discussion of the most obvious discrepancies is called for.[23] This will also serve as a first step toward a fuller analysis of the design.

Whatever the motivation for them, even the addition of hearth outlines lacking in the original represents an arbitrary reconstruction. Considering the size of the block of masonry, one could just as well have imagined two fireplaces, one on either side, though this would admittedly constitute a considerable shift of accent in the spaces involved.

A second change that must be observed has to do with the proportions of the service wing. Connected to the core structure by only a narrow passage wing, this approximately square complex has been given an almost imperceptible longitudinal orientation in the "reconstructions," while in the original it is clearly set perpendicular to the axis of the extension.

By all accounts the most problematic feature in the newer plans is, however, the detailing of the masonry brick by brick. Blaser writes in this regard:[24]

"The ground plan of the brick house is a good example of the manner in which Mies van der Rohe developed the art of the structure *from the very beginning*. The construction of a brick wall evolves from its very smallest divisible unit: the brick. Moreover, all openings are determined to be multiples of that modular unit" (emphasis mine).

Comparison with the surviving photographs reveals, however, that this precise reproduction of the masonry courses was not a part of the drawing of 1924; it simply could not be, given the medium (charcoal or Conté crayon) in which it was executed, for neither of these would have permitted such detailed drawing. It would follow then, that any calculation of the openings according to a fixed module (i.e., a determination of their clearances in multiples of the dimensions of a brick) is more than dubious. Since these openings reach from floor to ceiling with neither sills nor lintels, such a procedure would moreover be perfectly senseless. If one wanted to adopt the line of Blaser's structural analysis,[25] it would be the optimal span of the lintels, in this case identical with the beams of the roof construction, that

Illus. 15 Brick Country House, floor plan reconstruction (c. 1964).

Illus. 16 Brick Country House, floor plan reconstruction (after 1965).

wish to inform you that we are prepared to enter into negotiations with you regarding the sale of a building lot on Höhenstrasse. The price has been set at 2,500 marks the square meter."

See also the two letters from Mies to Albrecht on February 14 and April 30, 1923 (Chap. 1, notes 51, 52).

21 In this connection see also the last section of the chapter on the Concrete Country House.

22 Huse (*op. cit.*, note 10, p. 37 and p. 133) also reached the conclusion "that it was originally an actual project for a specific piece of property," but he overlooked the fact that the "earlier version" he used as evidence (reproduced in Hans Richter, *Begegnungen von Dada bis heute: Briefe, Dokumente, Erinnerungen,* Cologne, 1975, p. 53) is a poorly reproduced copy of Blaser's ground plan of 1965.

23 Naturally this "view" can only be declared false to the extent that we are here discussing the 1924 design. Since the more recent ground plans were done in the architect's studio, they certainly have documentary significance for Mies van der Rohe's late phase, especially since he himself took some interest in their preparation (see note 4).

24 Blaser, *op. cit.* (1972; note 4), p. 18.

25 Blaser himself avoided a precise definition of the concept of structure and limited himself to only a few references in his preface: "Mies van der Rohe develops his ideas out of the principles of construction, so that the forms of his buildings are the perfect expression of their structure. It is the aim of this book to show how Mies van der Rohe elevated construction to the status of art in his buildings, having clearly perceived its structure."
(Blaser, *op. cit.*, p. 10.)

Mies expressed himself on this point as follows: "Construction follows its own clear laws and can achieve nothing more at all. But when one raises construction to the level of expression, gives it meaning, then one can properly speak of structure. Construction properly fulfills a purpose, and structure gives it all a meaning." (From a 1966 interview, sections of which were printed in *Der Architekt*, Vol. 15, No. 10, October 1966, p. 324.)

26 The first projections to indicate the placement of each brick are found among the construction plans for the Wolf House in Guben. Even there they are quite clearly the result of later adaptation and by no means the point of departure in the planning process.

ought to have determined the width of the openings.[26]

For the sake of fully separating the original version (Pl. 3.2) from the later plans, let us examine one final point, namely, the different relationship in each case between the image and the projection surface—that is, the varying placement of the ground plan on the paper or drawing board.

One could object that within the framework of this investigation it is primarily the building itself, the actual vision communicated through the medium of drawing, that ought to be the object of our concentration, not the form of its representation. But this is only partially correct, for we are not so much dealing with working sketches chosen at random as with the final presentation of a planning process. In other words, one must distinguish between plans that serve merely as a means of communication within the architect's office on the one hand and drawings with some pretension to art conceived for outside viewers on the other. Doubtless both appeal to our ability to visualize spaces. But in judging the second group it is always the pictorial impression that is important; placed in the proper context, the architectural drawing loses its merely communicative function and becomes itself a work of art. As such, in its total effect it is necessarily influenced by the dimensions of the paper. In the specific instance of the ground plans for the Brick House this is especially relevant inasmuch as in each case the walls are extended to the edges of the sheet. Even without the added emphasis of an outside frame, the proportions are fixed here in purely pictorial terms.

To proceed, then, the ground-plan drawing from 1924 appears relatively narrow and elongated. In spite of the placement of the structure in the center, a definite dynamism is thereby attained, particularly in the left half of the drawing. By contrast, the "reconstructions" display a more balanced ratio of length to width; thus from the outset they were conceived as being more static.[27] Moreover, in the earlier of the more recent versions (Illus. 15) the whole complex has been shifted markedly to the right, so that the distance to the edge of the sheet is roughly the same as that to the upper and lower borders. Within the asymmetrical layout of the pictorial field it thereby appears to be centered in another, stronger sense. By means of this device the core structure appears to be firmly anchored in the picture plane and largely exempt from the play of opposing forces. While the dynamism of the original touches and permeates

all parts of the building equally, it is here concentrated almost exclusively in the free-standing wall lines radiating uniformly out of a static center.

The second version (Illus. 16) preserves the now standard sheet dimensions but moves the structure back to the center. This reveals that whoever was responsible for its creation thoroughly recognized the effect noted above and attempted to correct it in the sense of the original. He did not, however, see the decisive importance of the sheet format for the way the drawing works, so that his attempt at a return to the original could only be partially successful.

In sum, we must firmly remember that the most important difference between the earlier ground plan and the later ones is the considerably diminished dynamic energy of the latter. In spite of an obvious attempt, especially in the second version, to keep as close as possible to the original, the dynamic relationship of tensions that is so striking in the early ground plan has given way to a much more balanced composition in the reconstructions of the 1960s.[28]

Spatial Volumes and Dynamic Tensions

The comparison presented in the preceding section has already netted some important criteria for a critical evaluation of the design. There it was suggested that any such attempt has to take various factors into account. On the one hand, one must never lose sight of the descriptive nature of an architectural representation—that is, its qualities as a medium of communication. But we must also recognize a drawing's separate integrity, its effect as an autonomous work of art. In the present instance these two conflicting qualities could hardly be credited to the perceptive faculties of a viewer confronting them, but they are immanent in the drawings themselves—and in a manner that appears to be quite independent of the alterations in the plan. In the perspective view we are presented with a powerful structure of volumes clearly set off from the surrounding space—but this contradicts the strictly linear impression given by the ground plan with its deliberate avoidance of any grouping of masses.

Every plan naturally contains a certain degree of abstraction. It is only by supplying the third dimension in our imagination that we attain a more or less clear picture of the structure represented. A seemingly quite insignificant line in the ground plan that, at first glance, gives the impression of

absolute openness may actually indicate a fairly closed volume in the perspective drawing. However, when it comes to evaluating the glazed window openings that are major features of this project, this reading would lead not only to a rather traditional conception of space, but to one that contradicts the prevailing image of the Brick Country House as an early manifestation of "open space"—a declared cardinal principle of all of modern architecture.

It is therefore important to consider to what degree the demonstrated contrast between linearity on the one hand and plasticity on the other is not simply an apparent one rooted in the nature of the drawings themselves, each of which places its separated demands on the conceptual ability of the viewer who wished to decipher it. Could all of the critics who have dealt with the project have been deceived by simply misreading certain features of the plan? A thorough investigation of its spatial configuration will prove instead that both of these opposing aspects are necessary components of Mies's concept.

The complex of the house is made up of a limited number of elements. Essentially these are: orthogonally placed brick walls of uniform thickness, two masonry (chimney) blocks likewise equally massive, large glass surfaces the full height of the walls, and finally a flat roof that in places forms deep projecting overhangs. In the arrangement the walls can function as room dividers, room boundaries, or as free-standing elements defining the outside space. Such categorization should, of course, only be seen as a means to understanding, for in reality there is frequently a blurring of these separate functions. The radiating wall lines originate as sections of the exterior wall, for example, while others serve both to close off the house from the yard and to partition the inner space into which they project. This also explains why any structural differentiation is expressly avoided in spite of the unequal distribution of weight between bearing and nonbearing walls.

The walls themselves are conceived throughout as two-dimensional surfaces or screens, and accordingly they are largely prevented from coming together in such a way as to form cubic spatial elements. Here and there two walls may join at right angles, but they never intersect each other.[29] This kind of linking could theoretically be varied ad infinitum; corresponding three-part combinations are admittedly found solely in the service wing. The formation of projecting corners by changes in the course of a wall are

limited to the exterior, and even there it occurs but rarely, albeit at prominent spots. The only exception to this is the long wall on the left in the ground plan, which turns to the side at the bottom of the staircase leading to the second story — a variation that is logically justified, however, as this is the only means of tying the staircase to the larger spatial context. Any other solution would not only serve to isolate the stairs from the foyer, but would necessitate a reversal in direction: if one were to imagine the wall continuing in a straight line, for example, the staircase would appear to descend into the right-hand space, and at the same time the stairwell itself would appear cramped and narrow. Clearly the architect did not wish either of these effects. By breaking down the walls into individual elements not continuously connected to each other, he succeeded in designing the interior as a unified spatial continuum, but one that must not be confused with the type of "unified space" that would become important only in a later phase of Mies van der Rohe's career.[30] Sections of the house still form recognizable entities, even though they are no longer sharply differentiated from one another. The rooms flow into each other without obstruction, and in this continuum they forgo their original autonomy. U-shaped wall units creating nichelike bays are strictly avoided in the living wing. Neither do projecting corners occur, since the meeting of one wall with another always occurs at a spot somewhat back from the end. The character of the wall as a primarily two-dimensional screen is thus preserved even in side view. Space appears to be neither enclosed by structure, as in a niche, nor — aside from the chimney blocks — limited by mass, that is to say three-dimensional, "positive" corner shapes; it is felt rather to be in constant uninterrupted flow.[31]

We perceive these asymmetrically placed walls, unattached at either end, as being potentially movable, an effect that further strengthens the rhythmic nature of the space.[32] The dynamism of this interior communicates itself to the viewer, inviting him to move through these spaces — even if only in his imagination. No longer is interior space to be thought of as something enclosed and fixed; it must now be experienced in motion. The motion invited is not, however, directed toward a specific, static pole. That is the essential difference between this configuration and comparable spatial arrangements of the Baroque. On the contrary, the individual portions of the living area are accorded quite equal treat-

ment, and to an extent this also applies to the sequence of intermediary rooms, which show no signs of hierarchical order. The principle of fluctuating space is stated immediately at the two entry areas — in the service wing this comprises only a relatively narrow corridor — from which the adjacent rooms open off at angles. If one catalogs all the directions of movement possible here, a swastikalike configuration results — one that is already suggested in the placement of the defining walls. In order to distinguish this shape formally and connotatively from the swastika as a political symbol, with its burden of historical allusions, we will here employ the term "angled cross."[33]

Quite independently of its increasing use by anti-Semitic groups, German nationalists, and fascists since the close of the nineteenth century, the angled or hooked cross found widespread use in art and architecture until the twenties — and by no means only in Germany.[34] Doubtless its numerous connotations (as sun wheel, etc.) contributed to its popularity,[35] though in the Brick Country House — so much can be said here without preempting in detail our ultimate conclusions about its genesis — such connotations may be discounted straightaway. Fundamentally symbolic meanings were never exploited in the architecture of Mies van der Rohe, so we must limit ourselves to a direct reading of the motif, especially since the angled cross is not present here in the pictorial sense (even in the ground plan it is by no means obvious at first glance), but simply as a manner of structuring space. It must have been the formal expressiveness of the motif that fascinated Mies primarily, its inherent dynamism as it reaches out into space from a center and virtually captures it with its hooklike arms. For the same reason the motif can be found in architecture frequently enough; the examples reproduced here (Illus. 17, 18, 19) represent only an arbitrary sampling. It is in its alternate three-armed form that it appears in the ground plan of the Brick House, in the "distributor areas" located next to each of the two entryways. This three-armed version also provided the composition scheme for the previous project, the Concrete Country House, upon which, in all probability, Gropius in turn based his Bauhaus Building in Dessau.[36]

We are invited to compare further the simpler form of the cross suggested by the long walls extending out from the Brick House into the landscape. In the seemingly limitless extension of these arms, expressed by their termination only by the edges of

27 In both cases drawing board in the standard American format of 30 x 40″ was used, which gives a clear height-to-width proportion of 3:4. The proportions of the original version, however, judging from the photograph, would have been more like 1:1.8.

28 One might consider this a general tendency of the late period. As an example compare to the strictly "classical" conception of the New National Gallery in Berlin.

29 This can also serve as an essential criterion for a formal distinction between comparable compositions by Mondrian and van Doesburg.

30 As, for example, in the project for a museum (Museum for a Small City, 1942), in Crown Hall (1952–56), and in the Farnsworth House, but also in part even as early as in the Tugendhat House, where the free-standing walls are isolated elements subordinate to a clearly enclosed larger space.

31 The use of concepts such as "flowing" or "continuous" space in the literature is often utterly indiscriminate. It should therefore be stressed once more that the designation "flowing space" is only appropriate to the interior of a building, and is by no means suitable when describing the relationship between interior and exterior space.

32 Since there is no lateral tie, but every line or surface contains a dynamic current of force, according to Lipps (Theodor Lipps, *Ästhetik: Psychologie des Schönen und der Kunst*, Hamburg/Leipzig, 1903 and 1906, Vol. I, pp. 226–28, and Vol. II, pp. 441–44), that has the tendency — one might add — to extend beyond the end points, the impression is created that the walls could be slid along their axes. The asymmetric arrangement of the partitioning elements serves to further strengthen the effect described.

33 An important justification for this conceptual distinction is the fact that the angled arms in this case — in contrast to the intersecting bars of the swastika — do not radiate from a common point, but are instead grouped around an open center. The swastika therefore only arises as a "negative form" whereby the dynamic effect is transferred from the walls to the space itself.

34 Among other places, a huge hooked cross can be found on the title page of an issue of the Dutch journal *Wendingen* (Vol. 2, No. 1, January 1919); also in J. L. M. Lauweriks's designs for the Hagen artists' colony "Am Stirnband" from 1910, where it appears as a labyrinth of paths in one of the front yards as well as on the dining room ceiling of the Thorn-Prikker House (development plan and aerial perspective reproduced in *Wendingen*, Vol. 10, No. 8, August 1929, p. 9, and in Nic. Tummers, *Der Hagener Impuls: J. L. M.*

the drawings, the ground plan recalls an abstract mathematical figure: the (Cartesian) coordinate system. The cross in this particular embodiment defines infinite space, orders it into individual sections, but leaves it unaltered in its substance. While the previously described variants transfer the linear dynamism contained in the angularity of their arms onto the surrounding area and give it a specific orientation, the mathematical axial cross remains utterly neutral with respect to space. Because of the infinite extension of its intersecting axes there is no place for any flow of force as can occur in any finite straight line. Thus here even the linear tension that was earlier recognized as a major cause of the dynamic effect is lacking.

There is a limit to how much of what we have learned by looking at an abstract mathematical figure can be applied to this concrete example. In spite of all the similarities, there are obvious differences in the arrangement of the ground plan that do not fit the definition of a system of coordinates. For one thing, the free-standing walls extend only in three directions. The exposed service wing begins to expand in the fourth one, but its directional thrust is clearly checked by the slightly perpendicular placement of the end unit, especially by the massive perpendicular chimney block. For another thing, the walls do not share a common point of origin, and because of their offset alignment they do not even permit us to imagine a continuous axis. They are firmly anchored in the structure of the house, which is to a certain extent developed about the spatial center of their origin.

The anticipated interpretation needs a slight modification, however. Owing to the firm tie of these walls to the core of the house on the one hand, and to the impossibility of infinite extension of a straight line on the other, the continuous line is broken. These walls thus take on an unequivocal orientation: they radiate from the building. And therefore the following phenomenon arises: while any dynamism in the walls would have to result from their being finite, the linear tension so produced nonetheless implies an extension in our imagination beyond their end points—that is, the actual finiteness of the walls is what gives rise to the illusion of their infinite extension. Thus the outer wall lines appear to be infused with the same dynamism that we have encountered already in the free-standing interior ones. Only this time it does not reach out into the surrounding area as it

did in the interior, so that space remains largely passive to it.

Wolfgang Pehnt interpreted the design for the Brick Country House in a way that summed up the foregoing conclusions in a very few words:[37]

"Spaces do not spread out from a fixed and definite center, but rather an area of forms placed somewhat more compactly produces orthogonals, independent of any spatial definition. But the ground plan could also be read in the opposite way, seen as a network of lines intruding from the four directions of the compass. These give rise to a greater concentration of forms where they meet and thereby create the house. The physical substance of the wall does not serve to enclose livable space in Mies's work, but to delineate a field of interest. The living function is only of secondary importance in this complex of interrelated surfaces, unless one chooses to consider the fundamental openness and interrelatedness as the true, so to speak the higher, living function."

This unquestionably brilliant interpretation is one of the best ever written about the Brick Country House. It would seem to confirm once more the general view of this project, though never has that view been stated so clearly. At the same time, Pehnt bases his remarks somewhat one-sidedly on the ground plan alone, without paying any attention to the completely different, virtually opposite effect produced by the perspective view. This will be attempted in the following section.

In contrast to the starkly linear pattern of wall elements in the interior, the structure as seen from without resembles a closed stacking up of cubes clearly set off from the surrounding landscape. Much of this impression may derive from the massive effect of the projecting corner that dominates the view presented. The two huge chimney blocks, which seem to act as barriers against the expansive tendency of the interior space between them, provide additional compact structural mass. And finally, the effect is produced where experience tells us we should least expect it, namely in the window openings.

It is immediately apparent that here we are not dealing with windows in the traditional sense, since these glass surfaces extend to the full height of the story with neither lintels nor sills. Strictly speaking, the term "wall opening" does not apply in this situation. The walls on either side of

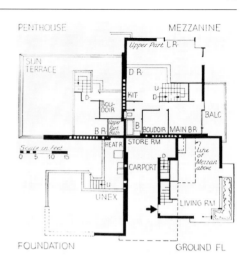

Illus. 17 Frank Lloyd Wright: Suntop House in Ardmore, Pa. (1939).

Illus. 18 "Fifty-by-fifty" House (proposal, 1951).

Illus. 19 Sheppard, Robson, and Associates: Lecturers' Apartments in Cambridge (1960).

them do not even lie in the same plane, but stand at right angles to each other. Accordingly, there simply is no continuous wall surface to be cut into or "opened." We must accept the fact that the glass surfaces here represent yet another means of defining space.[38] Further, these glass walls fail to exhibit a quality that some writers have held to be the quintessential characteristic of Mies's architecture: transparency. Comparison with the charcoal drawing of the Concrete Country House (Pl. 1.4) proves that one cannot possibly ascribe this to inadequacies in the representation, for there it is perfectly clear which glass surfaces are transparent and which are not. The effect stems rather from the specific qualities of the material, which produce completely different impressions depending on its use. As anyone can verify from personal experience, glass only appears to be a transparent substance when it is viewed against a light background, or, to use a more concrete example, when more than one side of a space is given over to glass. It loses this quality, however, when placed in front of a relatively dark background. Then it acts as a dark, impenetrable surface, reflecting the light falling on it more or less strongly depending on the position of the sun. This explains the difference in the shading of the panes in the perspective drawing. Mies had gathered his first experience in the handling of glass in 1922 (Illus. 20):[39] "My experiments with a glass model pointed me along the way, and I soon recognized that when using glass it is not a matter of light and shadow, but one of a rich interplay of light reflections."

Thus the closed appearance of the exterior of the brick project is anything but accidental; it is the result of precise calculation based on the previous office building designs, which led Mies to utilize the reflecting qualities of the material quite deliberately as an element of the design.

Because of the much greater intensity of the outside light, the described effect is reversed in the interior of the house. There the glass walls are so transparent that they virtually disappear, while at the same time the perpendicular walls fling one's glance out into the distant landscape. The illusion of an unbroken transition has been created, yet throughout the house the identity of the interior space is preserved both by the slight overhang of the roof and by those parallel walls that tend to mark its boundaries on one side of each opening. A distinction is only blurred somewhat in the

expanse of glass between the larger chimney block and the garden wall. There the inside space unfolds unobstructed out into the garden through a tunnel-like frame.

A very serious problem arises here, one that would appear to throw into question the value of such a radical new conception. This is the tendency for exterior space to expand into interior space because of the sheer superiority of its limitless volume. This could bring about the opposite of the desired effect by robbing the interior of its autonomy. This problem is avoided here, however, by means of the deeply projecting roof slab. The resulting uniformity in the ceiling height within and without characterizes the terrace as a partially open extension of the living room, so that the conflict is postponed to the area beyond the glass wall. As before this in the Concrete Country House, a transition zone has been created, thanks to which the independence of the interior space, though almost completely open to the garden, could be preserved.

To summarize, the linear structure of the project produces dynamic tensions which are most apparent in the interior walls but present as well in the lines of the radiating outer walls. While the interior space itself is infused with them, the effect of the freestanding outside walls on their surroundings is neutral. Putting it another way, the fragmentation of the structural substance into isolated wall elements creates a unified spatial continuum in the interior. This continuum is charged with the dynamic forces described and can with some reservations be characterized as "flowing space." It is to a great extent open to the landscape, but it is always autonomous nevertheless. In sharp contrast, the exterior gives the impression of a blocky, closed structure, a partial tie to the outside being provided solely by the slight overhang of the roof slab. The contradiction first appeared to derive from the respective representations of the perspective and the ground plan, but we now recognize that it is not a matter of inadequacy of representation but something deliberately intended. Thus this discussion would be incomplete if it did not attempt some explanation of this phenomenon. The proper approach for such an explanation was suggested near the end of the previous section.

A New Approach to Space

"In the huge hall of the train station, where

Lauweriks Werk und Einfluss auf Architektur und Formgebung um 1910, Hagen, 1972, pp. 38 and 55, ceiling design p. 44).

It is also evident in the title vignette of the handbill for the "Exhibition of Unknown Architects" presented by the Berlin Arbeitsrat für Kunst from 1919, and appears hidden in the seal of the Weimar Bauhaus, also from 1919 (on the right near the stick figure). See also in this regard Wolfgang Pehnt, *Die Architektur des Expressionismus*, Stuttgart, 1973, pp. 206 f. The conclusions reached by the latter, though cautiously phrased, appear unconvincing in some respects.

35 This seems to be the case in the title page from the journal *Wendingen* (note 34). The swastika is there surrounded by the Bible verse "En het woord is by God, in hetzelve is het leven, in het leven is het licht." The simultaneous appearance of the motif in the Arbeitsrat für Kunst and at the Bauhaus could be explained by the fact that it was seen as the symbol for a movement that sought to reform not only art but all aspects of life. Similar motifs as used by the National Socialists, who clearly had quite a different understanding of the word *reform*, are parallel phenomena and not evidence for any ideological affinity, as Pehnt seems to suggest.

36 See in this regard the section "The Dissemination of an Idea" in the chapter on the Concrete Country House.

37 Wolfgang Pehnt, "Architektur," *Deutsche Kunst der 20er und 30er Jahre*, Erich Steingräber, ed., Munich, 1979, p. 47.

38 Huse stresses this as well: *op. cit.* (note 10), p. 38.

39 Ludwig Mies van der Rohe, *op. cit.* (1922; note 11), p. 124.

Illus. 20 Model of Glass Skyscraper (proposal, 1922).

inner space with the outer. Or both can flow into one space....

Architecture, like sculpture, is three-dimensional, but differs from sculpture in that it not only exists in space but contains space. To form this contained or enclosed space, as well as the shell which encloses it, to relate it to the outside space by placing it in unformed, limitless space, is one of the basic architectural problems which Mies van der Rohe has solved in an unprecedented manner."

Although Hilberseimer thus by no means excluded the possibility in principle of a "universal" unity of space comprising inside and outside in equal degrees, at the same time he stressed the autonomous identity of Mies's interiors as "contained or enclosed space" in spite of its openness to the landscape. In so doing he differs noticeably from Walter Riezler, whose observations were not taken up by architectural criticism in its desire to hold fast to the principle of "open space." What Riezler said in his discussion of the Tugendhat House in 1931 could be applied to the Brick Country House almost word for word:[42]

"Here the new spatial concept that we have become familiar with in earlier works of this architect has been realized most decisively and completely. It is a space that is neither a basic form immediately perceivable as a whole nor one possessing distinct boundaries. Being organized by means of free-standing walls, it opens itself through huge glass panes...to outside nature. Everything that is static and composed tends to pale by comparison to the dynamism of these room sections flowing into each other, their rhythm only coming to rest outside, where it becomes one with the infinite space of nature."

Two years later, to be sure, Adolf Platz raised certain objections:[43]

"On the basis of all our previous architectural experience, a room has no 'gestalt' if it is neither a basic form immediately perceivable as a whole nor one possessing distinct boundaries. Architecture, according to Schumacher, is the design of space through the design of structure. If we choose to compare all known architectonic configurations — even of the loosest kind — we find that space nowhere flows away into nothing as it must when there is no boundary but glass. It always has some sort of limits, even if

40 Richard Lucae, "Über die Macht des Raums" (lecture given in the Singakademie on February 13, 1869), Berlin, 1869, p. 15.

41 Ludwig Hilberseimer, *Mies van der Rohe.* Chicago, 1956, pp. 41 f.

42 Walter Riezler, "Das Haus Tugendhat in Brünn," *Die Form,* Vol. 6, No. 9, September 15, 1931, pp. 321-32, quote p. 328.

43 Gustav Adolf Platz, *Wohnraüme der Gegenwart,* Berlin, 1933, p. 72.

we had first found ourselves, we had the impression that in the strictly artistic sense it was not a complete space yet. However, what made Sydenham [the Crystal Palace] so magical for us was the fact that we were in an artificially created ambience that has — I am tempted to say — ceased again to be a room. Here, as in a crystal, there is no real inside and outside. We are separated from nature but we scarcely notice it. The barrier between ourselves and the landscape is virtually nonexistent."

Richard Lucae (1869)[40]

To avoid the danger of a purely theoretical discussion, I will endeavor to illustrate the problems involved in the opening of space by drawing on the available literature. Basing his remarks on the Brick Country House, Ludwig Hilberseimer wrote in 1956:[41]

"The space concept of our age is characterized by a tendency toward openness, which has been influencing architecture increasingly ever since the Renaissance.... Architecture is placed in space and at the same time encloses space. Therefore a double problem arises — the handling of outer space, as well as the inner space. These two kinds of space can be unrelated to each other, or they can, by various means, be united. The outer space can merge with the inner, the

only apparent or suggested, that the mind of the observer supplements: think of the pillared courtyard, the open hall of columns, the enclosed garden. It cannot be the goal of our architecture to create formless space, but only space that for all its openness is still a physical, 'palpable' configuration. Infinity is formless space; but we give shape to sections of infinity."

Platz here anticipated some of the insights of Rudolf Arnheim, whose similar conclusions derived from Gestalt psychology.[44] One of Arnheim's theses reads: "The image of a square can be produced by four dots establishing the corners...."[45] Applied to architecture, this would mean that a roof supported by nothing but four columns — somewhat in the manner of Le Corbusier's structural scheme for a Domino house — can already represent the rudimentary form of a room, a "section of infinity," just as Mies was ultimately to accomplish in the Farnsworth House.

From the very beginning, then, Mies must have asked himself something like the following question: How can I achieve a maximum of "freedom in spatial design, give a free form to the space, open it, and tie it to the landscape,"[46] and thereby give its inhabitants the illusion of the greatest possible personal freedom and simultaneously a sense of being part of Nature (in the more all-inclusive sense of the term), without having to surrender one of the fundamental architectural values, namely its attribute of providing a self-contained and comprehensible section of the outside world that provides people with a sense of protection and seclusion?

Several answers were possible, and Mies proceeded to develop them in rapid succession. On the one hand, as in the Concrete Country House, it can be done by using parapets and aprons hanging from roof slabs, or — and here is the beginning of a most important solution — by creating projecting transition zones as buffers between interior and exterior space.

In the Brick Country House a third possibility in the form of large panes of reflective glass was explored, giving the exterior a closed, blocky quality. In the interior of this house, space is adequately delineated by the exterior walls lying in the same plane as the wall openings. Without referring specifically to Mies, Arnheim was quite correct when he wrote:[47]

"The effect of such screens depends on the ability of their open and closed spaces to act together as a partition, which is a flat plane or more nearly a surface layer of some depth. This effect is obtained in accord with a basic perceptual principle, namely that a line or plane need not be spelled out entirely, but will complete itself in the observer's mind if its structure is sufficiently represented."

The next step was to be the system of freestanding columns introduced in the Barcelona Pavilion. The areas marked off by it comprise the actual "interior space," while the border area beyond, covered by the deeply overhanging roof slab, can once again be interpreted as a transition zone (Pl. 10.16). Or in place of these, finally, adjacent courtyards surrounded by walls may be used, as is already suggested in the use of the outside walls to the side of the Barcelona Pavilion. This alternative was utilized most fully in the Court House designs of the thirties.

The Farnsworth House (1945-51) concludes a line of development in the work of Mies van der Rohe that stretches over more than two decades. The "conclusive" solution to the problem of space that it presents was in part anticipated in the lounge of the competition design for the Krefeld Golf Club from 1930 (Pl. 13.9, pictured on the left). And it was first used in a purely residential building in 1932, in the design for the Gericke House (Pl. 15.14).

"Space and structure are two manifestations of the same configuration," Platz wrote. "That space expresses itself as structure from without is self-evident."[48]

The Influence of de Stijl

"The ground plan, which itself appears to be a self-contained artistic achievement in the manner of certain Constructivist pictures, reveals that the architect places whole walls of glass between massive brick walls."

E. Strübing (1925)[49]

The decisive influence of de Stijl on the design of the Brick Country House and on modern architecture in general — at that time no distinction was yet made between Russian Constructivism and the Neoplasticism movement led by Mondrian and van Doesburg — was recognized relatively early, as the above quote from 1925 attests. Interestingly enough, reference was always made only to the painting of de Stijl. This may be in part because the architectural projects

44 Rudolf Arnheim, *The Dynamics of Architectural Form*, Berkeley/Los Angeles/London, 1977. Cf. August Schmarsow, *Barock und Rokoko: Eine kritische Auseinandersetzung über das Malerische in der Architektur*, Leipzig, 1897, p. 6.

45 *Ibid.*, p. 228.

46 Ludwig Mies van der Rohe, contribution to a prospectus from the "Verein Deutscher Spiegelglas-Fabriken," dated March 13, 1932; MoMA (1st version).

47 Arnheim, *op. cit.* (note 43), pp. 227 f.

48 Platz, *op. cit.* (note 1), p. 109.

49 E. Strübing, "Führer durch die Ausstellung," *"Typen neuer Baukunst," op. cit.* (note 3), p. 18.

Illus. 21 Theo van Doesburg: *Rhythm of a Russian Dance* (1918).

that van Doesburg developed in collaboration with Cornelis van Eesteren beginning in 1922 were—and still are—so little known.[50] But also it was certainly because of the extremely pictorial effect of Mies's ground plans, which represented in themselves, to quote the above writer, "self-contained artistic achievement." Platz took up the comparison again eight years later, elaborating somewhat:[51]

"The plastic cubism of the de Stijl group provided the experimental foundation for this new approach, for the Neoplastic experiments of van Doesburg, Mondrian, van Tangerlo [Vantongerloo], and van Eesteren all converged on the architectural model. The first works of the Weimar Bauhaus... and of Mies van der Rohe are the direct continuation of those Neoplastic designs.

"Here it was rather the influence of cubist (Neoplastic) ideas from the circle around the Dutchman van Doesburg and the de Stijl group that was of seminal importance, echoing as they do in the idealized designs of Mies van der Rohe."

Mies himself was quite firm, however, in his denial of any influence of Mondrian on his buildings.[52] And a brief comparison indeed reveals the principal distinction to be made. Mondrian's pictures, ignoring the first process of abstraction away from the concrete object, show a surface filled with a uniform (i.e., lacking a center, a point of gravity) grid composed of black lines, with fields of colors placed between them. In them the grid is never terminated at the edge of the canvas, but rather appears to continue out beyond the boundaries of the picture.[53] Thus Mondrian's paintings always represent only a portion of an ordered system perceived of as infinite; they are manifestations of a theosophic, cosmic vision deriving from the philosopher Schoenmaekers, and are ultimately based on Platonic ideas.[54]

It is true that the ground plan of the Brick House also suggests an infinite extension of the walls radiating in three directions across the property, but these have a definite orientation in that they clearly originate in the structure, and do not simply break in from the main points of the compass as Pehnt suggested.[55] The ambiguity that Pehnt discovered, permitting him to read the plan now one way and now the other, would tend to approximate the Mondrian concept, but it is not consistent with the analysis given above. Moreover, the grouping of wall elements around the source of the long walls—that "area of forms placed somewhat more compactly"— leads to a distinct centering of the drawing and therewith creates a higher field intensity in the middle of the picture, an effect that Mondrian deliberately sought to avoid in his later works.

Centering of this kind is, however, to be

Illus. 22 J. L. M. Lauweriks: Calling card (1912).

50 Most of the designs and models in the 1923 Paris exhibition Les Architectes du Groupe "de Stijl" (Léonce Rosenberg's Galerie "l'Effort Moderne," October 15–November 15, 1923) were being shown to the public for the first time. It is quite doubtful whether Mies was able to see them there, considering the difficulty of traveling at that time because of political conditions (the occupation of the Ruhr). At most, he would have known them from photographs—unless of course van Doesburg brought plans with him to Berlin before 1924.

51 Platz, *op cit.* (note 43), pp. 36 and 58.

52 For example, in an interview by Franz Schulze, "I always wanted to know about truth," *Panorama* (Supplement to the *Chicago Daily News*), April 27, 1968:
 Schulze: "One would think, perhaps, that he would favor Mondrian. His work might seem to be influenced by the clean lines of the great Dutch abstractionist. Is this true, Mies?"
 Mies (with emphasis): "The Museum of Modern Art thinks so. I don't. Really, my ideas were arrived at independent of Mondrian. I like him, don't misunderstand. But I bought Klee."
 Schulze: "Why didn't you also buy Mondrian?"
 Mies: "You don't have to have everything."

53 H. L. C. Jaffé, *Mondrian und de Stijl*, Cologne, 1967, p. 14; Meyer Schapiro, "Mondrian" in his *Modern Art: 19th and 20th Centuries. Selected Papers*, New York, 1978, pp. 233–61, especially pp. 236 and 238:
 "There is also his commitment to an openness and asymmetry that take us beyond the concreteness of the elements and suggest relationships to a space and forms outside the tangible painted surface. . . .
 In this art which seems so self-contained and disavows in theory all reference to a world outside the painting, we tend to complete the apparent forms as if they continued in a hidden surrounding field and were segments of an *unbounded grid*. It is hard to escape the suggestion that they extend in that virtual space outside" (p. 238; emphasis mine).

found in the work of van Doesburg, who was for a time in close personal contact with Mies van der Rohe. As early as 1936 Alfred Barr pointed out the direct connection between the ground plan of the Brick House and van Doesburg's 1918 composition *Rhythm of a Russian Dance* (Illus. 21).[56] That painting is composed of distinctly outlined bars that are strictly prevented from touching each other and do not extend beyond the frame. In contrast to the system of lines developed at roughly the same time by Mondrian, which is essentially "immaterial," or insubstantial, these bars stand out sculpturally against the surface. The center area that they describe is kept white, and is clearly set off from the grayish background of the border area, so that a distinctly spatial effect is achieved. In purely pictorial means, then, the same thing is expressed here that was observed earlier in the ground plan: a specific configuration of linear elements (wall screens) that are totally disconnected or only loosely attached to each other is capable of producing tensions that define space.

Other similarities are also to be found. In the gravitational center of the *Russian Dance*, for example, the two black bars and two dark blue ones once again describe an angled cross, a form that establishes the rhythm of the composition. The arrangement of the bars here resembles the wall arrangements in the two entry areas of the Brick Country House to such an extent that

any lingering doubts about Barr's suggestion of the influence of this work on Mies can be discarded. The motif is by no means an exclusive discovery of van Doesburg's, to be sure, but may derive in turn from an older design by Lauweriks. In 1912 Lauweriks had designed a calling card with a spirally expanding swastika in which the actual drawing appears to be the background, so that the white lines remaining take on the form of an angled cross whose arms radiate out from an open center (Illus. 22).[57] Both compositions could well have inspired Mies to the design of his Brick Country House (presumably Behrens would have served as the link to Lauweriks), but if only because of the closer formal similarity the influence of van Doesburg is more likely. Hilberseimer's comparison to Mondrian is nonetheless valid:[58]

"What Mondrian did in painting, with the means of painting, Mies van der Rohe does in architecture, with the means of architecture. He aims, like Mondrian, at the spiritual. There is, however, a great and distinctive difference in the work of these artists. Mondrian's paintings are self-contained works of art. Mies van der Rohe's plans are only a notation of his space concept. They are a part only, a projection, a horizontal section of a three-dimensional whole and cannot therefore be compared with a two-dimensional painting."

54 Cf. Jaffé *op. cit.* (note 53), p. 17, who designates Schoenmaekers as the actual catalyst of the group. See also Daniele Baroni, *The Furniture of Gerrit Thomas Rietveld*, Woodbury, N. Y., 1978, especially pp. 21-27.

55 Pehnt, *op cit.* (note 37), p. 47.

56 Alfred H. Barr, Jr., *Cubism and Abstract Art*, New York, 1936, p. 156 (illus. 162 and 163): "In the history of art there are few more entertaining sequences than the influence by way of Holland of the painting of a Spaniard [Picasso] living in Paris upon the plans of a German architect in Berlin — all within twelve years."

57 Reproduced among other places in *Wendingen*, Vol. 10, No. 8, August 1929, p. 8.

58 Hilberseimer, *op. cit.* (note 41), p. 42.

Walter Dexel, who as director of the Jena Kunstverein had done much to promote the spread of the modern movement in the twenties, but who above all was himself an outstanding artist,[1] decided in late 1924 to build himself a house. Presumably the stimulus came from an exhibition of modern German architecture that he organized (*Neue deutsche Baukunst*, Jena Kunstverein, November 2-December 12, 1924) which included works by Behrens, Gropius, Häring, Mendelsohn, Mies, and Bruno Taut, among others.[2] Mies was to have given a lecture on the occasion of the opening of the show, but he had to decline because of illness. On short notice Gropius's collaborator, Adolf Meyer, stood in for him.[3]

Obviously still undecided about whom to choose as his architect, Dexel turned to his friend Adolf Behne for advice. Behne's response was:[4] "I would probably choose Mies—but Gropius is closer, Berlin a long way away." Doubtless Behne was thinking mostly of the general difficulty of supervising a building project without having the architect readily at hand. He could hardly have known that the project would finally come to nothing for quite different reasons. In spite of that reservation, Dexel decided on Mies, who was given the commission at the beginning of January[5] and promptly announced that he would soon come to Jena to look at the site. In a letter from January 7, 1925, Dexel insisted that Mies keep the date he had set:[6]

"I have just received a card from Gera implying that you have important things to do in Berlin at the end of the week and that you are postponing your trip to Jena. Foolishly, I forgot to inform you that my father-in-law is leaving on January 13 for two weeks in Switzerland and that it is essential that we be able to present him with some general proposals at least before that time. Please either keep to our agreement and come on Thursday for certain, or, even better, plan your stay in such a way that we will have time to come to enough of an agreement right away about the exterior layout and the floor plan that my father-in-law can go off without worrying."

Grete Dexel's father, Karl Brauckmann, appears repeatedly in the correspondence, though not by name. To all appearances he had assured himself a voice in the planning of the project by offering to finance it. However, the artist's son Bernard Dexel confirms that the house was definitely to

be built for his parents, as even the disposition of the floor plan would appear to corroborate (Pls. 4.6-4.9).[7] By the middle of the month Mies received more detailed information from Jena.[8] In the following days and weeks there was a flurry of queries about the whereabouts of the promised drawings. The letters speak for themselves, for the most part, and therefore they are here quoted in full:[9]

January 22, 1925 (Grete Dexel):

"My father, who in his old-fashioned way considers agreements binding, has today requested that I send the plans to him in Switzerland immediately, thinking that 'as agreed' we have had them in hand for days now and are discussing them with you 'as agreed' today (the 22nd!). *We* are therefore somewhat chagrined. Perhaps you will prove the rule of not writing and not coming with an exception? Everything doesn't *have* to be straightforward, but for once something could be! Instead of question marks I'll use exclamation points today!!!"

January 24, 1925 (Walter Dexel):

"Nothing from you even today (the 24th)! I cannot refrain from letting you know that we are extremely upset. For business reasons we *must* be able to move into the house on October 1—preferably before. On January 3 I informed you that the plans *must* be submitted by the beginning of February, but we hear nothing from you. The local building authorities require *at least* four weeks as a rule; in our case I anticipate a denial and a long drawn-out battle (they refused me my illuminated sign a week ago).

I am in a considerable predicament wondering what I am to write my father-in-law in response to his repeated queries.

Since circumstances force us to insist that the matter be executed quickly, we have no choice but to ask you once more without further delay whether you wish to undertake the project under such conditions. If you do, you would have to decide to keep to deadlines mutually agreed upon and to conduct the necessary correspondence in a conscientious manner. For people whose store of patience tends to be below rather than above average, the idea of having an architect off somewhere who neither keeps his promises nor answers questions is most unpleasant.

We have written you three times already

without receiving an answer, and we are forced to assume that you are already in Switzerland without having even begun with our plans. Even if you have done them by now, I should consider the time remaining for their final development to be extremely brief. It can scarcely be expected that we will find ourselves in agreement over all details from the start.

No matter what, we expect an immediate response from you and a visit before the 28th. Since the Schwitters and Doesburgs are due to arrive then, we cannot expect to get any serious work done for those next few days."

January 28, 1925 (Grete Dexel):

"My father has just returned. I faced him with some trepidation and *swore that plans were on the way and would definitely arrive tomorrow*. Please do all you can to see that they do. Can't you come yourself? And bring them with you? Or do you want to send them ahead and come after we have had a chance to study them? *In any case extreme haste is essential. Otherwise the whole thing will come to naught.*"

January 29, 1925 (Grete Dexel):

"Since you aren't coming to us, we are coming to you. Arrive about 7:30 Friday, Anhalt Station, and will call you sometime later to see whether we can discuss the plans *Friday* evening and *Saturday morning* or at least one of those times."

Obviously nothing to speak of by way of plans was finished even then—not surprisingly, considering the far-too-tight deadlines given. On January 24 Mies had stated categorically:[10] "The project must be worth something or I won't allow it to leave the studio."

The clients could understand, and they granted still another postponement. But that deadline arrived and still there were no plans. Meanwhile, Adolf Behne tried to keep his friend informed about the progress of the work.[11] At the beginning of March Dexel felt that at last he was forced to decide to work with Mies no longer:[12]

"Unfortunately, I have no choice but to inform you on behalf of my father-in-law that he no longer expects to receive any plans from you, since the deadlines for delivery that you yourself set in Berlin have already been exceeded by more than four

Illus. 23 A. Meyer: Dexel House (proposal, May 1925). Illus. 24 A. Meyer: Dexel House, site plan.

weeks. He therefore feels obliged to consider the business as finished. He asks that you inform him how much he owes you. Personally, I regret that the affair has turned out this way."

Nevertheless, Mies must have managed to talk them into one last postponement, for Behne was able to report on March 16:[13] "Mies called me; he has had an inspiration about the house. EUREKA."

Still, the matter ultimately amounted to nothing more than a number of quick sketches and an episode equally painful for all parties. There was also an epilogue. Once more it was Adolf Meyer who volunteered to step in in place of Mies. The design that he submitted in May 1925 (Illus. 23, 24)[14] got as far as the construction-plan stage, but was finally abandoned because of resistance from the local building authorities. In support of his application to them Meyer asked the board of directors of the German Werkbund for a recommendation, and this document, drafted by Behrens, Mies, and Poelzig, was sent on December 22:[15]

"The German Werkbund has sent us your design for the Dexel House in Jena with the request that we give our opinion of it. We have examined your plans, and have found that the arrangement of the individual rooms and especially the siting of the building in the landscape meet all the requirements architecturally. The grouping of its masses is good, so the structure ought to make a very dramatic impression. There

1 Dexel's paintings and graphics show strong influences of Constructivism and de Stijl, with whose chief representatives he maintained close personal contacts. For biographical details on Walter Dexel see Walter Vitt (ed.), *Homage à Dexel (1890–1973)*, contributions to celebrate the artist's 90th birthday, Starnberg, 1980; also Werner Hofmann, *Der Maler Walter Dexel* ("Kunst und Umwelt" series, ed. by Eugen Gomringer, Vol. 4), Starnberg, 1972. Particularly recommended is the essay by Volker Wahl, "Walter Dexel als Ausstellungsleiter des Kunstvereins Jena," *Homage à Dexel*, pp. 55-64. See also the list of the exhibitions organized by Dexel compiled by the same author (ibid., pp. 65-71).

2 List of contents of packages containing exhibition material, dated October 29, 1924; LoC. Mies was represented by several projects, among them the design for a "Country House in Neubabelsberg" (the Brick Country House).

3 Vitt, *op. cit.* (note 1), p. 74, note 12.

4 Behne to Dexel, December 5, 1924; papers of W. Dexel, quoted in Vitt, *op. cit.* (note 1), p. 93.

5 W. Dexel to Mies, Jaunary 24, 1925; MoMA: "I informed you on January 3."

6 W. Dexel to Mies, January 7, 1925; MoMA.

7 The studio wing and the rooms for the Dexels' two sons support this assumption.

8 W. Dexel to Mies, January 15, 1925; MoMA: "Enclosed are the desired sketches. Forgive the delay. I have too damned much work. We eagerly await the results of all this!" Presumably the sketches mentioned were topographic ones with information about the site.

9 The letters quoted here are all in the Mies van der Rohe Archive, MoMA.

10 Mies to W. Dexel, January 24, 1925; collection of Bernhard Dexel.

11 Letter of February 11, 1925: "I have not heard anything from Mies directly."; and on February 21: "Mies left the day before yesterday for Switzerland." Quoted in Vitt, *op. cit.* (note 1), p. 94.

12 W. Dexel to Mies, March 3, 1925; MoMA.

13 Behne to W. Dexel, March 16, 1925; among the papers of W. Dexel, quoted in Vitt, *op. cit.* (note 1), p. 95.

14 The dating is based on information supplied by Bernhard Dexel in Hamburg. Additional reproductions of the design submitted by Adolf Meyer can be found in Henry de Fries, *Junge Baukunst in Deutschland: Ein Querschnitt durch die Entwicklung neuer Baugestaltung in der Gegenwart*, Berlin, 1926, illus. pp. 56 f. (5).

15 Board of Directors of the German Werkbund on behalf of Mies, Behrens, and Poelzig to Meyer, December 22, 1925; LoC.

can be no question of its spoiling the scenery; on the contrary, we feel that thanks to the way the simple cubic forms of the house are nestled so magnificently into the landscape they fit in with the hilly surroundings admirably. We would like to think that this building can soon be constructed."

In spite of this imposing testimonial from three of the leading German representatives of modern architecture, even the second submission of the plans to the building authorities was rejected.

In the light of the events just described, the quality of Mies's designs is rather striking, for in part they are astonishingly good. A certain inconsistency is obvious even at first glance: the surviving floor plans (Pls. 4.6-4.9), with variant disposition of rooms and location of the stairwell, differ markedly from the perspective sketches both in the manner of their execution and in the grouping of structural masses.[16] The living areas are disposed over two floors of a simple, rectangular structure to which a lower studio building is attached at one corner. The two areas joined at a right angle open onto a veranda facing the south,[17] the roof of which rests on either an extension of the east wall of the studio wing or on a segment of wall serving as a pillar (Pl. 4.8). The floor plan and interior arrangement seem comparatively conventional and distinctly inferior to Mies's earlier country house designs, so that we are forced to assume that the room layout was largely dictated to him. The manner of their drawing suggests that the floor plans were made at a first consultation with the clients, possi-

bly even prepared according to their specific instructions, especially since the precise labeling of the various rooms would appear to have been intended as an aid to communication during the discussion. The exterior view at the lower left of one of the sketches (Pl. 4.1) conforms most closely to this layout. The motif of two connected perpendicular wings of different heights can be found in one of Mies's two alternative designs for a house for himself in Werder (Illus. 25). It had also been suggested in his much more grandiose design for the Kröller-Müller Villa of 1912/13. The breakthrough announced by Behne ("he has had an inspiration about the house")[18] may explain the four additional pages of sketches that have survived (Pls. 4.2-4.5), which are of a much higher level than the first drawings. Here Mies managed to create a free disposition of structural masses in lively interplay with surrounding space, quite in contrast to the rather stiff arrangement first envisioned. Grouped somewhat loosely around a huge central chimney block, the wings become much shorter on the outside, a theme repeated in the terracelike downward slope of the terrain. This close adaptation of the structure to the contours of the landscape is a variation on the layout of the Concrete Country House from two years before, while the orientation around a dominant massive chimney block recalls the buildings of Frank Lloyd Wright in Chicago.

However, this promising start clearly came several weeks too late. The patience of his clients had been so thoroughly exhausted meanwhile, they felt it hopeless to continue working with Mies van der Rohe.

16 Nevertheless, there is no doubt that these are drawings by Mies van der Rohe himself. Typical, for example, is the spiral-shaped line to indicate a winding staircase in Plates 4.8 and 4.9.

17 The orientation derives from the faint directional arrow in Plate 4.6 (upper left); see also the site plan for Adolf Meyer's design (Illus. 24).

18 Behne to Dexel, March 16, 1925 (see note 13).

In contrast to the rather inglorious demise of the project in Jena, the design for the Eliat House at least managed to reach a conclusive stage. Dated incorrectly by Johnson to 1923,[1] the period of the conception of this project falls in the first half of 1925 as well. Contact between client and architect was effected by a mutual acquaintance, who wrote the following note to Mies in January of that year:[2]

"Herr Ernst Eliat (March-Privatstrasse 7[e]) visited me today. He wishes to have a house built somewhere outside the city. Though he is rather firmly committed to another architect already, it is still possible that you might be able to win him over for yourself. Perhaps it would be worth your while to get in touch with him."

Mies promptly set about trying to secure the lucrative commission for himself at the expense of his fellow architect. In the meantime, Eliat had brought in a neighbor, the architect Werner March, as an advisor,[3] giving the whole thing something of the air of a competition. The fact that some years later March was once again to have dealings with Mies in a very similar function would suggest that this was indeed the case. (On this later occasion Herbert Gericke entrusted March with the administration of a competition for a residence for himself on the Wannsee, and Mies submitted a design.[4]) On March 17, 1925, March wrote to Mies:[5] "On behalf of Herr Eliat I am enclosing the surveyor's sketch complete with elevations, and presume that you already have in hand the corresponding 1:500 site plan."

The two letters quoted above are the only written documents relating to this project to have survived, so that we are left to make conjectures about the further course of negotiations. In any case, the commission must have been given to Mies, for two of the plans (Pls. 5.4, 5.5) bear the customary inscriptions and were accordingly to be submitted to the building authorities for approval. Their date of June 17 provides an additional piece of evidence, and permits us to narrow the planning phase down to the spring of 1925. It is still uncertain what finally caused the project to come to a halt—a question that even the client's widow, now living in New York, was unable to answer.[6]

Beyond the two drawings already mentioned, which give floor plans for the basement story and the main floor, and the elevations of the lake side and the street side, only a sketchy site plan (Pls. 5.2, 5.3) has survived. The presentation drawing of the entryway (Pl. 5.1) that was reproduced by Westheim and was obviously done in color must have since been lost.[7] In any case, the discrepancies with the existing drawings are all in all rather trivial: except for the missing beams of the projecting concrete slab and the horizontal division of the glass terrace doors of the main entry, the perspective rendering corresponds with the street view given in elevation.

The projected site was an irregular, trapezoidal lot on the Fahrländer See,[8] which belonged to the borough of Nedlitz, near Potsdam.

The driveway to the residence runs into an elongated rectangular forecourt, and is flanked on either side by outbuildings, one of which can be identified as a chauffeur's dwelling because of its proximity to the garage (Pls. 5.2, 5.3). Their relatively sketchy outlines, obscured by corrections and reworkings, suggest that these annexes were a later addition that must have been made after the main building was already planned. Though first placed parallel to the street (a solution that was obviously immediately rejected), the outbuildings are oriented to the axes of the main residence, so that the unity of the entire complex is preserved.

Where there are no abutting buildings, the sides of the forecourt are lined by a chest-high hedge (see Pl. 5.1), giving it the appearance of a courtyard. At its far end, slightly off center, are the three glass bays of the main entry, covered by a deeply projecting concrete slab. On the other side of the hedge, along the right-hand side and protected by it from unwanted views, lies a multiterraced sunken rose garden similar to the one found in the Wolf House. However, the rest of the terrain appears to have been left in its original state. The main building presents a complex configuration of wings set around an approximately square central core (Pl. 5.5). This core includes a vestibule placed to the side and in front of the entry hall, with adjacent powder room and guest toilet, a corridor leading off from it that grows wider as it approaches the bedroom area, a butler's pantry (connected by means of a dumbwaiter to the kitchen below), and finally a winding staircase leading to the basement level to the left of the servants' entrance. One enters the house to the right of the main portal, which is obviously intended to be used only on festive occasions. The spa-

1 Philip Johnson, *Mies van der Rohe*, 3rd rev. ed., New York, 1978, p. 214 (no illus.; no further reference in the text).

2 M. Schmidt (Habke & Schmidt, Publishers and Booksellers, Berlin) to Mies, January 28, 1925; MoMA.

3 Werner March's address (1932): Marchstrasse 9, Charlottenburg (Gericke correspondence; MoMA).

4 See the chapter on the Gericke House.

5 March to Mies, March 17, 1925; MoMA.

6 Interview by Ludwig Glaeser with Frau Eliat in New York on February 4, 1976 (tape copy; MoMA).

7 Paul Westheim, "Mies van der Rohe: Entwicklung eines Architekten," *Das Kunstblatt*, Vol. 11, No. 2, February 1927, pp. 55-62, illus. p. 59 (top).

8 March to Mies (note 5).
 Nedlitz lies on the south shore of the Weissensee, which connects the Fahrländer and Jungfern lakes. Therefore some confusion cannot be totally discounted.

Illus. 26 P. Behrens: St. Petersburg Embassy (1911-12), view to the courtyard.

tial organization of the house offers unmistakable similarities to that of the Lessing House, but here the central core, fulfilling as it does manifold functions, has also been endowed with greater unity in the plan, while, in elevation, its lower roof line sets it off from the wings flanking it on both sides. At first glance it might appear that Mies grouped the subsidiary areas of the house somewhat arbitrarily into this central core. But on closer inspection it becomes apparent that the vestibule, corridor, staircase, and butler's pantry all share a similar function, namely, to provide access to other parts of the house while separating them spatially. As against the Lessing House, the floor plan thus noticeably gains in a clarity which the preceding design for the Concrete Country House doubtless helped bring forth.[9]

The spacious foyer immediately to the left, opening onto a projecting roofed terrace, is divided into three equal bays by the strongly accented roof beams. The openings between their supporting columns are filled with doors of glass, the framing of which extends clear to the ceiling. This foyer and its open forecourt thereby act as a spatial continuum, the placement of the pillars and the uninterrupted lines of the beams serving to heighten the effect. As in the Concrete Country House, the forecourt is set off from the exterior space by means of a slightly raised paving slab and by aprons descending from the sides of the projecting roof. The motif of glass doors between pillars recalls the vestibule of Behrens's St. Petersburg Embassy, which opens onto an

interior courtyard in a similar way, though there a column has been set in front of each pillar (Illus. 26). This ultimately derives from the glassed-in exedrae in Schinkel's design for the Csar's Palace in Orianda,[10] which anticipate to an astonishing degree the aspirations of modern architecture. While still in the office of Peter Behrens, Mies had served as local supervisor during the construction of the German Embassy in St. Petersburg. Moreover, he owned the volume of plates containing the Orianda designs,[11] so the direct influence of Schinkel is certainly possible, especially inasmuch as the unusual mullion arrangement in the presentation drawing (Pl. 5.1) is also present in the pavilion for the residence of the Csar.[12] On the other hand, the transition space projecting to the outside is to be found neither in Schinkel nor in Behrens, but is indisputably an innovation of Mies van der Rohe's, who thereby contributed decisively to the development of landscape-oriented architecture.

The actual living room of the house is reached from the rear of the foyer. A broad wall opening yields a view through to the small winter garden situated outside the opposite wall opening. The orientation of the living room reverses that of the foyer, for there is a massive chimney on the courtyard side and a large window facing the lake. From the foyer a second opening leads to the dining room, which echoes the motif of the entryway in just the same way as did the living room in the Concrete Country House. The wider central bay in its ceiling— this too anticipated in the 1923 design

—accentuates the centering of the room and lends it a greater sense of repose. The alignment of the room runs parallel to the garden front, yet a four-paned window cut into the outer wall offers a broad view of the lake. A second chimney is centered on the back wall of the foyer, with a fireplace opening onto the garden terrace and protected by its projecting roof. The master bedroom suite fills a separate wing accessible only from the corridor leading off from the entry. One first enters a dressing room, it too provided with a fireplace, from which a narrow corridor leads past the bathroom to the bedroom, which opens by means of a glass door onto the rose garden. The downward slope of the property toward the lake permits, as in the Concrete Country House, the full exploitation of the basement level on the lower side. In addition to the kitchen, all the staff quarters and guest rooms are on this floor (Pl. 5.4).

The prominence of the chimney blocks, especially inasmuch as they are indented and provided with ornamental seams for purely decorative reasons in a manner quite untypical of Mies, shows the influence of the Prairie Houses of Frank Lloyd Wright, designs with which Mies was quite familiar thanks to two Wasmuth publications in 1910 and 1911 and the Wright exhibition in Berlin in the earlier year.[13] A similar division of wall surfaces by means of ornamental stripes in a contrasting color can be found, for example, in the Thomas H. Gale House in Oak Park, Illinois, of 1909. This is one of Wright's few flat-roofed residences from this period, and its cantilevered roof slabs may have been another influence on Mies's design.[14] But while Wright consistently used chimneys as the dynamic focus of a configuration, grouping structural masses loosely around them and ultimately orienting all of the interior spaces to them, Mies placed his against the outer walls of the two separate wings, so that they appear to press against them almost contrapuntally. Their vertical forms serve as strong accents in contrast to the horizontal lines of the various wings of the house reaching out into the landscape. Although Mies's chimneys are, in this respect, quite clearly related to Wright's— which are also consistently deployed in rhythmic opposition to one another—they never attain a comparable ideal significance. In part this is doubtless because the dominant tradition of the open fireplace widespread in Anglo-Saxon countries did not have a counterpart in Central Europe. Even in the early country house projects, one can see

how Mies reinterpreted them into structural elements related purely formally.

The sharp lines of the structure against the sky, accented by the soaring chimney blocks, are mitigated by the use of climbing vines against the walls. These serve to soften the crystalline hardness of the design. And they were to become a persistent motif in the work of Mies van der Rohe. Here it should suffice to refer only to the Krefeld Golf Club (Pl. 13.9) in this regard. This may indicate a further influence of Frank Lloyd Wright, who used plantings in a similar way, deliberately softening the staggered cubic masses of his Hollyhock House.[15] It is impossible to determine whether Mies was familiar with that project at this time, given the limited documentation available. But he could just as well have gotten the idea from the Susan L. Dana House from 1903, which design he certainly knew from one of the Wasmuth volumes already mentioned.[16]

The Eliat House is certainly not one of Mies van der Rohe's pioneering designs. Nonetheless, it represents an important intermediary step, one that attempts to build on the projects that immediately preceded it. New lines of thinking that had only existed as ideas on paper were here given a first trial in practice. And the insights gained from this concrete assignment provided valuable knowledge for the later work, especially since here a client had obviously been found who was perfectly willing to respect the goals and concepts of the architect.

9 Cf. the reconstruction of the "distributor area" in Chap. 1.

10 Karl Friedrich Schinkel, *Werke der höheren Baukunst, für die Ausführung erfunden*, 2nd Section: *Entwurf zu dem Kaiserlichen Palast Orianda in der Krim*, 3rd ed., Berlin, 1862, Plate 10.

11 See in this regard my essay, "Orianda-Berlin: Das Vorbild Schinkels im Werk Mies van der Rohes," *Zeitschrift des Deutschen Vereins für Kunstwissenschaft*, Vol. 35, Nos. 1-4, 1981, pp. 174-84.

12 Ibid., illus. 7, p. 182.

13 *Ausgeführte Bauten und Entwürfe von Frank Lloyd Wright*, n.p., n.d. [Berlin, 1910]. *Frank Lloyd Wright: Ausgeführte Bauten*. With a foreword by C. R. Ashbee, Berlin, 1911 (published as *Frank Lloyd Wright: The Early Work*, New York, 1968).

14 Reproduced in *The Early Work* (note 13), p. 64.

15 Reproduced in Arthur Drexler, *The Drawings of Frank Lloyd Wright*, New York, 1962, illus. 61 and 63. The motif appears at roughly the same time in the project for a townhouse from 1916 (idem, illus. 56). Regarding the genesis and dating of the Hollyhock House, built for Aline Barnsdale, see Kathrine Smith, "Frank Lloyd Wright, Hollyhock House, and Olive Hill: 1914-1924," *The Journal of the Society of Architectural Historians*, Vol. 38, No. 1, March 1979, pp. 15-33.

16 See *The Early Work* (note 13), illus. pp. 32-35. In his introduction to the unpublished catalog of a Frank Lloyd Wright exhibition at The Museum of Modern Art in 1940 (reprinted in Johnson, *op. cit.*, pp. 200 f.), Mies expressly referred to the Berlin exhibition of 1910 and the subsequent publication of Wright's designs: "The encounter was destined to prove of great significance to the European development. . . . His influence was strongly felt even when it was not actually visible."

Important with regard to possible influences of the Hollyhock House is this comment: "So after this first encounter we followed the development of this rare man with wakeful hearts."

To be sure, a possible stimulus from Peter Behrens as well cannot be discounted (see in this regard Wolfram Hoepfner and Fritz Neumeyer, *Das Haus Wiegand von Peter Behrens in Berlin-Dahlem*, Mainz, 1979, especially pp. 42-50), who may himself have been influenced by Wright. In this connection the study by Howard Dearstyne is informative. He was obviously quoting from a conversation with Mies van der Rohe when he wrote: "He went on to relate how . . . the latter [Behrens] had brought to the office the first reproduction of Wright's work which they had ever seen. (He referred, doubtless, to the magnificent Wasmuth portfolio, published in Germany in 1910.) Mies said, 'This came as a revelation to us.'"

(Dearstyne, "Miesian Space Concepts in Domestic Architecture," *Four Great Makers of Modern Architecture: Gropius – Le Corbusier – Mies van der Rohe – Wright*, The Verbatim Record of a Symposium Held at the School of Architecture, Columbia University, March-May, 1961, New York, 1970, pp. 129-40, quote p. 131.)

The commission for the Wolf House in Guben on the Neisse gave Mies van der Rohe his first opportunity to translate into actual fact the ideas that he had developed in his two country house projects.

It was through Frau Kempner, whose house he had seen in January 1925, that Erich Wolf first became aware of Mies.[1] The villa built by Mies at 5-7 Sophienstrasse in Charlottenburg (Berlin) for Maximilian Kempner around 1921 has come down to us only in the form of a planning sketch from 1919, one presumably based on an early stage of its design.[2]

The commission was likely given quite soon after Wolf first made contact with Mies, at the end of January or the beginning of February 1925. Nonetheless, it would appear that no specific results were available before the autumn of that year. Of the ninety-eight surviving plans, the two floor plans for the ground floor and the upper story dated October 19, 1925, and reproduced in plates 6.5 and 6.6 obviously represent the beginning of the planning process, at least as far as we can reconstruct it on the basis of the extant material. Since they are signed by both client and architect,[3] they were clearly meant to be submitted to the local building authorities for their approval. A series of facade elevations (Pls. 6.2-6.4), obviously reworked, was made around Christmas 1925,[4] and differs in various details from the floor plans. The remaining plans (Pls. 6.7-6.10), which by and large conform to the final version, do not contain anything that would permit more accurate dating, but are probably from the spring of 1926, when the first cost estimates were being solicited.[5] Additional drawings with finished details date for the most part from the following year — which suggests that the structure had been largely completed in the intervening period.[6]

Unfortunately, no interior photographs have survived, although the Wolf House was discussed and illustrated in various domestic and foreign periodicals at the time it was built.[7]

The property, on the lower side of Teichbornstrasse, consists of an uncommonly long and rather narrow parcel extending across the crest of a hill and bounded on the south by a road (An der Grünen Wiese) running along the valley side. As the site for the house Mies chose the upper edge of the steep slope, which, secured by numerous retaining walls, descends like a cascade to the valley floor.[8] Accordingly, the house came to stand roughly in the middle of the

property, completely filling its available width. Later, when Wolf decided to build an addition to the house, he was able to acquire the adjacent parcel to the west. This addition, intended to house an art collection, was also designed in the studio of Mies van der Rohe. The surviving plan for it (not reproduced)[9] shows it to be a large rectangular gallery with southern exposure and a winter garden. It abutted the kitchen and could be entered through the dining room. The winter garden, which served to filter the strong sunlight on that side, opened onto a garden terrace projecting out beyond the existing line of the building; its foundation can be seen quite clearly under construction in one of the photographs (Pl. 6.11, on the left). The plan has no date, but because of certain parallels to the Tugendhat and Nolde houses it would appear to belong stylistically to the period around 1930.[10]

The first set of floor plans (Pls. 6.5, 6.6) represents in many respects a modified version of the never-constructed Eliat House of only a few months before. The entire lower area around the dining room has been taken over virtually unchanged. Even the bay arrangement of that room, with its wider central section, has been preserved, and here again is the stepped, projecting chimney — opening toward the inside in this case — flanking the extended terrace and serving at the same time as a support for its cantilevered roof slab. The adjacent suite of rooms, consisting of living room, foyer, and vestibule with porch, varies the motif of the earlier entry hall, while the smoking room, here set off only by a glass wall, corresponds in orientation and layout (note the fireplace) to the living room of the preceding plan. The revised arrangement of rooms in the entry area produces a more intimate spatial impression here, one that has little in common with the monumentality of the previous solution. This is evident even in the rather obscure location of the main entry; instead of an inviting, open forecourt (cf. Pl. 5.1), the visitor approaching from the street is confronted at first with an utterly blank wall, until, led into an indentation in the wall to the right (Pl. 6.12), he reaches the front door.[11] The strict avoidance of a common axis in connecting interior spaces, with the resultant need to change one's direction frequently when passing through them, anticipates in a rudimentary way the essential configuration of the Barcelona Pavilion. The same is true of the treatment of freely projecting wall sec-

1 Reference in a letter from Wolf to Mies from January 26, 1925; MoMA.

2 Illustration in Paul Westheim, "Mies van der Rohe: Entwicklung eines Architekten," *Das Kunstblatt*, Vol. 11, No. 2, February 1927, pp. 55-62, illus. bottom of p. 57; reproduced in Philip Johnson, *Mies van der Rohe*, 3rd rev. ed., New York, 1978, p. 20. The surviving plans (MoMA 31.1-14), one of which (31.6) is dated March 15, 1922, all refer to the fixtures and the building of the gatekeeper's house completed later.

3 Signing for Mies was Hermann John-Hagemann, who was employed as Mies's right-hand man from January 1, 1924, to February 2, 1931, and who supervised the construction of the Mosler, Wolf, and Tugendhat houses (letter of recommendation from Mies van der Rohe; MoMA). John then went directly to Vienna to work on his own, and according to Ernst Walther, Jr., died in Berlin in 1945.

4 The blueprints reproduced are dated December 25, 1925.

5 A bid from the construction firm selected, dated March, 1926, has been found in the extant fragmentary correspondence (MoMA).

6 Photographs of the house were exhibited at the "International Plan and Model Exhibition," which was held as part of the Stuttgart Werkbund Exhibit of 1927 (*Werkbund-Ausstellung "Die Wohnung," Stuttgart 1927, 23. Juli-9. Okt.*, official catalog and guide, p. 104, cat. nos. 175-79). See also the publications cited below, of which the earliest appeared in the autumn of 1927.

7 Pictures can be found, for example in:
Ludwig Hilberseimer, "Internationale neue Baukunst," *Moderne Bauformen*, Vol. 26, No. 9, September 1927, pp. 325-64, illus. p. 337;
———, "Maison de Campagne," *Architecture Vivante*, Vol. 9, Fall/Winter 1927, plate 39;
C.Z. [Christian Zervos], "Mies van der Rohe," *Cahiers d'Art*, Vol. 3, No. 1, 1928, pp. 34-38, illus. p. 37 (2);
Will Grohmann, "Zehn Jahre Novembergruppe," *Kunst der Zeit*, Vol. 3, Nos. 1-3 (special issue), 1928, illus. p. 26;
J. E. Koula, "K panoramatu nové architektury," *Stavba* (Prague), Vol. 8, No. 1, July 1929, pp. 3-16, illus. p. 11;
Marie Dormoy, "L'architecture allemande contemporaine à Berlin," *L'Amour de l'Art*, Vol. 10, No. 9, September 1929, pp. 322-30, illus. p. 330.

8 Plate 6.11 only shows the upper part of the hill. A full view from the valley side can be seen in Johnson, *op. cit.* (note 2), illus. p. 38.

9 MoMA 30.14.

10 This placement is suggested above all by the

tions in the interior, already met with in the Brick Country House, through which the room gradually recedes in depth, and which at the same time permit one to see the beginning of their disintegration into isolated, free-standing wall segments. Taken up once more temporarily in the preliminary design for the Esters House (cf. Pl. 7.4), the resultant floor-plan scheme developed in the closing years of the twenties into a characteristic design principle of Mies's interiors (cf. Pls. 11.19, 12.3, and 17.6).

In the construction plan (Pl. 6.10), with its direct connection between the vestibule, foyer, and living room, the idea has been rejected once again, although the wall placement was largely preserved unchanged. The fireplace in the smoking room has been moved around to the completely closed eastern wall (even in Pl. 6.2, 6.4), and appears only in silhouette as a vertical rectangular block. By contrast, the second chimney block flanking the veranda has kept the stepped outline of the Eliat House, though the original wealth of detailing on its surface (Pl. 6.7) has been abandoned—with the exception of the notching of the corners (Pl. 6.11).

Essential changes since the previous planning stage affect the disposition of rooms in the service area and on the second floor, but they have left the established arrangement of structural masses fundamentally untouched.

The finalized version of the exterior as represented in plates 6.7 and 6.8 is distinguished among other things by the addition of a balcony over the northeast corner of the building.[12] But the primary change from the earlier version is to be seen in the different distribution of window openings. In contrast to what was originally a tendency toward symmetrical solutions (second story in Pl. 6.2, entry wall in Pl. 6.4), a freer arrangement of wall openings has been established. Moreover, in place of the smaller window panes originally envisioned there are large vertical ones the full height of the openings, which give the building a distinctly more imposing appearance.

The terrace on the south functions as an open extension of the house, for its retaining wall is made of brick to correspond with the rest of the structure, and it is paved in the same material. The effect is reinforced by the way in which the parapet joins the south wall of the dining room (Pls. 6.1, 6.13). The slightly sunken flower bed, with steps leading down to it between projecting facing blocks, has already been seen in a similar form in the Eliat House (cf. Pl. 5.2), and derives ultimately from the garden layout designed by Peter Behrens for the Berlin Tile and Cement Exhibition in 1910.[13]

In character, the Wolf House is distinctly a structure composed of volumes, but it lacks the lightness and openness of the later country houses—partly because its walls are bearing ones. Its overall shape, dominated by projecting and receding wings of different heights, reveals an exciting interplay of cubic forms, and surprising configurations develop as a viewer moves around it. The configuration of the street front is unquestionably dramatic (Pl. 6.12). The views from the terrace are equally so, but the same cannot be said for the view from the lower edge of the property, which is, in truth, less than satisfying. When seen from this point of view, the lower portions of the building completely disappear behind the retaining wall (Pl. 6.11),[14] an effect that was obviously not sufficiently considered during the planning. Without the single-story southeast wing, which is hidden behind the front terrace, the masses of the structure are concentrated in the western half of the complex, and the isolated vertical chimney block is incapable of offsetting the resulting imbalance. Some years later the design of the garden facade of the Tugendhat House would prove to be similarly problematic, and it is significant that it appears only as seen from above or head-on in all the perspective views. In the present instance, one might suppose that the addition of the gallery wing already mentioned slightly improved the situation, even though it completely altered the original scheme. Unfortunately, there are no surviving photographs to confirm this assumption, so it must remain mostly a matter of conjecture.

layout of the winter garden, with pool sunk into the paving, which is separated from the gallery by a glass wall the length of the room, thereby functioning as a transition zone between inside and outside (cf. Pl. 11.30).

11 See the illus. in Zervos, *op. cit.* (note 7), p. 37 bottom.

12 Sketched later in pencil on the floor plan (Pl. 6.10); already incorporated in Plate 6.9. The facade studies are labeled on the upper margin (here slightly cropped) as a "supplementary application," which indicates that they probably date from the spring of 1926.

13 Illustrated in Meyer-Schönbrunn (ed.), on behalf of the German Museum for Art in Business and Industry, Hagen, *Peter Behrens* (Monographien Deutsche Reklamekünstler, Book 5), Hagen/Dortmund, 1913, pp. 44 f. Involvement by Mies, who was at that time employed by Behrens, is by no means out of the question.

14 See the illustration in Johnson (note 8; illus. p. 38).

Illus. 27 Mies van der Rohe working on the Esters House.

It is to the personal friendship between Hermann Lange and Josef Esters, the two managing directors of the Verseidag (United Silk Weaving Mills) in Krefeld, that we owe the existence of one of the best-preserved structural complexes from the twenties, one that is in every way the equal of the Dessau Masters' Houses of Walter Gropius (1925-26) and Le Corbusier's buildings at the Stuttgart Werkbund exhibition of 1927.

The origins of the project are ultimately obscure. Sandra Honey presented the following background:[1]

"The two families knew Lilly Reich, Mies's erstwhile associate, in Frankfurt — the ladies were clients at her couture salon, and the gentlemen had visited her small silk exhibition, designed in collaboration with Mies van der Rohe in 1926. There, in Frankfurt, they met Mies."

Another version was given by Lüfkens, who referred to possible contacts between the important art collector Lange and the representatives of the modern movement in Berlin.[2] Family members have related, moreover, that the decision to build the two residences had been made long before, and that the properties on Wilhelmshofallee had already been bought. It is not impossible, then, that the choice of Mies van der Rohe could have been influenced by Friedrich Deneken, the director of the Krefeld Museum at that time, who had good contacts with Peter Behrens and was presumably quite well informed about the newest developments. An additional go-between might well have been August Hoff, the longtime president of the Duisburg Museum Society, where Mies had exhibited in 1925.[3] One way or another, it is more than likely that the clients had met the architect somewhat earlier, in which case we cannot exclude the possibility of a substantial contribution from the two Krefeld silk manufacturers toward the creation of the Frankfurt exhibition in 1926.

Their joint correspondence, covering the period from September 1928 to June 1930, reveals that control of the business side of the building project lay in the hands of Esters, who had a degree in law, while Lange was primarily involved in questions of design. This has been recently confirmed by Ernst Walther, Jr., who was entrusted by Mies with the local supervision of the construction in October 1928.[4] It is clear from an undated fee statement[5] that Esters made sizable payments to Mies as early as November 25, 1927, possibly in connection with the preliminary design that served as the basis for further negotiations. However, construction was not begun until the autumn of the following year. The structural calculations for the Esters House, comprising 124 pages, were completed on October 4, 1928, a few days after Walther, Sr., had complained about what he held to be far too generous materials estimates:[6]

"The amount of steel has turned out to be quite large. This is mainly a result of the liberal use of Peiner beams and your foolish estimates of carrying capacities."

Excavation work began at just this time, and it must have proceeded quickly.[7] Obviously it was intended that the foundations be completed above the basement level before the onset of winter. Presumably this was also the reason for the hectic activity at the beginning of the month and the overlapping starts.[8] On October 16 Hermann John, who was responsible for signing all plans leaving the studio, reported to Krefeld:[9]

"As the architect says, Lange is still hanging by a silken thread, and we must accept the possibility that the whole thing will come to a halt at the cellar level. I beg you to prevent it. It won't be easy but always keep one side higher than the other. One cannot leave it as a ruin if one wants to avoid giving the impression that there has been a bankruptcy."

The vacillation of the client is possibly explained by an increasing irritation at the delayed transmittal of the detailed plans, which were available in their final form for the Lange House only at the beginning of November.[10] According to the testimony of Walther Jr., however, it is doubtful that there was any serious risk that the building would not be finished.[11] Both houses were finished in the rough by the next summer, when they were approved by the local building authorities. The interior finishing required a number of additional months, and was not to be entirely completed before 1930.

Two photographs from the period around 1927 show Mies van der Rohe at work in his Berlin studio at Am Karlsbad 24 (Illus. 27, 28).[12] Several perspective views can be seen on the wall, among which are the two pastels of the preliminary design of the Esters House here reproduced (Pls. 7.2, 7.3). From this phase there are three other drawings as well: a facade sketch (Pl. 7.6), which differs from the perspectives by the addi-

1 Sandra Honey, *The Early Work of Mies van der Rohe*, folder for the exhibition of the Building Centre Trust and the London Goethe Institute, London, 1978. No references to sources. The Frankfurt silk exhibition put together by Lilly Reich and Mies is not documented in either photographs or written references.

2 Karl Otto Lüfkens, "Die Verseidag-Bauten von Mies van der Rohe (1933 bis 1937): Ein Dokument der Architektur des XX. Jahrhunderts," *Die Heimat: Zeitschrift für niederrheinische Kultur- und Heimatpflege*, Vol. 48, December 1977, pp. 57-61, here p. 59.

3 Reference in a letter from Salander (?), Bremen, to Mies of November 16, 1925; LoC: "heard recently that you exhibited some designs at Dr. Hoff's in Duisburg."

4 Conversation with the author in June 1981. Ernst Walther, Sr., who carried out Mies's structural calculations, had already worked in Peter Behrens' office, where Mies met him around 1910. The son, himself a structural engineer, was always available when the amount of work became too great for Mies's chronically understaffed office.

5 Lange/Esters Correspondence; MoMA.

6 Walther Sr. to Walther Jr., October 1, 1928; MoMA.

7 The Lange House was staked out on October 3, 1928; excavation for the Esters House began on the same day, for the Lange House on October 7. (All of the following dates given are taken from the correspondence.)

8 See note 7.

9 John to Walther Jr., October 16, 1928; MoMA.

10 On October 1 Walther Sr. had pressed for completion of the plans (letter to Walther Jr.; MoMA: "since we have to do all we can to finish Lange"), which clearly required several weeks more nonetheless, since the structural estimates are only dated November.

11 Conversation in June 1981; see note 4.

12 Originals in the possession of Georgia van der Rohe; one of them published in Will Grohmann, "Zehn Jahre Novembergruppe," *Kunst der Zeit*, Vol. 3, Nos. 1-3 (Special Issue), 1928, illus. p. 26.

Illus. 28 Mies van der Rohe working on the Esters House.

tion of a third floor on the northeast wing of the building,[13] and floor plans for the ground floor and the upper story (Pls. 7.4, 7.5).

In spite of striking parallels to the Lange House—the narrow band of windows set back above the upstairs hallway, for example (Pl. 7.6 and Pl. 8.4)—these drawings as well are definitely for the Esters House. Only one of the plans (Pl. 7.5) has a corresponding inscription, but the garden wall abruptly interrupted by the right-hand margin leaves no doubt that the Esters property is the one intended. Moreover, the position of the entrances supports this assumption, for they are not directly next to each other as they are in the Lange house, but flank the corner of the projecting wing.

The two pastels quite obviously represent the beginning of the planning process; in character they are purely presentation drawings, possibly based on previous

sketches. The following plan of the ground floor reveals a comparatively stronger articulation of the garden side, and corresponds in most details with the accompanying elevation. Neither is suited as a binding submission, either in scale or in precision of detail. The plan of the upper story, however, already contains typical features of a construction drawing. And here the thought of an adjacent service courtyard to the east with a separate garage and chauffeur's quarters, which would have necessitated the purchase of the adjoining property, appears to have been abandoned again once and for all.

The preliminary designs—according to the foregoing, one must distinguish two separate planning stages—are on the whole much closer to the buildings conceived after the Barcelona Pavilion than the project as ultimately realized would at first allow one to suspect. The virtually complete window wall of the garden facade (Pl. 7.2) and the

interior—built up largely with parallel wall elements and partially flowing transitions between areas (Pl. 7.4)—are characteristic design features of the Tugendhat House, which was only begun two years later (cf. Pls. 11.5, 11.19). Only traces of these can be perceived in the completed building. Because of a lack of documentary references, we cannot determine to what degree the client exercised an influence on the planning—even though the abandonment of continuous glass walls would suggest his involvement.

In all probability the client did not have anything to do with the changes made on the front side of the house. In contrast to the rather forbidding impression given by the present facade (Pl. 7.11), the solution suggested in the preliminary design appears immediately more pleasing (Pl. 7.3). In the design, the single-story wings projecting to the north serve to bind the complex to the flat terrain of the forecourt, so that the

building appears considerably lower. At the same time they soften the harshness of the abrupt and virtually unarticulated walls of the central structure, cradling it between them and seemingly preparing for it. Still, as in the Wolf House, it is a blocky, cubic treatment of structures that serves as the dominating element in the design, and the later changes to the plan derive from it.

Once the lateral extensions had been dropped, a solution giving more stress to the walls was adopted (Pl. 7.11, 7.13). Seen from the side, the presumably solid street front, fully closed on its western half, now reveals itself to be a comparatively thin sham wall that only partially encloses space. In an almost dialectical manner, then, the impression of plasticity resulting from this pretense is immediately reversed. A similar deception arises from the use of brick, which gives the impression of bearing masonry throughout, yet by contrast such traditional structure is completely negated by the broad rectangular window openings. The heavy reliance on steel beams,[14] without which such a construction would be scarcely thinkable, is nowhere visible. Yet it is not exactly concealed, for it is significant that the lintels over the windows are not marked by a vertical layer of stone, but are formed of simple stretcher courses. Once again a contradiction therefore arises, obviously deliberate, between the distinctly sculptural surface structure of the building and the almost weightless character of the outside walls that are seemingly relieved of any structural function.

All of this has little in common with the "functionalism" so frequently invoked, or with the "constructive" manner of building so emphatically demanded by Mies only a few years before.[15] Rather, in the Krefeld houses it is obvious that the predominant desire was to give expression to a specific concept of architecture that amounted to a suspension of the traditional contrast between interior and exterior space.

In order to achieve a new synthesis that did not fundamentally question the interior space itself,[16] it was necessary to break through the rigid limitations that have always existed necessarily in massive masonry building. But as long as the separation of supports and walls was not completed, which would have meant approaching the form of a skeleton structure, the exterior wall shell being maintained as before as both spatial boundary and supporting corset for the whole, the impression of solidity, of a self-enclosed volume—and that means a rigid differentiation between inside and out—continued to be decisive in the observer's sense of the space. It is precisely on this point that the "contradictions" evident in the conception of the building demand a more subtle way of seeing. Behind them there is nothing less than a successful attempt to replace bearing walls with screening ones, and thereby to question the basic assumptions of massive building.

The Esters House as well as the Lange House stand in this regard at the end of a line of development, one beyond which it is ultimately impossible to proceed with traditional means. The problem of opening up space to the maximum while preserving its integrity could be presented as an ideal here, but it was only with the differentiation between support and wall accomplished in the Barcelona Pavilion that a thinkable solution presented itself. It also explains why Mies refused to publish the two Krefeld houses, even though their quality is in no way inferior to his later projects. The conflict apparent in these examples between his architectural aspirations and the structural requirements in opposition to them had been surmounted and given a definitive solution by the time the projects were completed (1930). The close similarities between the Tugendhat House and these preliminary sketches nonetheless reveal that in spite of everything a continuity of development is present.

13 Wall and ceiling strengths were calculated at the request of the client so as to permit the creation of a third story at any time.

14 See note 6 ("liberal use of Peiner beams"), as well as the uncommonly large numbers of structural estimates (MoMA).

15 See, for example, Ludwig Mies van der Rohe, "Hochäuser," *Frühlicht*, Vol. 1 (New Series), No. 4, Summer 1922, pp. 122-24.

16 The problem, already discussed in detail in the chapter on the Brick Country House (especially in the section "A New Approach to Space"), can only be touched upon in this context. For all its openness, the identity of the interior space must be preserved, for otherwise it would tend to dissolve into formlessness. Therefore, by "suspension of . . . contrast" I do not mean the suspension of the distinctions, without which any differentiation of terminology would prove to be invalid.

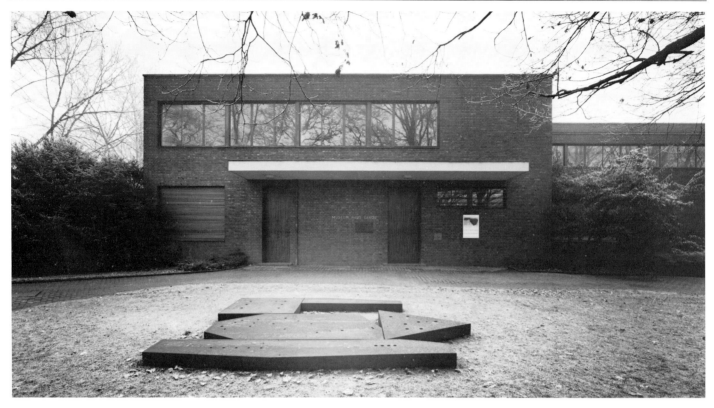

Illus. 29 Lange House, entryway (1981 photograph).

Aside from some minor variations, the history of the planning and construction discussed in the previous chapter is identical for both of the Krefeld houses.[1] Moreover, the stylistic conclusions deriving from the analysis of the Esters House apply without exception to the Lange House, so that basically only a few supplementary remarks are here required.

At first glance the street side of the Lange House presents a quite similar picture, but on closer inspection one becomes aware of a few essential differences (cf. Pls. 8.7 and 7.11). The most striking motif here is the double row of ribbon windows across the central section, of which the upper, narrower one recedes together with the top of the wall and thus completely disappears behind the projecting line of the facade. With this smaller row of windows it was possible to provide adequate illumination to the vestibules and bathrooms that separate the corridor from the row of bedrooms facing the garden (since this is not visible from the photograph, see Pls. 8.4 and 8.3). As was mentioned elsewhere, Mies originally developed this arrangement for the Esters House (preliminary design, Pls. 7.5, 7.6), though he discarded it in the final construction plans. The threefold division of the facade is much more strongly accentuated by virtue of this setback. Moreover, it is underscored by means of the strictly symmetrical arrangement of the lower band of windows, which would appear to suggest an unseen central axis. Because of the position of the steel supports, the row of windows ends with a narrower, three-part segment on either side, resulting in the rhythmical sequence 3-4-4-3. All segments are in turn subdivided by uprights of differing widths, and thus resolve into an underlying pattern of accomplished subtlety (1-2; 1-2-1; 1-2-1; 2-1).[2] The asymmetrical placement of the windows on the ground floor is only partially effective in opposing the centering tendency above.

Of the adjacent portions of the building, only the northeast wing is recognizably developed as an independent structure. A tendency for the facade to appear lopsided on this end is largely prevented by the massiveness of the closed brick wall to the west, which holds it in check. The result is a subtle equilibrium between a wall that suggests massiveness—but is nonetheless virtually insubstantial—and a three-dimensional volume whose impression of solidity is questioned by the frequent perforations in its skin. In this case the clear separation of these two elements from the central section does not appear to present any problem at first. It does, however, run into considerable difficulty from the fact that though the sole distinguishing feature of the upper setback is reflected in the width of the band of windows along the corridor below, its western end falls directly above a window opening on the ground floor. Moreover, even a brief glance at the floor plan (Pls. 8.3, 8.5) reveals that there is virtually no correspondence between the facade and the arrangement of the interior. The upper corridor does not run along the full width of the windows, for example, and the western portion of the exterior wall extends beyond the actual structure as a screen for the projecting verandas facing the garden on both floors. The demand for readability, clarity, and unambiguousness in the relationship between the interior and exterior of a building that is so often discussed in relation to modern architecture would appear to have been turned into its precise opposite here. Surprisingly, this applies as well to the northeast wing, which on closer inspection proves to be misleading also, the facade bearing no relation to the sequence of spaces inside.

Yet if the facade is to be read as pure surface divided up by means of window openings, the arrangement of which depends solely or predominately on formal, aesthetic considerations,[3] then the vertical downspout of the rain gutter assumes a distinct significance for the visual effect. It is the downspout rather than the right edge of the ribbon window that marks the dividing line between these two wall sections.

The mere fact that such an obviously secondary architectural element should suddenly become a dominant motif in the arrangement of the facade once more confirms the conclusions reached in the previous chapter; in a structure of masses designed to give an impression of solidity this would surely be inconceivable. Because of it we are required to interpret the wall primarily as a surface instead of a plastic, three-dimensional masonry block.

In closing, a few words must be said about the relationship between the two houses. The determining factor in the conception of these structures was the principle of repetition, the given theme undergoing only slight variations. The basic concept was one of an L-shaped facade arrangement with a projecting wing to the east and a completely closed wall to the west, a garden front stepped outward in the opposite direction so as to open toward the afternoon sun, with covered terraces on two levels at either end, and a floor-plan arrangement adapted to both structures with only minor alterations. The common point of origin for the structures is essentially the preliminary plan for the Esters House, which contained elements of both of the final designs.

The interrelationship between the houses (insofar as it is not already established by their side-by-side placement) is revealed only by more precise analysis of individual details. It is in no way a matter of their being obtrusively forced into a union that robs the individual arrangements of the facade of meaning if they are not viewed in context. But even though each of the houses constitutes a self-contained whole that has no need of a counterpart in order to be complete, a rich and subtle interplay of separate elements nonetheless emerges, creating a visual link across the intervening space. Thus, for example, the projecting roof wrapped around the corner of the Esters House guides one's glance from the service entrance to the front door, which, like the deeply projecting northeast wing itself, opens invitingly toward the neighboring house (Pl. 7.1). In the latter, however, both entrances lie close together and facing the street, and an otherwise unmotivated lawn area inhibits direct access from the side (Illus. 29, Pl. 8.7). The completely smooth and scarcely subdivided facade of the Esters House has no distinct termination on the west side that would offer some degree of balance to the strongly developed east wing. Thus the eye is led inevitably to the neighboring building, where it

comes to rest on that structure's sculptural east flank (Pl. 8.9). The corresponding portion of the facade in the Lange House is clearly set off from the center section, on the other hand, by the deep setback on the upper floor, creating a situation of greater balance at the outset. This building is also given a firmly defined corner by the strip of wall drawn back along the verandas and bracketing them, a glass insert having been placed both above and below (Pl. 8.7). In the Esters House there is a window in only the ground-floor level of this wall, while the wall is completely replaced by glass above, so that one sees the facade in cross section. The resultant openness to the west, appearing almost to invite visual contact, is answered in the Lange House by a U-shaped indentation of its east flank (Pl. 8.9), once more testifying to the original concept of the two structures as complementary.

Because of the manifold cross-references between the two structures, it would seem to be justifiable to refer to them as a *Gesamtkunstwerk,* one whose state of preservation—especially since the restoration of the Esters House that was completed in 1981—is virtually unique in the architecture of the twenties. The change in the buildings' function so admirably achieved once the city of Krefeld took them over as a museum required no significant alterations.[4] Naturally it was fortunate in this regard that the Lange House was laid out from the beginning for the display of a sizable art collection. The loss of the original furnishings, which were kept by the former owners, is of no particular consequence, especially since there were scarcely any original pieces involved. Mies was given a free hand only in the furnishing of the ladies' sitting room of the Lange House; everywhere else he had to make do with existing pieces.[5] It would, of course, be helpful if this room could be preserved as it was reconstructed for the 1981 exhibition (on the basis of a surviving plan and a contemporary photograph).[6] This is all the more desirable inasmuch as, since the removal of the furnishings from the Tugendhat House, anyone wishing to experience the total impression of a Miesian interior from this period can only refer to photographs.

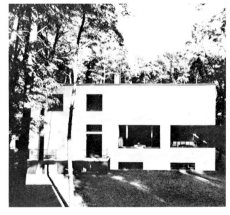

Illus. 30 W. Gropius: Architect's House, Dessau (1925-26).

1 Regarding the slight delay in the beginning of the construction of the Lange House, see Chap. 7, notes 7 and 10.

2 The different thicknesses of these posts is naturally a result of the fact that only every third pane can be opened, and that at these spots the framing had to be correspondingly stronger. Though therefore originally a technical consideration, this alternation of narrower and wider supports was undoubtedly utilized as a deliberate motif in creating a rhythmical arrangement.

3 This is by no means contradicted by the fact that Mies was influenced in the placement of window areas by the desire to create the best views and illumination in any given instance (see Ludwig Mies van der Rohe, "Bauen," *G*, No. 2, September 1923, p. 1). But whether the window openings are divided into three sections or four, whether they are ultimately taller or shorter, twenty centimeters to the right or a half a meter further to the left, is largely unaffected by this. It is precisely in this realm of the arrangement of the facade that some of the most important representatives of modern architecture adopted a purely pictorial concept in disregard of all "functional" considerations, thereby revealing in its ultimate import the influence of constructivist painting styles in general and of Mondrian in particular.

4 Particulars can be found in the folder prepared by Gerhard Storck for the 1981 exhibition (*Die Villen und Landhausprojekte von Ludwig Mies van der Rohe*).

5 This information from Walter Cohen, "Das Haus Lange in Krefeld," *Museum der Gegenwart*, Vol. 1, No. 4 (1930/31), pp. 159-68, this reference p. 164.

6 The plan for the furnishing of this room bears the inventory number 6.20 (MoMA); the photograph is reproduced in Cohen, *op. cit.*, p. 161. (In the same article, p. 160, there is also a view of the living room.)

"What would concrete be, what steel, without plate glass?

The ability of both to transform space would be limited, even lost altogether; it would remain only a vague promise.

Only a glass skin and glass walls can reveal the simple structural form of the skeletal frame and ensure its architectonic possibilities. And this is true not only of large utilitarian buildings. To be sure, it was with them that a line of development based on function (*Zweck*) and necessity began that needs no further justification; it will not end there, however, but will find its fulfillment in the realm of residential building.

Only here, in a field offering greater freedom, one not bound by narrower objectives, can the architectural potential of these technical methods be fully realized.

These are truly architectural elements forming the basis for a new art of building. They permit us a degree of freedom in the creation of space that we will no longer deny ourselves. Only now can we give shape to space, open it, and link it to the landscape. It now becomes clear once more just what walls and openings are, and floors and ceilings.

Simplicity of construction, clarity of tectonic means, and purity of materials have about them the glow of pristine beauty."

Mies van der Rohe (1933)[1]

Illus. 31 Exhibition halls at Gewerbehalleplatz (Glass Room: Halle 4).

This hymn to the use of glass in modern architecture — written at a time when political events in Germany were helping to bring about the victory of reactionaries over the ideals and aspirations of modern architecture — sums up a trend in residential building whose revolutionary character had become apparent — at the very latest — with the Glass Room at the Stuttgart Werkbund Exhibition of 1927. Preoccupation with the material as such goes back to the years around 1921, when Mies submitted his first designs for glass towers and office buildings, experimenting in them with the various effects of the "new" medium.[2] Those designs were indebted to the literary activities of Paul Scheerbart, to which Bruno Taut had already erected a monument in his glass pavilion at the Cologne Werkbund Exhibition of 1914.[3] Additional important influences were without a doubt the bold iron-and-glass structures of the nineteenth century (greenhouses, exhibition halls, railway terminals)[4] and — not to be forgotten — department-store facades from the turn of the century, of which Berlin boasted a number of superb examples. The brief flowering of Expressionist architecture in the period immediately following the First World War, against which background, with certain reservations, Mies's tower designs must ultimately be viewed, culminated in a veritable glass euphoria. The designs of Taut, Scharoun, and Wassily Luckhardt, to mention only three of its most important representatives, often left the boundaries of the fantastic far behind, practically losing themselves in mystical and cosmic associations. Glass — glistening in its transparency, brilliantly reflective in its many facets, seemingly insubstantial, and further enhanced symbolically by its compression into crystal — suddenly had become the metaphor for a movement that felt it could achieve, with the help of architecture, a complete renewal of human society.[5] However, that movement's idealistic claim that the world could be changed through architecture alone was one to which Mies failed to subscribe throughout his career — unless one chooses to see a weak reflection of this general mood of revolt in his demand for a spiritual expressiveness in building. But this can in turn explain why it was that the deeply rational Mies, as one of the few younger architects, managed to utilize the formal and transcendent qualities of glass long after the utopian Expressionist movement, burdened as it was by charges of otherworldliness, had lost ground, and

its fervent former champions had largely adopted the line of the "New Objectivity" (*Neue Sachlichkeit*). In his foreword to the official catalog of the Stuttgart exhibition, Mies provided a brief declaration of principles regarding the goals he himself represented, one that confirmed his strict disavowal of both extremes:[6]

"The problem of the New Dwelling is fundamentally a spiritual problem, and the struggle for the New Dwelling is only a part of the larger struggle for new forms of living."

The qualification contained in this statement characterized the inner attitude of Mies van der Rohe: Architecture is not the herald of a new style of life; it is not even the liberating factor for the changing needs of its inhabitants, which are rooted rather in the "altered material, social, and spiritual structure of our time."[7] At best, architecture can assist in expressing this structure, and thereby contribute toward providing "the soul with the prerequisite, the possibility, for existence."[8] A short article in the following year (1928) once more summarized the conclusions of his previous reflections:[9]

"Architecture is not a matter of fanciful invention. In truth, it can only be conceived of as a life process; it serves to express how man asserts himself vis-à-vis his surroundings, and how he manages to master them. An understanding of the times, of its tasks and its inherent possibilities, is the necessary prerequisite to architectural creation; architecture is always the spatial expression of a spiritual commitment.

Communication is constantly being improved. The world is shrinking more and more, becoming more and more visible even in its remotest corners. A world consciousness and a consciousness of mankind are the results.

Commerce begins to reign supreme, with everything forced to serve it. Profitability is becoming the law as technology determines our economic attitude, changing matter into power, quantity into quality. Technology presupposes a knowledge of natural laws and works in league with their forces. We are consciously exploring the maximum use of power. We are standing at a turning point in time."

The contribution to a prospectus quoted at the beginning of the chapter expresses quite unmistakably just where Mies felt architects ought to concentrate their efforts in

such a context. The real problem is not with the large buildings of business and government (the general field of utilitarian architecture), but in the fundamental redesign and development of residential building. It is here above all that new solutions are demanded by an era caught up in revolutionary changes. Only here will the principles of modern architecture, first developed in their application to other — one is tempted to say simpler — assignments, fully come into their own. The single, absolute prerequisite for a new conception of space, however — and ultimately this is what all of this is leading to — is glass; glass as a building material in its specific application as a "glass skin," by means of which space-defining walls may be reduced to a mere transparent membrane. The "freedom in spatial design" now achieved permits us to "give shape to space, open it, and link it to the landscape, thereby satisfying modern man's spatial needs."[10] Mies's contribution to the Stuttgart exhibition represents an early attempt to respond in practice to the demands arising from the basic theoretical position just described, and thus to reveal the direction for a future solution.

The program of the Stuttgart exhibition of 1927, organized by the German Werkbund under the general artistic supervision of Mies van der Rohe, was completely oriented toward the concept of "dwelling," as can be easily seen from the official publications.[11] In addition to the buildings of the Weissenhof area, which doubtless

1 Contribution to a prospectus of the Union of German Plate Glass Manufacturers, March 13, 1933; MoMA (final version of the manuscript sent off on the same date): "It is shorter than you expected, but I only wanted to inspire new building" (accompanying letter of the same date).

The preceding version shows trivial discrepancies in the last section: "These are truly architectural elements from which a new and richer art of building will develop. They provide a degree of freedom in spatial design that we will no longer wish to deny ourselves. Only now can we give shape to space, open it, and link it to the landscape, thereby satisfying modern man's spatial needs. Simplicity of construction, clarity of tectonic means, and purity of material will be the basis of a new beauty."

2 See Ludwig Mies van der Rohe, "Hochhäuser," *Frühlicht*, Vol. 1 (New Series), No. 4, Summer 1922, pp. 122-24. See also Carl Gotfrid, "Hochhäuser," *Qualität*, Vol. 3, concluding number 5/12, August 1922/March 1923, pp. 63-66.

3 Concerning the importance of Paul Scheerbart for architecture around 1920 see, for example, Reyner Banham, "The Glass Paradise," *The Architectural Review*, Vol. 125, No. 745, February 1959, pp. 87-89. Wolfgang Pehnt, *Die Architektur des Expressionismus*, Stuttgart, 1973, shows on the other hand, especially in his opening chapter, "Voraussetzungen" (pp. 23-62), a whole series of additional sources and currents that produce a more complex total picture.

4 An exhaustive presentation of glass structures and greenhouses, omitting utilitarian buildings such as railway terminals, etc., is to be found in the recently published book by Georg Kohlmaier and Barna von Sartory, *Das Glashaus: ein Bautyp des 19. Jahrhunderts*, Munich, 1981 (Studien zur Kunst des 19. Jahrhunderts, Vol. 43).

5 W. Pehnt, *op. cit.* (note 3), pp. 26 f. See also the critical article by Lain Boyd Whyte, "Bruno Taut und die sozialistischen und weniger sozialistischen Wurzeln des sozialen Wohnungsbaus," *Neue Heimat*, Vol. 27, No. 5, 1980, pp. 28-37.

6 *Werkbund-Ausstellung "Die Wohnung," Stuttgart 1927, 23. Juli-9. Okt.*, official catalog, foreword by Mies van der Rohe, p. 5.

7 *Ibid.* The complete text reads:
"The problems of the New Dwelling are rooted in the altered material, social, and spiritual structure of our time; they can only be comprehended within this context.

The degree of change in this structure determines the character and extent of the problems. They are anything but arbitrary. They cannot be solved with slogans, nor will slogans make them disappear.

The problem of rationalization and standardization is only a partial problem. Rationalization and standardization are only means; they must never be an end. The problem of the New Dwelling is fundamentally a spiritual problem, and the struggle for the New Dwelling is only a part of the larger struggle for new forms of living."

8 Ludwig Mies van der Rohe, "Die neue Zeit" (part of a lecture given at the Vienna Werkbund conference), *Die Form*, Vol. 7, No. 10, October 15, 1932, p. 306.

9 Ludwig Mies van der Rohe, "Baukunst in der Wende der Zeit," *Innendekoration*, Vol. 39, No. 6, June 1928, p. 262.

10 First draft of the manuscript of March 1933, quoted in full in note 1.

11 Official catalog (see note 6); *Bau und Wohnung*, published by the German Werkbund, Stuttgart, 1927; *Innenräume*, published on behalf of the German Werkbund by Werner Gräff, Stuttgart, 1928.

12 Illustrated in *De Stijl*, Vol. 8, Nos. 85/86, 1928, p. 125.

13 A query to this firm, which is still in existence (Süddeutsche Glashandels-GmbH, 7000 Stuttgart 31, Motorstrasse 9), proved fruitless, since neither files nor drawings regarding this project have been preserved. Among Mies's papers there was the plan here reproduced (Pl. 9.5), but no further references in the correspondence.

Illus. 32 Glass Room, view into dining area.

formed the chief attraction of the exhibition, it included a number of other presentations in and around the city, among them a large industry and craft show in the municipal exhibition buildings on Gewerbehalleplatz (Illus. 31). The Glass Room installed as part of this show took up the whole of Halle 4, which lay in a readily accessible side wing and was immediately adjacent to the exhibit of the German Linoleumwerke, which was also designed by Mies in collaboration with Willi Baumeister (Halle 5).[12] The commission for the Glass Room came from the Association of German Plate Glass Manufacturers, with headquarters in Cologne; its construction was carried out by the Süddeutsche Glashandels–A.G. in Stuttgart-Feuerbach.[13] Its dates correspond with the duration of the exhibition, which opened on July 23 and closed on October 9. On this latter date the Glass Room was dismantled, whereas the buildings of the Weissenhof Settlement, the financing of which had been taken over by the city with funds from its apartment-building program, were left in place.

The hall was divided into loosely connected spaces by means of partly free-standing glass walls (Pl. 9.5), their individual panes set in nickel-plated frames that are invisibly braced against the exterior structure (Pl. 9.4).[14] Tightly stretched strips of fabric sewn together formed a ceiling above the whole. The light falling on this ceiling — presumably from high, narrow window slits as in the adjacent room — provided a uniform brightness, and was the sole source of illumination. The floor was covered with white, gray, and red linoleum. The furnishings were sparse and somewhat bulky. In one space three white leather chairs and one (presumably) black one were grouped around two square coffee tables, the whole arrangement set off from the flow of visitors by means of a cord outlining two sides of the space (Pls. 9.2, 9.4). In another spot there was a writing table with chair facing an open wall of bookshelves (not illustrated, see Pl. 9.5).[15] And finally there was a single piece recognizable from its height and size as a dining table (Illus. 32).

On the basis of these furnishings one can make out three different "functional" spaces, the working area, living area, and dining area. In addition, there were more or less clearly established vestibules just inside each of the entrances, which were centered on opposite ends of the hall. The individual spaces flowed freely into one another, but at the same time they were distinguished by

different-colored floor coverings. The spaces defined by the flooring did not always correspond to those suggested by the rhythmic placement of the walls, so that transition zones emerged that could not be definitely ascribed to one space or another. There was one small totally enclosed space containing nothing but a piece of sculpture (Pl. 9.1, Illus. 32). This female torso by Lehmbruck[16] faced the dining area, but inasmuch as its head was turned to the side it also established visual contact with one of the vestibules. Also set apart was a narrow strip of space running in front of the seating area that was likewise completely sealed off (Pl. 9.2). Judging from the rather careless arrangement of potted plants in it, this was to be thought of as a kind of winter garden, although it is equally conceivable that Mies was here suggesting a view to the outside. The latter reading is supported not only by the indication of plantings, but even more strongly by the fact that this was the only spot where the exterior wall of the hall was not covered by glass.

A few comments on the glass walls themselves might be added. These were divided into panes of different sizes by their metal frames. The varying tones of the glass (mouse gray, olive green, clear, etched on one or both sides) provided different degrees of transparency. The gradations ran all the way from the completely clear to the utterly opaque and reflecting, including panels of only a milky translucence. These distinctions definitely influenced the spatial impressions and the arrangement of the various areas, while the rhythmic variations in the size of the wall panels created some spots of calm (large, horizontal panes) and some that tended to hurry one along (tall, narrow panes).

Though the prime intention here was to display to the public the medium of glass in its various applications as a building material, to which end the open-floor-plan solution was certainly appropriate, as was the somewhat flashy array of colors and shapes of the material,[17] Mies nonetheless managed to go far beyond the initial assignment. The identification of the individual partial spaces reflects the disposition of a rather large dwelling, excluding of course bedrooms, bathrooms, and service areas. This one-sided concentration on the living area corresponds with observations about the country house projects at the beginning of this study, which revealed a similar preoccupation. Only with his House at the Berlin Building Exposition did Mies begin to

include the bedrooms in his open-floor-plan scheme, and ultimately only in the Farnsworth House, which he created under completely different circumstances to be sure, can the same be said of the kitchen. The Glass Room, with its free-standing walls and flowing transitions, represents the first actual realization of the theme already developed in the floor plan of the Concrete Country House. There is a direct link from it to the Barcelona Pavilion and to the Nolde and Tugendhat houses that were begun at roughly the same time.

14 A listing of the materials and the firms involved is given in the official catalog (note 6), p. 91. Chrome-plated steel frames were first used in the Barcelona Pavilion.

15 An illustration of the working area appears in *Innenräume, op. cit.* (note 11), illus. 180, p. 118.

16 The exact title is *Girl's Torso, Turning.*

17 This may have something to do with the reaction of the patrons of the Barcelona Pavilion, who, when Mies asked what they thought the function of the pavilion really was, answered, obviously referring to the Glass Room: "We don't know — just build a pavilion, but not too much glass!" (Interview with Mies van der Rohe in December 1964, published in Katharine Kuh; "Mies van der Rohe: Modern Classicist," *Saturday Review,* Vol. 48, No. 4, January 23, 1965, pp. 22-23 and 61; given similarly also in H. T. Cadbury-Brown; "Ludwig Mies van der Rohe," *The Architectural Association Journal,* Vol. 75, No. 834, July/August 1959, pp. 26-46, on pp. 27 f., where the statement is in fact misinterpreted as "not too much class").

Preface

The inclusion of a building designed solely for the purposes of an exposition in a study devoted, as its title suggests, to an investigation of residential designs may seem unusual, but it is justified for a number of reasons.

For one thing, the basically nonfunctional Pavilion provides a "place to linger in"[1] and therefore represents a form of dwelling in a broader sense. This is expressed in its furnishings, among other things—which, contrary to what one would expect, are designed to accommodate a very small number of people, and are hardly adequate for large streams of visitors. Second (and it was this that ultimately led to its inclusion in this book), its construction represents a decisive, though not wholly unanticipated, turning point in the work of Mies van der Rohe. The formulation of new architectural principles achieved here—based on structural and formal innovations like the strict separation of supports and walls as well as the use of large expanses of glass (instead of exterior walls) made possible by that separation—led to such a degree of perfection that the solutions arrived at in this structure could be translated virtually unchanged into almost all of his later buildings. Thus the development of the following decades would prove to be largely incomprehensible without some knowledge of the Pavilion. The generous treatment of the historical and architectural contexts of this project in relation to others in this work is intended to reflect its central importance.

Questioning Earlier Interpretations

Mies van der Rohe's German Pavilion at
the Barcelona International Exposition in
1929 is generally considered to be one of
the key structures of modern architecture.
For half a century critics have admired it
without reservation; the available standard
works on the history of architecture, with
only a few early exceptions, examine it in
detail. In the very year of its completion
there appeared a flood of articles and es-
says on the Pavilion in both German and
foreign periodicals, quickly making the
building very widely known. Its considera-
ble bibliography, beginning with these,
served Juan Pablo Bonta as the basis for a
semiotic investigation of the laws governing
the interpretation of architecture in gen-
eral.[2] Comparison of the texts, regardless
of their considerable differences in quality,
resulted in what appeared to be a cyclical
sequence of prevailing interpretive ap-
proaches. Bonta then felt confident in
assuming from the similarities he had no-
ticed that there is a process of development
in the judgment of architecture that appears
to follow laws of its own.[3] In view of the
extraordinary influence of this building,
however, which cannot be compared auto-
matically to that of other examples, one
might well have doubts about the general
relevance of his conclusions.

Particularly problematic is the extremely
brief life of the Pavilion. As an "exhibit" it
survived for only a few months. As a result,
only a very few writers actually saw the
building, so that the available sources have
been only the surviving photographs, which
already represent a certain preselection. For
this reason interpretation has had rather
narrow limits imposed on it from the start,
as Bonta himself is prepared to admit.

Bonta also largely overlooked the fact
that the authors he quoted were almost
without exception architects, not art his-
torians—which necessarily results in a
rather one-sided emphasis. Consequently,
the Pavilion has only rarely been seen as an
historical phenomenon and subjected to an
appropriate careful analysis; on the contrary,
until well into the sixties the approach was
strictly oriented to the present and prima-
rily concerned with setting standards, mak-
ing almost no attempt to disguise its
propagandistic intent. In spite of the num-
ber of years since its construction, for most
authors the Pavilion stood as the preemi-
nent example of a movement, the so-called
International Style, with which, as a rule,

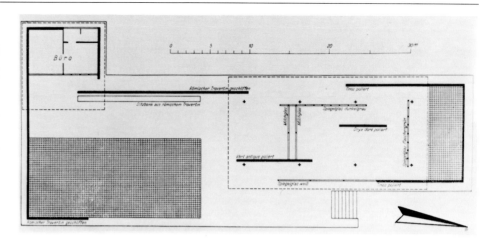

Illus. 33 Barcelona Pavilion, publication plan from 1929.

they still felt themselves more or less closely
associated.[4] Thus exalted to the status of a
model for a whole generation of architects,
the Pavilion required not so much critical
reconstruction and appraisal as vivid, ad-
miring description. Changes in the prevail-
ing conception of it therefore reflect only
the breaks and developmental leaps of a
movement that still subscribes to the princi-
ples and formal solutions of the twenties
while at the same time trying to carry them
further, so that precisely those aspects of
the Pavilion were stressed that seemed to
provide the most stimulus at a given
moment. Such a comparatively intuitive—
not to say subjective—procedure may ex-
plain the striking lack of methodical study
of the relevant documents, which has oc-
casioned a rather significant number of
misunderstandings.

Though Hilberseimer's monograph on
Mies is outstanding from an analytical point
of view and contains a number of remarka-
ble suggestions for further thinking,[5] the
largely essayistic contributions to journals
and periodicals of the postwar era have
rather tended to confuse things. It can come
as no surprise, therefore, that in addition to
a generally increasing superficiality result-
ing from the constant repetition of what has
already been said, the image of the Pavil-
ion popularly accepted scarcely corresponds
in its essential points with the actual
structure.

The ground plan that was frequently pub-
lished in the years after 1929 (Illus. 33),
was long considered to be the only known
original plan.[6] As reproduced here from
the *Zentralblatt der Bauverwaltung*, it in-
cludes an indication of scale and explana-
tory notes concerning the different materials
used in the various wall segments. The

drawing was specifically prepared for publi-
cation purposes, and therefore portrays the
structure—the comparatively thick walls
make this quite clear—somewhat sche-
matically. Nonetheless, it appears to be
thoroughly reliable in its basic dimensions.
Still, the ground plan has been considered
to be unsatisfactory in a number of respects,
especially when in the early sixties there
was renewed discussion of rebuilding the
Pavilion.

Then, in his monograph published in
1965, Werner Blaser presented a second
plan that appeared to make up for the obvi-
ous weaknesses of the previous one (Illus.
34).[7] Not only is it clearer, but it is striking
for the extraordinary precision in its render-
ing of details. The thickness of the walls is
now given in the proper relationship to the
measurements of the foundation, which no
longer appears to hover in empty space,
but rather lies nestled in natural surround-
ings, framed by trees and shrubbery. More-
over, the outlines of furnishings provide an
exact impression of the arrangement of arm-
chairs and stools, giving weight to the rea-
sonable assumption, based on existing
photographs of the interior, that Mies
wished to have the furnishings taken into
account as integral components of the whole
composition. The chief advantage of the
plan was, however, its representation of the
so-called "grid" formed of paving stones
seemingly one meter square. This grid,
which was utilized above all in the later
works of Mies van der Rohe, from the first
designs for the IIT campus to the New Na-
tional Gallery, appeared to present us with
the key to an interpretation by means of
which we expected to advance significantly
toward a true understanding of Mies's
architecture. At the same time it seemed to

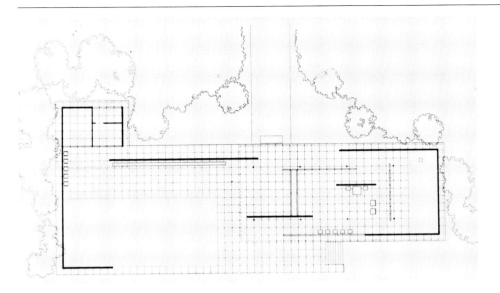

Illus. 34 Floor plan reconstruction (W. Blaser, c. 1964).

confirm the close relationship between Mies and Mondrian and the de Stijl group not only on a purely formal level, but in a very concrete and basic sense.

In general, the view has been first of all one of a spatial continuum described in such phrases as *universal space* or *continuous space* that have come into common usage. Comparable to the pictorial compositions of Mondrian and van Doesburg, this is expressed by the use of an orthogonal grid, which is to be understood in turn as the visible manifestation of a larger, all-encompassing system of reference permeating all matter in much the same way as does the Newtonian ether. In this way, however, critics would appear to presuppose an ideal cosmic unity that, translated symbolically into the grid of the platform, virtually serves as the basis for the Pavilion, and thereby ties it into a universal context.[8]

A thesis that could claim a certain validity up to that time was presumed, on the publication of this new plan by Blaser, to be a certainty: namely, that Mies developed the concept of the grid as early as the twenties, a period that owed much of its tremendous artistic dynamism to the far-reaching activities of de Stijl, and particularly Theo van Doesburg, whose initial influence on Mies is beyond question. The continuity in his oeuvre seemed to be secured thereby, and the theory resting upon that continuity fortified by the indirect evidence of its possible origin.

Yet if one compares the two ground plans in close detail, substantial doubts about the authenticity of the later one arise. Calculations based on the proportions of the two plans reveal a number of discrepancies, pri-

marily with regard to the grid. Even if one allows for a certain distortion of the drawings in the process of reproduction, the grid by no means corresponds to the earlier scheme. The overall length of the building, which according to Blaser's ground plan, would have to amount to precisely 53 meters, must have measured 56 meters at least. This not only puts the dimensions of the platform in question, but even the module of the grid itself. If one assumes a uniform dimension for the slabs, they would have to measure 1.10 meters on a side, whereas Blaser gives the figure of 1.00 meter.

Research determined that the ground plan Blaser published was prepared shortly before 1965 in Mies van der Rohe's studio in Chicago. In addition, a document containing a number of details about the Pavilion has turned up in the correspondence, obviously from the same source,[9] on the basis of which the drawing was presumably produced at that time. As far as the architect's late phase is concerned, one is perfectly justified in according a certain documentary value to the drawing—especially since, according to Blaser, Mies took an interest in its preparation; but as a reconstruction of the original plan of the structure it proves to be completely unreliable.[10]

A comparison of the 1929 publication plan with the existing photographs also reveals a number of discrepancies. Even a superficial glance of the well-known view in Plate 10.9 reveals one fact that would at first appear to be trivial, but that is of considerable importance in the interpretation of the structure. As can be clearly seen at

1 Walther Genzmer, "Der Deutsche Reichspavillon auf der Internationalen Ausstellung Barcelona," *Die Baugilde*, Vol. 11, No. 20, October 25, 1929, pp. 1654-57: "it should merely invite the passing exhibition visitor to some shorter or longer period of rest and contemplation" (p. 1655).

2 Juan Pablo Bonta, *Architecture and Its Interpretation: A Study of Expressive Systems in Architecture*, London, 1979. Portions previously published in Bonta, *Mies van der Rohe: Barcelona 1929* (Anatomía de la interpretación en arquitectura: Reseña semiótica de la crítica del Pabellón de Barcelona de Mies van der Rohe), Barcelona, n.d. [1975].

3 Ibid., (1975), p. 57:
"I found that my corpus made sense only if one classified it into a number of categories —eight to be more precise—each of them characterized by a certain consistency in the way the authors interpret the meaning of the building. Further, it became apparent to me that categories follow each other according to a certain internal logic, as in a dialectic process. . . . In other words, they can be taken as constituting the anatomy of the process of interpretation."

4 Philip Johnson expresses this clearly in the Epilogue to the third edition of his monograph: "I thought of it as hagiography, exegesis, propaganda—I just wanted to show that Mies was the greatest architect in the world." (*Mies van der Rohe*, 3rd rev. ed., New York, 1978.)

5 Ludwig Hilberseimer, *Mies van der Rohe*, Chicago, 1956.

6 Taken from Walther Genzmer's article "Die Internationale Ausstellung in Barcelona," *Zentralblatt der Bauverwaltung*, Vol. 49, No. 34, August 21, 1929, pp. 541-46, illus. p. 542.

7 Werner Blaser, *Mies van der Rohe: Die Kunst der Struktur*, Zurich/Stuttgart, 1965.

8 Expressed thus above all by Steven K. Peterson, "Idealized Space: Mies-conception or Realized Truth?" *Inland Architect*, Vol. 21, No. 5, May 1977, pp. 4-11:
"For Mies, the ultimate symbol was not the frame as structure, but the grid as independent geometry—the abstraction, not the fact" (p. 8).

"The abstraction in Mies' work is not a preference for pure simplicity as such, but a philosophical network applied to architecture; it is philosophical abstraction, the logical isolation of aspects from the total in order to reveal essential relationships.

What we experience in a Mies building as a result of this abstraction, is both the flat fact of material elements and the idea of an 'unformed and limitless' space. The bare fact

the right edge of the photograph, the podium does not—as the drawing would lead us to believe—continue around the entire building, but breaks off just behind the northwest corner. At that point the wall rises directly from the ground, with no trace of a foundation. Further, the long bench does not line up with the connecting wall to the office annex, but stops well before its southern end (Pl. 10.12). Clearly then, even the plan from 1929 does not give us a precise image of the building as constructed. With some caution one might designate it as an ideal ground plan, one that presents the Pavilion abstractly, so to speak, and freed from specific material and spatial conditions.

For these reasons a thoroughgoing investigation of the Barcelona Pavilion seemed unavoidable. The analysis will demonstrate to what extent the validity of previous interpretations has been put into question.

The Sources Available

The Mies van der Rohe Archive in The Museum of Modern Art owns a large collection of original photographs, which with few exceptions were published in various journals at the time of the Barcelona Exposition. It also preserves a number of small snapshots from the separate phases of the Pavilion's construction. As far as drawings go, several ground plans have been preserved that provide some insight into the course of the planning process. In a systematic examination of the Archive's holdings roughly twenty additional construction plans and detail drawings were discovered, which had been erroneously identified as relating to other projects. And finally, two important plans surfaced among the previously uncataloged papers of Lilly Reich.[11] In 1972 the Kunstbibliothek Berlin acquired from Sergius Ruegenberg, a one-time collaborator of Mies van der Rohe's, a so-called sketchbook containing, among other things, some early perspectives of the Pavilion.[12] These sheets, only later bound together, are for the most part by Ruegenberg himself, yet there are among them, especially for the Pavilion, sketches in Mies's own hand.

Unfortunately, only a small portion of Mies's files and planning materials from the period before 1938 managed to survive the war, and this is preserved today with the rest of his papers in New York. For that reason the correspondence regarding the

Barcelona Pavilion is only available in part. There is an obviously complete letter file covering the period from the end of May 1929 to the beginning of 1930, starting therefore just before the completion of the structure. The files of the German Exhibition and Fair Authority (Deutsches Ausstellungs- und Messeamt), which was entrusted with the German section of the exposition and therefore must have possessed at least copies of correspondence with Mies, were destroyed in a bombing raid in 1943.[13] Aside from isolated references in the roughly contemporary correspondence regarding the Lange and Esters houses, the essential documents for a his-tory of the planning and construction of the building are lacking. On the other hand, we do have the minutes of the executive meetings of the German Werkbund from July 5 and October 13, 1928, and from March 4, 1929, which have provided valuable insight into the state of negotiations on those occasions. Further important conclusions were drawn from interviews and conversations with Mies from the fifties and sixties, although Mies's comments were not always consistent. Finally, contemporary articles, supplemented by information taken from the newspaper clippings preserved among Mies's papers, provided one of the main sources for this investigation.

Thanks to the countless details derived from such a wide variety of sources, it was ultimately possible to reconstruct the Pavilion with relative accuracy and to outline the history of its origins. In evaluating these documents a certain caution was at times required, since comments after the fact, including the commentaries of Mies van der Rohe himself, reveal a certain tendency to make something legendary out of the project, one that does not always conform to historical fact. The original material itself is by no means free of contradictions, to which we will have to return in some detail.

The Origins of the Pavilion

The idea of a major exposition in Barcelona goes back to the time immediately before the outbreak of the First World War. Planned at first within the smaller framework of a special presentation of the electrical industry, the events of the war long postponed its realization, even though Spain was one of the few countries of Europe to

maintain neutrality during the military action.[14] Further postponed again and again by economic or political difficulties, concrete preparations for the exposition finally began in the second half of the 1920s. Meanwhile, the original concept of the exposition had undergone extensive revision. When the year 1929 was at last agreed upon, what was originally to have been only a regional event had developed into a project that could justly claim to be in the tradition of the great World's Fairs, though to be sure it was not called that officially.

The fact that here for the first time the Weimar Republic was given an opportunity to present itself outside its own borders as an equal partner within the community of nations explains the ambitious expectation officially accorded the project. Ten years after the end of the war the image of Germany as a presumptuously conservative state characterized by self-glorifying illusions of empire and a pathetic reverence for its Kaiser was still widespread abroad. The young democracy wished to counter this with a restrained expression of its progressiveness and distinctly international orientation.[15] The government sought a new means of expression, untainted by historical allusions. This internal drive for self-representation may well have been decisive in the selection of the architect. From an economic standpoint, the industries involved hoped for additional exports to Spain, which was just about to curtail the importation of foreign wares by means of a policy of increased protective tariffs. At the same time they wished to better contacts with the Latin American market, which traditionally had strong ties to its former mother country. The simultaneous Ibero-American exhibition being held in Seville promised good contacts with the firms and suppliers represented there. All in all, then, the promise of commercial successes seemed favorable.[16] The participation of Germany in Barcelona can only be properly understood against this background. In the late summer of 1928 there were as yet no signs of the crises looming on the horizon that would prematurely destroy most of the hopes that had been placed in the exposition.

The selection of Mies van der Rohe as the principal architect by the Commissioner General of the Reich, Georg von Schnitzler, must have been made before July 5, 1928.[17] As is well known, Mies's assignment not only involved the construction of the Pavilion, but artistic supervision over the de-

sign of all German sections in the various exhibition halls. The available sources give conflicting statements about the relative importance of the two tasks.

Mies himself later liked to suggest that the decision to build a national pavilion was made at practically the last minute. As he told it, France and England had abruptly overridden the plans of the Spanish organizers and decided to build pavilions of their own, whereupon the German Reich felt it had no choice but to do the same.[18] This is contradicted by the minutes of the German Werkbund executive meeting of July 5, 1928, however, which indicates that it was intended to "create a structure for the representation of Germany."[19] Therefore the thought cannot have come as such a surprise as Mies later wished us to think it had. Nevertheless, it is still an open question to what extent this structure was at first envisioned only as a kind of information stand, something similar to the Glass Room at the Stuttgart Werkbund exhibition of 1927. Further, it is uncertain just when it was decided to construct the building. A reference to negotiations in November 1928, not further specified, could provide an approximate starting point, and otherwise fits in well with the dates available.[20] Near the end of the previous month Mies had significantly increased the number of his employees by making new appointments, and had opened a branch office a few doors away — a clear indication that the preparations for the exposition were then taking concrete form.[21]

We will have to come back to the events of that winter in dating the plans. But for now it may be supposed that the planning process was essentially completed by the beginning of February 1929, for the first contracts had been let in January, and at that time the drawings had already been sent out for engineering calculations.[22] Shortly afterward the technical branch of the studio moved to Barcelona.[23]

A few weeks later, however, the whole project seemed to be endangered by a budget reduction. There followed a temporary cancellation of the contract, and on March 4 Mies reported at a meeting of the Werkbund that one could no longer count on the construction of the Pavilion.[24] In newly scheduled negotiations it was finally decided to continue with the construction after all, which, because of the temporary cessation of work on the building, had fallen considerably behind schedule.[25] In spite of increased efforts it was impossible to make

as percept and the silent, empty space as concept are held together through the assumed axiom of geometry" (p. 5).

9 Undated letter file in the Mies van der Rohe Archive; MoMA.

10 Cf. the later ground plans for the Brick Country House discussed in Chap. 3.

11 Only fragmentarily preserved as the result of losses during the war, the papers of Lilly Reich, the longtime companion and co-worker of Mies van der Rohe, are also available in The Museum of Modern Art.

12 See in this regard Ekhart Berckenhagen, "Mies van der Rohe und Ruegenberg: Ein Skizzenbuch," *Jahrbuch Preussischer Kulturbesitz*, Vol. 10, 1972, pp. 274–80, illus. 79–82.

13 Reference in [Anon.] *Rückblick auf ein halbes Jahrhundert: Von der ständigen Ausstellungskommission zum Ausstellungs- und Messe-Amt der Deutschen Wirtschaft e.V.*, prepared by the Ausstellungs- und Messe-Ausschuss der the Deutschen Wirtschaft e. V., Cologne, Cologne, n.d. [1957], p. 48.

14 A concise presentation of the earlier history is given in Genzmer, *op. cit.* (note 6), p. 541. Somewhat more detailed information is given in John Allwood, *The Great Exhibitions*, London, 1977, p. 135. Also in Alfredo Baeschlin, "Barcelona und seine Weltausstellung," *Deutsche Bauzeitung*, No. 57, July 17, 1929, pp. 497-504.

15 Georg von Schnitzler, commissioner general of the German division, expressed this clearly in his opening speech: "We wished here to show what we can do, what we are, how we feel today, and see. We do not want anything but clarity, simplicity, honesty." (Quoted by L. S. M. [Lilly von Schnitzler], "Die Weltausstellung Barcelona 1929," *Der Querschnitt*, Vol. 9, No. 8, August 1929, pp. 582-84, quote p. 583.)

Guido Harbers, "Deutscher Reichspavillon in Barcelona," *Der Baumeister*, Vol. 27, No. 12, December 1929, pp. 421-27, confirmed: "Mies van der Rohe's newest creation deserves to represent German culture in the now peaceful *competition of nations*" (p. 421).

In words similar to those of von Schnitzler, Richard von Kühlmann stated, in "Blick von Barcelona auf Deutschland," *Berliner Tageblatt*, Morning edition for December 1, 1929: "The form is sure, controlled, almost sobering, and at the same time *modest....* Perhaps events...have made it easier for us to approach problems of form with fewer presuppositions."

Justus Bier, "Mies van der Rohes Reichspavillon in Barcelona," *Die Form*, Vol. 4, No. 16, August 15, 1929, pp. 423-30, summarized: "Mies van der Rohe's structure pres-

ents itself as being so bold and forward-looking that the nobility of its appearance has won out over all resistance, and won many a friend for a *new Germany*" (p. 424).

[All emphases, save those of Harbers, mine.]

16 The economic aspects were particularly stressed in an unsigned newspaper article: "Deutsche Seide in Barcelona." *Kölnische Zeitung*, third edition, January 3, 1930.

17 Minutes of the Executive and Committee Meeting of the German Werkbund on July 5, 1929, in Munich; MoMA: "Jäckh informed us that the negotiations regarding Germany's participation at the International World Exhibition Barcelona 1929 have been concluded, and that Commissioner General Dr. von Schnitzler, Frankfurt, has entrusted the artistic supervision to our vice-chairman, Mies van der Rohe. This means the designing of the various German entries and the creation of a structure for the representation of Germany."

18 Interview with Mies van der Rohe in December 1964, reproduced in Katharine Kuh, "Mies van der Rohe: Modern Classicist," *Saturday Review*, Vol. 48, No. 4, January 23, 1965, pp. 22-23 and 61: "You know there were already seventeen enormous general buildings — really palaces — planned for the exhibition when representatives of the German government heard that France and England were each putting up separate national pavilions. So they decided to have one, too. I asked, 'For what purpose?' They said, 'We don't know — just build a pavilion, but not too much glass!'"

19 See note 17.

20 Letter from Mies to von Kettler, July 23, 1929; MoMA.

21 Hermann John to Ernst Walther, Jr., October 21, 1928; MoMA (Lange/Esters Correspondence): "For a few new employees have been taken on for Barcelona who for the time being will be working at this place. But will soon form a branch office (outside the building). (Location not yet precisely determined.)"

In the expense accounts for Barcelona the following names, among others, appear: Claus, Eggerstedt, Förster, Gutte, Kaiser, Otto, Pabst, Ruegenberg, Ulsamer, and Walther, Sr. — and, as free-lance co-workers, the ladies Hahn, Uhland, and Lichtenau (decoration), as well as Mies van der Rohe's boyhood friend Gerhardt Severain, who was responsible for the typographic design in the exhibition halls.

The branch office that was opened in the late autumn of 1928 was located next door

up for the time lost, so that everyone involved felt it would be impossible to complete the structure in time.

The ceremonial opening of the exposition took place on May 19, 1929, in the presence of the Spanish king Alfonso XIII and the royal family. A week later the German sections including the Pavilion were also opened to the public.[26] Along with the German ambassador, the Spanish royal pair once again participated in the dedication ceremonies. But behind the visitors' backs work was still going on at a fever pitch. The office annex, for example, could not be used before July 17, while the layout and planting of the garden were obviously delayed well into August.[27]

After being officially extended, the exposition closed in January 1930. Halfhearted attempts to find a buyer for the Pavilion and put it up somewhere else after it had been disassembled came to naught, largely because of the developing world economic crisis.[28] The rumor circulating from time to time to the effect that its components are resting well packed in some Spanish warehouse is pure wishful thinking. The steel was sold on the spot after the building was dismantled; all of the marble and travertine went back to the firm in Germany that supplied it, where it was presumably put to some other use.[29]

The expenses for the German contribution to the exposition came to a total of roughly 1,100,000 Reichsmarks. Of this, the Pavilion, including its furnishings, cost some 340,000 RM alone, which was paid by the German Reich. The remainder, aside from a few small subsidies, had to be borne by the exhibitors.[30] The entire sum corresponded to the original cost estimates, but exceeded the reduced budget of March 1929 by nearly 200,000 RM.[31] This cost overrun continued to be argued about right up to year's end, the Commissioner General at one time finding himself forced to enact a stop payment. After bitter and protracted negotiations the Reichstag finally agreed to guarantee the sum of 550,000 RM to cover the deficit, so that at the last minute a declaration of bankruptcy could be avoided.[32]

It seems hopeless to try to determine the actual reasons for the additional expenses from the many contradictory statements of those involved. Mies himself and Lilly Reich blamed them on the incredible rush to complete the building in time, which—occasioned by the stall in construction and local difficulties in the delivery of the re-

to the studio in Berlin W 35, Am Karlsbad 26a.

22 John to Walther, Jr., February 10, 1929; MoMA (Lange/Esters Correspondence): "Your old man [*Ernst Walther, Sr.*] pulled it off. To be sure, he is still finishing the figures for the pavilion [*the display of the linoleum industry at the Leipzig Building Fair*] and also the drawings, but he returned the plans for Barcelona."

23 The architect's office to von Schnitzler, September 28, 1929: "Thus the most important contracts were already let in January and February, and at the end of February the technical branch was moved to Barcelona so as to be able to proceed with the larger construction work."

24 Minutes of the executive meeting of the German Werkbund on March 4, 1929, in Berlin; MoMA:

"Mies reported on the surprising response of the finance committee of the Reichstag to the request for a second payment for Germany's participation in the World Exposition in Barcelona. He explained that the exposition could not take place with the funds approved by the Reichstag to date. A last attempt will be made to raise funds from elsewhere, but it would appear that the representative pavilion and the Werkbund section cannot be carried out."

See also the partially contradictory comments in the correspondence: confidential communication from Mies to von Kettler, August 23, 1929; letter from von Kettler to Lilly Reich, September 10, 1929; report of the accounting office to von Schnitzler from September 28, 1929; Lilly Reich to von Kettler, November 25, 1929 (all MoMA).

25 The letter of August 23 speaks of an "interruption to all work at the end of February because of the budget negotiations," which is said in the letter of September 28 ("budget negotiations at the beginning of March") to have lasted ten days. On November 25, however, there is mention of a "three-week interruption in the work in Berlin because of temporary annulment of the contract." (See note 24.)

26 See in this regard H. S. [Heinrich Simon]; "Weltausstellung 1929," *Frankfurter Zeitung*, first morning edition for June 5, 1929.

27 Letter from von Kettler to Mies, July 15, 1929; MoMA.

28 Letter from von Kettler (by H. Habbe) to Lilly Reich, October 29, 1929; MoMA: "Further, please urge Mies to make some statement regarding the sale of the Pavilion."

Von Kettler had already written to von Schnitzler before this: "Since both in Germany and here various parties have shown interest in the Pavilion, there is some hope that it can be sold, though there have been no firm negotiations yet."

See also the correspondence between Lilly Reich and Gabriele Seeger on December 29, 1929, and January 5, 1930.

29 E. W. Maiwald to Mies, March 5, 1930; MoMA: "Since all of the marble from the Pavilion is leaving here in a few days for Hamburg, and the travertine is to follow in two to three weeks, I would be grateful if you would approach Köstner & Gottschalk. Since you know the material better than anybody, I feel it would be appropriate if you first talked with Köstner & Gottschalk about the possibility of reusing it, for naturally I am eager to get what we can out of the Pavilion as soon as possible. In accordance with your telegram, I will sell the steel framing here, and hope to get out of it enough to cover the costs of dismantling. The chrome-plated steel columns are also going to Hamburg, and I have written to Berliner Metall-Gewerbe that I will be able to negotiate only when I know for certain what is to become of the Pavilion. Perhaps you could let me know soon what you, or possibly Herr Köstner, feel to be a most profitable use for the material."

30 A precise schedule of the expenses for the Pavilion can be found in the enclosure in the letter from the building office to von Schnitzler on September 28, 1929 (MoMA).

31 Concerning the total budget, see the minutes of the executive meeting of the German Werkbund on October 14, 1929; MoMA.

32 The Reich's Minister of Finance (by Trendelenburg) to the German Commissioner General (von Schnitzler), December 15, 1929; MoMA.

quired materials—meant increased expenditures due to overtime shifts.[33] Delayed payments on the part of the exhibitors, who under the pressure of the deteriorating economic situation hoped to decrease their contributions, may well be another reason for them. Finally, the possibility that Mies failed to scale down his concept in spite of the budget reduction is a suspicion that can doubtless be entertained, but which would require concrete proof. The fact remains, no matter what the reasons, that this development contributed decisively to the later fate of the Pavilion.

The Separate Planning Stages

As Sergius Ruegenberg has related on a number of occasions, the creation of a flexible working model was the beginning of the planning process. For this a base slab of plasticine had been prepared, into which small panes of glass or celluloid and strips of cardboard pasted over with colored Japanese papers could be inserted.[34] By repeatedly rearranging these "wall planes" a ground plan scheme could be infinitely altered—which made the development of a satisfactory solution considerably easier. A further advantage of this procedure was the opportunity it gave to visualize the spatial effect of any given alteration. Once a specific stage of planning had been achieved, one of Mies's co-workers—often Ruegenberg, but occasionally even Mies himself—would capture the respective variant in a quick perspective sketch, of which two typical examples are presented here (Pls. 10.3, 10.5).

With respect to the general facts, there is not the slightest reason to doubt the accuracy of Ruegenberg's testimony. But as for the relative importance and chronological sequence of the individual steps, a slightly limiting elaboration is required. It would appear to be completely impossible, from an understanding of Mies van der Rohe's method as based on precise knowledge of his papers, that even such a provisional model existed at the very start of planning, before he had at least a more or less firmly circumscribed basic concept. This assumption is confirmed by his use of certain materials like colored Japanese papers to imitate marble and snips of celluloid to represent extended surfaces of glass; they alone attest to a specific conception of the building's character.

It is probable, then, that Mies approached the task on his own before giving his co-workers any precise instructions. Countless sketches of some of the later buildings have been preserved, with ground plan designs as a rule making up the vast majority. Likewise, it can be assumed that in the case of the Barcelona Pavilion a whole series of studies preceded the experiments with a model, sketches that were destroyed along with so much else once they were no longer required in the further course of the work. The drawings reproduced here, based on the model, therefore belong to an advanced stage of planning.

The perspective of the front of the building, taken at an angle (Pl. 10.3), shows the most differences compared to the completed structure, suggesting that it may be the earliest documented version of the Pavilion. The cantilevered ceiling slab is not yet supported by free-standing columns, but rather rests solely on the steel framework of the glass and marble walls.[35] Transparent plate-glass panes make up the front of the smaller, atrium-like inner courtyard, drawing one's glance toward the sculpture placed there, a roughly life-sized figure sitting half upright and facing the viewer, its legs forming sharp angles, a simple block of stone serving as its base and resting place.

A dividing wall of tall, rectangular slabs of travertine (?) placed well forward under the edge of the roof screens the southern, unroofed half of the platform from the street. The resulting enclosed space also takes on the character of a courtyard, while later it is broadly open to the east and serves rather more the function of a terrace. Whether and to what extent pools of water were already anticipated for the courtyards is an open question, since the drawing provides no clear indications one way or the other.

Between the two courtyards lies the roofed central space, set somewhat back. Framed on all sides, it stands out as an independent structure. Compared to the openness that was developed in the next stage, in which the boundaries between inside and out tend to blur, it gives the impression of a self-enclosed space, in spite of the extensive use of glass in its exterior walls. On the whole, a number of decisive features of the later Court Houses designs are here anticipated: the motif of a transparent structural core set back between flanking segments of wall and firmly clamped between them by the overhanging roof has obvious parallels in the Hubbe

33 See notes 24 and 25.

34 Conversation with the author in December 1979; see also Berckenhagen, op. cit. (note 12), p. 275.

35 Reproduced in Berckenhagen, op. cit. (note 12), illus. 79, as well as in, among others, *Architektenzeichnungen 1479–1979*, catalog of the exhibition of the same title in the Kunstbibliothek, Berlin, edited by Ekhart Berckenhagen, Berlin, 1979. The other sketch exhibited on that occasion—which was erroneously dated by Berckenhagen, on the basis of the platform's being level with the ground, to the beginning of the planning process (Pl. 10.5)—is, on the contrary, the only surviving garden view of the Pavilion. The placement of the supports in a manner different from the completed building—the two back rows are visible—puts it quite close to the somewhat later ground plan which has here been called Plan I.

and Ulrich Lange projects from the middle thirties (Pls. 17.1 and 18.7). In the completed building these parallels, though subconsciously still present, were no longer so clearly marked.

The position and orientation of the front access to the platform in Plate 10.3 are indeed the same as those of the final version, though the base projects forward as a narrow wall extension. Because of this edging along the side, the lower landing of the stairs, elevated by two steps above the level of the street, appears to be firmly tied into the foundation slab, which in turn largely preserves its closed outline. Mies used a basic rectangular shape here for the foundation slab, treating the approach to the upper platform as simply a cut in it. In all succeeding plans, however, the base is set back along the full length of the stairway approach, which is level with the ground, so that this lower area loses its original orientation and becomes instead a forecourt more closely related to the street.

Assuming that there are no further gaps in the stock of sources, which under the circumstances is admittedly quite possible, it appears that from here on the main focus was increasingly on the scheme of the ground plan. Now the majority of the drawings are of a large format, presenting the building in a ratio of 1:100, a clear indication that the architect's ideas had taken concrete form, and that planning had entered a decisive phase. Chronologically, the ground plans can be divided into two groups, of which the earlier one can still be dated with relative assurance to 1928. Since the plans bear no date, this assumption is based primarily on Mies's own comments—mostly in interviews from the fifties and sixties. At that time, he recalled precisely how, in the search for an appropriate material for the free-standing wall in the interior of the Pavilion, he had chanced upon a large block of onyx at a Hamburg importer's, buying it at his own expense to make sure that it would be available.[36] At this point, therefore, there obviously had still been no final decision about the financing of the project, even though this event certainly took place after the commission had been given. If there had been no assurance at all that he would be reimbursed, Mies would hardly have taken such a risk.

As in the case of all the other walls of the Pavilion—excepting the narrow end pieces—the onyx wall was not made up of massive blocks, but rather of an inner steel skeleton onto which thin slabs, only three centimeters thick, were fixed on either side. The cost of materials and the expenses of transport were thereby reduced considerably, especially since the individual slabs were delivered from Germany ready for installation. On the other hand, this method demanded extreme care and precision in every respect, not only in the preparation of the marble, but also in the planning, for all the measurements had to be calculated in advance down to the millimeter. Once the cutting of the slabs had begun, only the smallest changes were possible.

The Legend of the Onyx Block

Onyx doré quarried in the Atlas mountains in Morocco is one of the rarest and therefore most expensive types of marble. When an insurance claim had to be made to cover two spare slabs damaged in transport, the local construction office estimated the loss as amounting to at least 8,000 RM.[37] Eight slabs and four end pieces were needed for the entire wall, hence the value of the material must have come to at least 60,000 RM for this wall alone—roughly a fifth of the total cost of the Pavilion (without furnishings).[38] Considering the enormity of this sum in the economy of those years,[39] we can assume that Mies sought to make optimal use of the block's given dimensions, so as to avoid having smaller unusable pieces left over once the cuts had been made. Thus in calculating the dimensions of the slabs it is likely that he based them on the measurements of the raw, uncut block, especially since there was none too much of the material to begin with. If one assumes the loss of a centimeter with each cut, the original block was probably a flat rectangular one measuring about 2.40 x 1.60 meters, its thickness somewhere between 60 and 90 centimeters, depending on the number of extra slabs provided for.[40] It is likely that precise calculations regarding the optimum division of the block began immediately after its purchase; with them, the proportions of the onyx wall were definitely fixed. We may assume that Mies, so as not to have to completely redesign the structure from the beginning, essentially contented himself with adapting the ground plan here and there to the new conditions, which occasioned only slight alterations in the overall scheme. This process, which he described after the fact, gave rise to countless misunderstandings, however, that in

36 Tape of an interview conducted by Horst Eifler and Ulrich Conrads in October 1964; RIAS production, Berlin. Issued as a disc recording: *Mies in Berlin*, Bauwelt Archiv I, Berlin, 1966.

37 Letter from von Kettler to von Schnitzler, July 15, 1929; MoMA.

38 In the letter in note 37 the total cost of the Pavilion without furnishings and interior details was estimated to be roughly 300,000 RM. The detailed accounting of September 28, 1929, gave the final sum of 338,422.18 RM, one that includes all the auxiliary schedules. Far over half of this sum was for the marble alone: including finishing and installation, 187,580 RM.

39 To provide an approximate point for comparison: for the Nolde House project from the same time, an imposing structure even for that period, with nearly 450 square meters of floor space, the estimated cost was roughly 100,000 RM. The cost of the Lemke House, built three years later, and comparatively more modest, was between 20,000 and 25,000 RM.

40 The wall consisted of a total of eight slabs (four on each side) of 235 x 155 x 3 cm each, and four end pieces of 58 x 155 x 18 cm each, which when fitted together formed a single large slab. If one adds the two mentioned replacement slabs, the dimensions of the original block—figuring a centimeter's width for each cut—must have been 235 x 155 x 58 cm.

time took on the dimensions of a full-blown legend.

At the heart of this legend is the claim that the dimensions of the onyx block determined not only the proportions of the wall, but, to a greater or lesser degree, those of the entire structure. Obviously the champions of this thesis envision a kind of "module" from which all of the measurements of the Pavilion could be derived—something like the diameter of a column in antiquity, which according to Vitruvius provided the basic unit for all the dimensional relationships of a temple.[41]

Interestingly enough, the idea of a module first surfaced at a time when modern architecture had already passed its flowering and had established itself as an artistic and cultural phenomenon. In their search for its historical roots, critics increasingly reflected on the somewhat more traditional aspects of the work of Mies van der Rohe.[42] In architecture itself a parallel development took place at the latest since the fifties, one that made itself particularly visible in Mies's increasing tendency to create symmetrical designs. But this should not lead one into premature conclusions. To be sure, the continuing influence of Schinkel, especially in the very last projects, is unquestionable, and the New National Gallery in Berlin would be scarcely imaginable without an intimate knowledge of classical architecture. Still, the podiumlike foundation of the Barcelona Pavilion and the roof supported by columns do not prove that this was but the modern version of a long-familiar theme. The podium could be justified, if necessary, by the slight inclination of the site, while the regular grid of supports, thanks to the intersecting wall segments and the reflecting coverings that tend to mask their structural function, fails to produce the sense of order conveyed by a classical sequence of columns.

As far as a *system* of proportions derived from the free-standing wall is concerned, it was the interviewers and not Mies himself who introduced the theme.[43] Mies clearly referred solely to the height of the building, which as he said stood in a direct relation to the dimensions of the onyx block:

"This block had a certain size. So I had only the possibility to take twice the height of the block, then make the Pavilion twice the height of the onyx block."[44]

A demonstrable, calculable system of proportions underlying the plans—whether of a rational or geometrical nature—is moreover in no single case apparent.[45] Yet that is precisely what is implied by the terms *module, dimensions,* and *proportions* chosen in the interviews, which lead us to think of simple mathematical relationships such as 1:3 or 1: 2.[46] And when speaking of proportion, Mies obviously was thinking of something totally different from mere construction models that one can learn, and that can be applied, once developed and in general circulation, without a modicum of artistic intuition. As a teacher he was above all concerned about developing "a *sense* of proportions" in his students.[47] Quite in contrast to the rationalism so often spoken of in his architecture, he in fact transferred this whole question into the realm of the purely intuitive and aesthetic, one necessarily unapproachable for rational definition. Therefore we must reject the thesis that he was here working with a system of proportions based on a fixed module. It is nonetheless true that the free-standing onyx wall was of some significance for the conception of the Pavilion. On the basis of the available sources and various scattered statements by Mies van der Rohe, a series of conclusions presents itself:

1.

The planning, as Mies indirectly confirms, was already in an advanced stage before the discovery of the onyx block: "Since I had the idea about the building . . . we had to go and look around huge marble depots, and there I found an onyx block."[48] And in another context: "I already had the idea of what I wanted in the Pavilion, but had not fully developed it yet; it was still a little unclear. And then I said, 'Come on, boys, don't you have something else, something truly beautiful?' And I was thinking of this free-standing wall that I planned for the inside."[49] The length of that wall varies considerably from its ultimate length in some of the ground plans—which proves that these plans had been completed at the time suggested above.[50]

2.

Quite apart from the choice of material accomplished with the purchase of the onyx doré, the wall, highlighted by its placement alone as the focus of the building, appears to have played a decisive role in the planning of the Pavilion from a relatively early date. Another quote from Mies serves to confirm this: "One evening as I was working late on the building I made a sketch of a free-standing wall, and I got a shock. I knew it was a new principle."[51]

41 John Peter expressly used the term *module.* (Interview with Mies van der Rohe; issued as a record, *Conversations Regarding the Future of Architecture,* Reynolds Metals Company, Kentucky, 1956.)

Eifler and Conrads (note 36) speak in a similar way: "the quantity, that is to say the dimensions of this onyx block, determined the dimensions of the legendary Pavilion."

The implication was already made in Ulrich Conrad's article "Mies van der Rohe: Ich mache niemals ein Bild," *Bauwelt,* Vol. 53, No. 32, August 6, 1962, p. 881 (excerpts from an interview at the Krupp works in Essen from the spring of 1962).

42 Colin Rowe's essays from the forties and fifties ("The Mathematics of the Ideal Villa," 1947, and "Mannerism and Modern Art," 1950), though little noticed at that time, have doubtless tended to show the way. (Reprinted in Colin Rowe, *The Mathematics of the Ideal Villa and Other Essays,* Cambridge, Mass./London, 1976.)

43 See note 41.

44 *Conversations Regarding the Future of Architecture, op. cit.* (note 41).

45 A letter from Vernon Geisel to Diana Faidy of November 17, 1969, proves informative (MoMA): "The architects who worked with Mies here, one for a period of 26 years, have asked me to assure you that Mies never used an approach to proportioning which consciously employed any mathematical models. The 3 by 5 and 5 by 8 proportional arrangements of structural bays do recur in his work. But any other approximation of mathematical derivations in window or elevation proportioning is purely happenstance."

46 See note 41.

47 Kuh, *op. cit.* (note 18), p. 23.

48 *Conversations, op. cit.* (note 41).

49 *Mies in Berlin, op. cit.* (note 36).

50 In Plan I (Pl. 10.2) its length is 7.70 m, in Plan II (Pl. 10.4) still 6.55 m.

51 Interview on February 13, 1952: "6 Students Talk with Mies," *Master Builder,* student publication of the School of Design, North Carolina State College, Vol. 2, No. 3, Spring 1952, pp. 21-28, quote p. 28.

3.

Assuming for the moment that a direct relationship did exist between the measurements of the wall and the original form of the onyx block, this would have been surely only the logical consequence of purely practical considerations—just as the height of a brick wall is only a multiple of the individual layers of brick and mortar. In the present instance, a prime consideration must certainly have been to utilize the expensive marble as efficiently as possible. But here, as before, the decisive precondition for a unified scheme of proportions is simply not in evidence, namely a uniform basic dimension from which all the remaining dimensions are ultimately derived.

4.

Presumably the misunderstanding rests on the confusion of two independent factors, which should be kept separate: namely the central importance of the free-standing wall on the one hand—exclusively the matter of an artistic motif—and the transposition of the dimensional ratio of the block to the separate slabs on the other, which was done solely for reasons of economy. It may be that the block, as Mies maintains, determined the height of the Pavilion and thereby to a certain extent influenced the entire complex as well. However, a fixed system of proportions cannot be demonstrated, either in the plan or the onyx wall itself (3.10 x 5.86 m). Rather the suspicion arises that mathematical or geometrical correspondences in the ground plan were deliberately avoided, even where they appeared to be perfectly justified from a structural point of view—as for example in the placement of the cruciform columns, which form apses of 6.96 x 7.70 m, and are therefore only approximately square areas.[52]

If one assembles all of the previous conclusions, it is certain that the discovery of the onyx block in a Hamburg marble warehouse, which occurred "in the middle of the winter," according to Mies, who once even specified the year 1928,[53] led to a decisive turning point in the planning process. All of the plans that show the free-standing wall to be its ultimate length of 5.86 meters would then necessarily date from sometime after that event, while those with different dimensions must be reckoned as being earlier.

The sequence of the drawings within these two groups can then be achieved by close comparison of the various ground plans. And the relative dating that results can be supported by written documentation. An important factor here is the observation repeatedly made in the correspondence to the effect that the unfavorable terrain toward the rear of the plot necessitated a repeated shifting of the foundation stakes and ultimately required the relocation of the street in front of the Pavilion.[54] Since this is also given as one of the main causes of the cost increase during construction, one ought to be cautious in evaluating the statement. If one proceeds on the basis of the available fixed points, one thing is certain: the distance between the Pavilion and an already existing flight of steps leading up the slope of the plot on the west varies from one plan to the next; at the beginning that distance was still relatively short, and with the continuing alteration of the design it became increasingly larger (Pls. 10.2, 10.4).

52 The large pool could be cited as a further example; its dimensions are 21.48 x 9.90 m (measured in floor slabs, 20 x 9 units), by which the ratio 1:2 is only approximated.

53 *Mies in Berlin, op. cit.* (note 36).

54 Statement for the files signed by Walther Sr. and addressed to Mies, July 8, 1929; MoMA:

"The Reich's Pavilion was staked out several times in its entire extent on a spot planned for it within the plot because of local conditions. The ground was so high, especially at the spot where the large pool was to be, and above all under the office addition, that construction work had to begin 10.58 m in front of the original survey.

Various negotiations with the Spanish exposition committee . . . resulted in the determination that we were 5½ meters out into the former street, and we had to promise to have that portion of it surveyed and macadamized . . . at our expense. . . ."

The letter from the architect's office to von Schnitzler on September 28, 1929, already quoted a number of times, presents a different interpretation, however: "We were forced by protests from the Spanish exposition committee to move the building site by 7 m, which necessitated raising and strengthening the foundation work considerably, and forced us to change the position of the street. . . ."

Plan I (Pl. 10.2)

With the ground plan here designated as Plan I, Mies made the decisive step from the sketch discussed earlier toward the project as it was completed in the following year. The line of wall originally stretching to the left of the front steps has been completely abandoned, so that this part of the platform is now completely open to the street. On the other hand, the placement of the walls in the right-hand, roofed section of the Pavilion corresponds by and large to the final scheme. For all the similarities, nonetheless, a number of significant discrepancies must not be passed over.

As the given width of the already existing flight of steps at the rear of the platform proves, this plan is likewise based on a scale of 1:100. With an overall length of 67 meters, the structure as conceived here exceeds the dimensions of the executed building considerably, which only measured 56.6 meters along its north-south axis.[55] The platform itself, roughly three meters away from the foot of the steps, is placed quite close to the slope rising right behind it. Because of its larger dimensions, however, it projects a bit further to the east, that is, toward the street, than the succeeding version, which was considerably reduced in size and therefore essentially narrower, though there the distance to the slope has been increased by an additional 2.5 meters to a total of 5.8 meters.

The dense vegetation indicated by the irregular wavy line surrounding the structure reaches right up to the edge of the platform, only retreating from the south and west sides of the roofed annex, creating a protected open space accessible only from the office. With the exception of this small garden, the Pavilion lies completely surrounded by shrubbery and trees on three sides. Since at the same time the only exposed side, the front, allows a virtually unobstructed view into the interior, we are here presented with the phenomenon of a building that has virtually no visible exterior. Stress has clearly been placed on the frontal effect, as is also shown by the arrangement of the approach, the placement of which has been largely taken over from the previous sketch. The former extension of the platform flanking the front stairs is here replaced by shrubbery, which serves as an edging for the lower stair landing of marble slabs.

One would approach the structure perpendicularly, then make a sharp left turn

Illus. 35 Version with three rows of cruciform columns (late 1928).

that leads directly up onto the top of the platform. Only a further turn of 180 degrees permits a view into the interior of the roofed area. There are only seven steps in this flight instead of the final eight, but the platform can scarcely be less than 1.20 meters high, especially since the slightly projecting lower landing has presumably been raised one step above street level. These observations contradict the argument often raised by Mies during the course of later budget negotiations to the effect that the height of the podium had not been planned in advance, but had turned out to be necessary as a result of the topographic conditions, and therefore had to be considered as an unpredictable cost factor.[56]

The greatest differences between this plan and the completed structure are to be seen in the left half of the ground plan. The larger pool is still in a central position, and is approachable from all four sides. The southern end wall is set some distance apart from the rim of the platform, stopping several meters before its front edge, without turning north and running parallel to the street, as it does in the succeeding versions. The office extension, open to the small garden, appears to consist largely of glass, like the central area, and is given an interior arrangement similar to the "flowing space" of the main tract. This is doubtless one of the prime reasons why this early

version appears to be more homogenous in many respects than the ground plan as finally realized, which diverges from the dominating scheme in the office annex at the upper left corner by having a glass wall only on the front side[57] and traditional closed interior spaces (see the reconstructed ground plan: Pl. 10.7).

The plan includes no indication of the construction of the roof, and therefore leaves it an open question whether at this point Mies had already conceived of a uniform system of supports. Now, of course, the Pavilion is rightly held to be the first building constructed by him in which the division of structural and room-defining elements is carried out in a consequential way. Yet it is certainly conceivable that this idea materialized only during the further course of the planning, and that Mies originally intended to use bearing walls. The wide roof overhang would argue against such an assumption, however, as well as the relative thinness of the walls, which could hardly have been adequate for the support of such a weight. Accordingly, we must here assume a skeletal construction, visualizing three rows of supports, considering the broad spans, which would correspond in part with the roughly contemporary sketches (Pl. 10.5, Illus. 35).

Plan II (Pl. 10.4)

Compared to the plan just discussed, the dimensions of the podium in Plan II are considerably reduced, already approximating, with the exception of small deviations, those of the ultimate solution. As far as concerns the division of the central area that was taken over basically unchanged from the first design, the proportions as originally established are generally preserved. At the same time, the distance from the slope has been broadened slightly to 5.80 meters, without causing any corresponding shift in the line of the front. As in the completed structure, the front stairway now shows eight steps. Assuming a rise of 15 centimeters for each step, one can calculate the height of the platform above street level to be 1.20 meters.

The essential differences appear primarily in the left half of the drawing: the large pool has been shifted from the middle out to the front corner of the platform, where it is closely bracketed by the boundary wall, which has now been extended and turned to the north. In the office extension, the comparatively open interior arrangement of the first design has given way to separate, clearly defined rooms. Though still partly open to the platform, these are now given a more or less one-sided orientation to the west, while along the southern edge of the structure there is a solid wall instead of the glass wall originally planned.

Further changes from Plan I have to do primarily with the podium, which no longer extends beyond the walls on all sides, but has been cut off on the two narrow ends, so that here it appears to be clamped between the boundary walls rising directly from the ground. The relationship between the Pavilion and its foundation thus underwent a partial reversal: while the podium was originally quite obviously the bearing element, the stable basis for a dynamic arrangement of seemingly sliding wall elements, now it is the outer walls themselves, firmly anchored in the ground, which set a clear boundary to the platform and thereby fix the outline of the whole. In the process the Pavilion gains a considerably greater solidity, especially now that it appears for the first time, even when viewed from an angle, as a sculptural whole, the facing of the lower stair landing having been abandoned. Now that the resulting forecourt extends to the north beyond the boundary of the plot it forms a virtual extension of the street space that leads the approaching visitor directly toward the front stairway.

In the covered area of the Pavilion in the present plan there are indications for a total of six supports that are not, as opposed to the later eight, symmetrically placed beneath the roof. Obviously the north end wall was to take over the function of the fourth pair of supports, which certainly would have compromised the unity of the structural system. Pencil lines at various spots reveal the attempt to divide the platform into a regular grid. From these it is clear that the network of joints between the paving stones was a later accommodation to the existing scheme, and thus can hardly have constituted the point of departure that the theory of the "grid" seems to imply.

Plan II thus furthers the development of the structure considerably beyond the previous design. Preserved unchanged, though placed slightly differently, on the other hand, are the three rectangular blocks that were obviously intended to serve as bases for reclining or kneeling sculptures. In each case they stand as focal points at the end of a major viewing axis, visible even from a distance. Of these intended sculptures only Kolbe's *Morning* was ultimately exhibited, rising above the smaller of the two pools.[58] The limitation to a single statue—however much financial reasons may have played a part in the decision—was of extreme importance for the conception of the Pavilion.[59] In contrast to the original attempt (Plans I and II) to establish various centers of gravity, as Mies arranged the focal points roughly equally about the entire ground plan, this resulted in a shift of gravity and a concentration of visual accents to the northern half of the Pavilion. In this way the area that was already distinguished by the expensive onyx wall, studiously arranged furnishings, and the single free-standing cruciform column (Pls. 10.6, 10.18) was given even further importance. In the sequence of the individual spaces a kind of hierarchical gradation was thus achieved, one in which the atriumlike inner court represented a highlight second only to the area in front of the onyx wall.[60] With its statue rising up above the black surface of the water (Illus. 36) it is reminiscent, and certainly this is no accident, of a *naos*, the cella of a Greek temple, at the end of which the cult image, often likewise inaccessible, was to be found.[61]

Illus. 36 Atrium with pool and sculpture by Kolbe.

Plan III

As the identical division of the office extension reveals, the plan bearing the inventory number 14.7 represents a refined version of the previous one, so that the reproduction of it here is unnecessary. Moreover, the close connection of this design to the second one can be seen from the correction later made in the luminous wall, which had originally been drawn quite thin, as before, but was altered so that the two glass faces were separated by a distance of 1.10 meters. Now, for the first time, the platform displays a complete grid network, where before the division into slabs was only suggested. Slight changes in the extension of the podium and in the dimensions of the individual wall elements can largely be explained as adaptations to the presence of the grid. At 5.90 meters, the length of the onyx wall corresponds roughly to that of the wall as constructed, which leads to the assumption that this drawing was made after the purchase of the marble block.

The distance from the slope is the same as it was before, but the pavement continues to the point of the seventh step of the existing flight of stairs. Accordingly, Mies must have toyed with the idea of building up the ground behind the Pavilion to the height of the top edge of the platform—which in fact proved necessary after the repeated shifting of the Pavilion's position. This leads to certain interesting conclusions; among them, that he permitted the structure to develop much more freely on the side facing the slope, so that it no longer appeared to be crowded against the hillside. The placement also provides us with proof that neither the podium itself nor its established height, which as we have shown was fixed early on, was solely the result of the topographical situation. In gross contradiction to his own later statements, it was rather an essential component of the whole concept as envisioned by Mies from the start. If the existing ground contour had been left as he found it, the podium could have been lowered considerably, if not totally eliminated. But obviously Mies did not want to give up the idea of a podium under any circumstances. He was even prepared, if necessary, to face considerable additional expense as a result of the earthmoving and the much larger material requirements.

Additional Plans and Drawings

The final series of detail and construction drawings reveals but slight discrepancies with the completed structure, and must therefore belong to the final planning stage. Since the structural engineer had the plans at the beginning of February,[62] it must be assumed that these were developed in January 1929, though later revisions are by no means out of the question. One of the sheets shows the long connecting wall leading to the office extension with the stone bench in front of it, and here for the first time the bench does not run clear to the end of the wall. To all appearances the reason for such a change was the intention to orient the bench supports according to the joints in the wall and paving slabs. The drawing is thus of a more recent date than all other existing ground plans—in which the bench is either not present at all (Plans I through III) or runs clear to the southern edge of the wall.[63] The rest of the material includes a schematicized cross section of the Pavilion that contains no new information, detail drawings of the various framing elements (for the glass walls, the luminous wall, the doors), and a cross section of each of the two pools. The latter are of some significance inasmuch as they contain handwritten comments about the tile surfaces of the two basins. According to them the inner pool was to be finished with black glass tiles—which corresponds to the reports of a number of eyewitnesses.[64] The larger outside pool is remembered, by contrast, for the light green tint of its water.[65] We can no longer determine whether this was also created by colored glass tiles or, more likely, simply by painting the inside of the basin.

In this context the blueprint of one further drawing deserves to be mentioned (Illus. 37). It was presumably made by the firm of Köstner & Gottschalk, which supplied all of the marble for the project. In addition to various outlines of the front edge of the podium and of the walls facing the street, it provides an exact floor plan of the platform complete with the precise calculation of its travertine slabs. The measurements are given to the exact millimeter in every case, so that even the tiniest discrepancies in the grid are readily apparent. This confirms the earlier statement that the sides of the square slabs did not measure 1.00 meter, as Blaser claimed, but 1.10 meters. Moreover, the grid was subjected to additional variation, so that the slabs in the front right corner of the Pavilion vary between 81.6 and 114.5

55 Plan I itself bears no scale, so that the stairs ascending the slope constitute the only point of reference.

56 See note 54.

57 The interior disposition of the office annex was subjected to changes up until the last minute. No ground plan corresponding to the ultimate solution has survived. One can, however, presume that the wall openings indicated in the publication plan (Illus. 33) were narrow, high windows like the one that was finally placed in the north wall (Pl. 10.16).

58 The large interior perspective as well as a number of the early sketches call for a half-reclining sculpture here, which could have been a statue by Maillol or possibly an early work by Lehmbruck. As Ludwig Glaeser rightly remarks, however, the final choice must not be considered as something he was forced into. "Although Mies preferred reclining statues, he ultimately chose a standing figure for the designated place in one corner of the small pool, *probably because all principal views were framed vertically.*" (Ludwig Glaeser, *Mies van der Rohe: The Barcelona Pavilion,* New York, 1979, unpaginated; emphasis mine.)

A telegram from Mies van der Rohe to Lilly Reich, February 22, 1929 (MoMA), shows that the decision in favor of the Kolbe statue must have been made relatively early: "Give Kaiser the photo of the Kolbe sculpture and the book on Lehmbruck so that [we can] negotiate with the appropriate gentlemen here."

59 Plan III contains no information about this at all; another ground plan (Inventory No. 15.51) shows only a single rectangular pedestal, which was later changed into a square base.

60 Glaeser, *op. cit.* (note 58) sees this as a spatial arrangement virtually reminiscent of sacred spaces: "The way Mies accomodated the public and ceremonial functions suggests analogies with a Romanesque church plan: the open part of the Pavilion representing the atrium, the roofed part the basilica replete with nave and aisles, and the end walls the apse formed by the walls around the small pool. It even had a monumental altar piece in the golden onyx wall which, although shifted perpendicularly out of axis, clearly marked the Pavilion's ritual center."

Illus. 37 Platform paving blueprint (Köstner & Gottschalk, spring of 1929).

centimeters. Smaller variations can be found also in the vicinity of the onyx wall and the inner pool, as well as along the back connecting wall, whose joints were thereby given a symmetrical arrangement in relation to the paving slabs. Here again, then, it was the partitioning of the vertical surface that was the determining factor. Thus any symbolic significance of the platform grid can be largely refuted, for the variations in slab dimensions are based purely on formal and aesthetic principles. This scarcely supports an interpretation which claims to see the grid network of the Pavilion as the reflection of a cosmic system of reference.

In this drawing the platform breaks off directly behind the connecting wall, while at the same time it extends out to the beginning of the existing steps leading up the slope—which are not, however, included in the plan. The distance to the slope amounts to a constant 5.50 meters. Only in the completed building does it increase to some ten or twelve meters—a distance that could no longer be paved with the available, precut slabs. There was nothing to prevent these from being used elsewhere, however, so that in the rear of the platform an additional connection to the office annex was possible (see Pl. 10.16).

Construction

Unfortunately, a number of important plans are missing that might have given us information about the kind and the arrangement of the foundations or the construction of the roof. We would have to make do with pure speculation were it not for the above-mentioned photographs that show the Pavilion during its various building phases (Illus. 38, 39).

The podium, they reveal, did not consist of a poured concrete slab as one might at first expect, but rather of an elaborate brick structure. The outer margins as well as the spots where the cruciform columns would stand were connected by rigid foundation walls. This framework was given additional strength by means of I-beams stretching from front to back with sections of barrel vaulting between them. The places where the vaults joined were filled with gravel to the rim of the foundation walls, creating an even surface that was then covered with travertine. With the exception of the outside walls of the annex, which were likewise built of brick and covered with plaster, all of the free-standing walls had an inner skeleton of iron framing, faced on either side with marble slabs of a thickness of three centimeters (Illus. 40). Only the narrower end pieces were solid stone the full 18 centimeter thickness of the wall, thereby forming smooth terminations.

The treatment of the roofs of the Pavilion remains unclear. Here as well a reinforced-concrete construction is out of the question. According to Mies's collaborator Ruegenberg, the iron framework was given a sheathing of simple boards above and below, which was sealed with tar paper to protect against the rain and covered with a layer of plaster on the underside.[66] For a building intended to stand but for a brief period of a few months this would of course have been sufficient. Nonetheless, the elaborate foundation work and the thickness of the beams appropriate to carry a considerably greater weight raise certain doubts about whether this was the solution originally planned. It is conceivable that the pressure of deadlines in the last weeks before the opening of the exposition,[67] possibly also a temporary lack of skilled workers at the final stage, might have forced the adoption of this makeshift solution. Further, we must not dismiss the possibility that it was thought that here, as in the office extension, certain savings could be made to offset the reduction in the budget imposed in the spring.

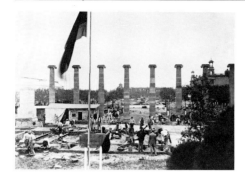

Illus. 38 Construction of the platform foundation.

Illus. 39 Erection of the steel frame.

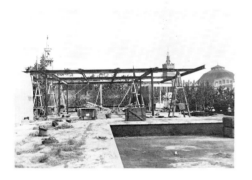

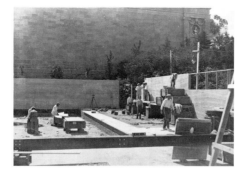

Illus. 40 Placement of the travertine slabs.

Illus. 41 The exposition grounds at night.

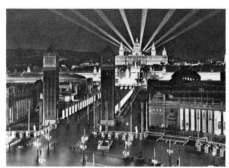

The Exposition Grounds

Barcelona is dominated to the southwest by Montjuich, a hill roughly 650 feet high, which rises directly above the harbor and the old city. The exposition grounds occupy its more gentle north slope, the one facing away from the sea (Illus. 42). Two concave arcs of colonnades lead up to the main entrance on the Plaza España, which is flanked on either side by two free-standing campaniles in the Venetian style. From this point a broad avenue leads straight back to the foot of a monumental flight of stairs, at the top of which the expansive domed complex of the National Palace stands dominating the entire area. Most of the large exhibition halls lie on either side of this central axis, as do the Palace of Alfonso XIII and its mirror-image counterpart named after the queen, each of which is made up of two structural blocks, one set lower and somewhat back from the other. Their offset placement lends weight to the crescendo of the flights of stairs and assists in preparing for the ultimate spatial finale of the National Palace. The strict axial disposition of the grounds, utterly indebted to beaux-arts traditions, appears at first glance to be perfectly conventional. To be sure, an open space placed asymmetrically to the left of the entry axis creates a clear relaxation of the scheme, but this effect is largely suspended by an excessive accumulation of smaller buildings and pavilions. Only the narrow perpendicular square in front of the stairs opposes the one-sided orientation toward the National Palace, thereby relieving the hierarchical structuring of the grounds of some of its rigidity. Its effect is further enhanced by the placement of the large fountain in the center of that square, for it prevents a straight-line approach to the palace without obstructing that goal from the visitor's view.

The whole conception, as well as the palaces named for Alfonso XIII and Victoria Eugenia, was the work of Puig y Cadafalch, who was surely Spain's most important architect in the years after the death of Antonio Gaudí.[68] For reasons that can no longer be discovered, Puig was not consulted in the planning of the other exhibition buildings. This aroused a certain amount of criticism, particularly from abroad, especially since the formal design of the other palaces was rejected even by more conservative observers. As far as the general outfitting of the exposition grounds is concerned, however, the lavish lighting mechanisms in the contemporary Art Deco style were received with general approbation (Illus. 41).[69]

61 Here, even more than the resemblance to the ground plan of Romanesque churches pointed out by Glaeser (*op. cit.*, note 58), an analogy to the open cella of the Hypaethros described by Vitruvius presents itself. (Vitruvius, *Zehn Bücher über die Architektur*, Darmstadt, 1976, p. 145.)

62 See note 22.

63 For example, in MoMA 15.51 — as well as in all of the publication plans.

64 Bier, *op. cit.* (note 15); Genzmer, *op. cit.* (note 1).

65 Bier, ibid.

66 Conversation with the author in December 1979.

67 See notes 24 and 25.

68 Interesting in this connection was the suggestion by John Macky, who confirmed that Puig was not entirely unknown even to the representatives of modern architecture: "Walter Gropius, who spent a few days with him just after the turn of the century, acknowledged Puig's influence when he embarked on his Werkbund-Bauhaus course." (*The Journal of the Society of Architectural Historians*, Vol. 38, No. 1, March 1979, pp. 47 f.)

69 For example, by von Schnitzler, *op. cit.* (note 15); Baeschlin, *op. cit.* (note 14); William Franklin Paris, "The Barcelona Exposition: A Splendid but Costly Effort of the Catalan People," *The Architectural Forum*, Vol. 51, No. 5, November 1929, pp. 481-96; K. W. Johansson, "Illuminating the Barcelona Exposition," *The Architectural Forum*, Vol. 52, No. 1, January 1930, pp. 135-39.

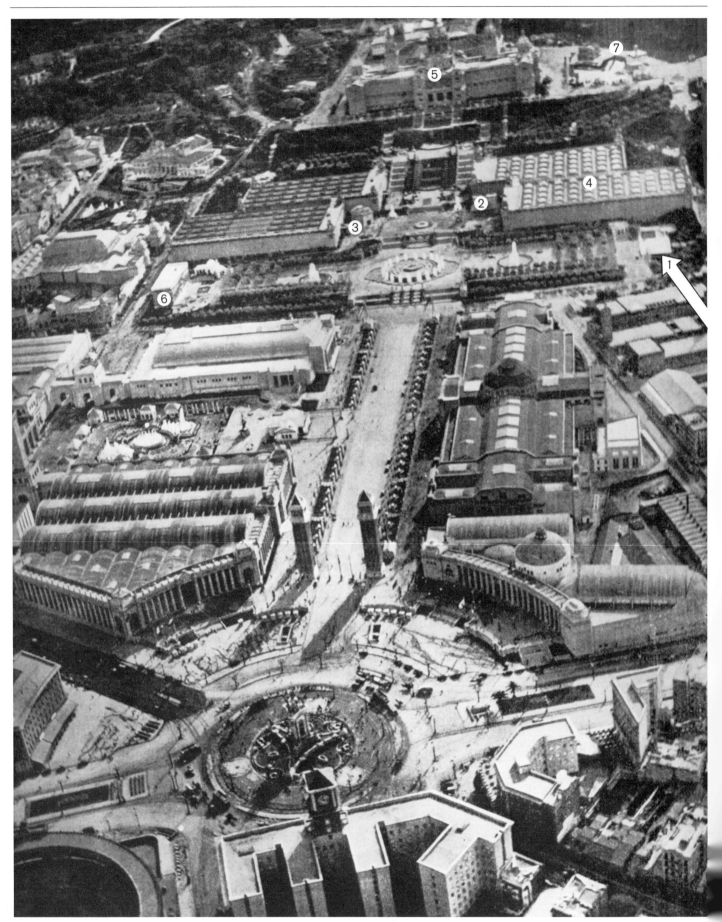

Illus. 42 Aerial view of the exposition grounds from the north: 1, Pavilion of the German Reich; 2, site originally set aside for the Pavilion; 3, the French Pavilion; 4, Alfonso XIII Palace; 5, National Palace; 6, Pavilion of the City of Barcelona; 7, location of the remaining national pavilions. The "Spanish Village" lies outside the frame of the photograph to the west of the German Pavilion.

The Siting of the Pavilion

Most of the national pavilions were located somewhat apart from the main traffic routes in the back portion of the grounds. One exception was the French Pavilion, which was set into the indented corner of the Victoria Eugenia Palace. This site was highly suited to the needs of the traffic, but aesthetically unsatisfactory, this impression being enhanced rather than softened by the pavilion's architecture.

According to Walther Genzmer, the corresponding spot in the indentation of the Alfonso XIII Palace was originally intended for the Reich's Pavilion.[70] But Mies declined this suggestion of the Spanish exposition committee for aesthetic reasons, and decided instead, with their agreement, on one of the narrow ends of the perpendicular axis. This was a plot in front of the long side wall of the above-named palace, closing the plaza in the form of a semicircle, but separated from it by a street. Its slope and a narrow strip on either side of its open, level area were at that time covered with dense shrubbery and small trees, which provided an effective frame for the Pavilion. The central axis of the plaza, which has been blocked by later building, was originally strongly underscored by the row of three large fountains and long rows of trees on either side. On either end, eight free-standing columns flanked by pylons further stressed its perpendicular orientation (see Illus. 38). This axis continued behind the Pavilion in the existing flight of stairs already frequently mentioned, creating a spatial tie to the "Spanish Village" that lay at the top of the slope, one of the main attractions of the exposition. These stairs also represented, in purely practical terms, a considerable shortcut, for the only other access to the village was by means of a winding road.

The site that was chosen offered a number of advantages over the one originally envisioned. In the first place, it was set apart from the general hustle and bustle, at some remove from the central thoroughfare. The danger of being overlooked because of the crowding of visual impressions was therefore avoided. One only needs to compare the blatant—but for all that extremely unfortunate—site of the French Pavilion. For most of the other national pavilions this disadvantage was not so apparent, but still they had to make do with relatively unfavorable terrain at the other end of the exposition grounds. And this meant that the concentration of visitors,

exhausted from their long trek—assuming that they even got that far without giving up and turning around—was often miserably low. By contrast, the German Pavilion provided an ideal resting place, where visitors could collect their strength before tackling the next attractions.[71] Moreover, thanks to its clever positioning as a focal point at the end of the perpendicular axis, it could be certain of being noticed. As a negotiable obstacle along the only direct route to the Spanish Village, it invited a casual stroll through its flowing spaces, and virtually forced visitors to respond to its architecture even at a nearly subliminal level. Both of these conditions, its position as a fixed resting place in the midst of the constant motion of the crowds and its function as a passageway at the focal point of the secondary axis, were certainly factors of central importance in the conception of the building. Without these two decisive preconditions it would be difficult to understand either its "open plan" or its complete lack of the traditional displays common in such buildings, a fact that critics generally regarded as a virtue.[72]

Considering all of the above, the Pavilion can be seen to have had an unquestionably advantageous position within the framework of the exposition. The fact that Barcelona, as the host city, erected its own pavilion at the opposite end of the plaza, directly across from it (Illus. 43), makes this exceedingly clear.

70 Genzmer, *op. cit.* (note 1), p. 1656.

71 Eduard Foertsch, "Die Weltausstellung in Barcelona," *Vossische Zeitung* (undated newspaper clipping from June or July 1929): "Virtually a refuge for anyone who feels oppressed by the buildings, towers, and fountains crowding in on each other helter-skelter and with great tumult at the entrance to the exposition!"

72 For example, Bier, *op. cit.* (note 15); Foertsch, *op. cit.* (note 71); Otto Völckers, "Der Pavillon des Deutschen Reiches auf der Ausstellung in Barcelona," *Stein Holz Eisen*, Vol. 43, No. 39, September 26, 1929, p. 609.

Illus. 43 View through the eastern row of columns toward the Pavilion of the City of Barcelona.

Problems of Relating the Pavilion to its Surroundings

When Mies was definitely given the commission for the design of the Pavilion in the second half of 1928, the overall plan of the exposition grounds was already fixed. The halls and building complexes to be built by the Spaniards were either already completed or in an advanced stage of construction. Any artistic influence from the foreign participants was therefore essentially out of the question, though as explained above there was a certain flexibility regarding the choice of a building site, which Mies clearly used to his advantage.

The advantages and disadvantages of the various possible solutions have been discussed in the preceding section. The lack of source material forbids setting up a definite hierarchy among the arguments in favor of the final choice. Yet there can be little doubt that in addition to practical considerations (lot size, advantageous location) Mies was above all governed by aesthetic decisions. In choosing the site he did, he had to deal with a spot that was already determined by a number of factors: visually, by its position at the end of the perpendicular plaza; architecturally, by the bordering Alfonso XIII Palace; and in terms of traffic, by the existing network of streets, especially the route to the Spanish Village, which ran straight across the parcel. Of the existing boundaries, clearly only the northern one was binding, for it appears as the sole constant in all the ground plans. Aside from that, the topographic situation of the site presented almost a natural frame for the Pavilion, thereby adding another factor that had to be considered in the planning.

Basically the architect has the freedom, of course, to ignore such factors to a degree—a plausible approach that in the present-day reaction against so-called "functionalism" in modern architecture is frequently disparaged and made the object of criticism. Wolfgang Pehnt summarized this widespread prejudice in a few trenchant sentences:[73]

"The Mies designs [here it is specifically the early projects to which he refers] make one difficulty quite apparent that would become crucial in modern architecture. They derive their whole air of self-assurance from being different, and being different in essential ways: the ideal versus the empirical, ubiquity versus localization. This style of archi-

tecture responds to its surroundings only negatively, only by rejecting them."

In this specific instance, however, such an approach would surely have had an adverse effect on the Pavilion, which, given its tremendous disadvantage in size, could scarcely have held its own in those surroundings—as the extremely unfortunate design of the French contribution to the exhibition clearly demonstrates. For similar reasons a neutral, passive concept for the Pavilion also appeared to be out of the question. Both points raise the question of why Mies —whichever approach he had in mind—decided to use precisely this tricky location. It would appear that he may have consciously selected a chance to wrestle with the specific conditions and limitations of the site, to confront them in the most positive sense—and indeed, as will be shown, by no means did this happen only in the case of the Barcelona Pavilion.

Although this aspect is not appreciated at all in the monographs that have appeared since 1945, a certain number of critics writing before that time considered it to be of relatively major importance. Walther Genzmer even went so far as to call the selection of the site "perhaps the most creative act of the architect," for, as he maintained, "it is the given situation…that essentially helped determine the whole form of the structure."[74] Genzmer, like Guido Harbers and Otto Völckers, emphasized the placement of the Pavilion in front of the long side wall of the Alfonso XIII Palace, which, with its large and virtually unbroken surface, provided an ideal backdrop for the smaller building.[75] Genzmer also approached the core of the problem with analytical deftness, stating that:[76]

"[It appears] virtually obvious that the main orientation of the Pavilion should be perpendicular to the palace wall, that in contrast to the considerable height of that wall the Pavilion should be quite low, and that in contrast to the calm unbroken surface of the wall it should be kept open and airy."

Harber's commentary in this connection was quite interesting, precisely with respect to comments being made today. It touched upon the problems of integrating new architecture, calling the Pavilion a "modern building in front of a traditional, conservative background." In closing, he stated: "We cannot see that—the proportional relation-

ships having been respected—the proximity of the two structures does not 'work.'"[77]

Comparable thinking is only rarely met with in writings on modern architecture in those years, and in no way constituted a programmatic component of architectural theory at the time. Even Mies van der Rohe's own sporadic statements dealt with completely different concerns. One could be led to suspect a certain amount of overinterpretation, were it not that concrete information contained in the recently discovered plans tends to confirm these isolated observations.

It is striking, for example, that in nearly all of the ground plans the exact distance from the adjacent Alfonso XIII Palace is indicated, and not only the distance to the end wall of the Pavilion, but to the center of the platform as well (Pl. 10.4). The exact relationship of the podium to the stairway at the back of the site, also indicated in each case, requires no further mention, for it has been discussed already in detail. It lay directly centered along the continuation of the middle axis of the plaza in front of the building, which is suggested in each drawing by a line of greater or lesser prominence. This line divides the wall of vert antique running perpendicular to it—certainly not pure coincidence—precisely into the proportions of the Golden Section.[78] In the two early plans this is further stressed by the placement of a piece of sculpture on the side of the wall facing the garden, while a third statue in the southern part of the platform is oriented along another visual axis running parallel to the street. The manner in which the Pavilion was nestled into the dense growth of shrubbery and trees on the site, clearly indicated in the first design, led, finally, to a close union of architecture and "landscape." The Pavilion thereby no longer appears to be a foreign object, but an integral part of its natural, that is to say largely untouched, preexistent surroundings.

The existence of a connection between the structure and its context has thus been demonstrated, yet the question of the specific quality of this relationship requires some clarification. To provide this, a detailed analysis of the architecture itself is necessary.

Toward a Reinterpretation of the Pavilion

The Pavilion was erected above a foundation sheathed in square slabs of travertine (Pls. 10.8, 10.9). This platform rose along the front to a height of 1.20 meters above the level of the street, and was therefore clearly perceived as a podium. The walls rising above it on that side were set back from the front edge of the platform by the width of one grid unit, so that the podium appeared as an independent, three-dimensional solid. At the narrower ends of the building, however, the foundation abruptly ended; the walls rose directly up from the ground with no transition of any kind. To be sure, the podium did not end at the point where the front wall surfaces did, but was continued far enough around each of the corners to produce an effective tie between the lower structure and the upper one. The slightly rising terrain approaching the slope behind the building was built up to the height of the platform. In this way an area was created level with the garden that was outlined by a double row of semicircular hedge at the foot of the slope (Pl. 10.16, Illus. 44).

For the relationship between the structure and the exterior space, the foundation proved to be of decisive importance. In its specific character, thanks to its considerable height and its blocklike massiveness, it was reminiscent of the podium of a Roman temple. As a result of the abrupt transition between the horizontal and vertical surfaces, as well as the hidden placement of the stairs when viewed from the plaza, its effect was even stronger than that of its Roman prototype. The building thus appeared to be set apart, separated from the earth on which it stood. Instead, it rested on the podium as though on an independent base, a relationship expressed above all in the quadratic network of lines on the platform. But this network was not, as has been frequently assumed, to be thought of as some kind of module that provided a binding measurement for the proportions and the arrangement of the walls and supports. Rather it stood for a geometric, but by no means "cosmic" system, providing a place of order in the face of the countless arbitrary details of the site—a system which can, however, adapt itself to the individual architectural situation wherever necessary.

The impression of the building's inaccessibility and remoteness is enhanced by the fact that the platform could only be approached by turning toward its northern edge. (By contrast, Mies arrived at a very

Illus. 44 The Pavilion as seen from the roof of the adjacent palace.

different solution in the cases of the plaza of the Seagram Building and the terrace of the National Gallery in Berlin.) The completely open design of the building stood in direct contradiction to this monumental barrier that was the podium (Pls. 10.10, 10.11). The wide opening of the building itself, only truly appreciated visually, thus completely contradicted the initial impression of remoteness and inaccessibility suggested by the podium.

At the narrow ends, however, this relationship was reversed. There the Pavilion was firmly anchored in the ground, appearing from without as a compact, closed solid. The shrubbery reaching clear up to the end walls strengthened the impression of the building's being rooted to the ground. Moreover, flower boxes planted with vines were set along the top edge of the south-end wall, and in time these vines ranged luxuriously down along the flat surfaces (Illus. 44, Pls. 10.16, 10.20).[79] Nature here extended almost symbolically onto the structure itself, causing the boundaries to blur even further. A similar effect was created on the north side because of the natural structure of the marble, the coloring of which was matched in the outer layer of plaster. The dark green veining of the Tinos marble blended visually with the surrounding cypresses and conifers, appearing to be the architectural crystalization of their organic forms (Pl. 10.17, Illus. 36). In the surviving photographs this is particularly apparent from the way in which the plants on the shadowed north side can scarcely be distinguished from the wall (Pl. 10.9).[80] The placement of the steps in the indentation of the podium must also be interpreted in connection with this particular point. Although the approach to the platform was located on the street side of the Pavilion, it could only be seen from the north. Toward the east, where the central axis of the plaza

73 Wolfgang Pehnt, "Architektur," *Deutsche Kunst der 20er und 30er Jahre*, Erich Steingräber, ed., Munich 1979, p. 45.

74 Genzmer, *op. cit.* (note 1), p. 1656.

75 Genzmer, ibid.; Harbers, *op. cit.* (note 15), p. 422.
 Baeschlin, on the other hand (*op. cit.*, note 14), began his criticism with precisely this point.

76 Genzmer, ibid.

77 Harbers, *op. cit.* (note 15), p. 422.

78 This is the only place in the Pavilion where a geometrical principle has obviously been applied.

79 The photographs of the Pavilion were obviously taken at different times, for in the later ones the vines have already grown significantly.

80 The original is clearer on this point than the copy, since a certain loss of depth in the process of duplication is virtually unavoidable.

represented the prime point of view, it was screened by the projecting side wall that was formed by a continuation of the front edge of the podium. Approach to the building was thus accomplished at a diagonal, along an ideal middle line between the two so different sides, which had to present itself as the only possible solution. The staircase thereby came to be placed precisely in the border zone between the north flank, "tugged to the earth" but completely closed off, and the wide-open front of the building, which yet appeared to have no direct access. At the same time the foundation, breaking off just around the corner, modifies the motif of the podium, decreasing its importance and hierarchical prominence and making it seem less of a barrier. The approach led along the closed Tinos wall, and with each step one came to see more of the outside terrace and the large pool, while the immediately adjacent wall of clear glass provided a first glance into the interior of the Pavilion. The step-by-step unfolding of the structure prevented a premature deviation from the path by increasingly attracting the visitor's attention.

The only side of which one can speak with a certain justification of a continuous transition between interior and exterior space was the back of the Pavilion (Pls. 10.16, 10.21). Here the platform ended at a level with the built-up garden area. The offset placement of the free-standing wall elements and the resulting multitude of views to the outside and along the length of the building would seem to make any clear division line impossible. Nonetheless, the concept of "open space" should only be used here with considerable reservations: the wall sections all ran longitudinally, and with the exception of the open middle axis they were placed quite close to the edge of the platform. In this way they completely screened the interior of the Pavilion from the garden. Narrow, perpendicular passageways on the front and back sides formed the only access, and could be closed off at night by means of glass doors that were removed during the day (Pls. 10.8, 10.20).[81] As the arrangement of the seating area in front of the onyx wall reveals, the real center of the building was moreover oriented to the front. The garden itself, with its semicircular boundary of hedges, focused on the Pavilion as well, and was spatially confined by the adjacent slope to the west. Comparable in this regard to the separated areas of the later Court Houses designs, it functioned more as an open extension be-

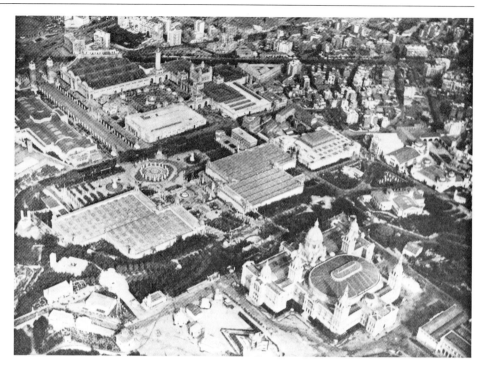

Illus. 45 Aerial view of the exposition grounds from the south.

longing to the Pavilion than as a section of unlimited exterior space.

The preceding analysis permits a return to the question of the connection existing between the Pavilion and its surroundings that had already been largely stamped architecturally and in terms of landscape as part of the overall concept of the exposition.

At the beginning it was pointed out how the central axis of the plaza affected the building's specific spatial situation. The long rectangular shape of the plaza alone created such an axis, which was stressed even further by its arrangement of fountains and plantings (Illus. 45, cf. Illus. 43). In addition to the three large fountains, one must recall the eight free-standing columns flanked by pylons at each end of the plaza. These were anticipated by four parallel rows of trees on either end, branching off from the allée plantings along the sides and leaving a narrow corridor down the center. The axis that resulted, virtually concentrated like a ray of light, pointed directly toward the flight of steps leading up to the Spanish Village behind the Pavilion, and served as a means of visual orientation within the exposition grounds; it is thus both a visual axis and one to be walked along. Both of these aspects were incorporated in different ways into the conception of the Pavilion. Mies placed the building across this access like a barrier, but without interrupting it completely. The one-sided opening to the east created a new focus, assuming the function previously filled by the semicircular exten-

sion of the plaza. In the process a number of clear shifts occurred: the axis first struck the perpendicular wall of vert antique, and was thereby diverted toward the south, where its momentum was checked by the walls enclosing the area behind the large pool (Pls. 10.8, 10.9). At the same time, a reversal of one's glance was suggested by the stone bench in front of the back connecting wall. The same applied for the roofed central area with its large panes of plate glass on the right (Pl. 10.18), though it was not open to the outside to the same degree. The Pavilion was accordingly no longer an object to look at, but had become itself the point of origin of a system of axial relationships.

The passage axis, at first identical with the visual one, was treated in a completely different way, maintaining the actual direction of movement. The visitor walking along this axis was confronted with the podium-like foundation of the Pavilion, which from this angle first appeared to be a barrier (hence the impression of detachment and remoteness in the frontal view). The asymmetrical grouping of the open and closed secondary spaces along with the likewise asymmetrical alignment of the wall elements suggested the possibility of passing through the building; however, the approach to the platform hidden behind the side wall of the stairs, correctly suspected to lie within the indentation of the foundation, only became visible after one had taken a few steps to the north and thereby abandoned

the axis. The 180-degree turn required as one approached the stairs provided a first clue that the distant goal could in fact be reached. On the platform itself further movement along the direction of the axis was largely impossible. Only after changing directions a number of times could one finally leave the Pavilion on the garden side, by which time even the least interested of viewers could scarcely have remained untouched by the charm of the architecture.

The manifold interrelationships between the structure and its context have by no means been exhausted in this discussion. It must be noted that the relationships just described are basically a direct analogy to the arrangement of the plaza stretching out in front of the Pavilion. The plaza also acted as a perpendicular barrier across the main axis leading from the entrance on the Plaza España toward the monumental steps and the National Palace (Illus. 46, cf. Illus. 42 and 45). Somewhat like the podium of the Pavilion, the plaza is raised a few steps above the level of the street. And as with the wall of vert antique in the Pavilion, it blocks the direct approach to the staircase with the large oval pool located at its center. Just as the Pavilion was firmly gripped by the walls at its narrow ends, the plaza is clearly terminated on either end by means of the tree alignment and the placement of the columns, though here of course through passage is permitted. Thus one cannot dismiss the likelihood that in his design for the Pavilion Mies took some inspiration from the exposition plans developed by Puig y Cadafalch.

The manner in which the structure was related to a given context does not mean, however, that it was completely subordinated to the existing scheme. The Pavilion's separateness and integrity with respect to its organized surroundings remain unques-

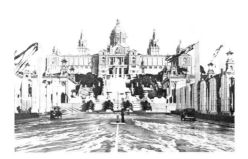

Illus. 46 Lower part of the staircase at the intersection of the two main axes.

tioned, and were clearly expressed in the development of its street front. The structure and its context entered into a fruitful confrontation that was to their mutual advantage. The rather halfhearted attempt to sell the Pavilion in toto and reconstruct it elsewhere—obviously supported by Mies only for the sake of form[82]—suggests that he believed that such a move would have preserved in fact only a fragment of his original concept.

The "ubiquity" of modern architecture therefore proves to be—at least as far as Mies is concerned, less so with regard to his countless followers—all in all a misreading. Bolstered by such generalized expressions as "International Style,"[83] by Sigfried Giedion's rather superficial attempts at interpretation,[84] and by Hans Sedlmayr's rudimentary, though incomparably more substantial criticism,[85] it proves to be a myth, perpetuated either consciously or unconsciously, that deserves once and for all to be banned from architectural history. In the case of Frank Lloyd Wright the inaccuracy of this thesis surely needs no further discussion. No doubt it would be rewarding to subject the work of Le Corbusier and Walter Gropius to a more detailed analysis along the lines here presented.

81 Ruegenberg claimed to remember that the doors were completely removed after the opening of the exposition, but that seems highly unlikely.

82 Lilly Reich to von Kettler, November 8, 1929; MoMA: "Mies is going to contact Herr Köstner [the supplier] with regard to the resale of the Pavilion's materials. We will let you know what comes of this. Generally speaking, Mies always did feel that it would be best to sell it back to him." See also note 28.

83 Henry-Russell Hitchcock and Philip Johnson, *The International Style: Architecture Since 1922*, New York, 1932. To be sure, this criticism does not apply for the "second phase" of modern architecture, which basically was begun with the publication of the book, and where this concept is by all means somewhat justified.

84 Sigfried Giedion, *Space, Time and Architecture: The Growth of a New Tradition*, Cambridge, Mass., 1941. Without wishing to question the importance of this first comprehensive study of the modern movement from the point of view of architectural history, let me also point out—regarding the analytical value of that work—the cautious judgment of Peter Collins (*Changing Ideals in Modern Architecture: 1750–1950*, London, 1967 [1965], especially pp. 287 f.)

85 Hans Sedlmayr, *Verlust der Mitte: Die bildende Kunst des 19. und 20. Jahrhunderts als Symptom der Zeit*, Salzburg, 1948; idem, *Die Revolution der Modernen Kunst*, Hamburg, 1955.

The Tugendhat House in Brno, Czechoslovakia, is the only larger residence that Mies was able to construct after 1929.[1] In spite of some serious changes in detail—to mention only the most obvious examples, the semicircular wall of Macassar ebony has been removed, the single-paned large window openings have mostly been replaced with multi-paned ones, and the passage in the upper story has been walled up—it has survived the war and the years of German occupation, still another sequestration after the arrival of the Red Army, and the strains naturally resulting from having been used for purposes for which it was not intended (a problem even as yet unsolved).[2] Persistent efforts to restore it to its original condition have been made since the early sixties, the city of Brno from time to time considering its possible use as a guest house and cultural center.[3] Some such plans seemed within reach when it was officially taken over by the city in February 1969, but have so far failed to materialize for want of the necessary funds.[4] We can only hope that the plan will not be totally abandoned, and that a satisfactory solution can be found in the near future. There is a certain urgency to it, not only so as to preserve in a form as close as possible to its original state Mies's last surviving work from this important phase,[5] but to protect one of the key works of modern architecture, a building that provided decisive stimuli to a whole generation of architects.

The basic requirements for a renovation could not be more favorable, since The Museum of Modern Art preserves among Mies's papers a nearly complete set of construction plans—including everything from detail drawings to specifications for ceiling fixtures and switch plates. By contrast, the earlier stages in the development of the house are documented only by the charcoal drawings here reproduced (Pls 11.2–11.5) and several alternative designs for the arrangement of the facade dating from April 1929 (Pls 11.10–11.13). The general outline and the disposition of volumes in these correspond to a great extent to the final version, but they reveal some considerable discrepancies in the formal arrangement. Hundreds of sketches by Mies van der Rohe himself that his onetime co-worker Hirz remembers have obviously been lost.[6] These small sheets, on which he gradually developed his ideas, could have provided valuable information about the course of the planning process. If one can easily get the impression that there was no direct connection between the projects in Barcelona and Brno and the Lange and Esters houses that were then under construction in Krefeld, or even that they are separated by a break in his development, it is largely owing to the loss of these preparatory sketches for the basic conception.

A reconstruction of the history of the building of the house proves equally difficult, for unlike the Tugendhat drawings, the correspondence was not placed in storage during the war, and since then is presumed to have been lost. In this connection a lecture given by Grete Tugendhat in January 1969 at an architectural conference in Brno has been extremely helpful, and it is from this—unless otherwise noted—that the following dates have been derived.[7]

According to her, she must have first met Mies as early as the summer of 1928, probably through the Berlin collector and art historian Eduard Fuchs. Fuchs was at that time living in the Perls House, which Mies had built around 1911, and the future Frau Tugendhat was a frequent guest there while she was in Berlin. Fuchs also commissioned Mies to design a gallery addition to his residence in 1928, and it was he who had secured for him the contract for the monument to Liebknecht and Luxemburg in 1926.[8] One can readily assume that he would also have recommended Mies in this instance, as soon as he learned of his friend's intention to build. The reason for her plans was her impending marriage to Fritz Tugendhat. As a wedding present, her parents in Brno had offered the engaged couple as a building site the upper portion of their own land lying between Parkstrasse and Schwarzfeldgasse.[9]

During the first meeting Mies showed them his early, epoch-making projects. There followed visits to three of Mies's completed buildings, of which Frau Tugendhat still remembered especially the Wolf House in Guben, which had greatly impressed her and her husband.[10] Thus both of them had quite a good idea what they might expect from their choice of an architect. Mies later was to maintain that at first they saw in him the builder of that neoclassical villa from 1911 (the Perls House), and that it took all of his powers of persuasion to win them over gradually to his plans; there may be a residue of truth in his claim, but all in all he was surely exaggerating.[11]

In emulation of the Wolf House, they first discussed building the one in Brno in brick as well.[12] But in that part of Moravia there was no tradition of building in that

1 While none of the larger projects, such as the Nolde, Gericke, Ulrich Lange, Hubbe, and Resor houses was brought to completion, the Lemcke House, built in 1932, was a much more modest commission (illus. in Philip Johnson, *Mies van der Rohe*, 3rd rev. ed., New York, 1978, p. 110). Only the Farnsworth House, completed in 1951, which certainly does not compare with the unrealized designs of the thirties either in terms of size or number of rooms, brought to an end the unbroken series of disappointments of the previous two decades that Mies had had to accept with regard to his private commissions.

2 See in this regard Julius Posener, "Eine Reise nach Brünn," *Bauwelt*, Vol. 60, No. 36, 1969, pp. 1244 f. See also Frantisek Kalivoda, "Haus Tugendhat gestern—heute—morgen," ibid., p. 1248 f. Important in this connection too is the article by Anna Zádor, "An Early Masterpiece by Mies van der Rohe," *New Hungarian Quarterly*, Vol. 10, Summer 1969, pp. 172-75. This last was graciously pointed out to me by Alfred Willis in New York.

3 Kalivoda, *op. cit.* (note 2), p. 1249.

4 A brief report on the desolate condition of the house today is given in a letter to the editor by Christoph Hillejan, "Sonntagshaus," *Häuser*, Vol. 2, No. 1, 1981, p. 150.

5 After the dismantling of the Barcelona Pavilion and the model house in Berlin, both of which existed only for the duration of their respective exhibitions, the Tugendhat House would become the only surviving structure from Mies's early maturity. The Lemcke House, which also survives, is better grouped stylistically with works from a later period.

6 Tape of an interview by Ludwig Glaeser, September 9, 1974; MoMA. The few surviving sketches more or less reflect the ultimate solution—which leads us to assume that they were made while the house was under construction or even possibly only after the completion of the house.

7 Copy of the manuscript in the Mies van der Rohe Archive, MoMA. Reproduced with a few trivial cuts in Grete Tugendhat, "Zum Bau des Hauses Tugendhat," *Bauwelt, loc. cit.* (note 2), pp. 1246 f.

8 Fuchs to Mies, March 24, 1926; MoMA (correspondence regarding the Liebknecht-Luxemburg monument).

9 All in all, this appears to be considerably more believable than the claim that the entire house was received by the newlyweds as a wedding present—as stated by George Nelson, "Architects of Europe Today. 7—Van der Rohe, Germany," *Pencil Points*, Vol. 16, No. 9, September 1935, pp. 453-60.

material and therefore neither experienced bricklayers nor facing bricks of sufficient quality were available, so Mies soon abandoned this idea. In September 1928 he was invited to take a trip to Czechoslovakia, which gave him an opportunity to familiarize himself with the specific characteristics of the terrain. At the end of October his co-worker Hermann John made a similar trip,[13] which may well have been for the purpose of surveying. In the Lange/Esters correspondence there is an indication that John made a second trip to Brno, "in order to finish the house there" (obviously it is the plans for the house that are meant.)[14] That document is undated, but on the basis of its position in the sequence of the file it must come from December 1928. Possibly there is here a direct connection with the note "send John," which appears in Mies's handwriting on the lower margin of an early drawing.[15] In any case, the first designs were completed by the close of the year; the discussion of them scheduled for the afternoon of New Year's Eve went on far into the night. That date permits us a rough chronological placement for the views and perspectives done in charcoal, which have the character of presentation drawings of the kind submitted to clients in similar cases for their decision.

Presumably the Tugendhats' answer was by and large positive, for after a few minor changes, construction was begun in June 1929.[16] Frau Tugendhat's description permits us to see the relative importance Mies gave to the individual aspects of his design, and therefore it deserves to be quoted at length:[17]

"The plan pleased us very much. We requested only three things of Mies, all of which he agreed to.

First, the steel columns on the upper story, in the bedrooms that is, were not to be free-standing, as he had planned, but were to be placed inside the walls, for we were afraid that in those small spaces one would bump into them. Second, the bathroom that was planned to open into our two bedrooms, so that our rooms would form a single undivided space—as was later done in the House at the Berlin Building Exposition —was to be set apart and made accessible from a small hall. Third, all of the windows were to be given adequate shades, for we feared that otherwise the rooms would get too hot in summer.

As I said, Mies accepted all of these requests without objection. When, however, during a later discussion my husband raised an objection about the fact that all of the doors were to extend clear to the ceiling, having been convinced by so-called experts that such doors would easily warp, Mies retorted: 'Then I won't build.' Here an essential principle of the structure had been put into question, and in such a case he wouldn't budge."

The above-mentioned alternative designs for the street and garden facades (Pls. 11.10-11.13) testify to a construction start near the beginning of the summer, for they were all made during the first half of April, and according to their legends were intended for submission to the local building commission for approval. A single note from the firm of Köstner & Gottschalk—placed in the wrong file—with which Mies had dealt for years, and which was to deliver, as in Barcelona, the free-standing onyx wall, gives us an impression of the state of construction in September 1929:[18]

"To my regret I have just learned that the block of onyx doré that I wanted to have saved for me in Wandsbek so you would have a chance to see it has meanwhile been sold.

It had been offered, as I discovered too late, to another project. But I have specified that another, larger block be ordered, and am waiting to hear about it. Since the situation itself is not yet all that urgent, and the block in question was a bit too narrow, no harm has been done."

From this point until the final completion of the house a full fourteen more months would pass. Finally, a year and a half after the beginning of construction, even the interior work had advanced far enough so that the clients were able to move in at the beginning of December 1930.[19]

The site at 45 Schwarzfeldgasse, on a ridge on the north side of the city, offers an unobstructed view of Brno and the Schlossberg, which rises opposite above the valley floor. Views and light conditions were therefore as favorable as one might wish, and in the orientation and disposition of the ground plan Mies took full advantage of them.[20] The topographical situation of the site, however, proved to be problematical, for it falls off sharply to the south. A broad, spreading complex like those in the early country house projects was therefore out of the question from the start. Instead, he

10 Frau Tugendhat only mentioned the Wolf House, which she described as the most recently built structure. The other houses she visited were not named in her lecture. The Krefeld buildings obviously could not have been among them, for excavation work on both of them was begun only in October 1928. Accordingly it would seem that the Urbig, Kempner, or Mosler houses are the prime candidates.

11 This claim is found in the previously mentioned article by G. Nelson, *op. cit.* (note 9), which was based on a personal conversation with Mies. To what degree Nelson may have taken these remarks out of context and "enriched" them with additions of his own is an open question.

12 G. Tugendhat, *op. cit.* (note 7).

13 Hermann John to Ernst Walther, Jr. (the supervisor of construction on the Lange and Esters houses in Krefeld), October 24, 1928; MoMA (Lange/Esters correspondence): "Nothing came of the trip to England. Instead, I'm now going off to Brno."

14 Kaiser (Mies van der Rohe's office) to Walther, Jr., undated (presumably December 1928); MoMA (Lange/Esters correspondence).

15 MoMA: Inv. no. 2.328 (Pl. 11.4, barely recognizable in the lower left).

16 G. Tugendhat, *op. cit.* (note 7).

17 Ibid.

18 Köstner to Mies, September 19, 1929; MoMA (Barcelona correspondence).

19 G. Tugendhat, *op. cit.* (note 7); shortened in the published version, thus appearing only in manuscript (MoMA).

20 Cf. the quite similar situation of the Wolf House (Chap. 6).

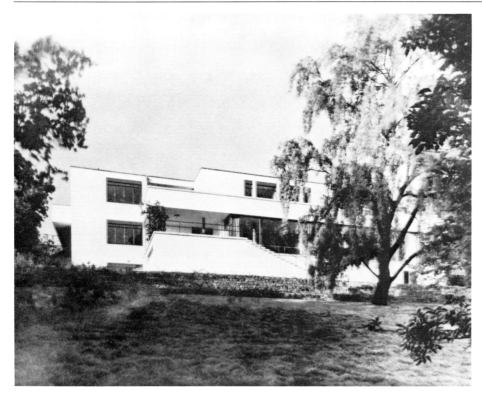

Illus. 47 Tugendhat House, view from the garden.

Illus. 48 Tugendhat House, entry hall looking toward the end wall of the children's room.

here developed a compact, two-story structure whose back partially cuts into the slope or at least closely hugs it (Pl. 11.6, cf. Illus. 49). The main floor, which does not rise above the level of the street, is therefore not visible at first. The visitor approaching from the north sees only the upper part of the structure (Pls. 11.16, 11.20).

Thus one enters directly onto the roof terrace, which on the street side extends out onto a forecourt created by fill (Pl. 11.18). The garage projects forward to the edge of this forecourt and closes it off on the right side, while to the left the building is set back a few meters and the ground drops, creating a small front yard. The garage has been combined with an adjacent chauffeur's apartment into a separate rectangular structure, which with the exception of an inconspicuous side door (Pl. 11.20) has no connection to the terrace. The chauffeur's apartment is reached by means of an open, cantilevered gallery running from the street along its west side, and its windows—excepting the single large one on the south side—open out onto this approach (Pl. 11.14, Illus. 47). This tract, lying perpendicular to the overall structure, appears to be completely set off by itself, and stands out in the ground plan in sharp contrast to the remaining and more complex portions of the upper story. Between the two wings stretches a covered passageway some five or six meters wide, leading to the forward edge of the platform, and

framing one's view of the castle on the other side of the valley (Pl. 11.22).

The southeast wing of the upper story measures roughly twice the size of the garage area, thus occupying easily half of the total area of the floor. Ignoring the entry hall projecting from the side, it is exclusively restricted to the Tugendhats' private rooms (Pl. 11.18). The bedrooms and baths are grouped into two rectangular blocks, this time with their broad sides facing the street and thus parallel to the axis of the main floor. Beginning from the northeast corner, they retreat stepwise toward the center of the platform, while at the same time they seem to separate from each other more and more, ultimately being connected only by the vestibule and their common roof. The outside suite of rooms comprises a guest room or maid's room, bath and drying room, and a corridor which is closed off from the entry hall and provides access to the adjacent children's rooms. These in turn are aligned so as to form a long block, the narrow end of which projects deeply into the entry hall area. At this point, however, in contradiction to the plan, the projecting end is not massively enclosed but set off with a paneled wall of cupboards (Illus. 48). On the north side of the entry space there is a narrow strip extending toward the east to meet the above-mentioned corridor.

On the northeast corner of the building the upper structure still follows the outline

of the main floor, to which it is firmly tied, with no indication of the division between floors. In the case of the parents' suite, likewise including a small anteroom and bath, this is no longer the case, for it stands back somewhat from the surrounding parapet as a separate structure on the upper platform. Stretching between two rows of iron supports (placed in the walls), it has no visible structural connection to the lower floor, appearing to hover independently above it (Pl. 11.31). A small passageway, through which one can step out onto the front part of the terrace directly from the entry hall, sets these bedrooms off from the children's suite, emphasizing the independence of the two areas while at the same time connecting them. On either end of the passageway is a door, the outer one glass,[21] the inner one wood to match the paneling of the entry, so that one need not be seen from the entry hall when passing from one suite to the other. With the exception of the guest room, which is the only one to face east, all of these upper rooms are oriented toward the south. Moreover, each has its own access to the terrace. The windows themselves are largely conventional in design, giving the upper structures a closed wall-like character. This impression is further stressed by the arrangement of the street front, which presents a closed surface broken only by a narrow strip of high windows (Pl. 11.20).

This, in turn, makes the entry hall stand

out even more strikingly (Pl. 11.21). Here, in place of walls, one finds tall rectangular panes of translucent glass that describe a semicircle around the inside staircase, behind the curve of which the main entry is concealed. In contrast to the unifying linoleum floors of the rest of the rooms, the entry hall is paved with slabs of travertine corresponding to the outside terrace. But there is a slight difference in level between the vestibule and the covered forecourt, marked on the outside by an extending base strip below the glass, that widens to a step in front of the entry (Pl. 11.21).[22] The unifying travertine flooring and the outside walls completely of glass show the entry hall to be a transition zone between inside and out—a motif we have seen in earlier projects of Mies van der Rohe's, though in different form. Inside, this ambiguity is expressed by its being largely sealed off from the closed bedroom suites, as is quite apparent from the floor plan. In the completed structure, however, this contrast may have been less striking, inasmuch as the massive wall elements are clearly set off from the wood paneling, and therefore make the boundaries of the space less well defined (see Illus. 48).

The massive, slightly projecting chimney block, which forms a sharply contrasting accent against the horizontal gutter line of the flat roof, serves at the same time to set off the entry hall from the adjoining wing. Set perpendicularly, like the garage wing, it breaks the line of the front of the building and leads the eye, as does the garage, into the building. The portion of the building flanked by these elements appears almost broken up into segments that are held together solely by the overriding roof slab that clamps the individual sections of the upper story firmly to one another. The front half of the slab rests on two cruciform columns encased in bronze, one of which stands by itself on the outside terrace, the other forming the pivot around which the inside staircase turns (Pl. 11.23). At some distance behind these there runs a closed wall that forces the visitor approaching from the forecourt to turn to the side. One might be tempted to decide instead on the open passageway to the right, but the way is blocked by an iron railing (Pl. 11.22). Thus one necessarily turns to the left, following the curve projecting from the vestibule, and is led into a funnel-shaped outside entry and up to the front door.

Like the living area, which will be discussed later, the arrangement of the up-

Illus. 49 Tugendhat House under construction, erection of the system of supports.

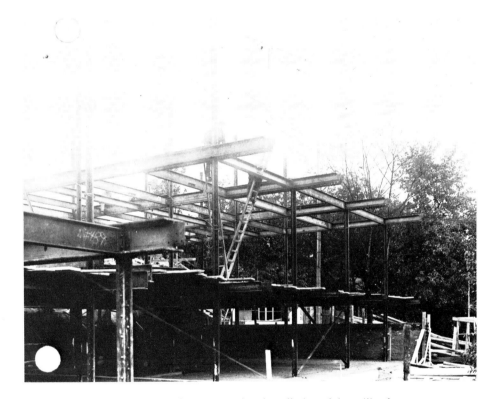

Illus. 50 Tugendhat House under construction, installation of the ceiling beams.

21 The only picture of this portion of the terrace I know, in which the glass door can be seen, is in W. Bisome, "Villa arch. Mies van der Rohe," *Mêsíc*, June 1932, pp. 2-7, illus. p. 2, bottom.

22 Correspondingly, steps have been placed before the bedrooms' terrace doors. See picture in Walter Riezler, "Das Haus Tugendhat in Brünn," *Die Form*, Vol. 6, No. 9, September 15, 1931, pp. 321-32, illus. p. 327, bottom.

per story constitutes an important part of Mies's overall concept. Deliberately avoiding axial alignment and precise correspondences, the structural blocks, either parallel or at right angles to each other, are fitted into a precisely calculated geometrical pattern seemingly oriented to the grid of the platform, but in reality primarily determined by the points in a system of columns established for structural reasons (Illus. 49, 50).[23] In spite of the asymmetrical deployment of masses, a balanced configuration is produced, in which each of the individual elements, carefully attuned to each of the others, is given its clearly defined and unalterable location. Even the slightest change would result in a noticeable disruption of the harmonic balance. In its calculation, the composition of the upper floor plan is reminiscent of the linear play of walls in the Brick Country House (Pl. 3.2)—with the important distinction that here, in place of those walls, are whole volumes, and the whole takes on almost sculptural dimensions. Thus it is ultimately space itself that becomes the dominant aspect, to which columns and walls are subordinated as merely the elements defining it:[24]

"What gives the building its quality is the proportions, and proportions don't cost anything. For the most part it is the proportions between things; it is not even the things themselves."

The graphic representation and the actual look of the structures of the Brick Country House and the Tugendhat House, are certainly anything but identical. The floor scheme, built up additively out of freestanding wall elements or autonomous spatial units, is immediately apparent in the abstract reproduction, but it is only perceived successively, if at all, in reality. Because of the necessarily limited angle of vision afforded and the resulting overlapping, the structures on the upper story of the Tugendhat House merge considerably more than one would think from the plan, appearing to interlock with each other.

One is justified in the assumption that this obvious discrepancy between the design and the finished structure is by no means accidental, but was intended by Mies from the start. The ground plans presumably prepared by Philip Johnson for the New York exhibition of 1932 (Illus. 51, 52) show unequivocally that the publication plans (Pls. 11.18, 11.19) represented an "adjusted" version, in which accuracy in the

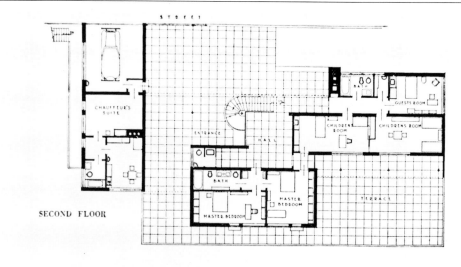

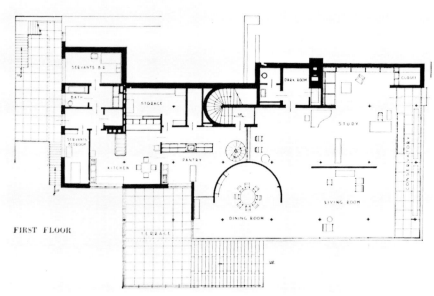

Illus. 51, 52 Tugendhat House, floor plans of the main and upper floors, as constructed.

representation was at least partially sacrificed in the interest of its effect as a drawing. This is particularly apparent in one critical area already discussed in detail, namely the division between the vestibule and the children's room. While Mies's plan presents a massive corner for the room, forming a blocklike intrusion into the space of the entry hall, Johnson correctly represents only the wall line running parallel to the street in full wall width, the considerably thinner west wall with its wood paneling connecting with it with a slight setback. The photograph (Illus. 48) clearly shows how this influences the spatial impression. Thus this difference, given what was said above—especially if compared with the opposite situation on the exterior of the parents' area (Pl. 11.22)—needs no further discussion.

The reason for these discrepancies appears to be relatively simple: to be able to communicate the principle of space presented above ("the proportions between things") as the actual basic design motif even in the medium of a two-dimensional drawing, Mies had to set off the individual areas from their surroundings in the form of clearly marked "cells." (Compare, on the other hand, the ground plan of the Brick Country House, where an appreciation of the indicated space is possible almost solely in an intellectual way.) But that also means that in order to show the relationships between the various spatial units he had to fall back on a manner of representation whose three-dimensional equivalent (that is, a traditional structure made up of a configuration of solid forms) had already been superseded in practice.

The spatial focus of the house is without question the living area, which takes up roughly two-thirds of the lower level and is reached directly from the entry hall by means of the winding staircase. The south side facing the garden is composed entirely of glass the full height of the room and across its entire width. Two of its large glass panes can be lowered completely into the ground (Pl. 11.28, Illus. 53). The eastern side comprises a narrow winter garden enclosed on either side by glass walls (Pl. 11.30). At the opposite end of the room one can exit through an outside glass door to the lower terrace (Pls. 11.8, 11.31), from which a wide staircase leads down along the wall of the house to the garden.

Here, several elements appear to be an almost direct imitation of Le Corbusier's Villa Stein in Garches, which had already been completed in 1927 (Illus. 54, cf. Illus. 47): the terrace cuts deeply into the body of the structure while projecting beyond the garden facade, the parapet of the upper platform runs straight across above the terrace as a narrow strip of wall, and the stairs are positioned in front of a continuous band of windows on the main floor. (These similarities are even more obvious in one of the preliminary designs, Pl. 11.13.) Walter Hirz, Mies van der Rohe's construction supervisor in Brno, recalls how shocked Mies was when this was pointed out to him.[25] For all of the correspondences between the two buildings, however, it must be remembered that the scheme—the arrangement of living room, covered terrace, and outside steps—had already appeared in principle in the Concrete Country House and the Barcelona Pavilion. The basic affinity revealed by this coincidence makes it plain why precisely this structure of Le Corbusier's should have influenced Mies van der Rohe, even if unconsciously.

The main floor of the Tugendhat House is comprised of a loose succession of spaces opening into one another. In addition to the regular grid of chrome-plated columns,[26] a wall of Macassar wood that encloses the dining area in its arc of slightly more than a half circle (Pl. 11.29), and an onyx wall extending behind the seating area serve to further define these spaces. Unlike its predecessor in the Barcelona Pavilion, this marble wall is made up of five solid vertical slabs only eight centimeters thick, with the veining of the sections symmetrically mirrored as much as possible (Pl. 11.26). Thus the pattern in the third and fourth panels (counting from the left), against which the

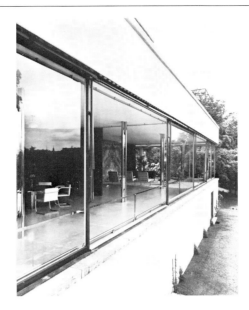

Illus. 53 View from the lower terrace on the garden side of the living room.

seating area is centered, suggests a curved, pointed arch, lending added distinction to an area that is already of major importance. Herr Tugendhat's desk stands behind the onyx wall (Pls. 11.25, 11.26), and beyond that lies a library set off by slightly projecting walls on either side.[27] Between the half-circle of the dining area and the lower landing of the staircase extends a broad pane of translucent glass illuminated from behind.

23 The bearing function of the steel skeleton is expressed only in the main floor, though even there the mirroring effect of the chrome covering tends to obscure its structural significance. On the upper floor the supports were largely relegated to the walls, however, at the clients' special request. See G. Tugendhat, *op. cit.* (note 7).

As in the Barcelona Pavilion, the individual bays in the Tugendhat House are not precise squares, but slightly elongated ones.

24 Interview by Detlef Schreiber and Peter C. von Seidlein with Mies van der Rohe, selections published in *Der Architeckt*, Vol. 15, No. 10, October 1966, p. 324.

25 Interview Glaeser/Hirz, *op. cit.* (note 6).

26 Naturally this applies only to the sheathing, while the inside consisted of four angle irons bolted together in the shape of a cross. The edges of the columns are more rounded than in the Barcelona Pavilion. Moreover, by using a bayonet system, in which the separate pieces of the sheathing interlock, screws were completely eliminated on the outside, allowing a smooth surface that enhanced the mirror effect.

27 A view of the back part of the room is to be found in Riezler, *op. cit.* (note 22), illus. p. 331 (top).

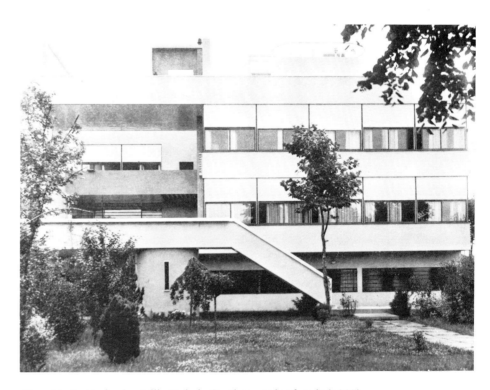

Illus. 54 Le Corbusier: Villa Stein in Garches, garden facade (1927).

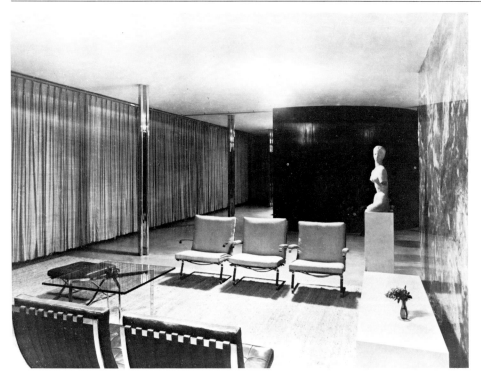

Illus. 55 Tugendhat House, living room at night.

In front of it stand a small smoking table and four Brno chairs (Pl. 11.24). Finally, mention must be made of the grand piano placed in the rear of the room.[28]

Individual areas can be closed off if necessary by draperies running on tracks, reintroducing the traditional concept of separate rooms without disrupting the unity of the space. At night, when the black, reflecting glass walls might well give an impression of emptiness and disorientation, additional curtains can be drawn along the garden front (Illus. 55).

With its workroom and library, winter garden, and its dining, music, and smoking areas, the inventory of rooms in the Tugendhat House corresponds in every respect to that of an upper-middle-class villa at the close of the nineteenth century. The furnishings, considering the elegance and diversity of materials (in addition to the ebony, chrome, and onyx, there were emerald green leather, ruby red velvet, and white vellum for the stools and chairs, black velvet and black and silver gray silk for the curtains),[29] far exceed the demands of pure and sober utility. Still one hardly has the impression of "preciousness," of "ostentation" and "excessive display," that Justus Bier felt to be a subliminal effect of the whole.[30] It is far more appropriate to speak, as did Walter Riezler, of a certain "luxury,"[31] but not in the sense of a desire to impose with a display of wealth. Rather what is

meant by "luxury" is a life style that is refined to the smallest detail, one primarily concerned with the maximum satisfaction of aesthetic needs, and which takes the greatest pleasure from "perfection in the design of every component as well as the use of precious materials."[32]

"No one can deny the impression [in the Tugendhat House] of a particular spirituality of a high degree dominating these spaces, a spirituality, to be sure, of a quite new kind. It is very much 'tied to the present,' and is therefore utterly different from the spirit dominating spaces of any earlier epoch. It is already the 'Spirit of Technology'—not in the sense of that narrow-minded practicality that is so frequently deplored, but in the sense of a new freedom in living."[33]

The Tugendhat House is, as Riezler suggested, as remote from the pomp and preciousness of the villa of the late nineteenth century as from the homey coziness of the "English Country House" which took its place around the turn of the century.[34] Needs had changed, to be sure, but the only social stratum capable of meeting them on such a scale had remained largely unchanged. Riezler's attempt to see the new spatial feeling here emerging "in the sense of the creation of a new humanity that derives from an utterly new spirit, one that

no longer focuses on the self-sufficient individual personality as did the previous European spirit, but rather causes the individual to be absorbed again into the general course of the world" thus seems overly ambitious. Riezler himself appears to have become aware of the shaky foundation upon which he was basing this euphoric pronouncement, for he immediately set about qualifying it: "This is not to say that precisely this present project, namely the creation of a single residence for a high-spirited personality, is the very project that can best demonstrate the new spiritual ideas. *Possibly, on the contrary, this project has been still somewhat determined by the sense of the epoch now approaching its end.* But," Riezler continued, "that is less important than the proof it provides that it is indeed possible to elevate oneself above the purely rational and functional thinking that has characterized modern architecture heretofore and into the realm of the spiritual."[35]

Mies van der Rohe himself had said, not long before: "We have to establish new values, show ultimate objectives, in order to obtain standards. For creating conditions conducive to the existence of the spirit is the one and only objective and right of every epoch, and so it is for the new one as well."[36]

Riezler regarded the living room as "a space that has neither an immediately comprehensible basic shape nor definite boundaries . . . (in which everything structural and at rest is subordinate) to the dynamism of these partial spaces flowing into each other, *the rhythm of which is only resolved outside, where it is absorbed in the infinite space of nature."[37] His interpretation contradicts a central concern of this investigation, which attempts to demonstrate, among other things, that Mies—however open and integrated into the landscape as his buildings may be—always ultimately managed to give a space its own formal identity and independence.[38] But rather than attempt a detailed analysis, I would like to quote what the inhabitants of the house themselves had to say, especially in the sections that I have emphasized.[39]

28 Illus. in Zádor, *op. cit.* (note 2), opposite p. 173.

29 G. Tugendhat, *op. cit.* (note 7).

30 B. [Justus Bier], "Kann man im Haus Tugendhat wohnen?" *Die Form*, Vol. 6, No. 10, October 15, 1931, pp. 392 f.

31 W. Riezler, *op. cit.* (note 22), pp. 324 f.

32 Ibid., p. 325.

33 Ibid.

34 Walter Riezler in response to Justus Bier, *loc. cit.* (note 30), pp. 393 f., here above all p. 394.

35 W. Riezler, *op. cit.* (note 22), p. 332 (italics mine).

36 Ludwig Mies van der Rohe, "Die neue Zeit," (from a lecture at the Werkbund conference in Vienna in 1930), *Die Form*, Vol. 7, No. 10, October 15, 1932, p. 306.

37 W. Riezler, *op. cit.* (note 22), p. 328 (italics mine).

38 See especially the section "A New Approach to Space" in Chap. 3 (Brick Country House).

39 Taken from *Die Form*, Vol. 6, No. 11, November 15, 1931, pp. 437 f.

See also the closing judgment of Ludwig Hilberseimer (*loc. cit.*, pp. 438 f., here p. 439), who determines: "The individual spaces are not closed off, but none the less are clearly determined — thanks to their general arrangement and their individual proportions." And further: "The paramount thing is, however, that this sequence of spaces, in spite of being open on all sides, in spite of the large surfaces of plate glass, does not appear to be open, but a completely closed room."

What the People Who Lived in the Tugendhat House Had to Say About It

In his answer to the question "Is it possible to live in the Tugendhat House?" Herr Riezler replies that the inhabitants are the ones who should comment. I really do feel a need to do so. I would like to preface my statement with the admission that I too am of the opinion that a private house is not the best and most proper place for the formation of Mies's spatial ideas, for the reason that true art—and that is what is intended in Mies's architecture, as opposed to craftsmanship—has never been created and cannot be created for the individual. But that does not have a lot to do with the question of whether it is possible to live in our house. For though Herr Bier thinks that Mies ought to be given projects that "engage his ability, which is worthy of the highest tasks of architecture, in the proper place, namely where it is intended to build a home for the spirit, and not where the necessity of living, sleeping, and eating requires a quieter, more muted idiom," it is precisely this that is the essence of Mies's work—that is, doing justice to the primarily spiritual sense of life of each and every one of us as opposed to mere necessity. To what degree this is proper and possible for everyone in a home, and not "where it is intended to build a home for the spirit," is a social question that Herr Mies cannot resolve. The crux of Herr Bier's criticism appears to me to be the claim that the preciousness of these rooms forces a kind of living for show, and suppresses intimate living. Whether or not it is because I have been "deadened"—as Herr Riezler thinks—I have in any case never thought of these spaces as being precious, but rather as being austere and grand—not in a way that oppresses, but one that liberates.

This austerity forbids merely passing time by "relaxing" and letting oneself go—and it is precisely this being forced to something else that today's people, exhausted and drained by their professional work, require and sense as a liberation. For just as one sees each flower in this room in quite an uncommon way, and every piece of art seems more expressive (for example, a piece of sculpture standing in front of the onyx wall), so too a person appears, both to himself and to others, to be more clearly set off from his surroundings. It is absolutely not the case that these spaces—as Herr Bier thinks—are completely finished,

and that one must be cautious lest anything at all be changed. As long as one does not disturb the arrangement of the whole, changes, we have discovered, are perfectly possible. *The rhythm of the space is so strong that small changes remain inessential. And as for the rhythm, I cannot agree with Herr Riezler when he says that it "is only resolved outside, where it is absorbed in the infinite space of nature." Though the connection between inside and outside is indeed important, the space is nonetheless entirely enclosed and self-sufficient; in this sense the glass wall functions completely as a boundary. If it were otherwise, I myself feel that one would have a sense of restlessness and exposure. But as it is, the space has—precisely because of its rhythm—a most uncommon restfulness such as a closed room cannot possibly have.*

As for its practicality, we too were dubious during the planning that the separation of the dining room would be adequate. As it turns out we have never noticed the smell of food. The velvet curtain sufficiently shuts off the dining room so that even the sounds of setting and clearing the table are not disturbing. And as for the possibility of isolating activities, I must admit that this question can only be answered later, when the children are grown; for the moment we have found that when there are guests or we are having a large party it is quite possible to separate individual groups sufficiently, so that they do not disturb each other any more than is customary.

We are counting, of course, on the fact that later the upper rooms, which were not furnished as mere bedrooms in the first place, will also partially serve as living rooms. We are very happy living in this house, so happy that we find it difficult to think of taking a trip, and we feel liberated when we come back from confining rooms into our large, restful spaces once again.

Grete Tugendhat

"Is it possible to live in the Tugendhat House?" This question, whether justified or not, can certainly be answered only by its inhabitants.

Herr B. makes the wrong assumptions when he suggests that we simply gave "an" architect "a" commission to build, and that Herr Mies van der Rohe could then create the "prototype of a dwelling" without any restrictions.

The truth of the matter is that among a number of illustrations of building projects we came upon some by the architect Mies van der Rohe, and since we knew more or less that we were looking for lightness, airiness, clarity, and honesty, we went to Herr Mies, and after knowing him only a short time gave him the commission. A commission that was precisely circumscribed with regard to the style of life we wished to lead.

Our wishes were fulfilled to such an extent that I often imagine that I had visualized exactly this house even before it was constructed—and yet this house is a "pure solution." That seems to me the greatest art of the architect.

Herr Bier, who presumably only knows the house from a few two-dimensional photographs—which can only give a quite inadequate impression of the work—Herr B. speaks only of the large main space, without recognizing that it is after all a part of the entire organism of the house. The inadequate delineation of this main space is criticized, as is its being "only open" to the outside and lacking a closed-off workroom, and the terms "ostentation and living on exhibition" are used.

The last statement is especially astonishing and a totally new concept for the occupants.

The individual "places" of the main room can be adequately transformed into "closed rooms" by heavy draperies; also it is quite possible, certainly in the library, to completely shut oneself off from the outside space of nature if one so desires – though I myself prefer the distant horizon to the restricting pressure of close walls when I am concentrating. Different groups at a party do not disturb each other more than they do in houses that are broken up into rooms. Is it really essential that the "man of the house" have a closed-off workroom? For my part I attach great importance to the fact that I do not have any workroom in this, my home; I leave my working place, just as I leave my professional self, outside—a luxury, admittedly. Moreover, the "gentleman's bed-room" can just as well be used as a work-room without one's being accused of living in "straitened circumstances." After nearly a year of living here I can absolutely attest to the fact that technically the house has everything that modern man could possibly wish. In winter the house is easier to heat than a house with thick walls and small double windows. Thanks to the floor-to-ceiling glass wall and the high placement of the house the sun shines deep into the room. In clear freezing weather we can lower the panes and sit in the warm sun and look out at the snow-covered landscape just as though we were in Davos. In the summer the sunshades and electric air conditioning provide comfortable temperatures.

The smell of food from the semicircular dining area has never been noticeable. If it were necessary to air the space, it could be accomplished in only a few seconds by opening up the glass wall. At night the glass walls are covered by light silk curtains, which prevent them from being mirrors. It is true that one cannot hang any pictures in the main space, in the same way that one cannot introduce a piece of furniture that would destroy the stylistic unity of the original furnishings—but is our "personal life repressed" for that reason? The incomparable patterning of the marble and the natural graining of the wood do not take the place of art, but they do participate in the art, in the space, which is here art. Moreover, "art" is permitted to take on a special importance in the form of a noble sculpture by Lehmbruck, just as our personal lives do—more freely than ever. And when I study the leaves and flowers that stand out like gleaming solitaires against the appropriate backgrounds, when I allow these spaces and all that is in them to affect me as a whole, then I have the clear impression: this is beauty, this is truth. Truth—one can have different notions about what that may mean, but everyone who sees these spaces sooner or later comes to recognize that here is true art.

For this we are indebted to Herr Mies van der Rohe.

Fritz Tugendhat

On July 6, 1929, Emil Nolde wrote to Hans Fehr: "We have to give up our beautiful idea of building; in so doing we are burying an ideal, but nonetheless I cannot let it go completely."[1]

Behind these brief words of the famous German painter to a Swiss friend lies the disappointment over the collapse of building plans that he had nourished for a long time, and on which he had obviously pinned his highest hopes. And therewith the realization of still another project of Mies van der Rohe's was to be denied. After his brief success in the second half of the twenties, this circumstance was to be the beginning of a long chain of disappointments that was broken only after Mies had firmly established himself in the United States. Caused in part by economic difficulties as a result of the worldwide crisis, and then aggravated after 1933 by the reactionary cultural politics of the National Socialist leaders, this development was symptomatic of the fate of modern architecture, of the decline of the modern movement in Germany. By the end of 1938 Mies found himself in a situation from which emigration offered the only escape. But nine years earlier there had been little cause for worry. The commission in Barcelona had just been carried out with success, and had brought the hoped-for recognition. Work on the Tugendhat House was proceeding apace, and promised to keep the studio, now once again reduced to the original staff, occupied for months.[2]

From the surviving correspondence it is not entirely clear what finally moved Nolde to withdraw the building application already submitted. It can scarcely have been essential differences of opinion about the building itself, inasmuch as Nolde speaks of an ideal in his letter, doubtless referring to Mies's design. Rather, it is likely that financial considerations were decisive here as well.

But what had preceded this note to Fehr? Before Mies became involved, Nolde had commissioned Edmund Schueler, an architect he had known for some time, to work up a design. His plans must have been completed by the beginning of 1928, but as early as the middle of that year Nolde had pulled back from this proposal.[3] Contact with Mies was presumably made through the dancer Mary Wigman, who could well have arranged for the commission thanks to her friendly relations with Nolde and his wife. Before the First World War she had studied eurythmics with Ada Mies, at that time still Ada Bruhn, in Dresden-Hellerau under Jaques-Dalcroze. Because of this they became close friends, and later that friendship was extended to include Mies. Although he had lived apart from his wife since the beginning of the twenties, the contact with Mary Wigman was preserved, and she often lived in his studio when she was in Berlin. In any case, Mies cannot have been entirely unknown to Nolde, who would have at least heard his name.

The first direct exchange of ideas between the two must have come by January 1929 at the latest. A telegram from the 24th of that month has survived, in which Nolde pressed Mies for an answer.[4] A letter from April 10 is more informative:[5]

"Our concern that the house will not be completed by the prescribed date is now so great that we are unfortunately forced to write you as follows:

You recognize that if we cannot move into the house by September 15 we will be obligated to pay a gains tax of 9,000 marks. If we are unable to get the finished drawing for the surveyor's office by Saturday the 13th, and you do not give me a guarantee by the same date that we will be able to move into the house by September 15, 1929 — whereby I am allowing for two weeks beyond the deadline you promised, namely the end of August — I must conclude that you are not in a position to keep to the promise, as indicated above, that you have repeatedly made me. I would then be forced, unfortunately, to do without your services. This would disappoint me most especially, for I value you highly as an artist."

To all appearances, however, the assignment was completed just in time. Among the drawings for the Nolde House were two sheets containing elevations of the four sides of the house, showing the project in virtually its final stage (Pls. 12.4, 12.5). They are dated April 13, 1929, and in the lower right corner of each appears the customary legend, from which we may presume that they were intended for submission to the local building authorities.

In an addendum to the building application dated April 15 Mies requested that the office grant a special approval, for his design called for considerably more square footage than that permitted for the site. As a counterconcession, Nolde was prepared to guarantee that he would never add an additional story on top of the single-story house as planned.[6] Later in the same month

1 The letter, to which Dr. Martin Urban graciously referred me, is in the archives of the "Seebüll — Ada and Emil Nolde Foundation."

2 In connection with the extensive preparatory work for the German sections at the Barcelona International Exposition of 1929, of which Mies was the artistic director, a branch office (Am Karlsbad 26a) had been established in Berlin. Even in Barcelona as many as twelve employees were engaged, while the number of his co-workers was normally between two and four.

3 Pointed out by Dr. Urban.

4 Telegram from Nolde to Mies, January 24, 1929; MoMA.

5 Nolde to Mies, April 10, 1929; MoMA.

6 Mies to the local building authorities in Zehlendorf, April 19, 1929; MoMA.

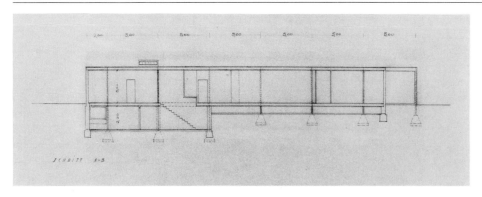

Illus. 56 East-west cross section (dated April 13, 1929).

Illus. 57 Construction drawing, detail (dated April 28, 1929).

a structural engineer was engaged to provide the necessary calculations.[7] Minor difficulties obviously arose in connection with the legal distance required from the adjacent lot to the west, on which there was an existing structure quite close to the boundary. In a second site plan, therefore, the ground plan has been shifted half a meter to the east, with the result that this side ends up shorter by precisely the same amount. Apart from this, however, there were no further changes.[8]

But in the course of the next few weeks something developed that would jeopardize the realization of the plans once and for all. On June 8, Mies requested the building authorities not to proceed any further with the application. The letter, signed by one of Mies's co-workers, reads as follows: "Herewith we request that you ignore the

building application submitted on April 15th last, since the client does not intend to build at this time."[9] The letter from Nolde to Fehr was written a month later.

The site was an irregular, roughly trapezoidal corner lot in Berlin-Zehlendorf, the same one for which Edmund Schueler had already prepared a design. It comprised a total of a scant 1,600 square meters, and was bounded on the south and east by two streets, Am Erlenbusch and Sachs-Allee.

Detailed information about the project as Mies planned it, beyond that which is contained in the drawings themselves, is given in the explanatory report accompanying the building application. According to it, the house was to be a flat, one-story building with a partial cellar and with exterior walls of stucco. In construction it was to consist of a steel skeleton with wall sec-

tions built up of masonry—a method already utilized in the nineteenth century[10] and ultimately derived from the method of half-timbering. Mies had first used it in his apartment block in the Weissenhof Settlement in Stuttgart in 1927. In the present instance the supports, each with its own foundation, follow a square grid with a module of five meters (Illus. 56). In the secondary areas there are smaller bays of only two meters on a side, thus permitting greater flexibility in the floor-plan arrangement. The vertical beams are braced below the floor with crossed struts, and firmly held at the top by the iron roof framework, which also included crossbracing (Illus. 57, cf. Illus. 50). Inside the space itself, however, some of them are completely free-standing, and even where they are not visible because of connecting walls there would have been no need for lateral struts. This structural method made it possible, above all, for an arrangement of interior spaces and a disposition of the outside shell that are to a great extent independent of the bearing elements. Both had already been attempted six years before in the Concrete Country House. But Mies's decisive step had only been taken in the Barcelona Pavilion, which was under construction at the very moment (spring 1929) that the plans for the Nolde House were being developed. While the Barcelona Pavilion was an attempt to realize visible separation of supports and walls throughout, here this is achieved only in the living and studio areas. In all of the other rooms the steel skeleton remains hidden inside the walls. This also applies to the exterior, which was to be painted over the flat stucco surface. After bids had been received from several contractors, a rough cost breakdown was put together in the studio.[11] According to this estimate the price of the completed house without interior furnishings was expected to run to a total of 99,833 Reichsmarks, which must have been close to the limit established by the client.

In the Nolde House, as well, Mies did not employ a geometrical scheme from the start; he began to develop the grid—just as in the Barcelona Pavilion—only after planning had reached an advanced stage. The sequence of the most important planning phases can be recreated approximately with the help of the surviving drawings.

The earliest version of the ground plan (Pl. 12.1) still shows a relatively disorganized conglomeration of rooms, giving the structure a comparatively restless and some-

what unbalanced outline broken up by a number of indentations. The steel skeleton is not even suggested, though judging from the thinness of the walls it was assumed even here. The isolated columns appearing in the version immediately following (Pl. 12.2) show beginnings in this direction, to be sure, but without submitting to an overall scheme. At the same time, in the north-facing housekeeping area the considerably freer interior arrangement of the preceding version gives way already to a more closed grouping of rooms.

Only in the third version (Pl. 12.3) does the skeleton system come fully into its own, with which the ground plan gains a marked amount of clarity thanks to the simplification of its outline and a more rigid arrangement of spaces occasioned by the regular placement of the supports. The two elevation drawings from April 13, 1929, mentioned above, reveal only minor differences in the arrangement of windows. These can be explained on the one hand by the fact that the wall projection had to be adapted to the placement of the outer row of supports. In one case, namely that of the window of the caretaker's apartment in the northwest corner of the building, the pillar would have fallen within the opening, which might have given rise to difficulties in the fitting of the window frame. But the real reason for the change in plans seems to have been a desire for a unified set of measurements. In contrast to the previous solution, the individual windows now can be divided into either two or three panes of uniform size throughout, which is surely an economic advantage. Since this alteration could be made without influencing the structural elements of the house, the preparation of an additional ground plan might have seemed unnecessary—in any case, none has survived.

Taking these discrepancies into consideration, the third version thus largely corresponds to the ultimate one as it is given in the schematic projection drawings of the two site plans. The revision at the beginning of May 1929 was to all appearances occasioned by the need to shift the entire complex an additional fifty centimeters away from the western boundary of the lot. It is limited to the decrease on the east side already mentioned—a change that was of no particular consequence for the total layout of the building.

The core of the house is comprised of a long and relatively narrow structure that widens by steps to the southeast. The housekeeping area that branches off to the north seems to be strongly set off from the main structure, distinguished as it is by a more conventional wall and window arrangement. To be sure, the windows here as well rise clear up to the underside of the roof slab without any actual lintel, but they only begin at chest height throughout, while all of the other wall openings extend to the floor.

Because of the placement of the building, the rest of the lot is divided into two unequal portions: a garden area facing south and a courtyard or forecourt accessible from Sachs-Allee on the north, which is bounded on its west side by the projecting housekeeping wing. The two open spaces are joined at the edges by narrow strips of ground that could not be built on because of the setback restrictions in force. The main entrance is located in an indentation at the angle between the two wings, which comprise an L-shaped configuration. Completely glassed, it extends for the width of a full bay and is set back by two meters. It is not entirely clear from the drawings whether the porch thus created is open toward the courtyard or protected by a second wall of glass. The visitor then enters a spacious vestibule, where he can be received by the staff, which has direct access from the kitchen. On his left, and again only separated by a glass wall, he can see a large hall of more than a hundred square meters that can presumably be shut off by means of curtains or may even be totally open to the foyer. This view is by no means unexpected, however, for the hall can be seen from the porch. In contrast to this, the passageway into the living room, likewise furnished with a glass door, is concealed between the overlapping ends of two offset walls that block the view to the south. As in the Concrete Country House, Mies was concerned with making a clear visual separation, in spite of all of the openness of the floor plan, between the various degrees of privacy within the house.

A second glass entry at the end of the north wing leads into a corridor connecting two maids' rooms on one side and a small one-bedroom apartment for the caretaker and his wife on the other. This corridor runs directly toward the kitchen, which occupies, as befits its function, the transition zone between the two parts of the building. At this same point, though separated by a pantry or storeroom and two wall cupboards set back to back, there is another room that can only be reached from

7 Confirmation of contract from structural engineer Salomonsen to Mies, April 23, 1929; MoMA.

8 The two site plans prepared by the state surveyor Jaquin are dated April 22 and May 7, 1929 (Nolde correspondence; MoMA).

9 John (Mies's co-worker) to the Zehlendorf building authorities, June 8, 1929; MoMA.

10 See, for example, the Menier Chocolate Factory in Noisel-sur-Marne (1871-72) by Jules Saulnier, illus. in Sigfried Giedion, *Space, Time and Architecture*, 5th ed., Cambridge, Mass., 1966, p. 205.

11 Nolde correspondence; MoMA (undated).

the central part of the building. Judging from the indication of a bed, this could well be the guest room that is specifically labeled in one of the earlier plans. Given its connections to the dressing room and to the Noldes' adjacent bedroom, it could as well be used by one of them from time to time.

The unlabeled room here tentatively designated as a pantry or storeroom between the kitchen and the guest room lies at the upper end of a wider hallway that represents the central connection between the individual functional areas of the house. The bedrooms are reached from this hallway. Across from them is the bathroom door, and to the left of it the stairway down to the cellar. This hallway offers the shortest route from the kitchen to the dining room, which in turn opens into the adjacent living room, separated from it only by a free-standing wall element. The living room, extending for fifteen meters across three full bays and completely oriented to the south, is the actual core of the layout. Parallel to its large-paned glass wall facing the garden is a second wall of glass enclosing a long, narrow space suitable for houseplants or some such vegetation. As a variation on the basic form of the winter garden this solution has two advantages. On the one hand, it offers a certain amount of protection against being seen from the street without unnecessarily limiting the view from inside out. At the same time it forms a kind of buffer zone, a circumscribed artificial "landscape" placed between the interior and exterior space, and serving as a transparent green setting for the living area.

As a result of the repeated breaks in the back wall, the depth of the living area decreases by steps toward the east. The spaces between the offset wall lines that project deep into the room are closed off with glass and in part with solid partition walls, but in each case they are characterized as transition zones. They lead, in turn, to the vestibule, to Nolde's studio, and out onto a projecting covered terrace. Entering the studio, one first passes through a small room separated by two doors, possibly intended to serve as storage for the painter's records, but which in addition to its basic function provides a noise barrier between the studio and the living areas.

The placement of the interior walls corresponds to the threefold setback of the south side of the house, which thereby appears to turn toward the afternoon sun while by and large retaining its clear orientation to

the south. Aside from the housekeeping wing, the only window to the west is in the portion of the living room that is set off as a dining area, and it is obscured from the living room itself by the free-standing partition. The plantings indicated in the elevation drawings are by no means mere decoration, for they provide an additional screen against the neighboring lot, one that also limits views into the bedroom diagonally opposite. The entire north side of the house is closed with the exception of the two entrances. The same applies to the eastern part of the central area, though because of the setback required by the lot boundary a further south-facing window could have been included. This represents the only direct outside opening into the large hall behind it, which suggests that it would doubtless have had insufficient light. More especially, the adjacent studio, which is basically only a nichelike extension of the main room, would have been in utter darkness. The additional daylight entering from the vestibule would scarcely have been adequate to improve the situation satisfactorily. Given the particular requirements of Nolde's work as a painter, a reliance on artificial light must also be dismissed, especially since the room was intended as both exhibition space and studio. Accordingly, only a skylight would appear to solve the problem, a device frequently encountered in comparable structures. The advantages of such a solution cannot be easily dismissed. On the one hand, it is possible to install the ceiling openings in such a way that direct rays of sunlight are avoided as much as possible, though the northern location would have guaranteed that already. More important, therefore, is a further argument that has to do, once again, with the function of the space as an exhibition hall. Since under the circumstances windows in the ordinary sense were not desirable, the walls could be continued without interruption. This, in turn, created additional wall surface needed for hanging pictures.

In spite of a number of things that justify some kind of a skylight, there is no concrete suggestion of one in the surviving plans. There is no question, nonetheless, that even the earliest version of the ground-plan (Pl. 12.1) was based on the idea. The central position of the hall, surrounded on all sides by rooms, precludes any other possibility of natural illumination. It remains unclear, of course, whether the indication in the middle of the hall might be read as a skylight. It could just as well suggest a kind

of elevator with which larger paintings could be lowered to or brought up from a storeroom located in the cellar. (A similar arrangement was originally planned for the Lange House.) On the basis of the dates available we can say that the span of development of the Nolde project occupied almost the whole of the period from January to May 1929. Thus it falls in a period when the Tugendhat House was also undergoing all of its decisive planning stages. Both buildings immediately follow the Barcelona Pavilion, the planning of which took place largely in the previous year. And it is true that there are striking similarities to the Pavilion in the interiors of the two structures: the bearing steel skeleton reduced to a grid of isolated supports, the staggered sequence of wall segments that divide the space as free-standing elements, the chrome-covered cruciform columns—all of these had been developed in Barcelona first. The only real advance that would serve as the basis for a chronological arrangement of the projects is of a purely technical nature, and solely affects the foundation level, therefore lying, so to speak, below the surface. The regular network of vertical beams braced with diagonals up to the level of the cellar ceiling represents a considerable improvement compared to the more costly and in some respects retrograde foundation construction of the Barcelona Pavilion.

External differences are therefore all the more surprising. The deeply projecting roof slab, a motif that is a major element in the image of the Pavilion, is almost wholly missing in the later projects. By the same token, the broad opening of the structure to the outside space has been abandoned in favor of a rather dense arrangement intended to give the effect of mass. In spite of all the glass surfaces, the impression of blockiness once more predominates—an impression that generated a seeming contradiction between the interior arrangement and the exterior perspective in the Brick Country House. Though surely the uniqueness of the Barcelona Pavilion was based on its special character as an exhibition building, the differences between the two dwellings, which are likewise by no means minor ones, can be explained to a large degree by their completely different topographical situations, each requiring appropriate solutions. The lot that Nolde had purchased permitted a spreading ground plan branching out in all directions, one in which all of the functional areas could be arranged on a single level. In Brno, however, the uncom-

monly steep slope of the property necessitated a more compact structure expanding on an east-west axis exclusively. Appropriately, the side facing the valley here ends up being two stories high, the lower floor cutting deep into the hillside, so that the living space and the bedroom area are no longer side by side but one on top of the other. On the surface, therefore, the southern elevations of the two houses provide little basis for comparison. All the more emphatic, on the other hand, is the close similarity of the two structures as revealed by the entry side of the Tugendhat House facing into the slope. If one compares the facade designs from the 6th or the 16th of April, 1929 (Pls. 11.10, 11.12)—slightly altered later, to be sure—and the elevations of the Berlin project made at almost the very same time, it is impossible to have any further doubts about the direct relationship between them. All of this suggests that the break represented by the commissions in Barcelona and Brno is by no means so clearly marked as has been generally assumed. On the contrary, the drawings for the Nolde House, long believed to have been lost, contain a whole series of signs that permit us to recognize a more continuous development in the work of Mies van der Rohe. The relationship with the Brick Country House of five years earlier is quite obvious in the radiating wall lines of the preliminary designs, just as the somewhat later version (Pl. 12.2), with its noticeable centering around an asymmetrical point of gravity, ultimately refers to another characteristic of the brick design. Although in the case of the radiating wall lines we cannot discount the achieved effect of an interlocking between the structure and the surrounding space, this particular version of the ground plan confirms an assumption already expressed earlier, which saw something more of a practical function behind the walls projecting well out into the yard.[12] It is significant that the wall that here bends at a right angle and then runs along the boundary serves primarily as a screen, completely closing off the west flank of the building from the adjoining property. Thus it is basically a means to an end, a necessity first and a design element second, guaranteeing the occupants' privacy. Without this protective provision, the wide opening in the bedroom wall, lying right next to the property line as it does, would be scarcely conceivable. But this same feature reveals that the significance of the radiating walls is by no means limited to the task of serving as a barrier, however important this aspect might have been originally. For, as a logical consequence, a narrow interior courtyard is here created, one enclosed on two sides and functioning as an outside extension of the adjacent room. The segment of wall extended without break into the interior ties the two areas together again, giving added weight to the impression of spatial continuity between them. Since the window fills the full width of the room and thus does not appear to be something "cut out" of the wall in the traditional sense, it is felt to be not so much a caesura as a transparent membrane presenting no obstruction at all to the eye. The exterior enclosure and not the window thus establishes the boundary of the room. And it is only this exterior wall that provides a limit and resting place for one's glance.

The decisive step from the straight, radiating wall lines of the Brick House (placed there to exclude space) to the angled (and thereby at the same time inclusive) screening walls of the later projects is first accomplished, in spite of occasional earlier foreshadowings, in the Nolde design, introducing the breakthrough to a completely new understanding of space. The importance of this event, which was to bring about a revolution in architectural thinking, can be judged simply from the difficulty one has in capturing the phenomenon in appropriate words. Meanwhile, such common expressions as "continuous" or "flowing space" tend rather to obscure the situation, in that each of them places a single aspect in the foreground without consideration for the fact that hierarchical progression is an essential factor. Either they presuppose a unity that does not exist in this form, thereby overlooking the completely different character of the spaces in front of and behind the glass wall, or they imply the possibility of a sequence of spaces that can be turned around at will, while in fact it can only be read in one direction, namely from inside to outside. It is comparatively even more problematical to attempt to address these altered spatial relationships on a philosophical level, as has been done above all in the more recent Mies criticism.[13] Among other things it has produced the thesis of "universal space," frequently taken up quite uncritically, which—provided that such an abstract can ever be realized at all—would cancel out everything that architecture essentially is, namely space within space.[14] The inadequacy of the term in regard to the phenomenon described does

12 Cf. the respective paragraphs on the Brick Country House (Chap. 3).

13 Most recently in Peter Serenyi, "Mies' New National Gallery: An Essay on Architectural Content," *Harvard Architecture Review*, Vol. 1, Spring 1980, pp. 180-89, especially pp. 184 f.

14 Presumably the misinterpretation is based on a misunderstanding. In his book *The Master Builders*, first published in 1960, Peter Blake was still using the terms "universal building" and "universal solutions" without any philosophical implications:
"Did not buildings tend to outline their original functions? Did not functions change with increasing frequency in the modern world? . . . So the only kind of building which would make sense, in terms of functionalism, would be a building not adjusted to any specific function at all! This conception of 'universal building'. . . ." (Peter Blake, *The Master Builders: Le Corbusier, Mies van der Rohe, Frank Lloyd Wright*, 2nd ed., New York, 1976, p. 236.)

Blake here referred exclusively to the function of buildings, using the term *universal* to mean "of universal use," i.e., not restricted to any specific function and therefore flexible and adaptable. Obviously this statement, which was very concrete and intended to express pragmatic points of view, was first taken up without reflection. Only later was the term given a mystical connotation, possibly under the influence of Giedion's *Space, Time and Architecture*, with its allusions to a cosmological concept of architecture.

not, however, relieve us of the obligation to find an adequate name for it. Therefore let us here introduce the concept "expansive space." Unlike all previously adopted coinages it contains at least two important basic characteristics. First, it expressly suggests a *particular* space (not, that is, *the* "universal" space), which accordingly must be defined as such, in contrast to the unlimited exterior space from which it is excluded. Second, this space has the tendency to spread out beyond its boundaries without becoming a part of something completely different.

Because of these implications we can now undertake to differentiate between an inner, expansive core area and an exterior expansion zone. But as for every volume, such an interior space requires for its expansion a second volume. Otherwise it would threaten to dissolve into infinity, which would be tantamount to its ceasing to exist. The outer area marked off by the wall—the expansion zone, that is—thus possesses a certain three-dimensional integrity as well, but does not achieve the necessary spatial density, to be sure, to allow it to stand up against the core area as an equal.

The opening of the structure does not automatically cause an expansion of the interior, but leads, rather, to its disintegration as an individual spatial entity. Only the containment of the expansion zone in one form or another creates the possibility for this step by setting off the courtyard space from the whole of "universal space" and thereby defining it as a volume proper. That is the supreme and essential significance of the angular wall lines; that constitutes the fundamental difference from all that has gone before, with the possible exception of the Barcelona Pavilion, which, as a building not basically intended for permanent dwelling, in part obeys different laws. From this point a straight line runs directly to the Court House projects of the following decade.

The fact that the above motif no longer appears in the plans as they were intended to be executed is not so much the result of formal considerations as of the existing building regulations. A minimal setback from the neighboring property line obviously had to be maintained, and this wall running directly along the boundary consequently had to be abandoned. Although explicit references are missing, objections of this kind could indeed have motivated the revision of the design requested by the local building authorities in May 1929. In response to the altered conditions the bedroom was turned by 90 degrees to the south, and at the same time the size of the opening was considerably reduced. While it had taken up the entire width of the room before, it here conforms once again to the format of a traditional window, stretching from floor to ceiling as before but framed as it is by a strip of wall on both sides. Though the final version thus seems in spots somewhat more conventional than the preliminary designs, this should not blind us to the fact that it nonetheless anticipated future solutions in many respects. Compare for this purpose the exterior views with the elevations of the Hubbe (Pl. 17.5) and Ulrich Lange (Pls. 18.2, 18.14) projects from 1935. The prevailing, differentiated treatment in them—clearly limiting the principle of the open floor plan to the living area—was first revealed here, and thus likewise goes back to the Nolde House. On the basis of the various planning stages we can trace precisely in each case how the bedroom and guestroom area was subjected step by step to a more rigid scheme.

Thus the Nolde House represents the midpoint between the early country house designs and the Court House projects of the thirties in more than a chronological sense. To a certain extent it forms a link that ties the European buildings of Mies van der Rohe into a single, consistent line of development, and unites them into a more clearly self-contained grouping.

On August 16, 1930, the Krefeld Golf Club Association sent a letter to Mies inviting him to take part in a limited competition.[1] It was occasioned by the association's intention to build a clubhouse, including apartments for an instructor and a caretaker couple, on its grounds at Egelsberg in the suburb of Traar. It was to be constructed in two stages—a fact that was to be considered in the planning of the entire complex. The detailed conditions were included in the accompanying description of the competition; the inventory of rooms, for example, was thus largely fixed:[2]

"The clubhouse, with its changing rooms and shower rooms, is intended to serve the sports functions of the club. In addition it should have rooms for relaxation after sports and for social events. Finally, there must be offices for the club's administration in the building."

The following specifications were listed:
— changing rooms with 100 lockers for ladies and 150 lockers for men, with the necessary showers and washrooms,
— a bar with the usual accouterments,
— a large party room,
— one or two rooms for playing bridge,
— a covered veranda and an open terrace with an outside dance floor,
— a kitchen, together with pantry, storeroom, and wine cellar,
— an office, and
— a cloakroom.

"[Further,] a dwelling for a caretaking (employee) couple . . . to oversee the kitchen and the overall administration of the clubhouse . . . is to be a part of the clubhouse or has to be accommodated in the immediate vicinity."

It was suggested that only half of the required changing rooms and bathing facilities be provided in the first building phase. And it was thought that the bridge rooms and the party room could wait until the second one. But the initial project was to include the instructor's apartment (two rooms, kitchen, and bath), a workshop, a shop for the sale of sporting goods, and a waiting room for the caddies. Combined into an annex, these should "be unified in terms of space and architecture with the clubhouse itself, but not necessarily be a part of it structurally."

After Mies had inspected similar establishments in Berlin-Wannsee and Frankfurt am Main, and thus gotten a first impression of the assignment, he agreed on August 22 to participate. On September 30, 1930, or precisely six weeks later, the plans were sent off under the prescribed deadline to the offices of the association.[3] There, first of all, it was decided to have a public exhibition of the designs submitted.[4] Since the available material was obviously not suited to such a showing, Mies was requested to construct a model and prepare additional drawings.[5] At the end of October he sent to Krefeld "four sheets of perspective drawings as further exhibition material."[6] The surviving plan shows that at the beginning the construction of a model was also intended, but this was never done because of the expense and the lack of time.[7]

Because of the difficult financial situation, a final decision had still not been made by January of the following year.[8] Finally it was agreed that they would construct a more modest building, and on February 13, 1931, Mies was asked if he were disposed to take part—with the same group of architects—in a second competition.[9] Mies replied that he was certainly willing, but requested a postponement of the submission deadline, since at the moment he was "incredibly busy with preparations for the [Berlin] Building Exhibition."[10] Accordingly, a two-week extension was granted and the deadline was moved to March 31. Since the available correspondence breaks off at this point, there is no concrete evidence that Mies in fact prepared a revised version of the project. It may be that in the face of the continuing crisis it was agreed to terminate the competition prematurely, or it may be that Mies failed to participate after all because of other obligations. In any case, it appears that a second design was never developed.

At the end of 1932 there was once more an exchange of letters. In preparation for a large exhibition of his work in the Frankfurt Kunstverein, Mies had requested the return of the drawings still in Krefeld at that time, and they were promptly sent. But after the close of the exhibition a controversy developed over who in fact owned the plans, and this dragged on well into the following year. At last the directors of the golf association had to content themselves with a set of blueprints, while the originals remained in the studio of Mies van der Rohe.[11]

1 Directors of the Krefeld Golf Club Association to Mies, August 16, 1930; MoMA.

2 Competition documents sent with letter of August 16, 1930; MoMA.

3 File note; MoMA.

4 Mimeographed letter from the Golf Club Association to Mies, October 10, 1930; MoMA: "It has been suggested by some of the architects participating in the competition that we display the plans and models in public. We would like to assure you that for publicity purposes we would be delighted to arrange for an exhibition, in the Krefeld Museum, for example, and herewith humbly inquire whether you would also agree to having your plans and model exhibited in public before a decision has been reached."

5 Golf Club Association to Mies, October 14, 1930 (MoMA), referring to a conversation between the President of the Association, Rudolf Oetker, and Mies that had taken place the day before.

6 Office of Mies van der Rohe to the Golf Club Association, October 31, 1930; MoMA: "sent . . . four sheets at the end of last week."

7 It was on the basis of this plan (MoMA) that the model for the Krefeld exhibition in 1981 was made.

8 Golf Club Association to Mies, January 21, 1931; MoMA.

9 Golf Club Association to Mies, February 13, 1931; MoMA.

10 Mies to the Golf Club Association, February 18, 1931; MoMA.

11 Golf Club project correspondence; MoMA.

The Preliminary Design

Several of the numerous small sketches (Pls. 13.1-13.3) are so very different from the final version that it seems justified to speak of a preliminary design in this case. That these could have to do with the modified competition design of 1931 is refuted by the fact that they reflect a much more ambitious concept than the one that circumstances dictated. Therefore they can only be dated to the early phase of the planning process—that is, the days just before and just after August 22, 1930.

A circular, open pavilion, its roof slab supported by a ring of thin columns, rises above a knoll that has probably been built up artificially and expanded into a platform.[12] An angled but otherwise free-standing wall provides protection from the north and west winds without disrupting the view of the landscape. The entire upper terrace layout can be explained on the basis of the conditions of the competition, which called for both a covered and an open veranda. The pavilion shelters the "outside dance floor" that was also mentioned at the same time that it highlights it visually. The actual club rooms, the changing wing, and the two apartments are built into the hill, which they surround like a clamp, on two sides and three sides respectively. One approaches from the east along a wall running straight toward the back of the building ending up in a turn-around (Pl. 13.1).

Between the wall and the driveway runs a broad footpath that leads to the main entrance. To the right of it are a number of garage doors, one right next to the other, while obviously to the left, beyond the screening wall, lie the changing rooms. The apartments for the instructor and the caretaking couple would accordingly occupy the north flank that is not pictured. On the south and west, on the other hand, the more or less natural slope of the knoll was preserved (Pl. 13.2). A broad staircase here leads down from the edge of the upper platform to a second terrace at the foot of the south slope. Next to the bottom of it there is a small outbuilding that doubtless is connected with the underground portions of the complex and thus permits direct access to the golf course from the interior of the building. That purpose alone would hardly have required such an elaborate structure, so that we may assume—especially given the generous amount of glass—an additional function for it. Possibly the bar was located here, or a cafeteria that could be reached from the kitchen—in any case a space serving in one form or another as a gathering place for the club members.

Thus the requirements of the first building stage may be seen to have been fulfilled. The changes to follow from the future expansion are shown in another sketch from this series (Pl. 13.3). The building, which heretofore had occupied only the east and north, now extends around to the south side of the hill as well, and the staircase has been removed. The existing outbuilding is still preserved, but has been incorporated into the newly added party room. To the right this is connected to the considerably enlarged locker rooms clearly identifiable from the high narrow band of windows, which have been brought forward to the same point. These two share a common wall line, but because of their differing facade treatment they are not formally integrated. The locker side presents itself as being primarily closed and walled, whereas the bordering space has been completely opened up with glass. A projecting garden wall, similar to the one on the entry side, serves as additional screening from the terrace extending in front of the social room, and underscores the twofold function of this south wing that is already apparent from its facade.

This deliberate extension of the division between the various functional areas even to the outside serves to express the complexity of the project as outlined in the instructions, making the individual parts perfectly transparent and recognizable. The twofold nature of the association as a place for individual activities and as a social institution (as is suggested by the word *club*) was clearly understood by Mies, and he therefore did not attempt to obscure the fact, but rather expressly stated it in the layout of the building. In that respect, distinct characteristics of the final version were already realized here, no matter how significantly the two designs might otherwise differ. This desire to distinguish between the different functions of a building has its direct counterpart in Mies's country house projects of that time, where he was equally concerned with clearly separating the private areas from the rooms visitors would enter. Here, as there, the diversity of functional possibilities that was demanded—often leading one to expect virtually opposite solutions—is mirrored in an alternation of closed and open wings, of relatively conventional room groupings as opposed to large and complex spatial arrangements with extensive use of glass and only the suggestion of partitioning.

At first glance, this early version of the Golf Club appears to be without any parallel in the work of Mies van der Rohe. In many respects it anticipated certain tendencies of present-day architecture, which has—in reacting against the postwar International Style and what was considered the "Miesian" approach—in part turned once again since the end of the sixties[13] to a more earthbound style of building. But the visionary, almost utopian character of the preliminary project should not blind us to some of the obvious weaknesses of the design.

From a technical point of view, for example, the isolation of the underground areas would surely have presented difficult, if not insoluble, problems. The lighting and ventilation, especially in the employees' apartments on the north side, could hardly have been satisfactory. Conversely, the upper structures are so exposed to the weather that use of them during most months of the year would have been virtually unthinkable. The design of the entry side, which confronts the visitor with an unattractive row of metal garage doors, is no more convincing than the way the south flank of the building has been divided into two unequal parts, the projecting dividing wall serving merely as a makeshift distraction from the abrupt change in its facade. Altogether, the almost mannered division of functional areas attempted here threatens to pull the entire complex apart and destroy the unity of the whole. The crowning pavilion, for example, appears to hover unconnected above the substructure, their architectural relationship largely obscured by the mass of the knoll arising above the ground floor. It is also set apart in form and structure: the round disk of its roof slab and the delicate system of its supports that cause it to appear virtually weightless stand in direct contrast to the massive, rigid rectangular block of the core structure.

In view of these manifold difficulties, it is hardly surprising that Mies soon rejected the preliminary design and chose a new and completely different direction (Pls. 13.4-13.7). Much of what is in the preceding sketches seems so atypical that one would nearly be tempted to question its authorship were it not for the fact that the drawing is clearly Mies's. And yet, an epoch-making solution that would only be realized decades later is here proclaimed. The stepped, two-level division into an underground substructure whose roof is expanded into a

platform to serve as a base for a transparent, templelike pavilion is based on an architectural idea that would occupy Mies throughout his life, and culminate in the last structure completed before his death: the New National Gallery in Berlin, finished in 1968. This was preceded by the Bacardi Headquarters in Santiago de Cuba in 1957, which was never constructed because of the revolution, and the Georg Schäfer Museum for Schweinfurt (1960) that likewise never got beyond the planning stage.

The common precedent for all of these projects is to be found, however, in the work of Karl Friedrich Schinkel—more precisely, in his 1838 designs for a summer residence for the Russian Csar in Orianda in the Crimea.[14] These were posthumously published as a folio volume comprising fifteen plates, which had gone through four editions by 1878.[15] It has been stated that a copy was in Mies van der Rohe's possession from the twenties at the latest, and was used, according to Sergius Ruegenberg, his co-worker at that time, for purposes of study in the studio.[16] The influence of the Orianda project first reveals itself in its full scope in these sketches for the Krefeld Golf Club, though individual motifs (for example in the Eliat House and the Barcelona Pavilion) can be traced to it even earlier.

Mies's artistic involvement with Schinkel thus by no means broke off in 1921, when he abandoned the neoclassical style of his early career, but simply took place on another level that was no longer limited to forms. The "externally classicist formal idiom," as Westheim puts it, moved increasingly into the background after 1913 in favor of the "specifically architectonic solution."[17] While abandoning the "style," which is bound to its time and thus cannot be used in modern work, Mies now attempted to grasp the essential meaning of Schinkel's architecture and reinterpret it in his own buildings.

The Final Version of the Golf Club

The explanatory report that Mies himself drafted to accompany the competition design submitted on September 30, 1930, provides a rough impression of the arrangement of the entire complex. Moreover, it reveals the tremendous importance Mies gave to the specific topographical and climatic conditions of a given site. Without any understanding of these factors and their effect on

the planning process in each case it is virtually impossible to answer the question why a project took precisely this form or that. Therefore his commentary deserves to be quoted here in full:[18]

"Regarding the design of a clubhouse complex for the Krefeld Golf Club Association in Krefeld.

Site Analysis

A wide, bare cone that dominates the landscape for a considerable distance, and from which one has a broad, open panorama beginning in the south, continuing to the west, and on around to the north.
Wind and rain are usually from the northwest.

Planning Analysis

The complex serves as a place both for sports and for socializing.
The sports function is served by the locker-room building with training instructor's annex and offices.
The social function is served by the terraces and club rooms with their appropriate service areas and the caretakers' rooms.
The distance from town requires provision for considerable automobile traffic.

Solution of the Assignment

The broad knoll requires a low, spreading arrangement nestled into the landscape.
The panorama demands an arrangement open to the south, west, and north.
The prevailing wind and rain, however, require protection from the northwest.
I have, therefore, opened the uncovered and covered terraces to the view and the sun in the south and west, but protected both of them from wind and rain by means of a wall.
The lounge, on the other hand, is surrounded by glass walls, and offers a full view and a full amount of sun.
The placement of the service complex and the boiler-room chimney to the north, where it is exposed to the wind, avoids any nuisance from odors or smoke.
I have placed particular importance on the separation of the sports and social traffic.
The locker-room area is therefore closed toward the terraces on the west, opening instead toward the east.
The training instructor's apartment is set apart from the sports buildings, but close

12 Concerning the topographical situation and the orientation of the preliminary design, see the explanatory report quoted later and note 18.

13 See in this regard Arthur Drexler, *Transformations in Modern Architecture,* New York, 1979, illus. 264-73, pp. 128-31.

14 See my article: "Orianda—Berlin: Das Vorbild Schinkels im Werk Mies van der Rohes" *Zeitschrift des Deutschen Vereins für Kunstwissenschaft,* Vol. 35, No. 1-4 (1981) pp. 174-84.

15 Karl Friedrich Schinkel, *Werke der höheren Baukunst, für die Ausführung erfunden,* Part 2: *Entwurf zu dem Kaiserlichen Palast Orianda in der Krim,* 3rd ed., Berlin, 1868.

16 Conversation with Sergius Ruegenberg in December 1979 in Berlin. Ruegenberg was employed by Mies from November 1925 to July 1926, and again from September 1928 through February 1931 (reference letter in the possession of S.R.). I am indebted to Herr Ruegenberg for his gracious assistance.

17 Paul Westheim, "Mies van der Rohe: Entwicklung eines Architekten," *Das Kunstblatt,* Vol. 11, No. 2, February 1927, pp. 55-62, quote p. 56.

18 Ludwig Mies van der Rohe, explanatory report regarding the competition design, dated September 29, 1930; MoMA.

enough to give him ready access to them. The caretaker's apartment is directly adjacent to the service rooms.

Both dwellings have separate entrances removed from traffic in and out of the club.

Above and beyond the complement of rooms requested, I suggest the following additions and changes on the advice of experts and after inspecting existing complexes of a similar nature:

Drying rooms in the men's and women's locker areas for clothing that has got wet during play.

A row of makeup and dressing tables in the women's locker room.

Bedrooms for two employees in the service of the manager.

Service courtyard with loading access into the coal and beer cellars.

Dining room and lounge and separate toilets for chauffeurs, waiters, and other employees.

Refrigeration units for the kitchen, which at the same time provide cooling for the tap-room and the wine and beer cellar.

Writing and telephone room next to the large social lounge.

Covered automobile parking."

(This is followed by a rough cost estimate for the first phase of building.)

The concept as Mies presented it (Pls. 13.8, 13.9) is thus governed by three basic, programmatic precepts.

First, the various functional areas are divided, ensuring the separation of the "sports and social traffic" and the required service areas. Most striking is the separation of the training instructor's apartment, which comprises, with the offices and the sales room, a relatively independent structure on the southeast corner of the locker-room wing. The service rooms and the manager's dwelling, on the other hand, were for obvious reasons drawn into the rest of the complex more closely, both with access to the entry hall, from which, in turn, the bar, a cloakroom, and a corridor leading to the lounge branch off. But they too, in spite of being connected to the interior, are clearly set off on the outside. Further, Mies's text expressly refers to the fact that both apartments have been given "separate entrances removed from traffic in and out of the club," which guarantees no disturbance to the comings and goings of the members as well as a degree of privacy for the resident employees.

Second, particular emphasis is placed on the lighting and openness to the sun of both the terraces and the social lounge, along with an unobstructed view of the surrounding landscape. In so doing Mies was well aware of specific problems: the exposed situation offered a panorama stretching from one horizon to the other, to be sure, but it was also wide open to the wind and rain, from which appropriate protection was required. By means of the deft use of glass and the placement of a free-standing wall screening the terrace to the west, this disadvantage could be overcome without appreciably limiting the view and the amount of sunlight (Pl. 13.10).

The third and last precept was the desirability of closely tying the building to the landscape. Theoretically, at least, Mies thus refuted a fundamental criticism often raised against modern architecture: the accusation regarding its (seeming) autonomy, as represented by Hans Sedlmayr's book *Verlust der Mitte* of 1948 among others.[19] "Autonomy," according to Sedlmayr, means the presumed disregard of the architectural object for its concrete surroundings, which have been sacrificed to the claim of absoluteness, or better to a programmatic "openness to the universe." In a clear reference to Mies, though to be sure he is not mentioned by name as is Le Corbusier, Sedlmayr wrote:[20]

"Since the barrier against the outside is a transparent skin of glass, the boundaries that separate the building from the universe have been done away with. Architecture itself becomes part of the universe: interior space is merely a selected portion of the infinite space outside" (p. 52).

And further:
"Set off with crystalline severity from nature, the building closes itself against its surroundings as never before; on the other hand it opens itself as never before; these extremes come together, paradoxically, thanks to the discovery of the glass wall" (p. 146).

Without analyzing the possible justification and ultimate implications of this commonly held thesis, one could object that in the present instance we are expressly talking about the "wide, open landscape" and not about the "universe" (Pl. 13.11). It is to the landscape alone that the structure opens itself. Whatever this landscape might represent in a metaphysical sense, it is a specific terrain with its own vegetation and contained within a specific horizon, and therefore a

definite exterior space, not a "cosmic" and infinite—which is to say abstract—exterior space. Here Mies is basically only going back to the concept of the belvedere that has been common since the Renaissance, one that was also suggested by the form of the preliminary design and now appears to have been taken over into the main building itself. In contradiction to the presumed unrelatedness of architecture to its site, however, let us recall one sentence from Mies's explanatory report, one that begins —certainly not arbitrarily—the section under the heading "Solution of the Assignment": "The broad knoll requires a low, spreading arrangement nestled into the landscape," in other words, a structure that does not impose itself ruthlessly on the landscape, but subtly manages to adapt to it. Accordingly, he did not begin with some a priori plan that could be transplanted more or less to any particular place. On the contrary, careful analysis of the existing topographical data presented him with the necessary framework for his work. Our discussion of the preliminary design should have made it sufficiently clear that this is more than a mere theoretical requirement.

An additional important motif is finally the vegetation climbing across the entire south wall of the locker-room wing (Pl. 13.9), which directly contradicts Sedlmayr's claim that there is "no organic transition at all between the architecture and the landscape."[21] Architecture and landscape do not in fact confront each other as two isolated poles, "pure" and unrelated, but are in fact intertwined. While the vines, as a part of organic nature, break the sharp-edged lines of the structure and thereby take away some of the rigidity of the crystalline solid, the cubic forms of the architecture force the seemingly uncontrolled landscape into an ordered, geometrical scheme. This occurs in two ways. On the one hand, the wings fanning out from each other—as in the Concrete Country House and like the radiating wall lines of the Brick Country House—form a rudimentary system of coordinates that provides an orientation for the terrain originally devoid of bearings. On the other hand, the various views through the building's transparent walls direct the viewer's gaze toward a framed, and thus clearly defined, section of the landscape (Pl. 13.11), thereby giving form to "infinite exterior space" and gradually permitting the viewer to comprehend it visually.

None of these concepts—separation of functional areas, opening of the structure,

adaptation to the landscape—contains any fundamentally new perceptions; all have been discussed in earlier contexts. But it is worth noting that this is the first time that Mies himself put them in writing, thus confirming the results of the previous investigations in this book and giving support to the importance accorded them. Moreover, it is possible to show a whole string of further parallels to earlier buildings by Mies van der Rohe that have been fused into a new unity in the design for the Krefeld Golf Club. For example, the asymmetrical ground-plan arrangement, eccentric and thrusting out into space, goes back ultimately to the 1923 Concrete Country House. The entry area of the club also recalls the entry wing of that house, since both are perpendicular to the street front and covered by a projecting concrete slab resting on pillars. Considerably elongated, the entry wing here serves primarily as a parking place for automobiles—without surrendering its function as an approach to the building. Neither solution seeks to conceal their common prototype, the iron train-station roofs that had become common everywhere since the nineteenth century.

The passageway between the service wing and the locker-room area, though here for the most part closed by a dividing wall, can be found in the Tugendhat House in Brno (Pl. 11.22), while the structural framework of the cruciform columns with free-standing, nonbearing wall segments derives from the Pavilion at the Barcelona Exposition. The close connection with this pioneering building of 1929, in which Mies first applied the principle of the separation of walls and supports, is most obvious in the large social room of the Golf Club, which, like the Pavilion, is almost completely enclosed in glass. The roof slab projecting on all sides —present in this form neither in the Tugendhat House nor the Nolde design—likewise is a direct reminder of the Barcelona Pavilion. The paving slabs running around the outside make it quite clear that the room is resting on, not next to, the terrace (Pls. 13.8, 13.9)—this too a patent borrowing from the path-breaking Barcelona solution.

Nonetheless, an important development is here accomplished, one that would open up new possibilities for the future. In both the Barcelona Pavilion and the Tugendhat House, the interior had already been largely surrounded by glass walls, in the first case producing flowing transitions and in the second permitting the development of clearly defined volumes. But glass alone cannot cre-

ate space. Thus the main floor of the Tugendhat House facing the garden appears to be, in its entire height and width, simply cut out of what from the outside seems like a solid block made up of the imposing foundation and the parapet of the roof terrace directly above it (Pl. 11.1). Regardless of the opening, these vertical surfaces mark the dividing line between inside and out, and thereby secure the spatial coherence of the whole. It is they—and not the transparent outside walls—that basically define the living room that is held between them, for it continues to function as a room even when the huge panes are lowered into the ground. This in turn permits the complete omission of any particular emphasis on horizontal surfaces that might cause the boundaries to blur and replace them with an ambivalent intermediate area, as in the Barcelona Pavilion. There is such a transition zone in the lounge of the Golf Club as well. It is delineated on the one hand by the outer edges of the roof and the flooring slabs, and by the inner row of cruciform columns on the other. Between these, however, there runs a continuous wall of glass that produces a perfectly proper structure in spite of its transparency. This transparent membrane must not be read merely as the boundary of a given space, for it is the glass wall that creates this space that the projecting roof merely outlines. Without the transparent enclosure the quality of the space would change considerably. If one were to imagine the room as being completely open, there would still continue to be a spatial configuration encompassed by terrace, columns, and roof; it would not reveal the same density, however, and would therefore not evoke the same spatial impression.

This was the decisive step that would lead to the Court House projects of the thirties and on to the Farnsworth House from 1946-50, ending in the large, single-volume structures of the fifties and sixties.

19 Hans Sedlmayr, *Verlust der Mitte*, Salzburg, 1948, p. 99. The concept of "autonomous architecture" was derived from Emil Kaufmann's book *Von Ledoux bis Le Corbusier: Ursprung und Entwicklung der autonomen Architektur*, Vienna, 1933 (not 1932), from which Sedlmayr, as he expressly stated in his epilogue (ibid., p. 252), got the inspiration for his own book.

20 Ibid.

21 Ibid., p. 98.

"The dwelling for our time does not yet exist. But altered circumstances in our lives demand that it be created. Before it can be created it is essential that we have a clear idea of what our living requirements really are. Overcoming today's discrepancy in living conditions between actual needs and false pretentions, between genuine demand and inadequate supply, is a burning economic challenge, and a precondition to the advancement of culture."

Mies van der Rohe (1931)[1]

The German Building Exposition of 1931 took place at the Berlin Fairgrounds on Reichskanzlerplatz from May 9 to August 2. In eight exhibition halls and in an area totaling some seventeen acres, the newest achievements in the fields of architecture, city planning, and the development of construction materials were displayed by international exhibitors from twenty-two countries. Sponsors were the City of Berlin, represented by the Exposition and Fair Authority, and the Building Exposition Association established for the occasion, in which the leading organizations of the German building trades were represented. The German Werkbund was one of the representatives in an advisory council responsible for artistic, scientific, and social questions, but it was given a rather modest role in the development of the exposition,[2] and therefore essentially withdrew from active participation in the further course of preparations.[3] It is important to note this fact, inasmuch as some observers obviously still looked to the example of the Stuttgart Werkbund Exhibition of 1927 in judging the artistic and programmatic success of the Building Exposition, either consciously or unconsciously.[4] The history of the undertaking, which had first been conceived in 1926, is one of countless changes and reverses that can only be discussed here in very general terms.[5] After a first preliminary outline was drawn up by the Berlin Fair Authority in July 1926, the Building Exposition Association was constituted; it worked out a detailed program for the exposition, first scheduled for 1930, and presented it in the form of a published report.[6] After negotiations on the contract between the City and the Association regarding their mutual sponsorship of the event, it was decided in January 1929 to postpone it until 1931. A modified concept of the exposition from the same year[7] includes the provisional

design for construction on the fairgrounds, put together by Hans Poelzig and Martin Wagner, which, although in considerably reduced form, was ultimately built.

Up to this point, it was thought that the exposition would be a permanent one. Certain parts of it, among others a model community to be built within this framework, would remain in place and be supplemented annually with a "Building Month" that would have a different emphasis each time.[8] The outbreak of the world economic crisis, whose far-reaching effects were beginning to be felt quite severely by the building trades, forced considerable modifications of the plan at the beginning of 1930,[9] and by the middle of the year there was some question whether the project would be carried out at all.[10] The idea of a long-term exhibition and the planned demonstration buildings that were to have been a permanent feature of the grounds were sacrificed during this second revision of the plan.[11] Thus one of the main events to suffer was the section "The Dwelling for Our Time," which could only be realized as a temporary exhibit and had to be moved into one of the halls.

Otto Bartning had first taken on the direction of this section, and part of his original program has been preserved:[12]

"We will display three groups: the heritage, its reinterpretation, the new challenge. Each group is to show a particular living and cultural style of our time. The arrangement makes possible the presentation of all of the variety of contemporary residential forms, showing the living style of each group without prejudice, and provides for the appropriate recognition of quality work."

At another point—though it is unclear whether a free-standing complex of buildings was meant or whether he was already thinking of an integrated solution—he was more specific:[13]

"The program is expressed in the layout of the section, which will essentially create two large courtyards surrounded by the room arrangements, so that an overview and a spatial context is produced and not a tiresome, forced viewing sequence."

Shortly after this second comment was made in May 1930, Bartning stepped down in favor of Mies van der Rohe, but the precise reasons for his resignation remain a mystery.[14] On taking charge of the organization of the section, Mies threw out the concept of

1 Ludwig Mies van der Rohe, "Die Wohnung unserer Zeit," *Der Deutsche Tischlermeister*, Vol. 37, No. 30, July 23, 1931, p. 1038. This is a slightly shortened version of Mies's exhibition program for the section "The Dwelling for Our Time"; the complete original is printed in Wilhelm Lotz, "Die Halle II auf der Bauausstellung," *Die Form*, Vol. 6, No. 7, July 15, 1931, pp. 241–49, here p. 241.

2 See Alexander Schwab, "Werkbund und Bauausstellung," *Die Form*, Vol. 5, No. 7, April 1, 1930, pp. 195 f.: "that criticism of the program for the exposition was very heated in Werkbund circles, and last but not least that some important voices argued against participation in it. . . . All of this understood, the Werkbund is in fact practically only involved in Group 3 of the section 'The Dwelling for Our Time,' wherein the new challenge in living design is to be clarified."

3 Thus it was felt necessary to include a statement in the official organ of the Werkbund in March 1931 to clarify the fact "that it [the development of the section 'The Dwelling for Our Time'] is a matter of the exposition committee having given the commission to the architect on a personal basis, and that the German Werkbund has nothing to do with either the appointment or with his execution of it." ("Bildende Kunst auf der Bauausstellung," *Die Form*, Vol. 6, No. 3, March 15, 1931, pp. 113 f.; cf., however, the presentation in Schwab, *op. cit.*, note 2).

4 For example, the name of the Weissenhof Settlement crops up in Wilhelm Lotz, *op. cit.* (note 1), p. 249, while the following essay by Ludwig Hilberseimer ("Die Wohnung unserer Zeit," *loc. cit.*, pp. 249 f.) aims at a direct comparison. See also Herbert Hoffmann, "Die Wohnung unserer Zeit auf der deutschen Bauausstellung Berlin 1931," *Moderne Bauformen*, Vol. 30, No. 8, August 1931, p. 373, who specifically names the Weissenhof Settlement as the "precursor" of the Berlin Exposition, and Max Schoen, "Randbemerkungen zur deutschen Bauausstellung in Berlin," *Baukunst*, Vol. 7, No. 8, 1931, pp. 290–93, here p. 292.

5 A brief overview on the basis of press clippings is given by Friedrich Tamms, "Die Deutsche Bauausstellung Berlin 1931 im Spiegel der Presse," *Die Baugilde*, Vol. 13, No. 18, September 25, 1931, pp. 1439–43. More detailed information is in the exposition guide *Deutsche Bauausstellung Berlin 1931*, May 9–August 2, Official Catalog and Guide, published by the Exposition, Fair, and Tourist Authority of the City of Berlin. (Copy in the Stiftung Preussischer Kulturbesitz, Geheimes Staatsarchiv, Berlin.) The official publications

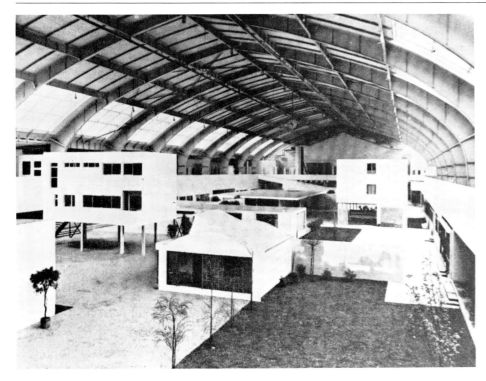

Illus. 58 Hall II of the Building Exposition, view from the gallery
(Mies van der Rohe's house in the background center).

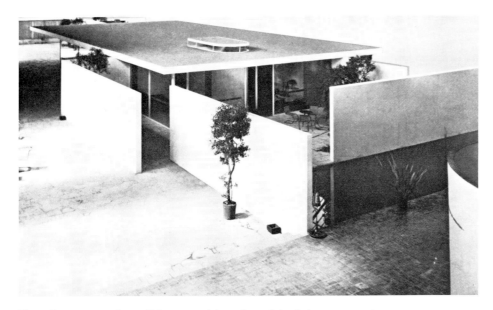

Illus. 59 House at the Building Exposition, view of the living courtyard.

his predecessor, which aimed for balance between the various architectural trends, whether of a progressive or conservative character. Instead, he demanded a program from the very beginning that amounted, as his basic declaration quoted above and obviously written in reaction to Bartning makes clear, to a solution of problems on principle:[15] "The dwelling for our time does not yet exist. But altered circumstances in our lives demand that it be created."

Hall II, the "New Auto Hall," already

existed at the northeast corner of the exhibition grounds, which included the area south of Kaiserdamm between the Heerstrasse and Witzleben stations and the Avus loop. It consisted of a huge, single space with a surrounding gallery halfway up the sides. It was on this gallery that the stands of individual suppliers of the building trade (marble, wood, wallpaper, painting and enameling firms, etc.) were set up, all designed by Lilly Reich.

Mies's preliminary design, which is

of the Building Exposition Association are sometimes extremely difficult to find, since most of them were not officially distributed on the book market. For example, I have been unable to locate the "comprehensive program publication" of February 25, 1930, which was repeatedly mentioned in the daily press.

6 *Deutsche Bauausstellung Berlin 1930*, Berlin, n.d. [1927]. (Copy in the Berlin Staatsbibliothek.)

7 *Deutsche Bauausstellung Berlin*, n.p., n.d. [Berlin, 1929]. (Copy in the Bayrische Staatsbibliothek, Munich.)

8 Ibid., pp. 10 f.

9 "Deutsche Bauausstellung 1931," *Vossische Zeitung*, No. 50, February 27, 1930.

10 Gustav Stotz to Lilly Reich, July 31, 1930; LoC.: "Meanwhile I have again heard that the Building Exposition isn't going to take place at all. Surely this question too will have been clarified by the fall."

 Regarding the difficult situation of the building economy, which necessarily affected the financing and extent of the exposition, see *Stein Holz Eisen*, Vol. 45, No. 12, July 20, 1931 (special number on the German Building Exposition), pp. 213-31; further, A. W. [A. Weiser], "Die Deutsche Bauausstellung Berlin 1931," *Die Bau- und Werkkunst*, Vol. 7, No. 10, July 1931, pp. 221-33, 236-44.

11 H. Hoffman; *op. cit.* (note 4): "as the limiting of the exposition program forced them to give up the erection of permanent dwellings and make do with temporary ones."

12 Quoted in the *Berliner Tageblatt*, No. 96, morning edition for February 26, 1930: "Organisation, Programm und Idee der grossen 1931 stattfindenden Bauausstellung." See also J. L., "Deutsche Bauausstellung Berlin 1931," *Germania*, No. 94, morning edition for February 26, 1930.

13 Otto Bartning, "Zum Programm der 'Wohnung unserer Zeit': Abteilung C der Deutschen Bauausstellung Berlin 1931," *Die Form*, Vol. 5, No. 9, May 1, 1930, p. 247.

14 G. Stotz to Mies, June 30, 1930; LoC.: "Today I got around to looking at the program of the Berlin Building Exposition, and especially at the part that you have taken over from Bartning. I am somewhat aghast at the scope of your portion, which requires taking in hand the preliminary work in great detail."

 See also Wilhelm Lotz, "Die 'Wohnkultur,'" *Die Form*, Vol. 6, No. 8, August 15, 1931, pp. 318-20: "quote from a program that originated with the previous artistic director of this section, who, as is well known, stepped down in favor of Mies van der Rohe" (p. 318).

 Bartning nonetheless continued to be a member of the advisory committee (see offi-

preserved in only one photograph, is a photomontage of the exhibition hall that permits us to see the kind of building to be carried out (Pl. 14.3): a loose sequence of flat-roofed pavilions connected to each other by walls and flanked by two taller structures. Below the gallery, the balustrade of which surrounds the hall as a broad band of wall and thus visually unifies the whole, there are additional exhibition rooms. At the back end of the hall, likewise closed by a smooth, single wall, one can climb a ramp up to the level of a raised platform, from which an all-glass, bridgelike structure leads across to the gallery. The broad open spaces between the individual pavilions are additionally broken up by pools, lawn areas, and pergolas. Here, then, there is a feeling of openness and airiness that was somewhat lost in the completed project with its more cramped arrangement of individual buildings (see Illus. 58).

It is fairly likely that the unidentified charcoal drawing reproduced as Plate 14.2 can be attributed to the Building Exposition. In its lines it resembles the preliminary design, which was rendered primarily in pencil, while the early perspectives of the Tugendhat House (Pls. 11.2-11.5), likewise done in charcoal and probably made before the end of 1928, are characterized, in spite of the dark shading, by a much softer, less granular style of rendering.[16] Stylistically, various things argue for its belonging here. The extremely thin roof slab resting on a single column, the continuous glass wall lining up with its outer edge, and the terrace cutting deep into the structure can also be found virtually unchanged in the preliminary design for the Building Exposition. One might object that the trees indicate that this sketch was for a building under the open sky, but if that were the case, the edges of the ceilings and the projecting roof slab would have had to be considerably thicker in order to accommodate a slight incline for drainage and the necessary insulation. Moreover, the view reproduced in Illustration 58 also shows a whole row of small trees inside the hall, supplemented by further greenery in the form of potted plants (see also Pls. 14.10, 14.11). All in all, then, much would suggest that this is an early version of the House at the Building Exposition quite closely related to the preliminary design or even preceding it.

All that ultimately remained of Mies's preliminary designs were the long connecting wall between the "Ground Floor Dwelling" (to use the official catalog title) of Mies van der Rohe and the adjacent building designed by Lilly Reich (Illus. 59, upper left corner)[17] and the arrangement of the two multistoried apartment houses set entirely or partly on pillars, which were moved somewhat closer together.[18]

The extremely brief catalog description, which does without any further details in contrast to the usual inventory of the individual rooms, characterizes in a few words the essential features of Mies's project: "Ground Floor House with related living spaces and adjacent garden rooms" (Pl. 14.1).

Only the front portion of the entry side, behind which the lady's bedroom lies, and the small housekeeping area in the separate northwest corner of the building—the latter comprising the kitchen, pantry, and maid's room, as well as including the cloakroom and guest toilet—appear to be massive and closed to the outside (Pl. 14.5). (This identification of the rooms' orientation is purely hypothetical, of course, but results more or less unavoidably from the layout of the separate functional areas. In this case the assumption is that the bedrooms open to the east, the living area to the south, and the dining corner to the west.) Only the kitchen and the maid's room have windows in the ordinary sense—which causes this part of the house to be set off still more strongly from the whole complex. The central portion is basically a single large space surrounded by glass and divided into smaller areas by free-standing wall elements. The projecting roof slab rests on chrome-plated round columns painted white on the outside. These are arranged in three rows of five each. At variance with the grid thus established, the entire glass-enclosed room is shifted one or two meters to the southwest, so that some of the columns on the north and east end up being outside. Better illumination of the living room and bedrooms is achieved as a result of this shifting, and the housekeeping area that projects on both sides is brought in under the rectangle of the roof slab (Pl. 14.4).

The wall elements, which are not connected to each other, reach out as free-standing screens into the outside space. There is a single exception to this, namely the wood-paneled partition between the seating area and the entry (Pl. 14.9).[19] With the exception of the two perpendicular walls that separate the bedroom and living area with the narrow passageway between them, and a parallel wall in front of the pool, all of the wall lines run in the direction of the main axis.[20] The whole of the complex of rooms

cial catalog, note 5, p. 160).

15 See the comment in Lotz (note 1): "the program that Mies drafted *before taking the work in hand*" (p. 241; italics mine).

16 Of course one must consider the relatively poor condition of the Tugendhat drawings, which show countless traces of blurring as a result of having been stacked one on top of the other for years before they were taken over by The Museum of Modern Art.

17 Designated in the catalog (note 5, cat. no. 31) as a "Ground Floor House," Mies's building is number 48 in the catalog. The wall line of Lilly Reich's house can still be seen quite faintly on the plan (Pl. 14.1, at the end of the wall extending to the right).

18 In addition, Mies was responsible for the furnishing of a "bachelor's apartment" (cat. no. 44) in one of the two apartment houses, while the remaining buildings and apartments were designed by other architects (including Gropius, No. 25; the Luckhardt brothers, No. 26; Häring, Nos. 32 and 33; Breuer, Nos. 36 and 36a; and Hilberseimer, Nos. 42 and 43). (See the official catalog, note 5, pp. 160-77).

19 In placement and formal design (five tall rectangular panels), it corresponds to the onyx wall in the Tugendhat House, for which, in turn, the one in the Barcelona Pavilion served as model. The arrangement of the seating area was similarly prefigured in the Glass Room of 1927.

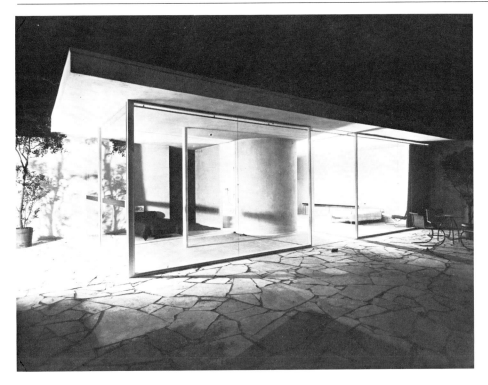

Illus. 60 House at the Building Exposition, living courtyard and bedrooms at night.

to the west thus appears to be even more strongly oriented toward Lilly Reich's neighboring Ground Floor Dwelling, while also — except for the dining area — lying broadly open to the south (Pl. 14.8). On the east, by contrast, a large inner courtyard is created, seemingly encompassing both terrace and bedrooms. Still, it is not completely closed, but rather permits one to look out between the offset walls (Pl. 14.11, Illus. 59). This zone marked off on all sides is clearly defined as exterior space by means of the irregular paving slabs,[21] but nonetheless it is sufficiently enclosed by the outside surrounding walls to function as an independent spatial entity, as a projecting expansion zone of the completely glassed bedroom suite (Illus. 60), and thus separated from the adjacent open areas. This seems to be precisely what is meant in the text of the catalog where Mies speaks in this context of garden *rooms.*

The free-floating roof slab of the house, supported only by columns, is not found in the preliminary designs, and signifies a direct borrowing from the Barcelona Pavilion. The free-standing wall elements reaching well out into the outside space, however, have their direct counterpart in the radiating wall lines of the Brick Country House. New is the way they form integral expansion zones set in front of the structure in the form of enclosed courtyards. The Barcelona Pavilion was a precursor here as well, to be sure, but the contemporary Nolde and Tugendhat projects reveal that the decisive step, the translation of the insights gained in Barcelona into a residential building, was yet to be taken. Only with the House at the Berlin Building Exposition was a line of development begun that would then reach its consummation in the designs from the mid-thirties (Hubbe House, Ulrich Lange House, "House with Three Courtyards").

20 As was the case with the Barcelona Pavilion, the walls consisted of an iron framework covered with plastered plywood panels. Because the wall was not a load-bearing element, its function was exclusively space-defining. And since the iron framework was attached to the ceiling, the projecting slab actually helped keep the walls upright and in place.

21 Lotz also expressed this opinion (*op. cit.*, note 1), commenting on this point: "Though these buildings were unfortunately . . . not built in the open air, it was intended to suggest by means of the flooring that the concept of 'living' is not limited to the living room, but that the surroundings also form a part of it" (pp. 247 f.).

And in another passage (Lotz, "Die 'Wohnkultur,'" *Die Form*, Vol. 6, No. 8, August 15, 1931, pp. 318-20): "In Hall II the *stone slabs* appeared to us to be symbolic, *suggestive of garden and open spaces*" (p. 319; emphasis mine).

The virtually completely preserved sketches and plans for this (by today's standards) rather imposing dwelling complex were a result of a small competition open to four prominent architects—all unknown to us except for Mies—that was sponsored by Herbert Gericke in the summer of 1932.[1] Such a practice, though certainly common enough in cases of public or commercial building, is rather unusual for a private client, especially inasmuch as it occasions considerable additional cost, and thereby makes for unnecessarily expensive planning. Presumably it was Gericke's position as director of the German Academy in Rome (Villa Massimo) that gave him the idea. Thus Gericke was not acting in this case as a private individual, but rather, as Mies was to express it, as someone "professionally involved in the cultural life of the nation."[2] The conflict that necessarily resulted between expectations based on the client's position on the one hand and his subjective wishes and notions and certain dilettantish ambitions on the other was acknowledged by Gericke himself, though only after the fact. It ultimately led him to a decision that could be satisfactory to none of the parties involved and was equally embarrassing to all of them. Further indication of this is contained in the correspondence appended to this chapter.

On June 8, 1932, the following invitation was sent to the architects selected:[3]

"Professor Gericke, the director of the German Academy in Rome, intends to build a small country house on his property in Berlin-Wannsee, Grosse Seestrasse 2–4. He would like to select the architect freely and without obligation, and has commissioned me to inquire whether you would be willing to provide him, along with three other colleagues, rough suggestions in this regard in exchange for a remuneration of your expenses in the amount of 500 Reichsmarks. The suggestions are to serve merely to assist the client in choosing the architect, and they will remain your own property. Professor Gericke is not purchasing any rights to them with this compensation, but will instead return them to you unused immediately after he has studied them. In the event that one of the submitted suggestions appeals to him, the client reserves the right to negotiate its further development with its author."

The letter was drafted by Werner March (1894–1976), later the architect of the Reich Sports Field for the Berlin Olympics, to whom Gericke had entrusted the orderly administration of the competition. All enquiries were to be directed to him as well, since Gericke himself was generally to be found in Rome. March's tasks consisted first of all of collecting the suggestions by the announced deadline and keeping them (unopened) until they could be studied by the client and his wife. At that time he was to open the submissions in his own studio in the presence of the couple and determine whether the prescribed conditions had been met, but without expressing any opinion of his own. Any form of recommendation on his part was thus expressly prohibited. Moreover, in order to ensure as objective a judgment as possible, the names of the individual architects were only to appear in an accompanying sealed envelope, and the submitted designs to be merely coded with a number. In the same mail the participants in the competition were provided with the following working documents: an announcement (building program), a site plan, a ground plan and cross section of the house that had been torn down, and also eight photographs of the property. The submission deadline was set for July 1, 1932. Accordingly, the architects had precisely three weeks in which to work out their proposals—a relatively limited amount of time considering the requirements to be met. In addition to a brief description of the structure, including explanation of any special technical installations if appropriate, and a rough estimate of its cost, the following were specifically to be submitted: floor plans, cross sections, and elevations in a scale not exceeding 1:100, as well as a site plan and a perspective drawing. All of the drawings could be done freehand, though the sheet size was not to exceed four-tenths of a square meter.[4] According to the receiving stamp, the invitation arrived in the studio at Am Karlsbad 24 on June 9. On that same day Mies informed March that he would participate.[5] In response to his query, March informed him on June 22, after having consulted with Gericke by telephone, that the project could "be designed quite freely, without any restrictions with regard to furnishings."[6] Four weeks later, on July 17, Mies was informed that Gericke had not chosen his design.[7] To all appearances, the other contestants likewise received a negative notification. A subsequent verbal offer from Mies van der Rohe assuring them of his willingness to rework his proposal without obligation was not responded to. On the basis of his own plans, Gericke ultimately gave the commission to an architect named Lesser, who had earlier sought to land the contract, but had been passed over in the selection of the competitors inasmuch as he was considered "a mere tradesman" (March).[8]

This generally unhappy outcome leads one to suspect that it was not Gericke who initiated the competition, for from the start he obviously was only halfheartedly involved in the whole affair, but March. Supporting such a suspicion is the uncommon concern for his colleagues that he demonstrated, especially for Mies, after events began to go badly for them. In addition, he likely had had considerable influence on the choice of the participants, since Lesser held him directly responsible for his having been left out—and in so doing threatened him by saying that "the last word has probably not yet been said" in the affair.[9] These questions can no longer be answered with certainty, and it is up to the reader to form an opinion based on the correspondence reproduced in full at the end of the chapter.

Although the conditions of the competition permitted all the freedom the architects could have wished in artistic terms, a whole string of instructions had to be considered—in part having to do with the placement of the house, in part with the inventory of rooms required—injunctions that in some cases carried detailed specifications. The limitations regarding the placement of the house resulted primarily from the terracing largely remaining from the previous building on the site, but also from the old, existing plantings of trees, which could not be tampered with to any great degree. In the disposition of the ground plan one was essentially limited to the level foundation slab of the former mansion that had been enlarged to form a terrace, though because of its considerable size it offered adequate room for innovative design. All of the above-named conditions were spelled out in the announcement that was drafted by March and incorporated the special wishes of the client:[10]

"Program for the construction of a one-family house on the lot at Grosse Seestrasse 2-4 in Berlin-Wannsee.

The new structure is to replace a large mansion, which has been torn down to the level of the cellar floor. The property is extraordinarily well located at the spot where Grosse Seestrasse runs into Potsdamer-Chaussee, and descends in three broad steps toward the Wannsee. The open central axis of the razed building is bordered on either side by dense and valuable old stands of trees. The retaining wall of the approach drive has been left as a vertical drop between the level of the street and that of the front yard next to the platform created by the cellar slab.

The new country house is to be designed for a family with two or three children. It is also to accommodate a staff of one man and three maids, as well as a children's governess. But it should be borne in mind that it should be possible for a single staff person to run the house.

Insofar as possible, a later expansion of the interior of the house by joining original adjacent staff rooms should be anticipated.

The house should be kept in the simple forms of the times and be in harmony with the landscape and the garden. In the interior, major importance should be given to the large living and dining room and the two large bedrooms. All remaining rooms are to be quite modest, designed for practicality and easiest possible maintenance. Cellar rooms should be limited to only what is absolutely essential. One should be able to walk into the yard from the living room at ground level, without steps. A small space for the placement of plants and aquariums (no ambitious winter garden!) should be situated where the lady of the house can easily care for them.

Whatever modern technical devices are utilized for cooling, drying, heating, ventilating, and laundry, thereby simplifying the use and maintainance of the house, should affect the design of the house and be briefly described. In addition to the central heating, there must be provision for heating only the main rooms by means of two or three stoves.

Rooms to be provided are:
a) Kitchen, pantry, larder, common room for the staff possibly combined with cleaning and ironing room, laundry, furnace room, staff bathroom, cellar, staff toilet.
b) 1 large living and dining room with fireplace (roughly 14 x 7 m), 1 small office.
c) 1 large bedroom with fireplace for the lady of the house with large closet or dressing room,
an adjoining terrace,
1 small bedroom for the man of the house,
1 connecting bath.
d) 1 large bedroom for the children with adjoining open terrace,
1 playroom (optional),
1 bedroom for the governess,
1 connecting bath.
e) 3 bedrooms for the household staff,
1 guest room, possibly one that would otherwise serve as a breakfast room.

The ground-plan solution should provide a maximum of sunlight, illumination, ventilation, heating efficiency, and spaces that are easy to furnish. The designer is permitted a great amount of freedom with regard to the above program.

The structure must not exceed a cost of 80,000 RM, however. In calculating its cost a basis of 40 RM per cubic meter is to be used.

Ceiling heights are expected to be roughly:
3.00 m on the ground floor,
2.75 m on the upper floor. (. . .)"

The design that Mies presented follows the program as spelled out above, but also provides for a number of important additions, described in his explanatory report:[11]

"Description

The author has studied the site in detail, both in good weather and bad and at all times of the day.
On the basis of his observations, he recommends placing the living area on the middle terrace, and in such a way that the main living room cuts into the steeply inclined slope of the garden, and that this living area does not lie precisely along the previous axis, but is shifted farther to the southeast. From here the view of both the lower garden and the lake is much more interesting, in the author's opinion, than that toward the Schwaneninsel and the bathing beach. Both the tree groupings in the lower garden and the intersections of the left shore of the Wannsee motivated this decision.
A further reason for this location of the main living room was the need to bring

1 Philip Johnson (*Mies van der Rohe*, 3rd rev. ed., New York, 1978, pp. 111 and 214) assigned the project to 1930, a date that cannot be correct in view of the surviving correspondence.
Werner March, in a letter to Gericke from September 19, 1932, quoted at the end of this chapter, spoke of "four well-known architects" without giving their names.
2 Mies to Gericke, November 3, 1932; MoMA (included at the end of this chapter).
3 Mies's copy; MoMA.
4 Ibid., enclosure ("Program").
5 Mies to March, June 9, 1932; MoMA.
6 Notice in the files of the Atelier Mies van der Rohe, June 22, 1932; MoMA.
7 March to Mies, July 17, 1932; MoMA.
8 See the correspondence presented below.
9 March to Gericke (confidential copy to Mies), September 19, 1932; MoMA (included at the end of this chapter).
10 Enclosure in the invitation to the competition written by March and dated June 8, 1932; MoMA.
11 Letter of explanation by Mies van der Rohe regarding his competition design, presumably dating from June 30 or July 1, 1932; MoMA.

ample sunlight into the house and at the same time provide the loveliest view of the Wannsee.

The open space between this living area and the terrace adjoining the street can easily be designed as a living-room garden, since its being at a lower level than the street keeps it from being visible and at the same time provides sufficient protection from the considerable noise of traffic.

The author has deviated from the prescribed program to the extent that he has not made do with only a single living room, but allows it to flow into a hall that both opens toward the living-room garden for the sake of the sunlight and permits a view from the dining area contained within it into a particularly serene portion of the yard.

The parents' bedroom suite also is attached to this large room, thus lying open to and on a level with the living-room garden. It provides for a walk-in closet for the husband, a separate dressing room for the wife. The desired fireplace has been accommodated. There is a connection between the staff room and the dressing room along a short corridor.

The staff room [common room] itself lies — as the plan shows — between the secondary stair and the kitchen. The pantry, which is separated from the kitchen by a glass wall, leads directly into the dining area in the hall. A service courtyard has been provided, along which are grouped the larder, kitchen, staff room, secondary entrance, staff toilet, cellar, and laundry.

On the upper floor — thus at the level of the street terrace — lie the children's room and the governess's room. They open onto a large garden terrace that lends itself well to sitting and playing inasmuch as it is partly covered and partly open, and faces to the south.

One enters the house itself by way of a covered forecourt. The narrow entry hall is closed toward the forecourt in translucent glass, but it is provided with a transparent glass wall toward the yard.

To the left of the entry, and set off by itself, is the small office requested.

The main living room is closed off with large panes of plate glass, some of which can be lowered, some slid to the side, and at the outside end of it there is the small winter garden requested.

Doors lead out from the main room into the lower yard and the living-room garden.

The fireplace lies at the transition from the main living room to the hall. The desired

stove heating is to be combined with the fireplace.

Forced-air heating has been provided for the living area and the main bedroom and can be utilized in summer for ventilation and cooling as well.

Hot-water heating is planned for all the other rooms, the whole system fired by an oil furnace.

The effects planned for the various rooms are illustrated in sketches."

The desire expressed in the announcement for "harmony with the landscape," though deliberately put only in general terms, has here been met in an additional sense inasmuch as Mies declared that a central goal of his design was to provide the best view of the lake while purveying a maximum of sunlight for the actual living rooms. This caused him to refrain from totally integrating the large living area into the lower main floor, leaving it instead as a structure only loosely tied to the whole complex, exposed on three sides through a continuous glass wall to the surrounding garden area (Pls. 15.9, 15.17). Together with the south flank of the house and the surviving retaining wall that March had mentioned, it embraces a large but practically self-contained inner courtyard (Pl. 15.12). The fact that this "living-room garden" is at a level well below the street provides adequate protection against noise and views from without. The service courtyard extending in front of the staff and kitchen area and closed off by walls on the other sides serves the same principle, completely screening the remaining part of the middle terrace and the lower "particularly serene portion of the yard" from the back wing of the building. In addition to the large living room requested, for which the suggested dimensions of 7 x 14 meters were adopted, Mies provided for a second hall that forms a rough square. The two are slightly staggered but at the same time connected so as to create, as in earlier projects, a unified space configuration that in turn consists of smaller, more intimate spaces (Pls. 15.13–15.15, 15.17).

Thus once again three decisive principles appear to predominate: the building is tied to the landscape as a result of its being largely open, the privacy of the inhabitants is protected by means of carefully placed screens, and there is a partial dissolution of the individual rooms in favor of a large living area with flowing transitions between

its separate functional spaces. These principles, which are expressly underscored in Mies's explanatory report, were of prime importance in his concept of the structure.

With the exception of the parklike garden stretching clear down to the shore, from which one can see virtually the whole of the Wannsee (Pls. 15.10, 15.13), the building is completely screened off against the outside. Thanks to a carefully contrived arrangement of rooms, placement of windows, and exploitation of existing clumps of trees, even the view toward the lake that presents itself from the middle terrace is subjected to careful selection. Thus the landscape is not presented to the inhabitants of the house as a whole, but rather in precisely calculated segments determined by the wall openings provided. Although the attitude toward Nature differs, for example, from the intentions behind the English landscape garden, it also contains a considerable aesthetic transformation: the object (i.e., Nature) is only perceived through an architectonic frame, and is thus subjected to the laws of composition. Consequently, the viewer is no longer confronted with the landscape as such, but only with a picture of a landscape, and it is the architect who determines what is to be seen.

In retrospect, the general potential for this development was already present in the early country house designs of 1923-24. But only in Mies's designs and buildings created between 1927 (Glass Room) and 1932 was landscape increasingly incorporated, a temporary high point in this regard being reached in the Gericke House at the end of that period. That these attempts were registered in Mies's description of this project but scarcely referred to anywhere else, may be accidental; aside from the explanatory report on the Krefeld Golf Club, commentaries of this kind have not been preserved from that period. More important is the fact that this attitude is revealed in the drawings that present, in addition to the usual exterior views, the effect that individual rooms would have — even including views from various vantage points.[12] It is significant that Mies deliberately avoided any differentiation in his manner of drawing between architecture and landscape. Though the latter tended generally to be merely an ornamental addition intended to convey a realistic impression of the architect's ideas (without necessarily being an integral part of the design), in Mies's drawings it was given equal treatment for the first time — even though it tended to obscure the architectural details (Pls. 15.13-15.15).

Finally, the Gericke design sums up the most important results of the previous years, making use almost exclusively of elements already familiar from earlier buildings and uniting them into a new overall concept. The passage created along the entry axis between the children's bedrooms and the service wing, though separated by glass walls at each end (Pl. 15.16), was already present in the Tugendhat House, as was the free-standing, semicircular winding stair and the motif of an iron pergola (Pl. 15.13; cf. Pl. 11.1). As in Brno, the living area takes up a major portion of the lower main floor, while the upper floor, which lies at street level, is set back to provide space for a generous roof terrace (Pl. 15.9). The branching, expansive disposition of the ground plan is derived directly from the Krefeld Golf Club, its influence visible even in specific details. The broad paved approach (Pl. 15.11) perpendicular to the vestibule thus corresponds in principle to the approach drive to the clubhouse, the projecting roof of which serves as a comparable accentuation of the entry facade. Similarly, the locker-room wing of the earlier building anticipates the situation of the staff rooms, turned away from the garden as they are, with windows only on the street side, while on the lake front there is a corridor with only a high, narrow band of glass for light (Pl. 15.1). The analogy is, however, most apparent in the large living room of the Gericke House, with its glass on all four sides. Even the fireplace wall projecting into the room and thus creating a nichelike extension of the space can be discovered in the lounge of the Golf Club (Pls. 15.13, 15.17; cf. Pls. 13.8, 13.11).

The formal discrepancies still subliminally apparent in the somewhat unsuccessful relationship between the main floor and the upper story in the Tugendhat House have here been solved conclusively, the Krefeld design—not to detract from its separate integrity—having served as the decisive intermediary stage. Thus the Gericke House represents a synthesis of what has come before, one in which a development of nearly a decade was brought to perfection. But at the same time a number of its details point to the future, as for example the completely glassed-in living area and the demarcation of separate exterior spaces, in which we begin to see typical elements of the later Court House designs. It would be wrong, then, to draw a clear dividing line between the buildings immediately following the Barcelona Pavilion and those originating after 1932/33, or even to assume any sort of break between them. In spite of all external contrasts, the design principles that had guided Mies since the early twenties are preserved essentially unchanged, the same basic intellectual commitment uniting the two groups of country house designs.

12 A similar kind of presentation can be found among the drawings for the Krefeld Golf Club project of 1930 (cf. Pl. 13.11).

The correspondence that developed in the wake of the Gericke competition reveals the extent of the difficulties an architect of the artistic integrity of a Mies van der Rohe had to deal with then, as now. At the same time, these letters permit us to see how much personal commitment was extended to him by those clients who finally agreed to transform his plans into reality. This alone gives them an importance that goes far beyond the specific occasion, as typical as it may have been.

March to Gericke, September 19, 1932 (MoMA):

"Dear Professor Gericke!

Your news of your decision regarding the building of your house and your having engaged Herr Lesser, utilizing your own plans, has continued to occupy me. I feel obliged to you, to the artists invited to compete, and to myself as well to tell you frankly once again how very much I regret such a conclusion to the whole affair. Since you have decided to design it yourself, I fear that the contract that you have made with Herr Lesser will be held against you because of your position in the German art community. The four well-known architects involved will scarcely understand, after all the trust they have extended to you, how you could have chosen to work with a mere tradesman instead of with a respected artist. Each of the four gentlemen will feel himself perfectly capable of creating a house, after further discussion with the client, that would do complete justice to his quite individual ideas. Once you had decided to take it in hand yourself, the right thing for a man of your position to have done would have been to seek the collaboration of an experienced building supervisor instead of Herr Lesser.

I also regret very much that you have not as yet responded to my suggestion and answered Herr Mies's very kind and generous offer to work further with you without obligation. At the time, I spoke to Herr Mies in this regard with your express agreement. I was given his consent, which I conveyed to you, and now I feel that I have been placed in an awkward position with him inasmuch as the offer I conveyed has not been acknowledged nor has he even been thanked for it.

I also cannot understand your justification for rejecting a reduction of Mies's solution as impossible, failing to credit him with being flexible enough to submit a totally new solution if given a clearer and more succinct list of requirements. You understand, if anyone does, the essence of artistic endeavor, and the infinite amplitude of its possibilities. Even at the time the competition was announced, Herr Lesser informed me in no uncertain terms over the telephone that, in regard to his exclusion from the competition, the last word had not yet been said; now, of course, with his purely commercial tenacity he has emerged victorious over the reticence of the true architects involved.

I beg you not to resent the candor with which I am letting you know how I feel, and would be pleased if it were yet possible to reach a solution that artistic circles would expect from a man such as you."

(Handwritten:) "Copy to Herr Mies van der Rohe with trust in his discretion and best regards! Sincerely, March"

Gericke to March (copy), October 5, 1932 (MoMA):

"Dear Dr. March,

First I would like to sincerely thank you for your intense interest, which you also revealed in the telephone conversation with my wife, but especially for your letter of September 19, which I can only respond to in this manner inasmuch as you have left for Brilow.

You are doubtless correct in your observations about the character of Herr Lesser. On the other hand, after the submissions to the competition I saw no other way to carry out my own plans than by choosing this very conscientious 'office.' I had to refrain from commissioning an architect of genuinely artistic abilities because I did not wish to get into intellectual boxing matches over the shape of each piece of molding and each doorknob, but need rather a subordinate personality 'to do what I wanted.' My respect for independent artistic work prevented me from expecting a man like Mies van der Rohe to concede to my very detailed suggestions that probably run counter to his own artistic ideas.

The same of course applies for many other good architects. We will now be getting a house for certain that I can live in, having done the best we can, we hope, to solve its various problems. I will gladly show you the plans the next time I am in Berlin. You can imagine that I myself am not very happy over the choice of Herr Lesser, but he offers the advantage that my letters and questions are answered promptly, and that from a business point of view the whole affair is proceding without a hitch.

I have written to Herr Mies van der Rohe, and would be grateful if you would have a look at the letter and forward it to him."

Gericke to Mies, October 5, 1932 (MoMA):

"Dear Herr Professor,

I owe you sincere apologies for not having tried to reach you more diligently by telephone. The purpose of these lines is to thank you very much for your readiness to discuss your building suggestions with me once again. If my intention to build is now being carried out in a manner that you would surely not approve of, there are definite reasons for this that I have communicated to Herr Dr. March in some detail. The unpretentious house that I am now building, derived purely out of my personal experiences and intended for my personal use, is so different from the former designs that I saw no way to bridge the gaps between my own ideas and those of others. My intention was either to find a solution to the problem with outside help, thus saving myself a good deal of work, or to solve the problem myself, in which case I claim the same privilege. It seems to me that the great number of unfortunate dwellings constructed recently are a result of compromise between clients and architects. In this instance it would have been all the more disastrous inasmuch as the so-called client had a very specific (probably bad) image of the completed house in mind.

So please do not be angry if things proceed as it now appears they will.

I hope you will give me the pleasure of coming to look at the result some time next year and telling me quite frankly how horrible you think it is."

Mies to Gericke, November 3, 1932 (MoMA):

"Dear Herr Professor,

Only today am I able to answer your letter to me, for I have been too busy the past few weeks with the reinstallation of the Bauhaus, and what I wanted to say to you would not have been of use any longer. I understand that you reserve the right to own a house as you picture it and wish it, but regret that there was no opportunity here to take a decisive step in the development of residential design.

I will not deny that we are disappointed that you have settled the matter in such a private way. From whom are we to hope for a willingness to contribute to the culture if not from the people who are professionally involved in the cultural life of the nation?"

Correspondence in the Mies papers ceases with the Gericke House of 1932,[1] beginning again only with the commission for the Resor House in 1938. Concrete references to the projects between these two are few and more often only accidental, which makes dating and attribution to a specific place or client extremely difficult — especially for the group of Court Houses.

This paucity of documentation also applies to the Mountain House that Johnson includes, calling it a "mountain house for the architect in Tyrol, Austria," and dating it to 1934, obviously relying on Mies's own recollections.[2] Ludwig Glaeser, however, who likewise drew on Mies's memory, gives the following presentation, which provides a more accurate idea of the origins of the project:[3] "This house . . . was inspired by a view he [Mies] enjoyed from a vacation cottage near Bolzano: a sloping plateau at the end of a mountain pass." This is supported by the fact that during the twenties and thirties Mies repeatedly spent several weeks with his family in the vicinity of Meran, where Ada Mies frequently took their three daughters in the summers. But there might be some doubt whether Mies could have remembered after well over a decade — Johnson's monograph first appeared in 1947 — the precise point at which he made these rough sketches for a design that never got beyond this rudimentary stage. One recalls, for example, the inaccurate dating of the early designs in the first edition of Johnson's book.[4] Stylistically, however, there would seem to be neither cause nor potential — given the lack of source material — for revising this dating, so we may presume the particulars to be accurate as they have been presented.

In addition to a number of small sketches presenting the building from various angles (from the side, from above and below — selected examples of which appear as Plates 16.2–16.6), there is one larger charcoal drawing (Pl. 16.1). Here as well the execution is relatively hasty, the low house spreading across the foot of a mountain indicated by only a few lines and cursory shading. The layout of the structure varies considerably

in the individual drawings, though there is one common feature: all show a massive corner structure facing the valley above a sloping foundation, completely windowless walls stretching away from it in both directions to embrace a terracelike platform (Pls. 16.3, 16.4). The masonry is comprised of irregular stone blocks, obviously only roughly hewn (Pls. 16.3, 16.6), thereby corresponding to the ruggedness of this rocky landscape. The slightly slanting foundation, which firmly anchors the low horizontal structure to the ground, also appears to repeat the profile of the jagged cliffs. In some spots the walls open up to reveal the interior, but at the same time they are firmly locked together by the cantilevered roof slab.

The structure on the terrace, consisting of two wings joined at the corner, has its back walls at the edge of the foundation, while on the side facing the mountains it is completely, or at least largely, glass. This L-shaped structural core has been shifted back and forth across the platform, and in some cases even pulled apart (Pl. 16.5, also in 16.4, though there held together by a common roof); ultimately — turned 180 degrees — it appears with the ends of the wings projecting well out to the exterior walls, which in turn pull back from each other beneath the projecting roof slab to create broad openings (Pls. 16.1, 16.6). Between the recessed angle of the structure and the massive corner wall there is thus created (though here not visible) a small interior courtyard, completely closed to the outside.[5]

As Glaeser has already noted,[6] Mies never seriously considered the construction of this project. Rather it was a study pure and simple, one inspired by the extraordinary charm of the spot, a kind of daydreaming[7] that would never be further developed. In this the Mountain House differs essentially from similar projects of earlier years. For the two country house designs from 1923–24, at least, we have seen that he did intend to realize them — even if financial conditions at the time prevented him from putting his plans into effect.[8]

1 There are some documents surviving from the middle thirties, but these have no direct relation to commissions or to projects on which he was then working.

2 Philip Johnson, *Mies van der Rohe,* 3rd rev. ed., New York, 1978, p. 96; illus. pp. 106–7.

3 Ludwig Glaeser, *Ludwig Mies van der Rohe: Drawings in the Collection of The Museum of Modern Art,* New York, 1969 (unpaginated). The comment "the second [house] Mies designed for himself" must be corrected as a result of the present investigation, for in addition to two versions for a house in Werder from 1914, the early country house designs would have to be included here (see Chaps. 1 and 3).

4 See especially the Preliminary Remarks to Chapter 1; the same can be said of the Gericke House (1932), which Johnson dated to 1930.

5 See also Glaeser, *op. cit.* (note 3); Johnson, *op. cit.* (note 2), p. 96.

6 Ibid.

7 Johnson, *op. cit.* (note 2), seems to imply as much also when he speaks of this project as a "romantic court-house."

8 See Chap. 1, "A Home for the Architect," as well as the correspondence mentioned in notes 51 and 52 of Chap. 1 and note 20 of Chap. 3.

"The house was supposed to be built on the Elb-Insel in Magdeburg, under lovely old trees [and] with a broad panorama of the Elbe.

It was an uncommonly beautiful building site. Only the position of the sun presented difficulties. The lovely view lay to the east, whereas to the south the view was utterly without charm, almost a disturbance. It was necessary to balance out this flaw by the layout of the structure.

Therefore I extended the living area of the house toward the south by means of a garden courtyard surrounded by walls, thus obstructing this view while at the same time preserving all of the sunlight. Downstream, on the other hand, the house is completely open, flowing freely over into the garden.

In so doing I not only followed the site conditions, but achieved a nice contrast of quiet seclusion and open expanse as well.

This layout also suited the residential needs of the client. For though she was going to be living in the house alone, she wanted to be able to maintain a casual social life and hospitality. The inner arrangement of the house is designed for this purpose as well, once again offering the necessary privacy in conjunction with fullest freedom of open spaces."

Mies van der Rohe (1935)[1]

The exact conditions leading to Mies's being given this major commission are as little known as are the precise dates of its planning, which may have begun as early as 1934.[2] Mies presumably first encountered the name of the client in the autumn of 1926, when he was asked in his function as member of the board and vice-chairman of the German Werkbund to respond to the membership application of Margarete Hubbe.[3] It is rather doubtful whether this led to a closer acquaintance, however. More probable is the agency of Emil Nolde, for whom Mies had designed a house in 1929 (see Chapter 12), and who was a friend of Frau Hubbe's.[4] Among the Nolde papers a letter has been preserved from March 22, 1935, in which she reports:[5] "His work on the plans has taken longer than expected. . . . When I have the house plans here I will certainly ask Herr van der Rohe to show them to you."

Thus work on the project must have started at the beginning of 1935 at the latest. A letter written to J. J. P. Oud by Lilly Reich on March 26 contains an isolated comment that could perhaps refer to the

Hubbe House. The passage reads:[6] "We have been working with Mies on the project for a small residence; it is still uncertain whether it will in fact be built." The final miscarriage of the project is already implied in the description of it quoted at the beginning, the manuscript of which dates from August of that year.[7] A letter of the following year, also from Lilly Reich to Oud, went into somewhat more detail:[8]

"Today I am approaching you with a request. M. has his fiftieth birthday on March 27, and for all sorts of reasons it would be desirable and nice if in one or another of the foreign professional journals some notice of it could be made. . . . Sometime in the next few days I will send you an issue of *Die Schildgenossen* in which one of Mies's latest projects is illustrated, which might be of interest to you. Sadly, it was not built, for the lady client sold the property. Another small project for Krefeld has also had to be abandoned. All of this is not easy for us; I myself also have only a few small jobs, but for M. it is especially difficult."

The resulting article written by Oud,[9] the publication of the design accompanied by Mies's own explanations in *Die Schildgenossen*, and a series of plans and sketches are all that survives from this project that Mies obviously approached with great personal commitment.

The preliminary design (Pl. 17.3), with its wings stretching far out into the landscape — the guest rooms and staff quarters to all appearances located in a separate building connected to the main one only by a linking wall — is a direct descendant of the Gericke House and the projects for the Concrete Country House and the Krefeld Golf Club, which prefigured it in terms of layout. The sheet of sketches (Pl. 17.4), however, reveals the gradual development of a closed courtyard scheme that is already fully marked in the square ground-plan variant (Pl. 17.5).

Within an area surrounded by walls that separate somewhat only on the east side to leave one broad opening, the main part of the house occupies roughly two-thirds of the north half, while reaching with its wings projecting toward the south and west clear to the opposite walls of the enclosure. (The orientation derives from the directional arrow in the preliminary drawing as well as from the details given in Mies's explanation quoted at the beginning.) In this way a series of inner courtyards results, with a larger open area on the south, a second courtyard

1 Ludwig Mies van der Rohe, "Haus H., Magdeburg," *Die Schildgenossen*, Vol. 14, No. 6, 1935, between pp. 514 and 515 (6 illustrations, corresponding to plates 17.1, 17.2, and 17.6-17.9). (The original manuscript, dated August 7, 1935, is in LoC.)

2 Aside from the above-mentioned manuscript, no written documents relating to this project have survived. The various planning stages, in part widely divergent, would argue for a longer period of preoccupation with this project, though these may also have followed one another in rapid succession.

3 Otto Baur to Mies, October 18, 1926; LoC.

4 The correspondence with Margarete Hubbe preserved in the Seebüll-Ada und Emil Nolde Foundation spans the years from 1935 to 1946, though the two clearly were acquainted even before 1935 (information supplied by Dr. Urban of the Seebüll Foundation).

5 M. Hubbe to Nolde, March 22, 1935; Seebüll -Ada und Emil Nolde Foundation (quoted from a communication from Dr. Urban, to whom I here express my gratitude).

6 L. Reich to Oud, March 26, 1935; original in the Nederlands Documentatie Centrum voor de Bouwkunst, Amsterdam, copy in the Mies van der Rohe Archive, MoMA. The identification derives from the letter from February 12, 1936, quoted below (note 8), where both the Hubbe House and the Ulrich Lange House are referred to as "smaller projects." Chronologically it is more likely that this is the Hubbe House, especially inasmuch as the letter to Nolde mentioned above (note 5) seems to suggest that planning was complete.

7 See note 1.

8 L. Reich to Oud, February 12, 1936; original in the Nederlands Documentatie Centrum voor de Bouwkunst, Amsterdam, copy: MoMA.

9 J. J. P. Oud, "Mies van der Rohe," *De 8 en Opbouw*, Vol. 7, No. 6, March 21, 1936, pp. 71 f., with 2 illus. (ground plan and photo of the model). The text (graciously translated for me by Jos van der Linde, New York) represents a first detailed appreciation of Mies van der Rohe and his position in modern architecture, but does not refer at all to the illustrations.

extending out from the guest rooms on the southwest corner, and finally a further open space between the maids' room and the entry hall. This hall lies somewhat set back toward the inside, preceded by a covered vestibule. Access is provided by a broad opening in the western wall and a fully glazed partition facing the inner entry hall, an arrangement reminiscent of the entry solution with its various transition zones in the Concrete Country House. The privacy of the courtyards, which are either completely or at least predominately closed off from the surroundings (the setback of the living room allows for passage out into the garden, see Pl. 17.7), permits maximal opening of the individual spaces, which in many spots flow without break into one another, separated only by glass doors and free-standing wall elements. The roof, supported by a grid of columns and resting on the surrounding wall, marks the separation between the interior and the exterior open spaces of the courtyards (see Pl. 17.9), and gives the required unity to the whole. The solution already attempted here remains characteristic of the following, final version.

Compared with this early design, the construction version (Pl. 17.6) reveals a clearer differentiation between the service wing and the more private areas of the house lying directly opposite. On either side of the entry area, these two front wings now flank a large living room that projects deep into the courtyard and is surrounded entirely by glass walls. It is divided lengthwise by a free-standing fireplace wall that appears to be of massive blocks of stone, though a masonry structure faced with slabs seems more likely (Pl. 17.8). The smaller portion of this large space to the north serves as a dining room, while the living room lies on the other side of the wall to the south. From here a wide corridor leads to the bedroom, which abuts a separate guest suite in the front part of the south wing. In the northwest corner of the building are staff quarters, set into the service wing as an independent and separate group of rooms.

The opening in the east, created by a break in the surrounding wall and affording an open view of the river landscape, is here considerably wider than in the preceding version. Nonetheless, the courtyard continues to be clearly defined spatially by means of the sections of surrounding wall projecting in from the end walls (Pls. 17.7, 17.9). Also decisive for this impression are the cantilevered roof slab and the paving stones that extend into the garden, which in this case can be read in only one way: the structure has burst its own boundaries and strains to extend itself outward.

The initial sketch shows that the character of the Court House, which can here be seen for the first time in its mature form, was by no means given from the beginning, but only gradually began to take shape during the course of further planning. This would tend to argue against an early dating of the projects discussed in Chapter 19, if indeed they are not preliminary stages still basically related to the House at the Berlin Building Exposition. The incompleteness of the documentary sources prohibits a definitive pronouncement in this regard. Nonetheless, with all due caution, let us risk the hypothesis that it was only with the Hubbe House and the roughly contemporary Ulrich Lange House that the decisive step was taken and the series of Court House designs was introduced.

Documentation regarding the dwelling designed for Ulrich Lange (son of Hermann Lange), which was to be built on a site in Krefeld-Traar between Buscher Holzweg and Moerser Landstrasse, is even scantier than that of the Hubbe House. The project was connected with the marriage of the client in 1935—which limits the period for the development of the design to that single year. The comment in the letter of Lilly Reich's from February 12, 1936, that was quoted in the previous chapter indicates that the undertaking had miscarried, presumably for good:[1] "Another small project for Krefeld has also had to be abandoned." The greatest obstacle proved to be the local building authority, which first refused a building permit on the basis of the "unsightliness law," which was used by the Nazis to restrict modern architecture. Only after considerable intervention on the part of the Lange family, which used all the influence at its command, was permission granted after all—but with the reservation that the house be screened from the street by means of a wall of earth, at which Mies is said to have been deeply hurt and declined any further revision.[2] It is a matter of conjecture whether the two applications to the building authorities are reflected in the two planning versions Johnson identifies as the first and second Ulrich Lange projects.[3] It must be borne in mind that the roughly contemporary Hubbe House underwent several developmental stages as well, though to all appearances there were no corresponding obstacles.

A letter from Ulrich Lange to Mies on November 7, 1949, indicates that there was also a model for this project, but it did not survive.[4]

The preliminary design (Pls. 18.1–18.3) shows a T-shaped configuration of two closed, rectangular areas separated by a corridor with glass doors on either side that serves at the same time as an entry hall. The larger of the two contains an elongated gallery and the bedrooms and staff quarters, while the smaller wing comprises a single large living room with adjacent kitchen and pantry. Both open onto a large courtyard surrounded on three sides by walls and leading out to the garden at the plane of the outer edge of the living room. The garage is a separate structure in the utility courtyard—which is defined only by a low hedge—and is tied to the rest of the complex by a common roof slab supported by a single cruciform column. This slab also extends across the opening at the end of the living-room courtyard, creating a covered terrace.

Illus. 61 Floor plan, variant of the construction design.

Here as well it is supported only by an isolated column and the flanking walls.

The two wings with closed walls and the clearly defined spaces distinguish this project from the buildings of earlier years. Even the sleeping areas of the master bedroom, which corresponds to the living room in proportions and in size, can be separated by means of curtains so that definite partial rooms result. The design of the French windows also marks a break, for although they extend to the full height of the rooms, at least on the court and garden sides, they are clearly designated as breaks in the wall, the boundary against exterior space additionally stressed by the latticed arrangement of mullions, which divide them up into square panes.[5] Only the open entry hall and the deeply projecting roofs recall the designs developed during the years around 1930.

The transformation into the second design was accomplished in several pages of sketches (Pls. 18.10–18.12), two of which come close to the ultimate solution (Pl. 18.13, a variant of which is given in Illus. 61). The entire complex is now contained in an area surrounded by wall, though the driveway into the service court and the opening into the garden were preserved in slightly altered form. In the center of the house lie the kitchen and pantry, which are placed behind a curved, S-shaped wall (see Pl. 18.12). The basic shape of this wall is repeated in the whole disposition of the layout, in that it is based on two walls radiating from the core area in opposite directions (Pl. 18.11) to embrace the living-room court and the service court within their angles—thus creating an elongated rectangle that is open on the one side to the garden, on the other to the forecourt (Pls. 18.10, 18.13). The arrangement of the living area resembles that of the Hubbe House, though the closed nature of the rest of the rooms is still largely reminiscent of the first Ulrich Lange project.

1 See Chap. 17, note 8.

2 In Ludwig Glaeser (*Ludwig Mies van der Rohe: Drawings in the Collection of The Museum of Modern Art*, New York, 1969, unpaginated) there is the following account, based on reports of the people involved: "The house remained a project because the authorities, banning modern architecture after 1933, refused a permit unless the building was hidden from the street by an earth berm."

3 Philip Johnson, *Mies van der Rohe*, 3rd rev. ed., New York, 1978, pp. 114–17 (no further mention in the text).

4 Ulrich Lange to Mies, November 7, 1949; MoMA. (After the war Ulrich Lange tried to get Mies to take up the project once more, but he declined because of too much work.)

5 A similar subdivision of glass surfaces can be found in the Lemcke House of 1932 (illustrated in Johnson, p. 110).

The term *Court Houses,* which Johnson correctly used to categorize the Hubbe and Ulrich Lange projects as well,[1] applies to a series of Mies van der Rohe's dwelling designs from the thirties that as yet cannot be precisely dated or related to a concrete location or commission. It has seemed likely that Mies, practically forced into inactivity by the restrictive cultural politics of the National Socialists, was here attempting to perfect a concept that had already made its appearance, essentially, in the House at the Berlin Building Exposition. Probably first conceived within the framework of the Bauhaus curriculum as an assignment for advanced architecture students, the idea of the Court House seems to have originated during the time of his teaching in Dessau, which would confirm the date of 1931 as a starting point.[2]

With regard to technique and the degree of development, the individual sheets differ considerably: they include everything from hasty pen and pencil sketches on tracing paper (Pls. 19.1, 19.2, and 19.3–19.5) to carefully rendered ink drawings (Pl. 19.10, Illus. 64) and large collages, in which, in addition to clippings from photographs and color reproductions, various wood veneers were used. Aside from the sketches and the clean drawing of a ground plan in pencil (Pl. 19.6), drawing stock in the standard American format of 30 x 40 inches (76.2 x 101.6 cm) was used in every case, for which a date earlier that 1938 is out of the question. Furthermore, these are as a rule not Mies's own drawings, but the work of his students, produced at the Armour Institute in Chicago (after 1940, the Illinois Institute of Technology) on the basis of earlier project studies in part already done in Germany.[3]

Although a direct link with the end phase of the Bauhaus is thus provided, the dating of the Court House designs to the period between 1931 and 1938 (suggested by Johnson and by and large adopted by Glaeser) stands up only with considerable reservations. Several dated term projects preserved in the Berlin Bauhaus Archive and a ground plan published by Howard Dearstyne and described in a contemporary letter comprise the only sure starting points.[4] At the same time one must bear in mind that after the closing of the Bauhaus by the new authorities a small group of former students continued to study with Mies on a private basis[5]—so that in questionable cases a date of 1934 is not necessarily impossible. Furthermore, we must distinguish between

Illus. 64 Mies van der Rohe: Court House with Curved Wall Elements (proposal, 1930s).

Court House schemes in the narrower sense, based on the principle of a mutual dependency of glazed interior spaces and open exterior ones within a walled area, and those projects in which the courtyard has merely the character of an enclosed garden area or is bound to the structure as a kind of atrium.[6] However, the latter include most of the Bauhaus designs that have been preserved, which would thus appear to be nothing but preliminary stages. The problem of dating the Court House designs thus focuses on the sketches done in Mies's own hand. The only certainty is that they were done in the period before his emigration to the United States, since the sheets by and large conform to the German DIN-format.[7]

One sketch that had previously been unidentified can now be ascribed with certainty to the Hubbe House (Pl. 19.2, cf. Pl. 17.8), while the others at least fall within its orbit.[8] To be sure, the similarity in this case is not to the final version, but to the square ground plan of the planning stage immediately preceding it (Pl. 17.5); this adequately explains the trivial discrepancies (for example, two rows of cruciform columns and the missing fireplace niche). All of the pen drawings were presumably produced at one time, however, since Mies generally preferred pencil or charcoal and only rarely used this medium. Accordingly, it is possible that these are all preliminary studies for the country house designed around 1935 for Margarete Hubbe in Magdeburg, which would invalidate the dating to 1931.[9] If one ignores the drawings and collages made a

few years later, the group of the European Court Houses boils down to but three separate designs: the Hubbe and Ulrich Lange houses and the House with Three Courtyards, which is, judging from various sketches, the sole independent project represented (Pls. 19.3–19.5; the slightly altered clean drawing shown in Pl. 19.8 as well as the corresponding perspective, Pl. 19.7, were done only in or after 1938).

But even this design seems to have some relationship to the Magdeburg commission. The frequently repeated motif of the circular skylight (Pls. 19.3, 19.4) can already be found in an early variant plan for the Hubbe House (Pl. 17.4), where it was likewise ultimately abandoned. Moreover, other arguments can be advanced that suggest a close connection between the two projects: in the same folder of sketches, which contained in addition to the above-mentioned preliminary studies the drawings for the House with Three Courtyards, there were a number of sheets containing subdivision suggestions for the Hubbe property on the Elb-Insel, among them the examples illustrated here (Illus. 62, 63).

Several things suggest that Mies had here envisioned a development of Court Houses —for one thing, the way the parcels grew increasingly smaller as planning proceeded. To this end, however, a correspondingly "space-saving" dwelling type first had to be developed. The subdivision of the property could have been fixed from the beginning, but, judging from the drawings, this was probably not the case. The House with Three

Illus. 62 Mies van der Rohe: Subdivision suggestion for the Hubbe
property in Magdeburg, partial solution (c. 1935).

Illus. 63 Mies van der Rohe: Subdivision suggestion for the Hubbe property (c. 1935).

1 Philip Johnson, *Mies van der Rohe*, 3rd rev.
ed., New York, 1978, p. 96, illus. pp. 97-121.
The inclusion of the Lemcke House and the
Gericke House seems to make little sense,
however. The former, a simple L-shaped
structure, does not include a courtyard at all,
and while the living-room garden in the
Gericke House reveals features of an enclosed
open space (to this extent thus helping to
prepare for the later solution), the complex as
a whole, with its wings extending in all
directions, is diametrically opposed to the
idea of the Court House.

2 See in this regard Hans M. Wingler, *Das
Bauhaus: 1919-1933. Weimar, Dessau, Berlin
und die Nachfolge in Chicago seit 1937*,
(Bramsche 1962), 3rd rev. ed., Cologne, 1975,
pp. 507 f. (*The Bauhaus: Weimar, Dessau,
Berlin, Chicago*, Cambridge, Mass./London,
1978, pp. 540 f.)

3 Ludwig Glaeser, in his *Ludwig Mies van der
Rohe: Drawings in the Collection of The Mu-
seum of Modern Art*, New York, 1969, funda-
mentally kept to Johnson's dating but gave as
a date for the creation of the collages of the
period around 1939: Of them he wrote:
"Executed after 1938 with the help of his
students at the Armour Institute in Chicago,
these montages are elaborations on Mies's
earlier studies of court houses. Although he
had used the montage technique before, he
had never employed it so systematically as a
teaching method, which explains why many
montages exist in several versions."

4 Howard Dearstyne, "Mies at the Bauhaus in
Dessau: Student Revolt and Nazi Coercion,"
Inland Architect, Vol. 13, No. 8, August/
September 1969, pp. 14-17 (it is not abso-
lutely clear from the letter to his mother from
December 20, 1931, quoted there that it is a
Court House in question). Also in Eckhard
Neumann, *Bauhaus and Bauhaus People*, New
York, 1970, pp. 215 f. Already previously in
*Four Great Makers of Modern Architecture:
Gropius — Le Corbusier — Mies van der Rohe —
Wright*, The Verbatim Record of a Symposium
Held at the School of Architecture, Columbia
University, March-May, 1961, New York,
1970, pp. 129-40, especially pp. 136 f.: "The
second house I did for him in Dessau was a
court house...." See also the illustrations in
H. M. Wingler, *op. cit.* (note 2).

5 Letter from Mies to H. O. Schumacher
(Düsseldorf) of August 30, 1934 (LoC): "In
the event that your nephew, after completing
his practical experience in an architect's office,
still desires to advance himself artistically, I
would be prepared to permit him to take part
in seminar work that I conduct with several
young architects." Dearstyne relates that he

Courtyards might well have been just such a prototype to be constructed in this specific context. That would, moreover, explain the conspicuous figures giving square meters in the margin of the sketches (Pls. 19.3-19.5), which appear on some of the subdivision plans as well. While in the latter case the overall dimensions of the individual building sites are indicated, in the former case only the developed area is calculated. If one includes the adjacent courts, however, the calculations would largely coincide.

The idea of dividing up the property must have existed for a long time, for even the preliminary design for the Hubbe House envisions a subdivision (Pl. 17.3). On another plan (Illus. 63), however, the final ground plan has been indicated, so that the entire project can hardly have been completed before the spring of 1935. Accordingly, the House with Three Courtyards would also date from early 1935, though in this case it is not altogether out of the question that planning may have begun during the last months of 1934.[10]

The Court House with Curved Wall Elements is more difficult to attribute. It is similar in type to the Hubbe and Ulrich Lange (second project) houses, but stresses completely new stylistic accents (Illus. 64). To be sure, the preliminary design for the Hubbe House also reveals a semicircular room (Pl. 17.3) which, like the S-shaped curved wall in the final version of the Ulrich Lange House, appears to announce a freer, less rigidly orthogonal floor plan disposition. The surviving drawing is from the period around 1939, but could well have been based on older sketches. In spite of certain aspects that are admittedly interesting, the House with Curved Wall Elements ultimately remains an isolated case, one that would not be repeated in the work of Mies van der Rohe.

To summarize, the Court House designs of the thirties reveal a number of distinct advantages over the earlier dwellings of Mies van der Rohe. The first of these would be the far greater freedom in floor-plan layout. The close relationship to specific site conditions that had previously dominated his designs[11] gave way to a virtual independence from given topographic characteristics, and this could lead to total insulation from the outside. Views and available sunlight, the two factors that determine the orientation of rooms, can thereby be treated independently, whereas before they were always mutually related.[12] At the same time there is the possibility of considerably denser development: because of the surrounding walls virtually any given number of Court Houses can be linked together without any reduction of privacy. The model of a Group of Three Court Houses, built at the end of the decade in Chicago, shows what such a structural grouping, now familiar as "atrium housing" or "carpet development," might actually look like (Pls. 19.9-19.11).[13]

A further important advantage of the Court House concept has already been discussed in some detail in another context: with the individual courtyards, clearly defined open spaces have been created that can be visually integrated into the interior layout. Thanks to these projecting "expansion zones"[14] the spatial integrity of the interior is now preserved as much as one might wish in spite of the fact that the exterior walls are totally given over to glass. The relationship between the structure and its surrounding has, however, changed fundamentally. This sealing off toward the outside precludes the subtle integration into the landscape that still largely characterized the buildings and projects of the twenties and early thirties with their wings reaching out in all directions. Landscape has now been reduced to a mere prospect (Pl. 17.8, 18.6, 19.2), an unreal, beautiful "picture" beyond the precinct set off by walls. The former interdependency has thus given way to a relationship of separateness and seclusion.

himself was one of these students who stayed with Mies for a period after 1933.

6 Cf. the illustrations in H. M. Wingler and H. Dearstyne (notes 2 and 4).

7 DIN 476 (A4) is 210 x 297 mm; suggested in 1922 by the standards committee of the graphics industries. The sheet dimensions in Pls. 19.1-19.5 range between 209 and 213 mm in height and between 297 and 298 in width (cf. the different sheet formats of the drawings for the Resor House of 1938, Pls. 20.1-20.8).

8 Johnson dated the sketch in question c. 1931 *(op. cit.,* p. 99 top), as did Glaeser *(op. cit.,* plate 6). The exterior views of a Court House reproduced in Johnson doubtless also go back to the preliminary design for the Hubbe House (see especially Johnson, illus. p. 108 bottom, and the outline presented on the right edge of Pl. 17.5, here). A pencil drawing reproduced by Johnson, p. 97, is likewise to be ascribed to the Hubbe House on the basis of the river landscape depicted in the background.

9 Some of the sketches reproduced by Johnson and Glaeser that would have to refer to the Hubbe House (see note 8) were dated by them to the time around 1934 (Johnson, illus. pp. 108 f.; Glaeser, plates 7-9). As already suggested in Chap. 17, Mies could have begun planning as early as the end of 1934, in which case these dates would be correct.

10 Johnson and Glaeser (notes 1 and 2) date this to c. 1934, which comes close to the present conclusions.

11 Cf. especially Mies's explanatory report regarding the Gericke House quoted in Chap. 15.

12 See in this regard Ludwig Mies van der Rohe, "Haus H., Magdeburg," *Die Schildgenossen,* Vol. 14, No. 6, 1935, between pp. 514 and 515 (reproduced in full at the beginning of Chap. 17).

13 Dated to 1938 in Johnson, *op. cit.* (note 1), p. 108, but probably not begun before 1939.

14 L. Mies van der Rohe, *op. cit.* (note 12): "Therefore I extended the living area of the house toward the south by means of a garden courtyard surrounded by walls."

Mies owed his first major commission in the United States to Alfred Barr, Jr., who was at that time director of The Museum of Modern Art in New York. Mrs. Resor, as a member of the board of trustees of the museum, had asked for his suggestions regarding the choice of an architect.[1] The contact was made in June or July 1937, after construction on a project by the Boston architect Marc Peter had been prematurely suspended.[2] On August 20, 1937, Mies arrived in New York accompanied by the clients, only to leave immediately for an inspection of the site at the Resors' ranch near the Snake River, in Wyoming, where the house was to be built. He stayed in New York until March 1938. While returning to Europe, on April 5, 1938, he received word that for the time being there could be no thought of carrying out the plans:[3] "I am sorry on account of business conditions I shall not build on my property at Wilson, Wyoming."

Nevertheless, the project was taken up again in November 1938.[4] The revision necessitated by the required reduction in scope was completed in March 1939,[5] but it was to prove just as fruitless as the other attempts to build the structure.[6] A final inquiry from Mies van der Rohe in January 1941 reveals that even at that point he had not given up hope entirely:[7]

"I wonder if you would be kind enough to let me know if you expect that the Ranch House in Wyoming will be built this spring and summer. The revision of the plans and correction of the working drawings will take a certain amount of time and I should like to be forehanded in the preparation of them."

The Resors had required that Mies make as much use as possible of the standing portions of the construction that had been abandoned earlier. Therefore the location and general disposition were more or less given: the house was to be built across Mill Creek, a water course that had probably once driven a water wheel, and which branched off from the Snake River to describe a gentle oxbow to the west before rejoining the river farther downstream.

On his arrival at the ranch in the autumn of 1937 Mies discovered four narrow bridge pillars covered by a temporary floor. The center two stood directly in the stream bed, and a two-story service wing had been built against one of the outer ones on shore.[8] After making a thorough inspection of the existing structure he decided on the following changes: the floor of the bridging wing

was to be removed and the pillars reduced from 9 feet to 7 feet 6 inches.[9] He further specified: "remove parapet around present service wing," whereby he could have meant either a projecting balcony or the balustrade of a roof terrace. On the basis of these comments it is possible to identify without question the portions of Mies's design that were taken over from the previous structure (see Pls. 20.9–20.11). These include the flat, virtually wall-like pillars with their rounded edges and above all the rectangular service wing, the south side of which angles off toward the lower course of the stream.[10] It is also clear that Mies wished to keep the structure as low as possible. The sketch reproduced in Plate 20.1 shows the ideal solution as he saw it, and which he would certainly have realized had he not been bound by the existing structures.[11]

The first planning phase, completed in the spring of 1938, is relatively well documented, all things considered, while for the later revisions there are scarcely any drawings. The planning material comprises two alternative designs, both of which, according to John Barnley Rogers and William Priestley, Mies van der Rohe's co-workers on the project, were worked out to the construction stage.[12] The differences have to do exclusively with the western end of the structure opposite the service wing, and even there are limited primarily to the ground floor. The discarded version, which for purposes of clarity will here be designated Variant A, still shows a relatively closed solution (Pls. 20.9–20.11). The outer walls, set well behind the projecting upper story that is supported by two cruciform columns, leave enough space for a covered driveway, though the vestibule leading straight to the main staircase is relatively modest as a result. In Variant B there is instead a spacious entry hall surrounded by glass on three sides, with an open staircase leading upward along its back wall (Pls. 20.3–20.5).[13]

The sketch reproduced in Plate 20.2 could have to do with the revision of the project undertaken during the winter of 1938/39. The most important changes are mentioned in a letter of Mies van der Rohe's of March 25, 1939.[14] The son's room is now situated on the ground floor and the upper open porch and the garage have been discarded, as has the fishing-tackle room, together with the writing alcove above it, doing away with the entire extension on the north side of the east wing.[15] The entire west wing is also considerably shortened—a change that

1 Contrary to Peter Blake's version of the affair (*The Master Builders: Le Corbusier, Mies van der Rohe, Frank Lloyd Wright*, 2nd ed., New York, 1976, p. 227), the role Philip Johnson may have played is not certain, since in the correspondence (MoMA) the only name that appears is that of Alfred Barr.

2 Plans for this earlier project have not survived. The presentation of the planning history has been kept appropriately brief in order not to anticipate more than absolutely necessary a monograph currently being prepared on the Resor House by Nina Bremer. I would here like to thank Professor Bremer for her generous support in the assimilation and evaluation of the material.

3 Stanley Resor to Mies (*Queen Mary*), April 5, 1938; MoMA.

4 File memo by John B. Rogers (co-worker of Mies van der Rohe's in America from 1938 to 1942) about changes the client desired, dated November 28, 1938; MoMA.

5 Mies to Mr. and Mrs. Resor, March 25, 1939; MoMA.

6 On July 6, 1940, Mies wrote to Mrs. Resor (MoMA): "I should enjoy coming out to the ranch for a week between the 15th of August and the 1st of September. . . . Mr. Rogers will be in Idaho at that time and will come down and join me at that ranch, if that is agreeable with you. . . . I am sorry to say that the model of the ranch house arrived in Chicago in a badly damaged condition. I will try to have it rebuilt and sent out to you before I arrive."

7 Mies to Stanley Resor, January 29, 1941; MoMA.

8 File memo dated October 21, 1937; MoMA.

9 Ibid.

10 A considerable extension of the service wing by means of an addition on the north side was planned. Aside from a secondary stairway, it was to contain a room for fishing tackle on the lower level and above it a small writing area. The building juncture can be seen by the thickness of the dividing wall (Pl. 20.11) and the difference in room height (Pl. 20.9, upper right), which necessarily resulted from the reduction of the pillars. (The areas to be constructed would therefore have been located at a lower level than the existing wing.)

11 The date of the drawing is uncertain. It could either stem from the very beginning of the planning or be related to the idealized model prepared for the New York exhibition of 1947, the original of which is preserved. Philip Johnson (*Mies van der Rohe*, 3rd rev. ed., New York, 1978, p. 155 bottom) showed an alternative version that ignores the specific characteristics of the building site. Its main floor rests simply on a lower base that is somewhat set

can be adequately explained by the requested reduction in the inventory of rooms. A corresponding floor plan reflecting these comments has not as yet been found, so this discussion must be limited primarily to the project of the winter of 1937/38.

All of the walls in the wing to be constructed, as well as the fireplace wall over the western bridge pillar, were to be built of rough-hewn quarry stone, which could be brought from a quarry near the farm without any major transport problems. In terms of structure, Mies resorted to his proven method from Barcelona and Brno, in which the walls had no bearing function, but merely served as spatial dividers. As in those buildings, the bearing framework of the house consisted of a skeletal steel structure with free-standing cruciform columns. Instead of the bronze sheathing originally planned for these columns, the modified design from the spring of 1939 provided for a simple coat of paint as an economy measure.[16] For the outer covering Mies chose black bird's-eye cypress—that would have had to be imported from the South—for its durability, but at various times there was also talk of planks of Douglas fir, which was considerably easier to come by.[17]

The bridge wing, reserved exclusively for the living area, is completely glassed on either side. The large panes of plate glass are set back roughly a meter from the edge of the floor and the roof line, so that a kind of catwalk is created outside. Aside from practical considerations—window-washing could thus be accomplished much more easily—the intention here may well have been once again to avoid an abrupt transition to the outside. The cantilevered floor slab and the overhanging flat roof form a projecting transition zone that effectively contributes to the sense of space, mediating between the interior and the exterior. In one series of sketches the various possibilities of giving the living area a clear boundary in spite of its being so open are explored (Pls. 20.6-20.8). Among other means, the suspended aprons that were used in the Concrete Country House appear again (Pl. 20.8).

The two collages reproduced here (Pls. 20.12, 20.13) reveal how much Mies van der Rohe's thinking had changed.[18] There is now only a trace of a "tying the space to the landscape," which had still been a declared goal of the architect as late as the beginning of the thirties.[19] Looking through the glass wall one is struck instead by an impression of visual distance, of detachment. The landscape here appears to the viewer no longer as a spatial frame of reference, but takes on a distinctly pictorial, almost stagelike character that Mies attempted to make even more apparent by means of the strictly frontal reproduction in parallel planes of the panorama presented. The selection and arrangement of the "picture" are already given by the architectonic framing elements, and are thus largely beyond the viewer's control. The difference between it and the Klee painting[20] enlarged to wall size (Pl. 20.13) is at best only slight. Just as the painting is given a new reality quotient by the unusual context and the lack of a frame limiting and defining the picture plane, the landscape projected in the opening conversely loses much of its three-dimensionality and takes on a distinctly pictorial quality, essential characteristics of the work of art having been imposed upon it.

The 1942 design for a Museum for a Small City (Illus. 65) expresses this tendency with an even stronger emphasis: here the wall and window surfaces are completely broken down into individual planes that can no longer be readily perceived as belonging to a three-dimensional context. In effect, the viewer has been robbed of virtually every opportunity to differentiate between real and fictional space, between the subjective spaciousness of the work of art and the objective spaciousness of the views opening out behind it. Orientation is made even more difficult in this case because relatively flat landscape photographs have been chosen, in which depth appears to be largely suppressed in favor of an overall decorative and pictorial effect. By contrast, the dramatic events in Picasso's *Guernica* appear to be incomparably intensified. Nonetheless, the collage communicates an indisputably three-dimensional spatial feeling by means of the placement of the overlapping planes and the heightened plasticity of the two sculptures, a feeling that is, of course, restricted to the interior. The effect of disorientation thus seems to derive exclusively from the glazed wall surfaces. One unconsciously asks "why" of all this, but first it is important to determine more precisely to what degree a similar effect applies to the actual structure and is not merely a product of a particular quality of the representational medium. Two essential aspects must be kept in mind above all, for they do derive from intrinsic qualities of the actual wall openings: namely the selectivity of the resulting views and, necessarily related to this, the fact that they are framed by

back. The working model of November 1937 was already in poor condition by 1940, and a few photographs may well be all that remains of it; see note 6.

12 For this information I am indebted to a gracious communication from Professor Bremer.

13 The corresponding floor plans (MoMA 100.605 and 100.606),not reproduced here, date from March 1938.

14 See note 5; the client's desire that the scope of the project be reduced is clear from a file memo from November 28, 1938 (note 4).

15 See note 10.

16 Letter of March 25, 1939 (note 5).

17 Ibid.

18 Pictured are the huge window walls of the Resor House, one facing south, the other north. In Plate 20.13, at least, the photograph used did not match the actual view, which may suggest that it was created at a later date.

19 See the prospectus contribution of March 13, 1933, quoted at the beginning of Chap. 9.

20 The color reproduction is a segment of the 1928 *Bunte Mahlzeit* (Colorful Repast).

21 Dagobert Frey, "Wesensbestimmung der Architektur," *Kunstwissenschaftliche Grundfragen*, 2nd ed., Darmstadt, 1972, pp. 92-106, quote p. 99.

22 Nicolai Hartmann, *Ästhetik*, 2nd ed., Berlin, 1966, p. 148 (emphases mine).

Illus. 65 Mies van der Rohe: Museum for a Small City (proposal, 1942).

the planes that constitute the room.

In this regard Dagobert Frey aptly commented that an object seen through an opening automatically "takes on a pictorial, painterly character. It is significant how in such circumstances an impression of irreality is immediately apparent."[21] Nicolai Hartmann came to a similar conclusion when he distinguished between a naive, preaesthetic feeling for Nature and what he called a truly aesthetic approach to a landscape:[22]
"In all of this the element of *distance from the object* is missing. The observer feels himself to be standing in the landscape, and not merely in spatial terms. Obviously that is essential for his impressions: he sees himself taken up, accepted, surrounded, and may even feel a tendency to become one with Nature. Thus not only the aesthetic response, but the objectivity of the surrounding Nature is to a great extent annulled.

It is against this primitive surrender to Nature that the aesthetic objectification [perception] of the landscape sets itself off. How this comes about is a secondary question. But it does occur, and indeed first of all by pausing before individual *pictorial impressions*. For example, a *perspective* opens up, *framed* by nearby trunks and branches, …*the whole works like a 'picture,'* unsought, unintended, possibly a complete surprise.

Now the viewer is lifted out and set apart. *Rather, he is confronting the landscape.* He has actually only just now become a gazing spectator, and thereby subject to aesthetic pleasure.…*The essential factor is the pictorial character, the limitation, the selectivity* [of the scenery]."

Accordingly, these observations are not restricted to the collages but must apply as well to the spatial effect of the Resor House insofar as the landscape here as well should assume an "unreal" (D. Frey), pictorial, and ultimately two-dimensional character. The deliberate transformation of the landscape into a picture is the necessary prerequisite for the increasing openness of Miesian space. For only in this way can the interior maintain its identity and integrity, provide shelter and security, and nevertheless convey a feeling of freedom. Without this scenic backdrop that "closes" the room, it would expand into the infinite, which would be tantamount to its total dissolution. Solely its having been "set apart" guarantees it a separate existence. In the Resor House a line of development that was already evident in the Court House designs took on a dimension that suddenly opened up new, if not previously unsuspected, possibilities. From this point to the Farnsworth House only one small further step was necessary.

"Nature should also have a life of its own. We should avoid disturbing it with the excessive color of our houses and our interior furnishings. Indeed, we should strive to bring Nature, houses, and people together into a higher unity. When one looks at Nature through the glass walls of the Farnsworth House it takes on a deeper significance than when one stands outside. More of Nature is thus expressed—it becomes part of a greater whole."

 Mies van der Rohe (1958)[1]

Mies here summed up in a few simple words the essence of the conclusions of the foregoing investigation. The higher unity of man, architecture, and Nature was the goal reflected in all his buildings from the early country house designs to the Farnsworth House. With this theme, the reconciliation of man and Nature by means of architecture, he placed himself clearly in a tradition that had its beginnings in antiquity and has, since the villas of Palladio, affected people's thoughts and yearnings up to the present day. Poussin and Lorrain as well as the later protagonists of the English landscape garden, Schinkel as well as Wright, have all felt themselves equally committed to this idea. They all strove in their own way for a compromise with Nature. Schinkel and Wright developed the models that Mies first emulated before rapidly finding his own way, one that he was to follow to its logical conclusion: the total opening of the structure. Perhaps more than his predecessors, however, he was at the same time conscious that the unity of house and landscape represented an ideal that can never be fully achieved, and that can only be envisioned by means of a largely intellectual approach. That may explain why he put frequent emphasis on the "spiritual" in architecture: the most urgent problems that the architect has to deal with are, according to Mies, not so much of a technical or formal nature, but rather of a philosophical kind.[2]

At the close of the preceding chapter it was shown how Mies attempted to solve these problems. Since a total union of the architectural space and its natural setting cannot be achieved unless that space loses its identity, the unity he is striving for can only be accomplished on a "higher" (that is, a more abstract) level. Landscape must thus first be transformed into another state belonging to another sphere of reality. Where his earlier projects used mediating zones to allow a gradual transition to the open landscape, Mies's transformation of three-dimensional space into a picturelike backdrop occurred mainly on a perceptual level. That is what was ultimately meant by the sentences: "When one looks at Nature through the glass walls of the Farnsworth House it takes on a deeper significance than when one stands outside. More of Nature is thus expressed—it becomes part of a greater whole."

With the house for Edith Farnsworth on the Fox River near Plano, Illinois, Mies had been given a unique opportunity to realize this concept in its purest form. Since the client was a single woman, who wanted to use the structure only periodically as a vacation and weekend house, the floor plan could be completely attuned to the needs of a single person. A further advantage proved to be the remote situation in the middle of a still largely undisturbed riverbank landscape, far from any other buildings or public roads. There was therefore no need to screen the house from the outside or even to divide it up into individual areas of privacy.[3] With the exception of the most private necessities, for which (in the event of guests) two separate bathrooms were provided, all the functions of daily life take place in a single large space that is organized into four areas, at least by suggestion, by the projecting side walls of the closed core area.

Mies and Edith Farnsworth had been introduced by a mutual acquaintance in the winter of 1945/46, and had quickly become close friends. This contact may have encouraged the decision to build the house. In any case, planning was begun as early as May 1946, extending then until well into the following year. The watercolor reproduced here (Pl. 21.1), which Johnson mentioned in a letter of May 1947, dates from this period.[4] With the exception of slight discrepancies in the dimensions of the porch and the projecting terrace, the drawing already reveals the basic form of the house. Only the core area—with its plumbing requirements—would be subjected to a total revision, during which Mies ultimately chose a symmetrical solution (Pl. 21.2–21.5).[5]

After an interruption of two years, the project was taken up again in the spring of 1949, and construction began in the late summer of that year. Thanks to the self-supporting steel construction, which required no extensive foundation work, the building rapidly took shape (Pl. 21.9). In the autumn of 1950 the relationship between Mies and Mrs. Farnsworth began to worsen dramatically, and in February 1951, even before the house was completed, an irreconcilable break occurred. A subsequent case brought against Mies by Mrs. Farnsworth,[6] in which she accused him of inadequate planning and insufficient attention to the construction of the house as well as an unjustified cost overrun, was settled in his favor.[7] Much more wounding to him was the press campaign against him initiated two years later by the magazine *House Beautiful*, especially since, in addition to Mrs. Farnsworth, even Frank Lloyd Wright allowed himself to be goaded into dissenting commentary on the International Style, decidedly directed against Mies.[8]

This is possibly the reason why Mies dedicated himself exclusively to other kinds of building projects after this unhappy postlude, and from this point on had nothing more to do with the design of private dwellings.[9]

What is clearly new in this project is not so much the use of glass on all sides, which had already been achieved in a promising way in the lounge of the Krefeld Golf Club (Pl. 13.9) and the living room of the Gericke House (Pls. 15.1, 15.9). Nor is it the act of raising the building from the ground—in this case necessary because the river often overflows its banks in spring—for this can be seen as early as the Concrete Country House.[10] Both of these principles may have been attempted in the preliminary design for the Berlin Building Exposition, which provided for a bridgelike structure surrounded by glass at the outer end of the exhibition hall (Pl. 14.3). New here, however, is the placement of the supports on the outside, in front of the horizontal roof and floor slabs, which therefore appear to hover above the ground rather than to be supported (Pl. 21.13). Only in this way could such an impression of floating be achieved. The carrying I-beams welded to the outside edges of the framework provide the facades with a strong relief, so that the panes of glass stretching between them and set back somewhat are clearly designated as openings (Pl. 21.10) and not as dark reflecting surfaces that screen the inside (cf. Pls. 11.1, 14.2, 15.12; Pls. 21.2, 21.7). The light entering from all sides creates a condition of complete transparency (Pls. 21.11, 21.12) that would destroy the solidity of the house were it not elevated above the ground. (It was thus by no means only practical considerations that led to this step.) Moreover, the borderline of the space is defined almost exclusively by the I-beam supports, an impression reinforced on the inside by the fact that the glass walls do not continue behind them, but butt up against them, creating

Illus. 66 W. Gropius and M. Breuer: H. G. Chamberlain House in Wayland, Mass. (1940).

small indentations (Pl. 21.14). Outside, the pillars end just below the narrow cornice that runs around the whole building and ties it together as well as closing it off at the top.

A direct model for the Farnsworth House may well have been the 1940 Chamberlain House in Wayland, Massachusetts, by Walter Gropius and Marcel Breuer, which Mies presumably knew (Illus. 66). The veranda— here closed only with screens—floats above the ground in the same way, reveals pillars likewise placed on the outside, and is closed off at the top by a narrow cornice just as in the Farnsworth House. Ultimately, however, it is the differences that are important: the wooden pillars do not "hold" the structure, but carry beams suspended between them on which the roof and floor slabs rest. Moreover, the floor slab is extended upward around the sides, giving the veranda a clear spatial boundary that is further stressed by its vertical wooden siding. It is precisely this comparison that underscores the tremendous significance of the Farnsworth House, of which Mies himself was to say:[11]

"The Farnsworth House has never been truly understood, I think. I myself have been in this house from morning until evening. Until then I had not known how colorful Nature can be. One must be careful to use neutral tones in interior spaces, for outside one has all sorts of colors. These colors are continually changing completely, and I would like to say that it is simply glorious."

With the Farnsworth House a course of development stretching over more than thirty years was brought to a close, one that was guided ultimately by a single goal: "to bring Nature, houses, and people together into a higher unity."[12] In the country house projects of Mies van der Rohe modern architecture made its contribution toward the realization of an ideal that has defined human spiritual needs since antiquity.

1 Quoted from Christian Norberg-Schulz, "Ein Gespräch mit Mies van der Rohe," *Baukunst und Werkform*, Vol. 11, No. 11, November 1958, pp. 615 f. (It is based on the article "Talks with Mies van der Rohe," *L'architecture d'aujourd'hui*, Vol. 29, No. 79, September 1958, p. 100.)

2 See the quotes in Chaps. 9 and 11.

3 As Mies himself said: "The Farnsworth House is a house for a single person; that made the job easier." (From an interview for the BBC from May 1959; portions appear in Mies van der Rohe, "Ich mache niemals ein Bild," *Bauwelt*, Vol. 53, No. 32, August 6, 1962, pp. 884 f.)

4 Philip Johnson to Mies, May 22, 1947; MoMA.

5 The correspondence regarding the first planning phase has not been preserved. All details have been taken from the trial documents, from which it was attempted to reconstruct the original sequence of events (see note 7).

6 Anonymous, "Edith Farnsworth sues Mies," *Architectural Forum*, Vol. 95, No. 5, November 1951, p. 67.

7 Trial documents in the Mies Archive; MoMA.

8 A comprehensive presentation is in Peter Blake: *The Master Builders: Le Corbusier, Mies van der Rohe, Frank Lloyd Wright*, 2nd ed., New York, 1976, pp. 242-49.

9 Immediately following the Farnsworth House, but still before the press campaign of the spring of 1953, three additional projects were completed: The Caine House, which was to have been built in Winnetka, Illinois, but was never constructed (1950; illustrated in Werner Blaser, *Mies van der Rohe*, 2nd ed., Zurich, 1973, pp. 114 f.); the idealized project of the "Fifty-by-Fifty House (1950-51; illustrated in Philip Johnson, *Mies van der Rohe*, 3rd rev. ed., New York, 1978, pp. 180 f.; see also Illus. 18 in the present volume); and the McCormick House, built in Elmhurst, Illinois, in 1951-1952 (illustrated in Werner Blaser, *Mies van der Rohe: Lehre und Schule*, Basel, 1977, pp. 172-79). The first two designs are variations on the principle of the Farnsworth House, while the third was constructed of prefabricated facade elements and was thought of as the prototype for a later serial construction.

10 Concerning the close relationship to the living room of the Concrete Country House, especially in the sequence of spaces, see the appropriate section in Chap. 1.

11 Interview, May 1959 (see note 3).

12 See note 1.

Bibliography

The listing of bibliographical sources is arranged in the order of their appearance. Individual essays and additional references may be found in the notes to the separate chapters.

Monographs

Philip Johnson, *Mies van der Rohe*, New York, 1947 (3rd revised edition. New York, 1978).

Max Bill, *Ludwig Mies van der Rohe* (Architetti del movimento moderno 12), Milan, 1955.

Ludwig Hilberseimer, *Mies van der Rohe*, Chicago, 1956.

Arthur Drexler, *Ludwig Mies van der Rohe*, New York, 1960.

Peter Blake, *Mies van der Rohe: Architecture and Structure*, Harmondsworth, 1960.

Four Great Makers of Modern Architecture: Gropius – Le Corbusier – Mies van der Rohe – Wright, The Verbatim Record of a Symposium Held at the School of Architecture, Columbia University, March–May, 1961, New York, 1970.

Werner Blaser, *Mies van der Rohe: Die Kunst der Struktur*, Zurich/Stuttgart, 1965 (paperback edition, Zurich, 1972).

Ludwig Mies van der Rohe, catalogs of the exhibitions in the Art Institute of Chicago and the Berlin Akademie der Künste, Chicago and Berlin, 1968.

Ludwig Glaeser, *Mies van der Rohe: Drawings in the Collection of The Museum of Modern Art*, New York, 1969.

Peter Carter, *Mies van der Rohe at Work*, New York, 1974.

Lorenzo Papi, *Ludwig Mies van der Rohe*, Florence, 1974.

Peter Blake, *The Master Builders: Le Corbusier, Mies van der Rohe, Frank Lloyd Wright*, New York, 1976.

Ludwig Glaeser, *Ludwig Mies van der Rohe: Furniture and Furniture Drawings from the Design Collection and the Mies van der Rohe Archive* (The Museum of Modern Art), New York, 1977.

David A. Spaeth, *Ludwig Mies van der Rohe, An Annotated Bibliography and Chronology*, New York/London, 1979.

Essays and Aphorisms by Mies van der Rohe

"Hochhäuser," *Frühlicht*, Vol. 1 (New Series), No. 4, Summer 1922, pp. 122-24.

"Bürohaus," *G*, No. 1, July 1923, p. 3.

"Bauen," *G*, No. 2, September 1923, p. 1.

"Gelöste Aufgaben: Eine Forderung an unser Bauwesen," *Die Bauwelt*, Vol. 14, No. 52, December 27, 1923, p. 719.

"Baukunst und Zeitwille," *Der Querschnitt*, Vol. 4, No. 1, January 1924, pp. 31-32.

[Review] "P. Troop: Entwicklung und Aufbau der Miete," *Die Baugilde*, Vol. 6, No. 5, March 15, 1924, p. 56.

"Industrialisierung des Wohnungsbaus – eine Materialfrage," *Der Neubau*, Vol. 6, No. 7, April 10, 1924, p. 77.

"Industrielles Bauen," *G*, No. 3, June 1924, pp. 8-13.

"Zum neuen Jahrgang," *Die Form*, Vol. 2, No. 1, January 1927, p. 1.

[Response to the objection of Walter Riezler] *Die Form*, Vol. 2, No. 2, February 1927, p. 59.

[Foreword to] *Werkbund-Ausstellung "Die Wohnung," Stuttgart 1927, 23. Juli – 9. Oktober*, Official catalog, published by the directors of the exhibition, p. 5.

[Foreword to] *Bau und Wohnung*, Published by the German Werkbund, Stuttgart, 1927, p. 7.

"Zu meinem Block," *ibid.*, p. 77.

[Introduction to the issue devoted to the Werkbund Exhibition] *Die Form*, Vol. 2, No. 9, September 1927, p. 257.

"Baukunst in der Wende der Zeit," *Innendekoration*, Vol. 39, No. 6, June 1928, p. 262.

"Über Sinn und Aufgabe der Kritik," *Das Kunstblatt*, Vol. 14, No. 6, June 1930, p. 178.

"Die neue Zeit," *Die Form*, Vol. 5, No. 15, August 1, 1930, p. 406 (reprinted *op. cit.*, Vol. 7, No. 10, October 15, 1932, p. 306).

"Haus H., Magdeburg," *Die Schildgenossen*, Vol. 14, No. 6, 1935, between pp. 514 and 515.

"Museum," *Architectural Forum*, Vol. 78, No. 5, May 1943, pp. 84-85.

[Introduction to] Ludwig Hilberseimer, *The New City*, Chicago, 1944, p. xv.

"A Tribute to Frank Lloyd Wright," *The College Art Journal*, Vol. 6, No. 1, Autumn 1946, pp. 41-42.

"Acceptance by Mr. Mies van der Rohe" (speech given upon receiving the Gold Medal), *Proceedings of the American Academy of Arts and Letters and the National Institute of Arts and Letters* (2nd Series), No. 14, New York, 1964, pp. 331-32.

Additional, in part unpublished writings in Philip Johnson, *Mies van der Rohe*, 3rd revised edition, New York, 1978, pp. 186-204.

Interviews

George Nelson, "Architects of Europe today: 7 – Van der Rohe, Germany," *Pencil Points*, Vol. 16, No. 9, September 1935, pp. 453-60 (no direct quotes).

"6 Students talk with Mies" (Interview of February 13, 1952), *Master Builder*, The student publication of the School of Design, North Carolina State College, Vol. 2, No. 3, Spring 1952, pp. 21-28.

Conversations Regarding the Future of Architecture (recording), Reynolds Metals Company, Kentucky, 1956.

Christian Norberg-Schulz, "Talks with Mies van der Rohe," *L'architecture d'aujourd'hui*, Vol. 29, No. 79, September 1958, p. 100 (in German as "Ein Gespräch mit Mies van der Rohe," *Baukunst und Werkform*, Vol. 11, No. 11, November 1958, pp. 615-16).

H. T. Cadbury-Brown, "Ludwig Mies van der Rohe," *The Architectural Association Journal*, Vol. 75, No. 834, July-August, 1959, pp. 27-28.

Peter Carter, "Mies van der Rohe: An appreciation on the occasion, this month, of his 75th birthday." *Architectural Design*, Vol. 31, No. 3, March 1961, pp. 95-121.

Peter Carter, "Mies van der Rohe," *Bauen + Wohnen*, Vol. 15, No. 7, July 1961, pp. 229-48 (contains excerpts from an interview).

"Mies van der Rohe: Ich mache niemals ein Bild," *Bauwelt*, Vol. 53, No. 32, August 6, 1962, pp. 884-85 (contains, among other things, excerpts from a BBC interview of May 1959).

Peter Carter, "Mies," *20th Century*, Spring 1964, pp. 138-43.

Mies in Berlin (recording), Bauwelt Archiv I, Berlin, 1966 (from an interview with RIAS Berlin in October 1964).

Katharine Kuh, "Mies van der Rohe: Modern Classicist," *Saturday Review*, Vol. 48, No. 4, January 23, 1965, pp. 22-23 and 61.

[Excerpts from an interview with the Bayrischer Rundfunk on the occasion of his 80th birthday] *Der Architekt*, Vol. 15, No. 10, October 1966, p. 324.

Franz Schulze, "I always wanted to know about truth," *Panorama* (supplement to the *Chicago Daily News*), April 27, 1968.

Country Houses and Projects

Die Villen und Landhausprojekte

Country Houses and Projects

1 Landhaus in Eisenbeton
Datierung: Anfang 1923
Auftraggeber: vermutlich Entwurf zu
einem Wohnhaus des Architekten
Ort: Potsdam, Berliner oder Nauener
Vorstadt (?)

1.1 Gartenansicht
1.2 Modell, Hofansicht
1.3 Modell, Gartenansicht
1.4 Gartenansicht, Kohlezeichnung

1 Concrete Country House
Date: early 1923
Client: house for the architect (?)
Location: Berliner or Nauener Vorstadt (?),
Potsdam

1.1 View from garden
1.2 Model
1.3 Model
1.4 View from garden

2 Haus Lessing
Datierung: 1923
Auftraggeber: Lessing (keine weiteren
Angaben)
Ort: Neubabelsberg bei Potsdam

2.1 Grundriß

2 Lessing House
Date: 1923
Client: Lessing (no further information
available)
Location: Neubabelsberg (near Potsdam)

2.1 Plan

3 Landhaus aus Backstein
Datierung: Anfang 1924
Auftraggeber: vermutlich Entwurf zu
einem Wohnhaus des Architekten
Ort: Zunächst für Potsdam (?), später für
Neubabelsberg geplant

3.1 Gartenansicht
3.2 Grundriß (Dachkanten- und Fenster-
linien nachgezogen)

3 Brick Country House
Date: early 1924
Client: house for the architect (?)
Location: originally planned for Potsdam (?),
finally planned for Neubabelsberg

3.1 View from garden
3.2 Plan

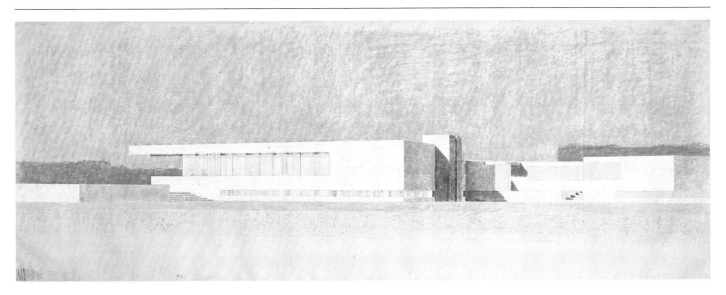

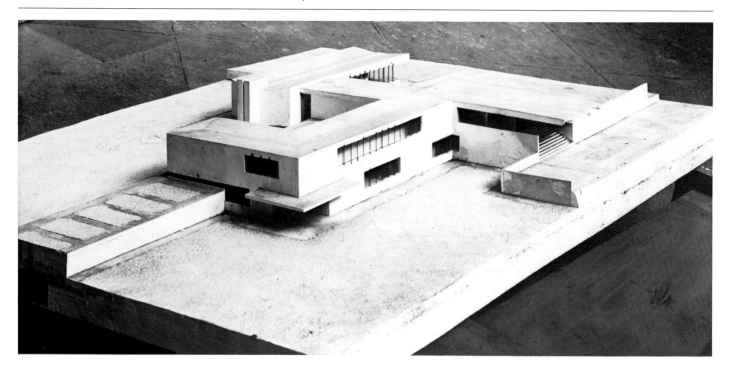

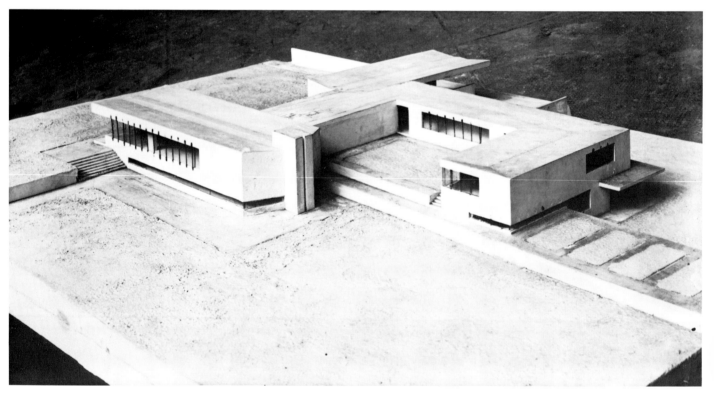

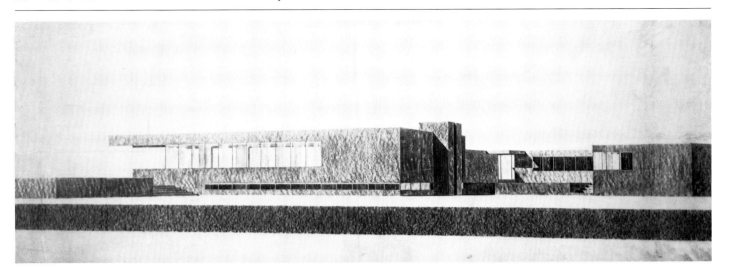

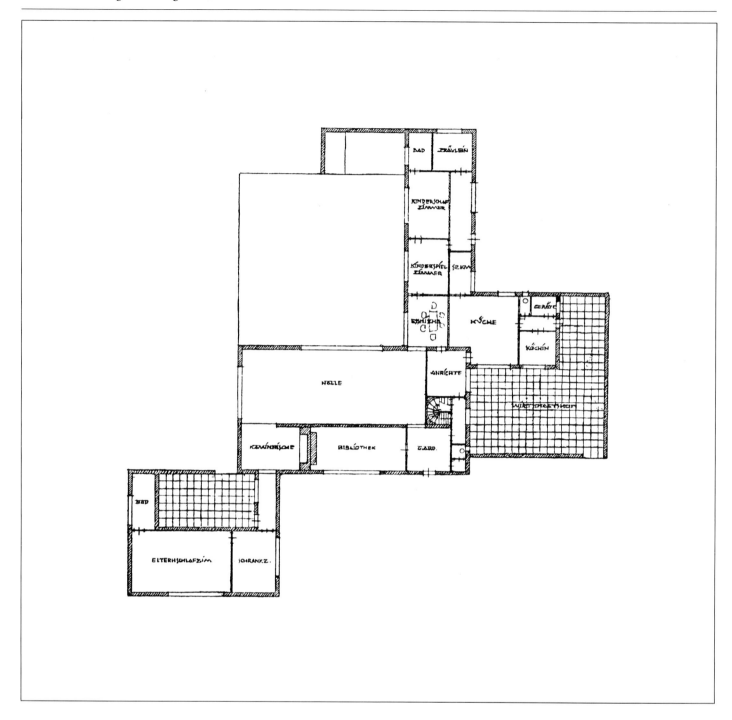

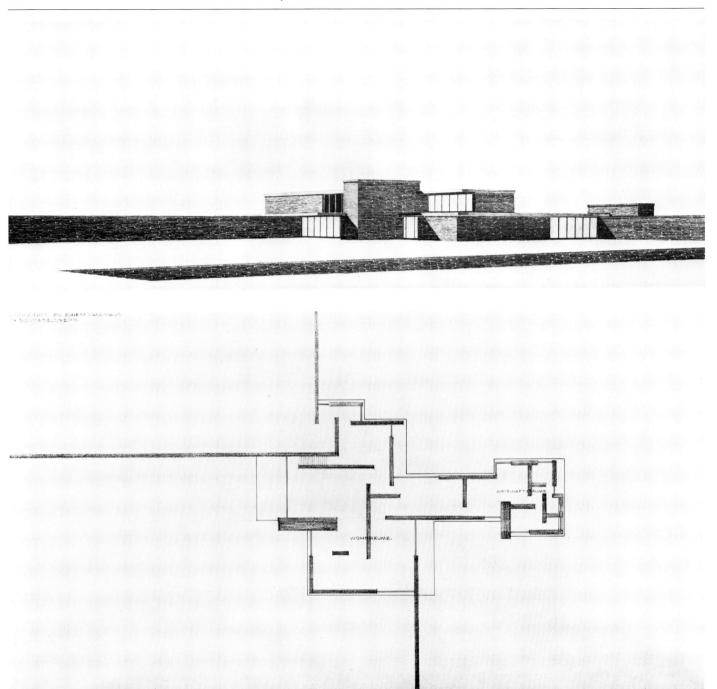

4 Haus Dexel
Datierung: Anfang 1925
Auftraggeber: Walter Dexel, Maler
Ort: Jena, Fuchsturmweg

4.1 Skizzenblatt
4.2 Skizzenblatt
4.3 Skizzenblatt
4.4 Skizzenblatt
4.5 Skizzenblatt
4.6 Grundriß Erdgeschoß
4.7 Grundriß Obergeschoß
4.8 Grundriß Erdgeschoß (Variante)
4.9 Obergeschoß (Variante)

4 Dexel House
Date: early 1925
Client: Walter Dexel, artist
Location: Fuchsturmweg, Jena

4.1 Sketch
4.2 Sketch
4.3 Sketch
4.4 Sketch
4.5 Sketch
4.6 Ground floor
4.7 Upper floor
4.8 Ground floor
4.9 Upper floor

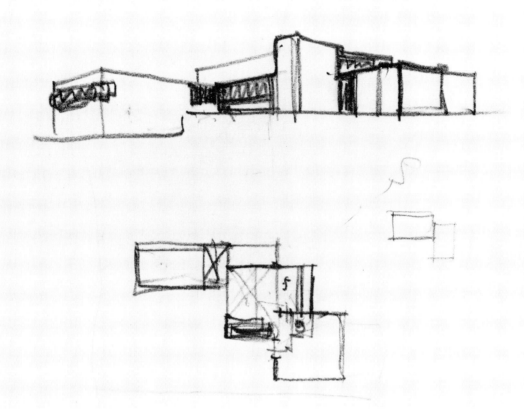

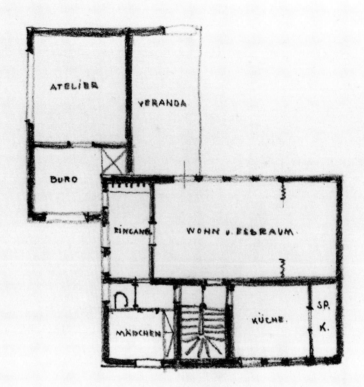

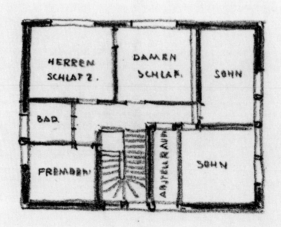

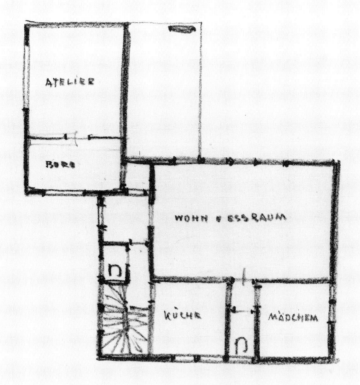

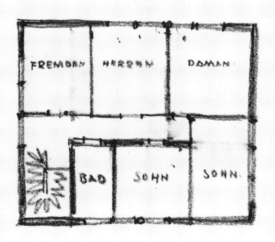

5 Haus Eliat
Datierung: 1925
Auftraggeber: Ernst Eliat, Bankier
Ort: Nedlitz bei Potsdam, Grundstück am
Fahrländer See

5.1 Eingangslösung
5.2 Detail aus 5.3
5.3 Lageplan
5.4 Aufriß Gartenseite und Grundriß
 Tiefgeschoß
5.5 Aufriß Straßenseite und Grundriß
 Hauptgeschoß

5 Eliat House
Date: 1925
Client: Ernst Eliat, banker
Location: at Fahrländer See, Nedlitz
(near Potsdam)

5.1 Street elevation
5.2 Detail of 5.3
5.3 Site plan
5.4 Lower floor and garden elevation
5.5 Main floor and street elevation

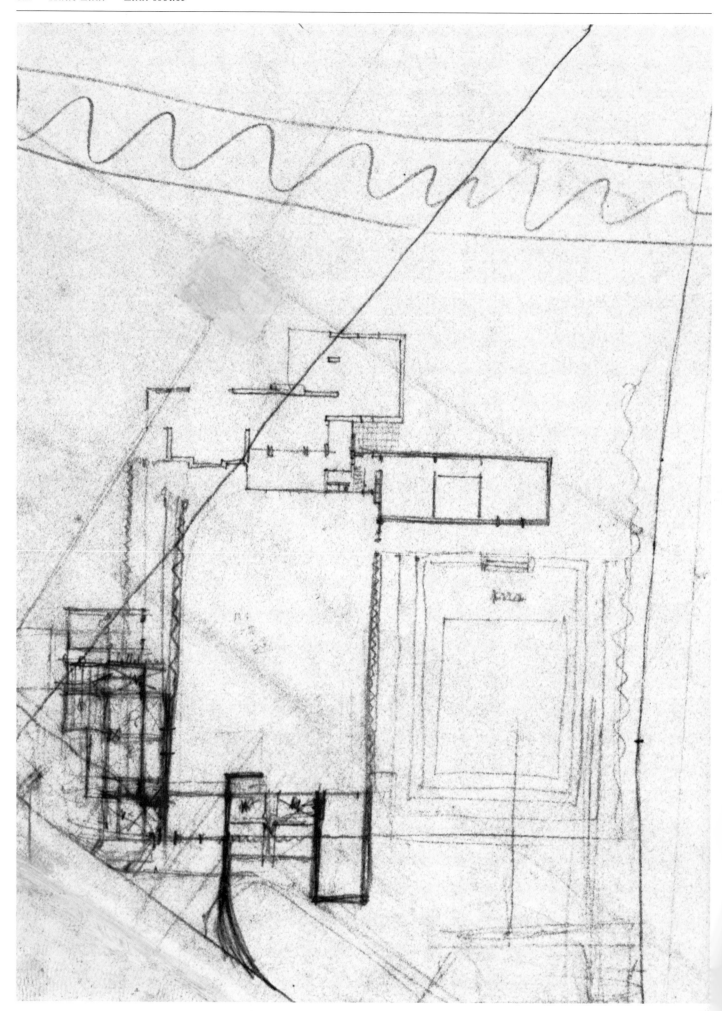

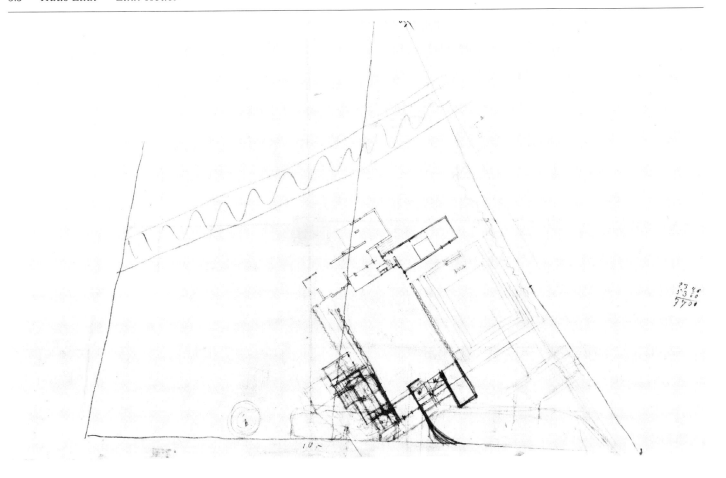

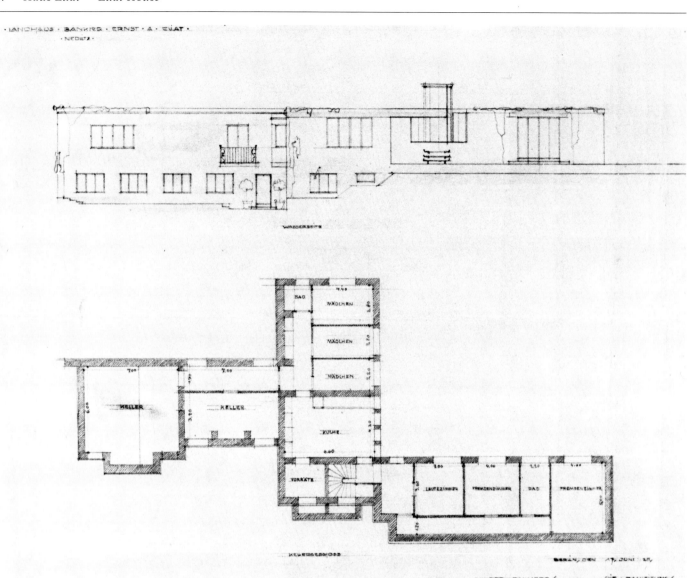

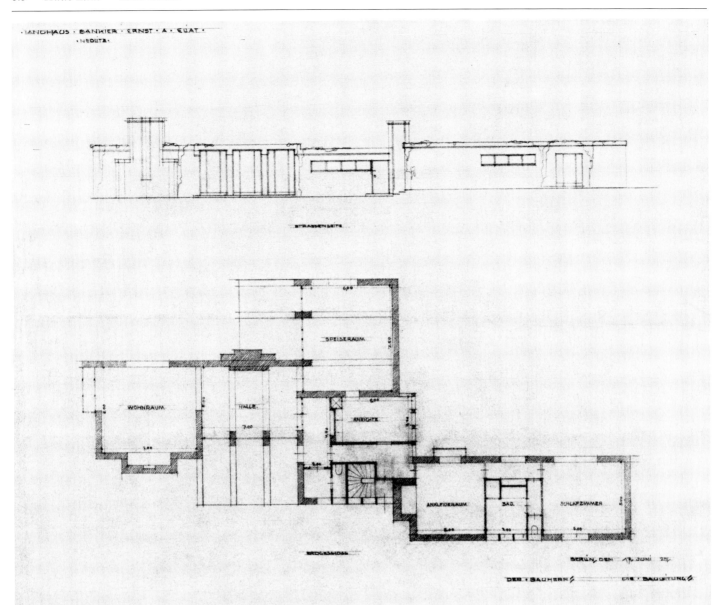

6 Haus Wolf
Datierung: 1925–27
Bauherr: Erich Wolf, Fabrikant
Ort: Guben, Teichbornstraße
Auftragsvergabe: vermutlich Januar oder
Februar 1925
Baubeginn: nicht vor Ende 1925
Innenausstattung: 1927

6 Wolf House
Date: 1925–27
Client: Erich Wolf, businessman
Location: Teichbornstrasse, Guben
Date of commission: Probably January or
February 1925
Beginning of construction: not before
late in 1925
Furnishings: 1927

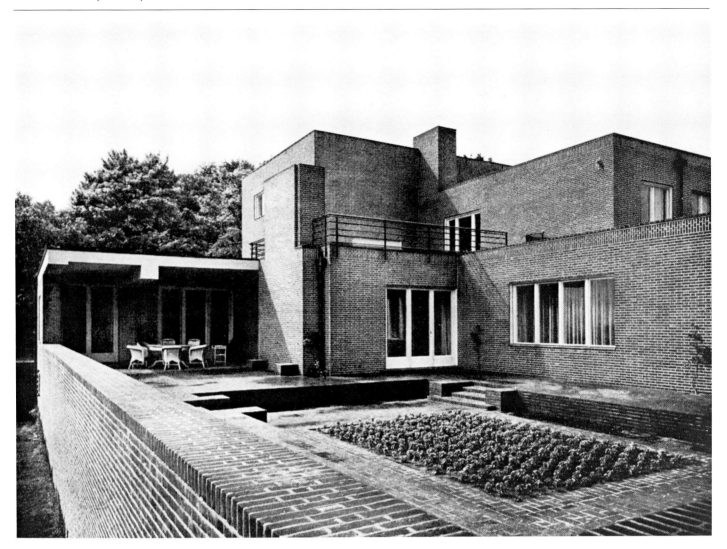

LANDHAUS · ERICH WOLF · GUBEN ·

I

ANSICHT VON DER GRÜNEN WIESE.

LANDHAUS · ERICH WOLF · GUBEN ·

II

ANSICHT VON DER TEICHBORNSTRASSE.

LANDHAUS·ERICH WOLF·GUBEN· ᴶᴵ·

ANSICHT VOM LINDENGRABEN.

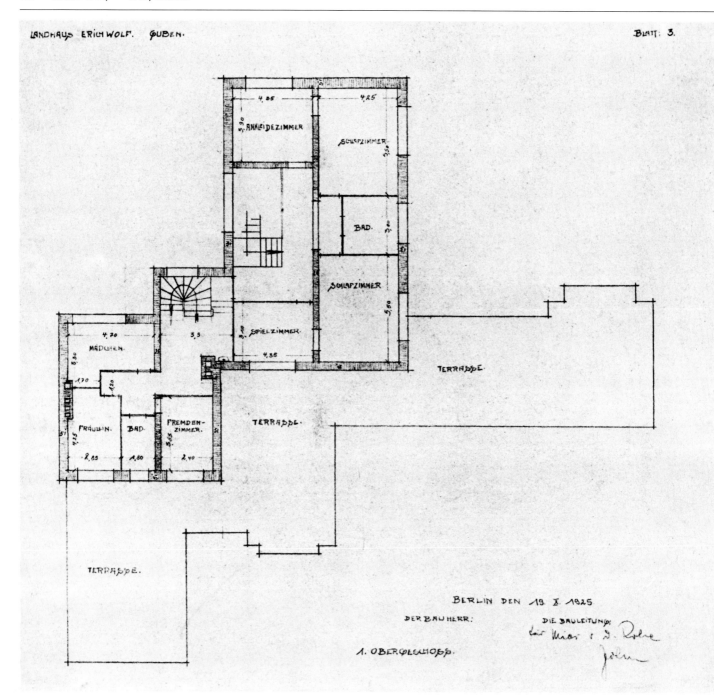

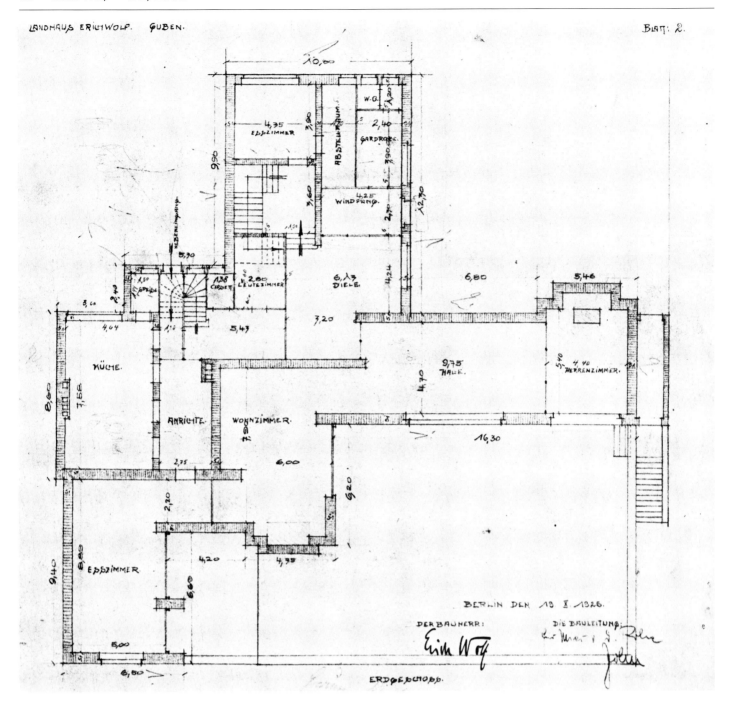

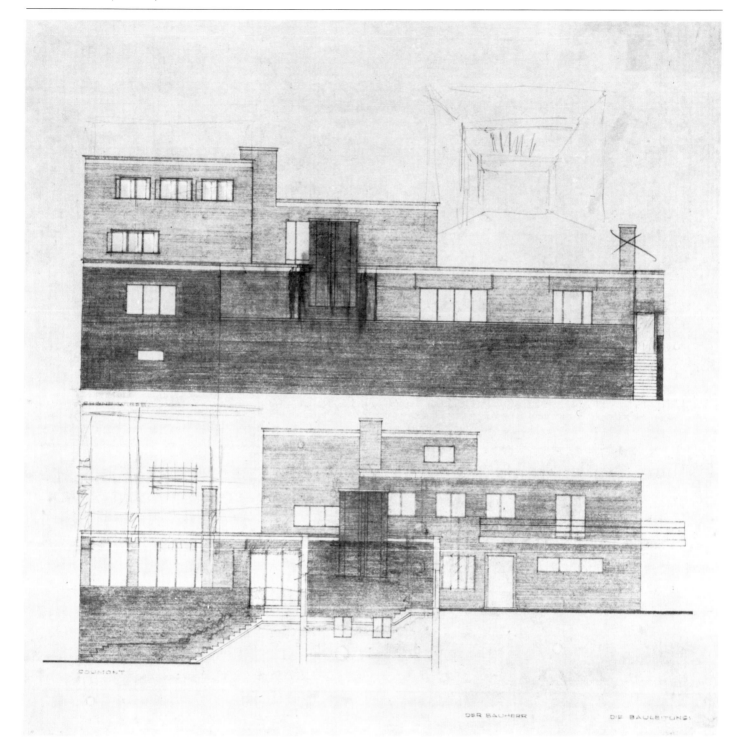

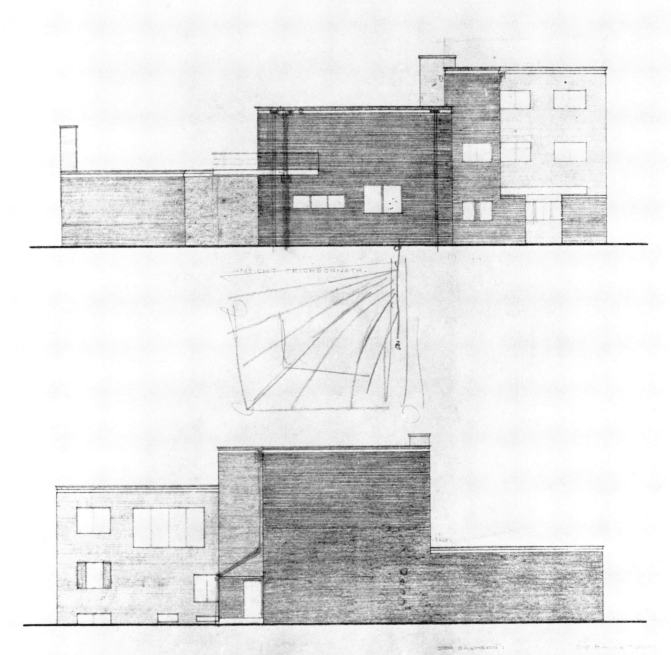

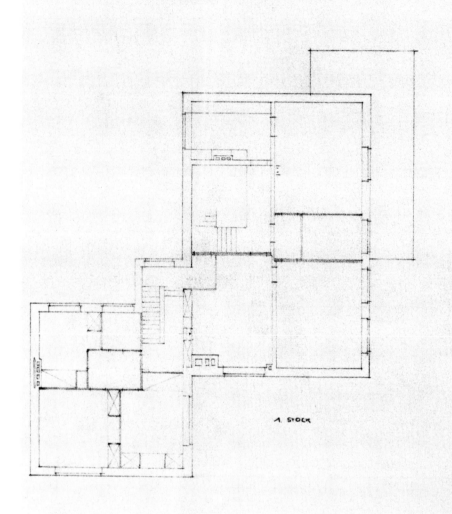

1. STOCK

DACHGESCHOSS

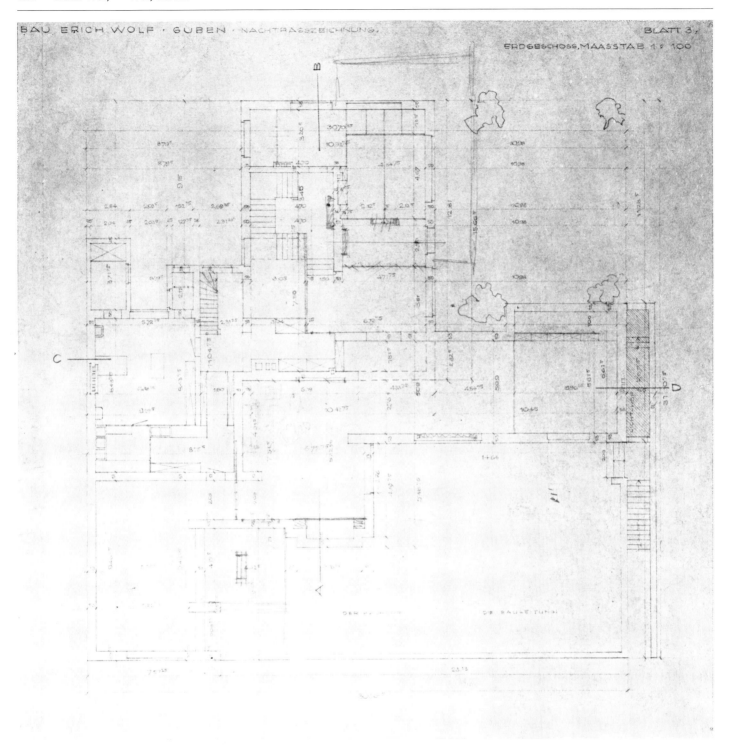

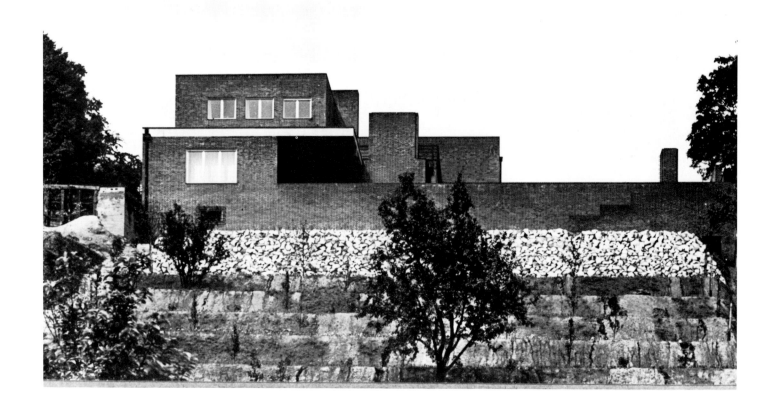

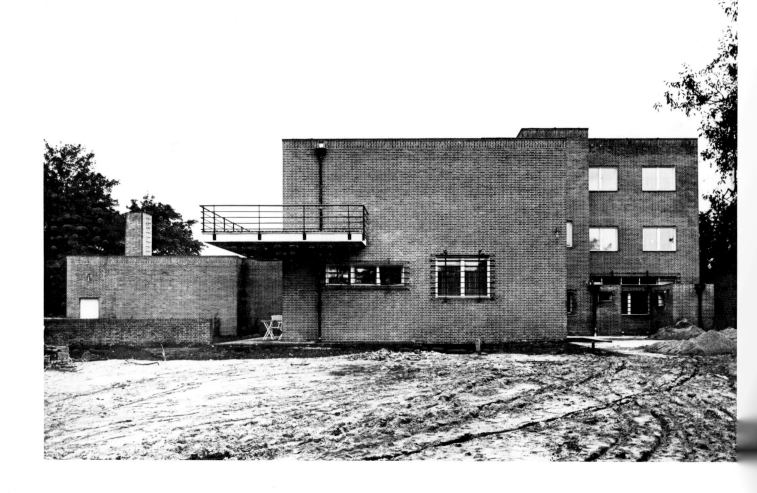

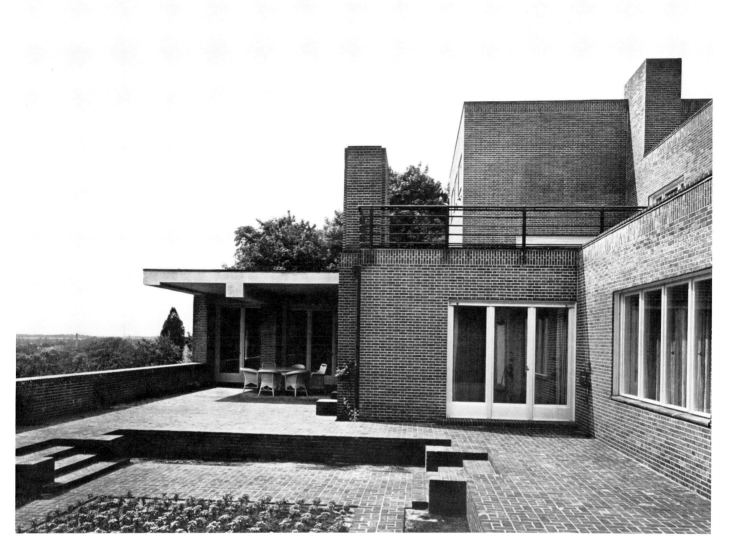

7 Haus Esters
Datierung: 1927–30
Bauherr: Dr. Josef Esters, Seidenfabrikant
Ort: Krefeld, Wilhelmshofallee 97
Auftragsvergabe: Ende 1927
Baubeginn: Oktober 1928
Innenausstattung: ab Herbst 1929

7 Esters House
Date: 1927–30
Client: Dr. Josef Esters, silk manufacturer
Location: Wilhelmshofallee 97, Krefeld
Date of commission: end of 1927
Beginning of construction: October 1928
Furnishings: starting in fall 1929

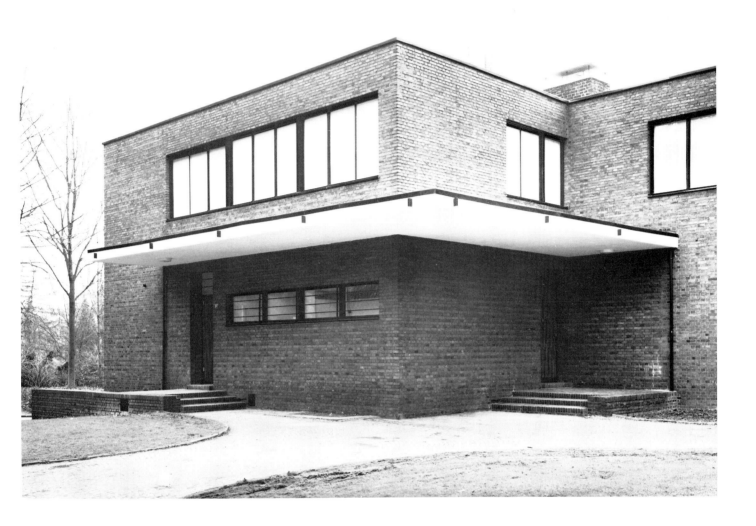

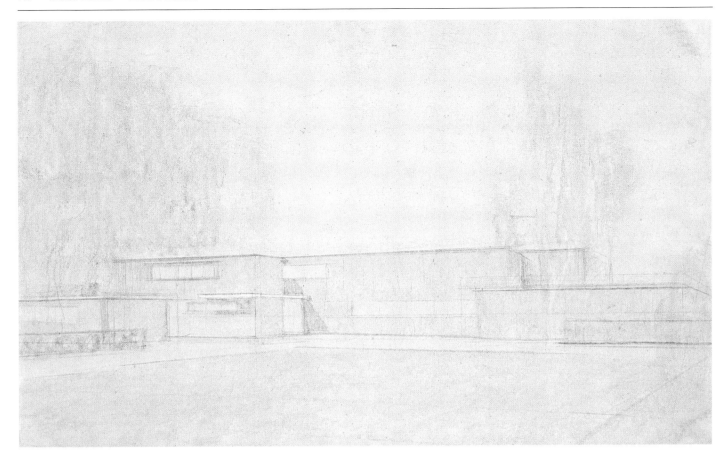

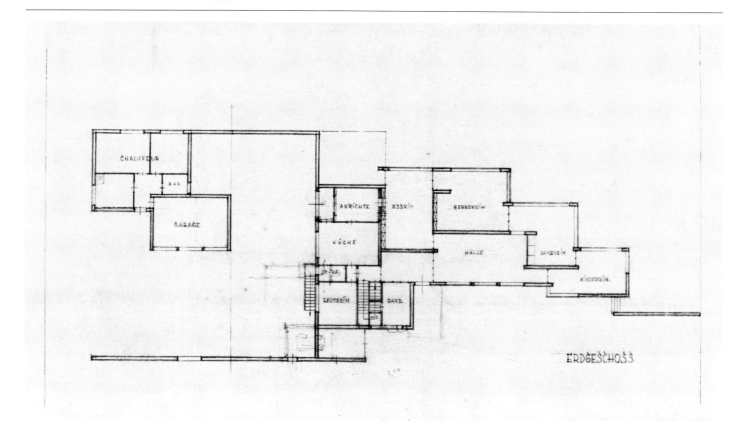

LANDHAUS DR. ESTERS KREFELD

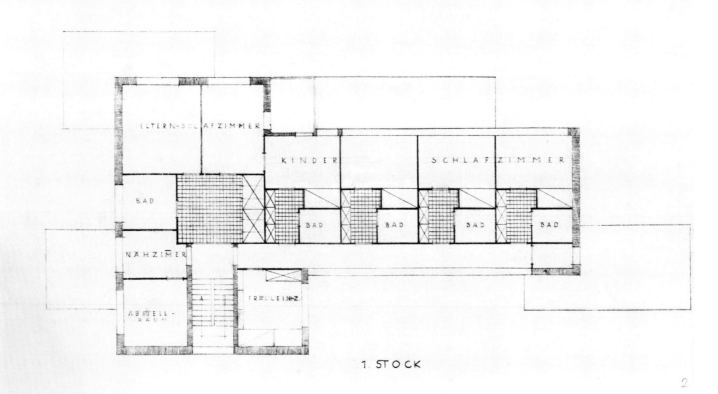

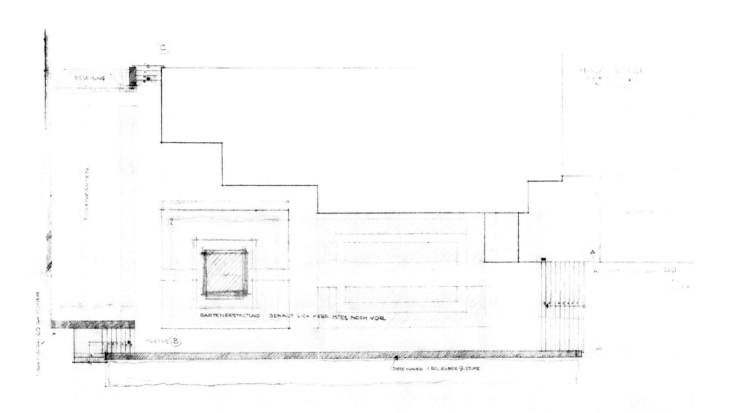

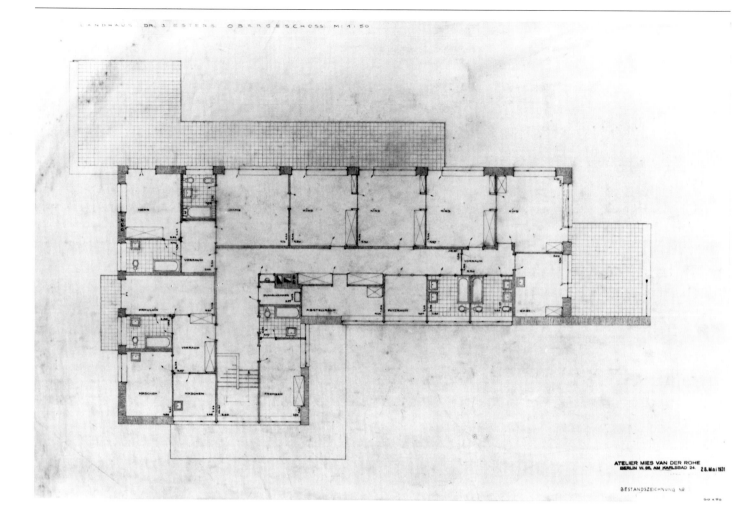

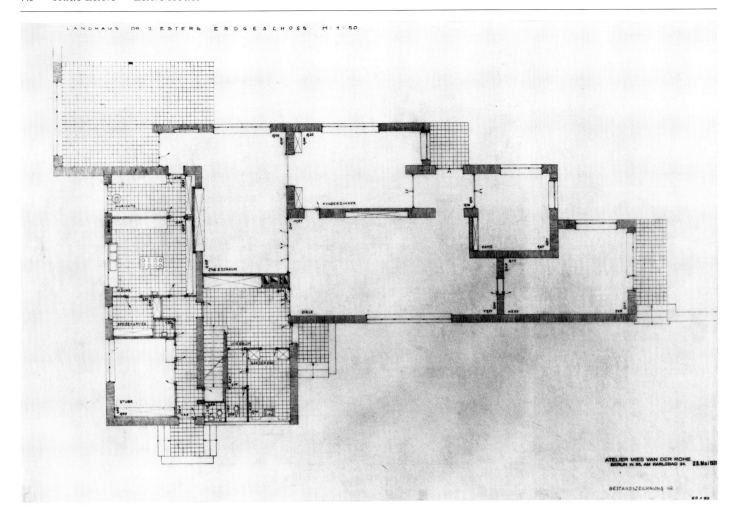

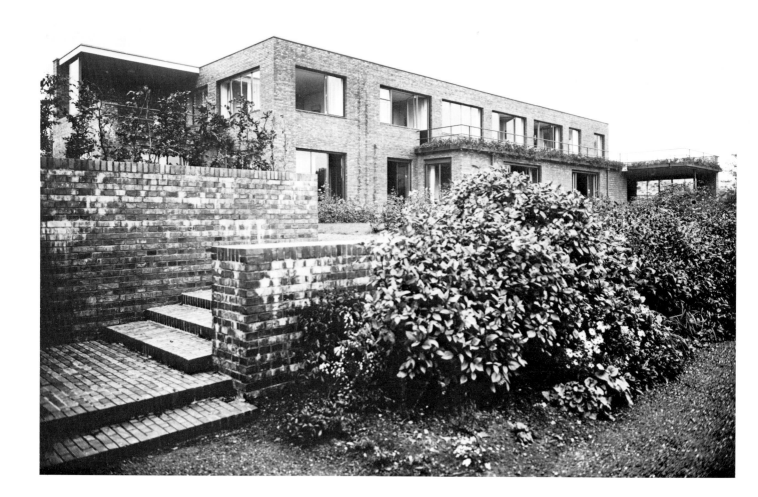

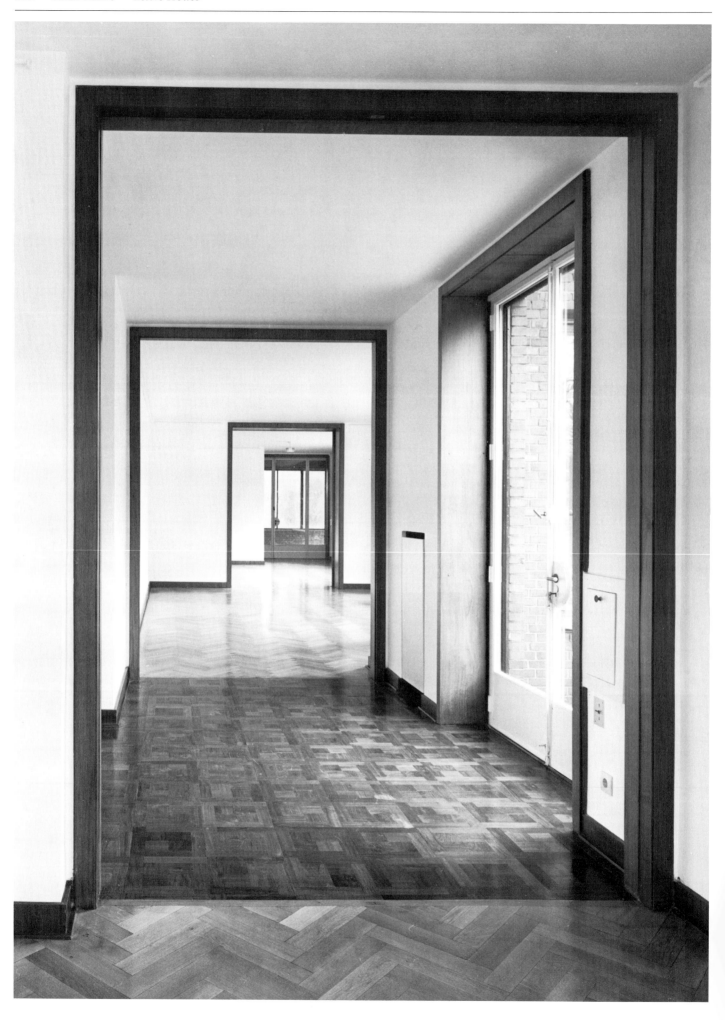

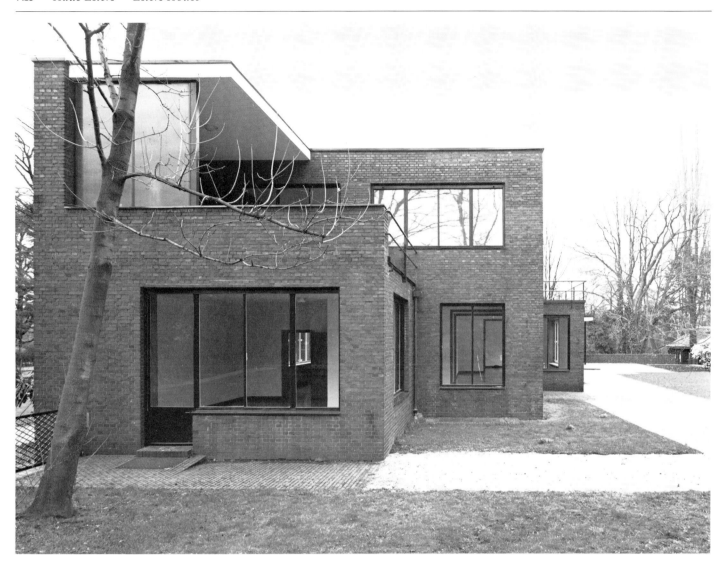

8 Haus Hermann Lange

Datierung: 1927–30
Bauherr: Hermann Lange, Seidenfabrikant
Ort: Krefeld, Wilhelmshofallee 91
Auftragsvergabe: Ende 1927 oder
Anfang 1928
Baubeginn: Oktober 1928
Innenausstattung: ab Herbst 1929

8.1 Gartenansicht (Detail)
8.2 Steingerechter Aufriß (Detail
 Gartenseite)
8.3 Grundriß Obergeschoß
8.4 Vier Aufrisse
8.5 Grundriß Erdgeschoß
8.6 Gartenansicht
8.7 Straßenansicht
8.8 Blick von der Eingangshalle in den
 Garten (Aufnahme 1981)
8.9 Ostansicht (Aufnahme 1981)

8 Hermann Lange House

Date: 1927–30
Client: Hermann Lange, silk manufacturer
Location: Wilhelmshofallee 91, Krefeld
Date of commission: end of 1927
or early 1928
Beginning of construction: October 1928
Furnishings: starting in fall 1929

8.1 View from garden
8.2 South elevation. Detail
8.3 Upper floor
8.4 Four elevations
8.5 Ground floor
8.6 View from garden
8.7 View from street
8.8 View from entrance hall towards
 garden. 1981
8.9 View from east. 1981

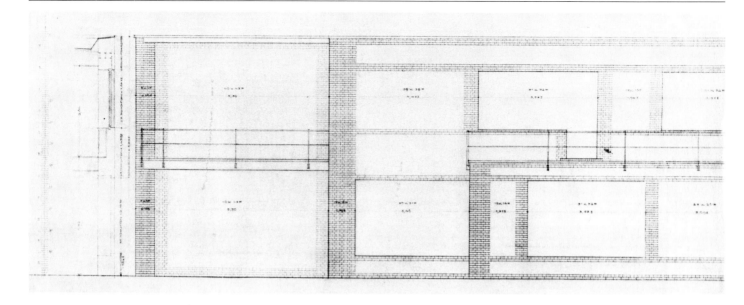

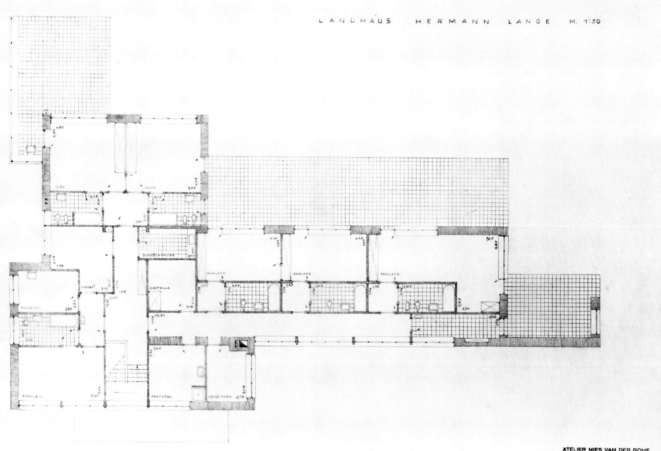

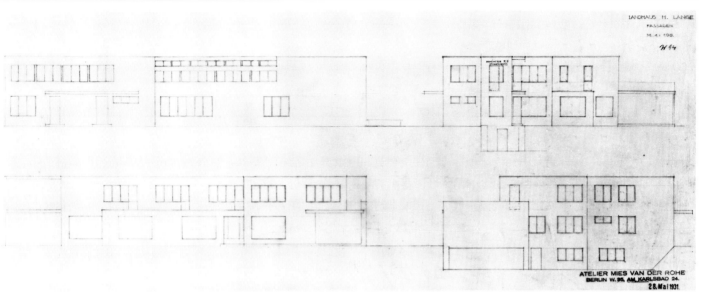

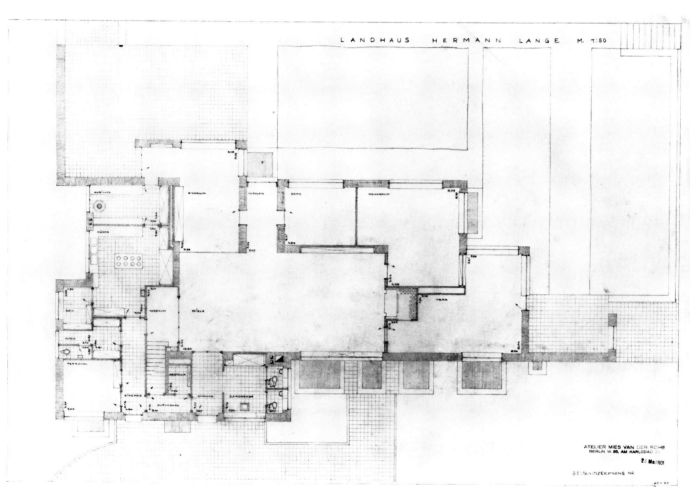

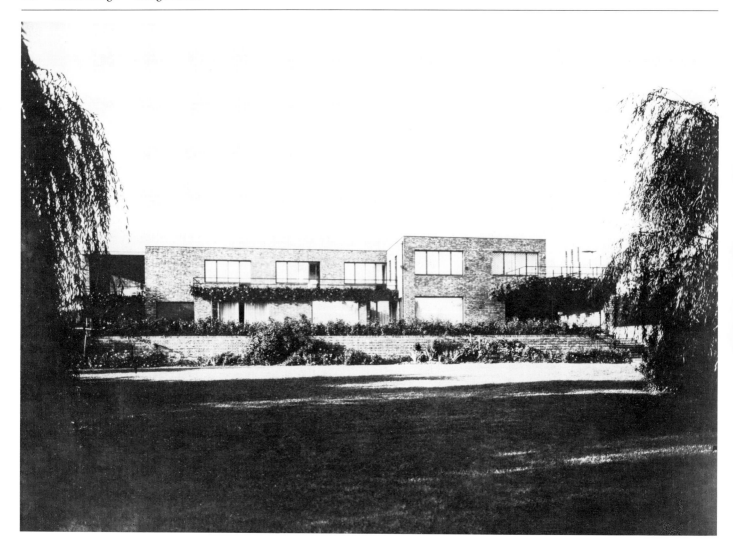

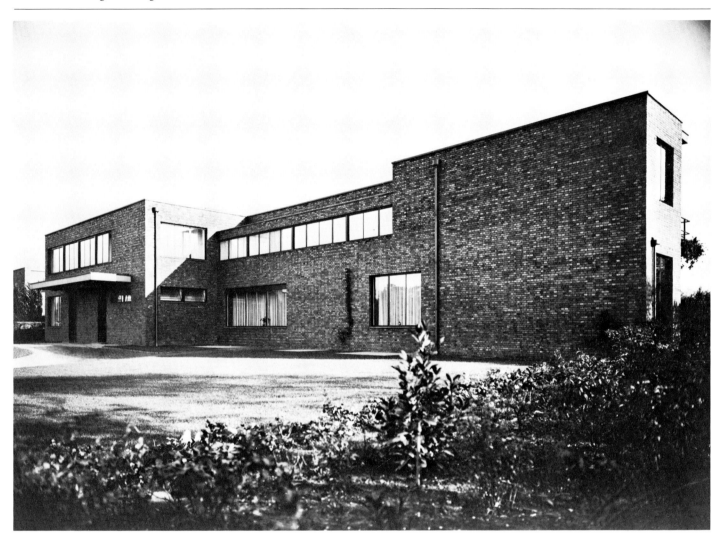

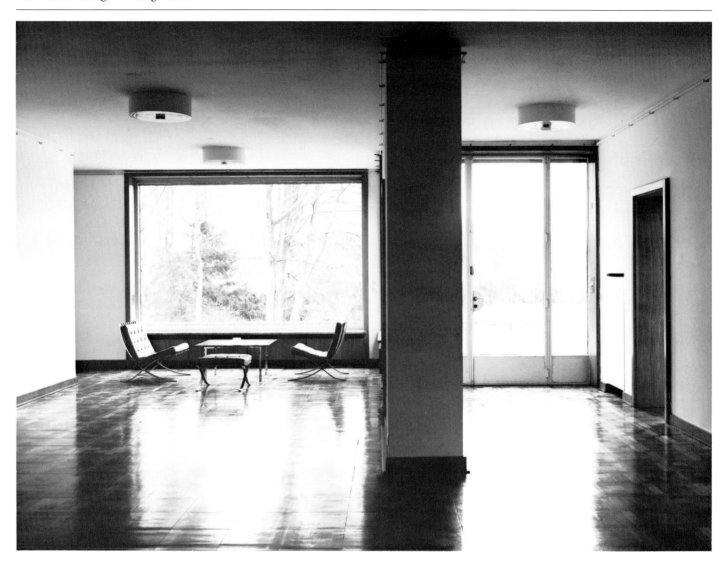

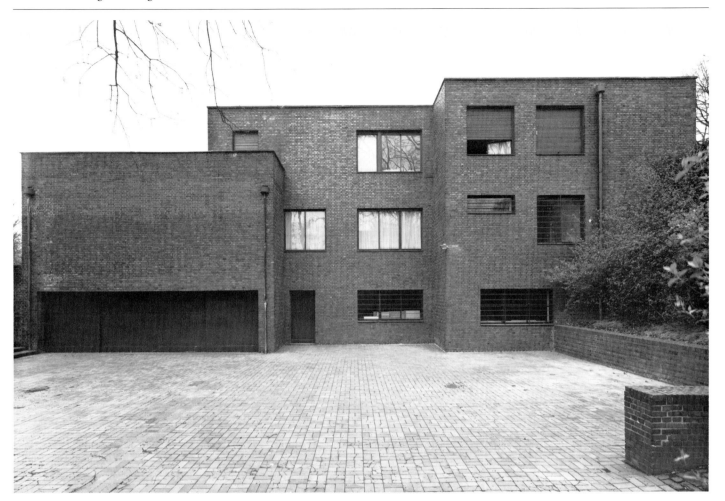

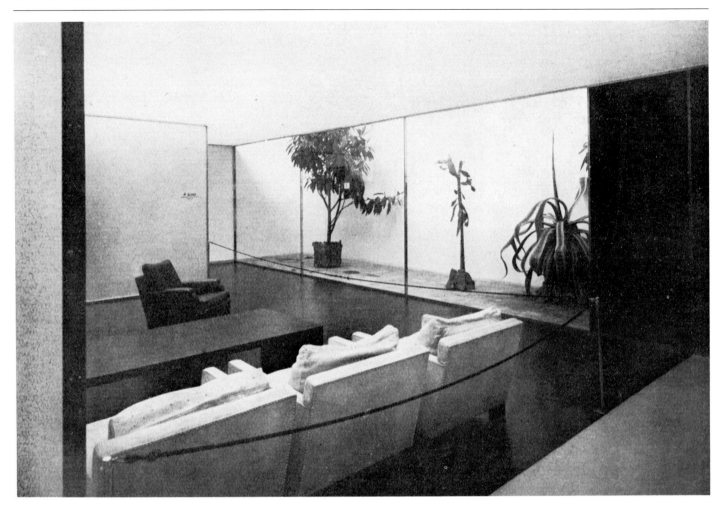

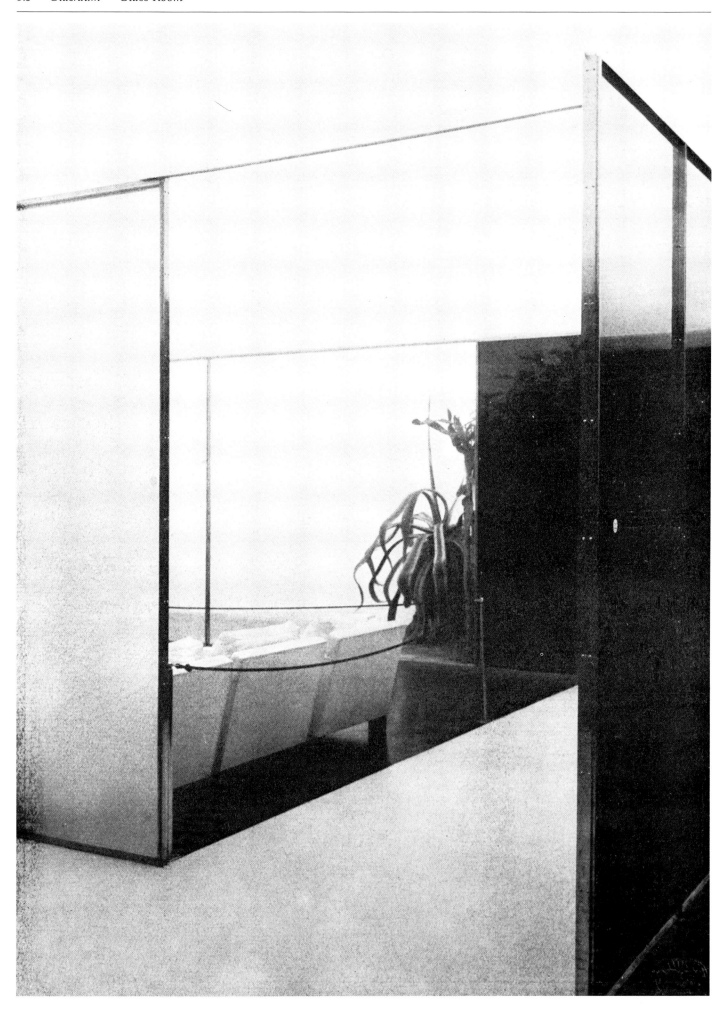

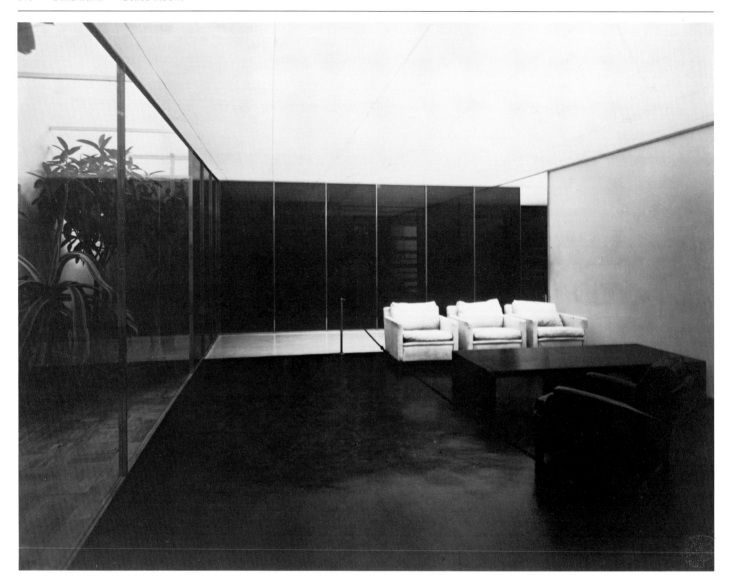

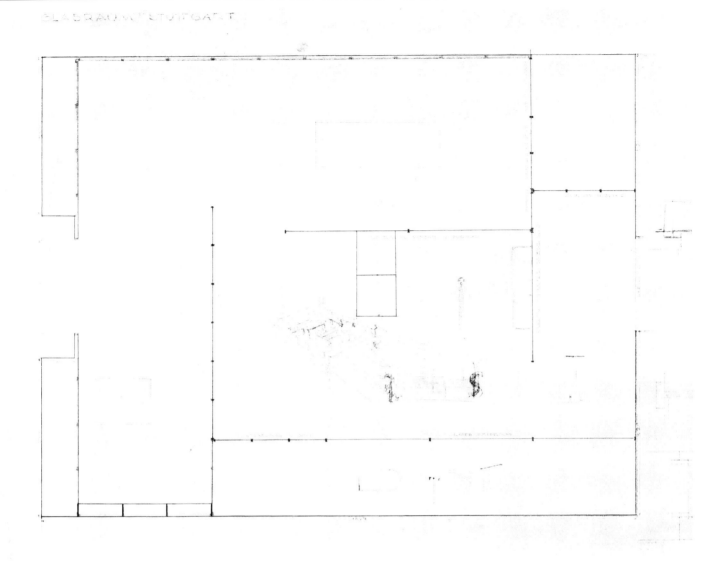

10 Barcelona Pavillon

Datierung: 1928–29
Bauherr: Deutsches Generalkommissariat
auf der „Internationalen Ausstellung
Barcelona 1929", im Auftrag des Deutschen
Reiches, Reichswirtschaftsministerium
Ort: Barcelona, Ausstellungsgelände am
Motjuich
Auftragsvergabe: Sommer 1928
Planungsbeginn: November 1928
Baubeginn: Frühjahr 1929
Fertigstellung: Ende Mai 1929

10.1	Während der Bauarbeiten
10.2	Plan I
10.3	Straßenansicht (Vorprojekt)
10.4	Plan II
10.5	Gartenansicht (Planungsstadium)
10.6	Innenansicht
10.7	Grundriß (Rekonstruktion 1979)
10.8	Straßenansicht
10.9	Straßenansicht
10.10	Eingangsbereich (Blick nach Norden)
10.11	Blick vom großen Wasserbecken
10.12	Blick vom Büroanbau
10.13	Blick zum kleinen Wasserbecken
10.14	Wasserbecken mit Kolbe-Statue „Der Morgen"
10.15	Wasserbecken mit Kolbe-Statue
10.16	Blick zum Büroanbau
10.17	Innenansicht
10.18	Innenansicht
10.19	Innenansicht
10.20	Ausgang zum Garten
10.21	Gartenansicht mit erleuchteter Glaswand

10 Barcelona Pavilion

Date: 1928–29
Client: The German General Commissio-
ner for the „International Exhibition
Barcelona 1929" (in charge of Deutsches
Reich, Reichswirtschaftsministerium)
Location: exhibition area at Montjuich,
Barcelona
Date of commission: summer 1928
Project starting: November 1928
Construction starting: spring 1929
Completion: end of May 1929

10.1	Pavilion during construction work
10.2	Plan I
10.3	Street elevation. Preliminary scheme
10.4	Plan II
10.5	Garden elevation. Preliminary version
10.6	Interior perspective
10.7	Plan. Reconstruction drawing. 1979
10.8	View from street
10.9	View from street
10.10	Entrance area. Looking north
10.11	View from edge of large pool
10.12	View from office annex
10.13	View towards small pool
10.14	Small pool with sculpture
10.15	Small pool with sculpture
10.16	View towards office annex
10.17	Interior
10.18	Interior
10.19	Interior
10.20	Rear entrance
10.21	View from garden with illuminated light-wall

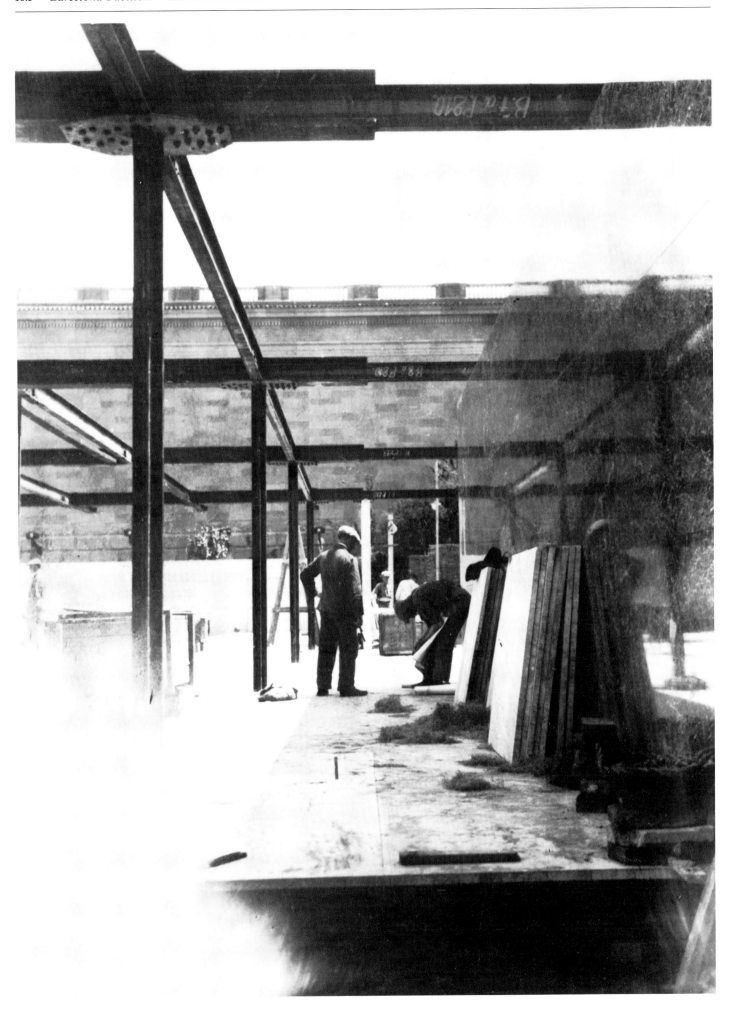

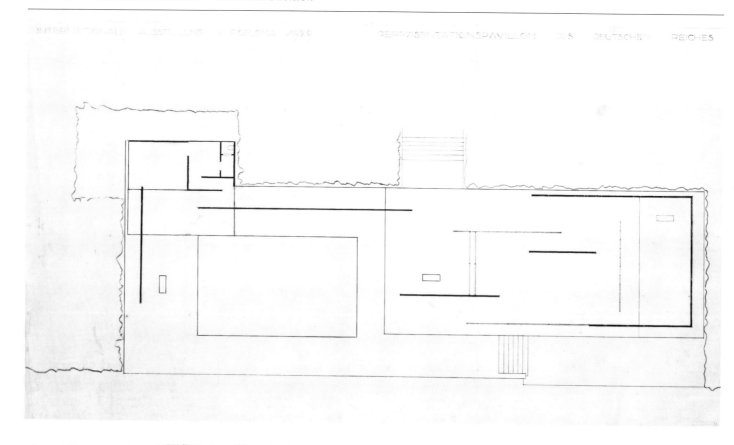

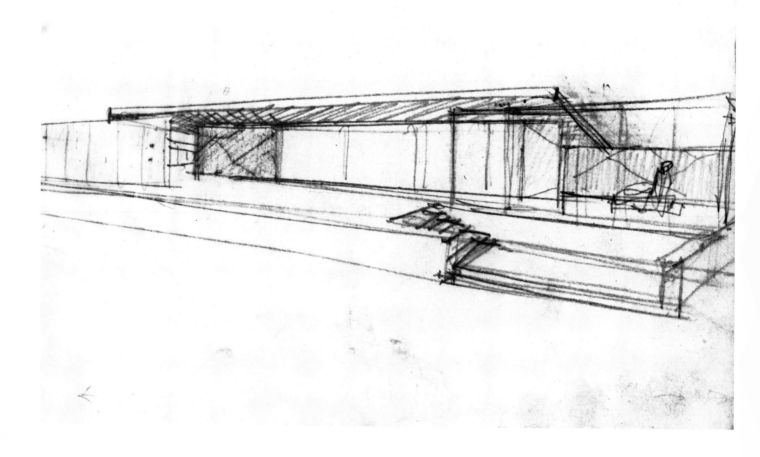

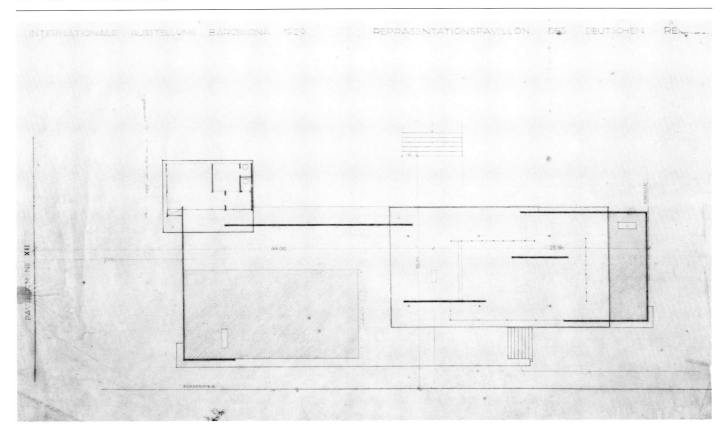

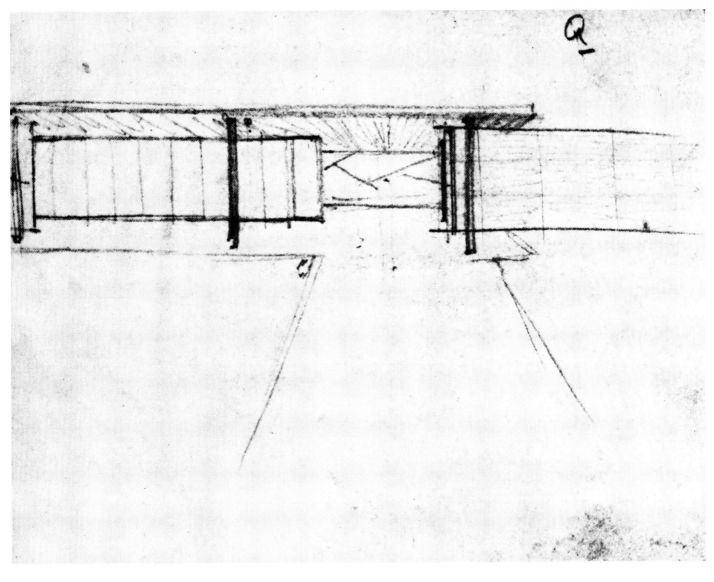

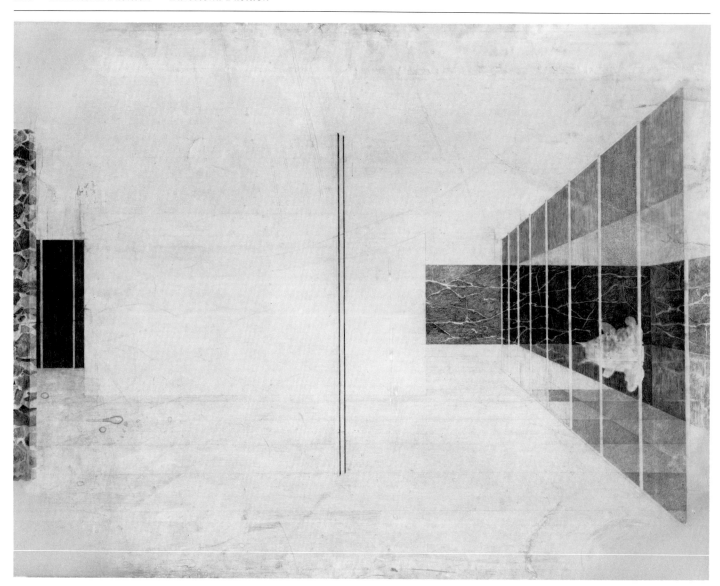

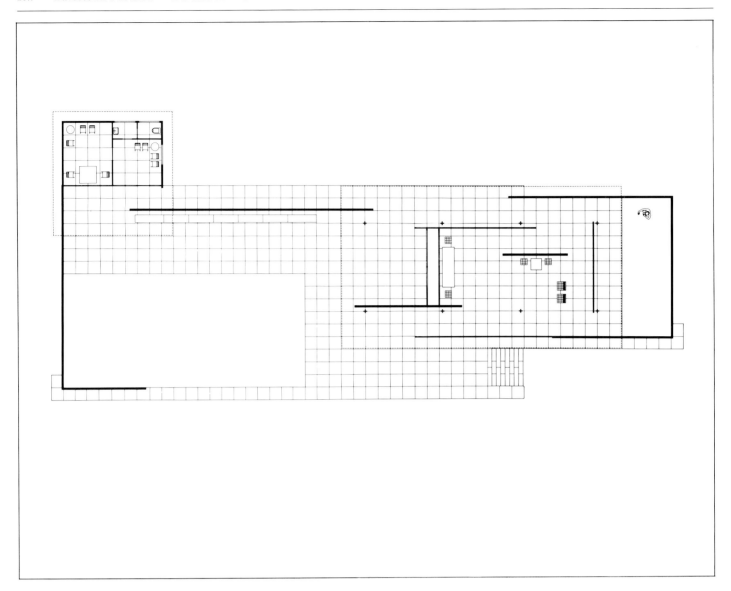

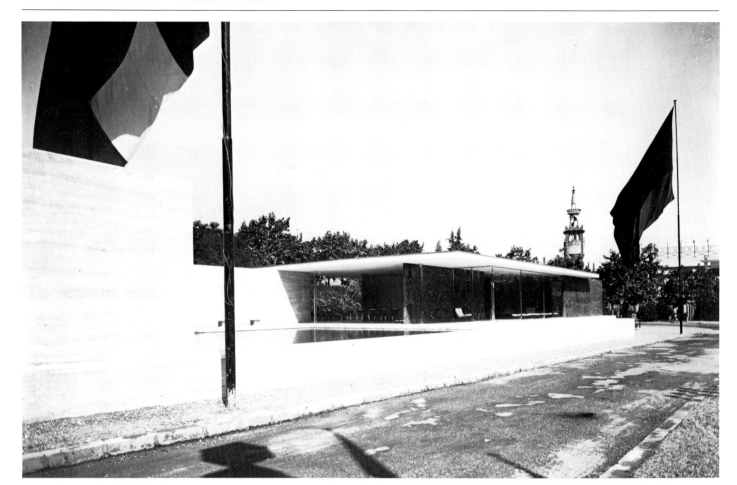

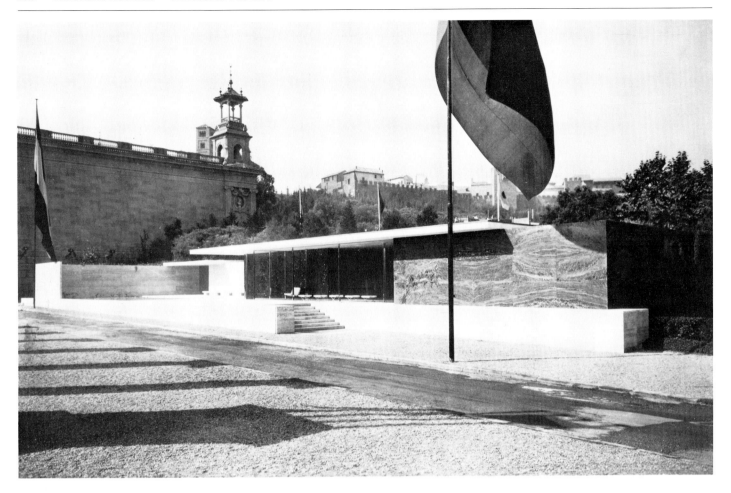

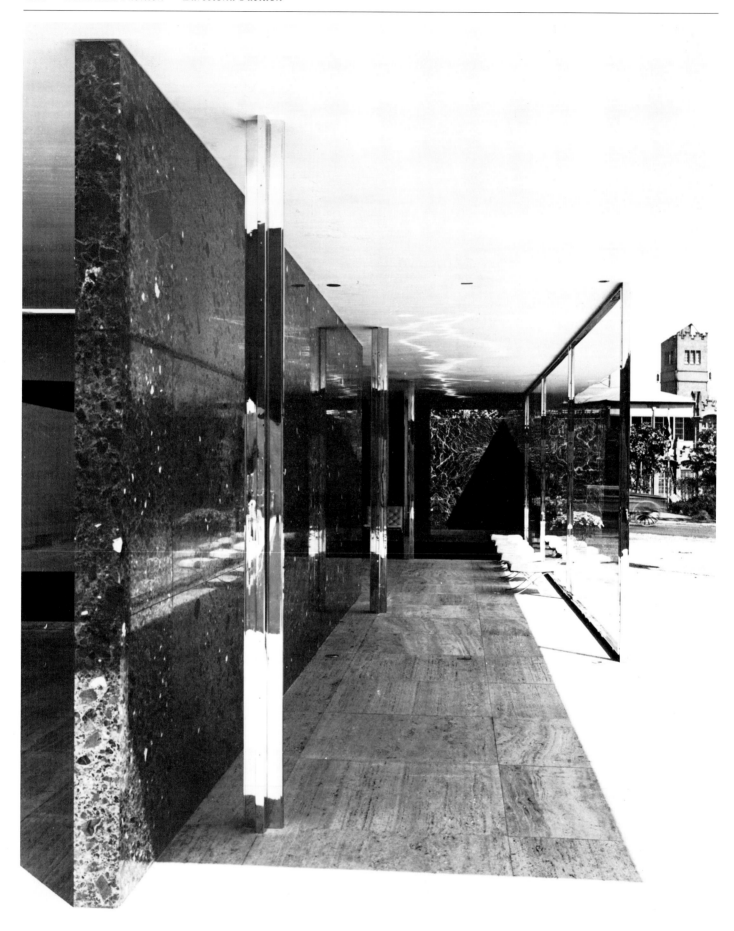

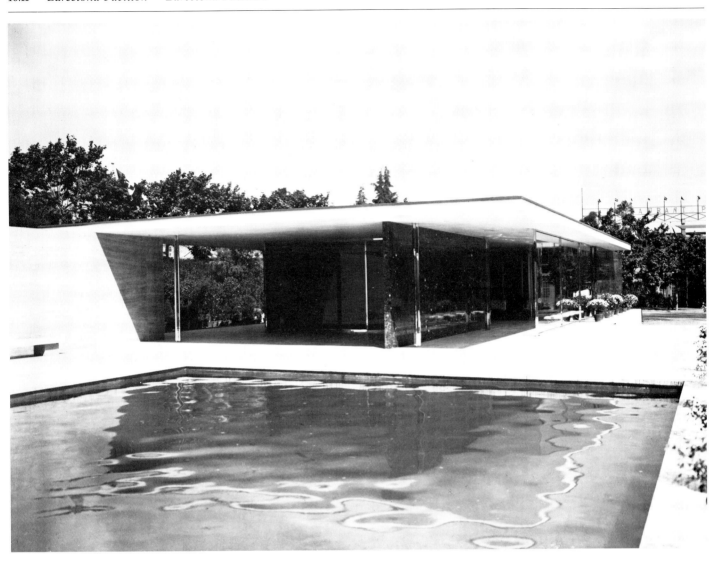

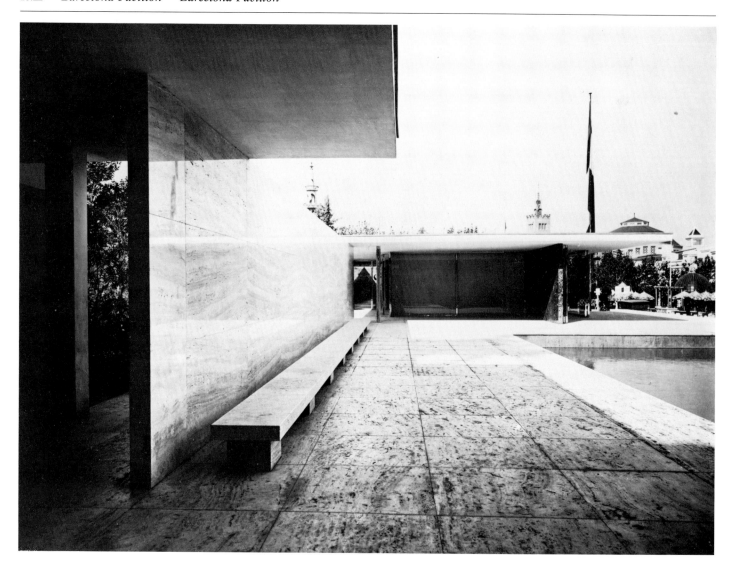

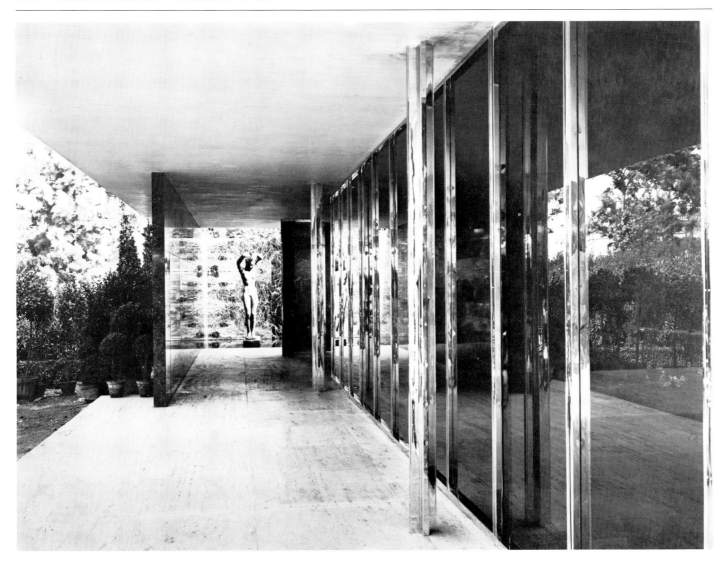

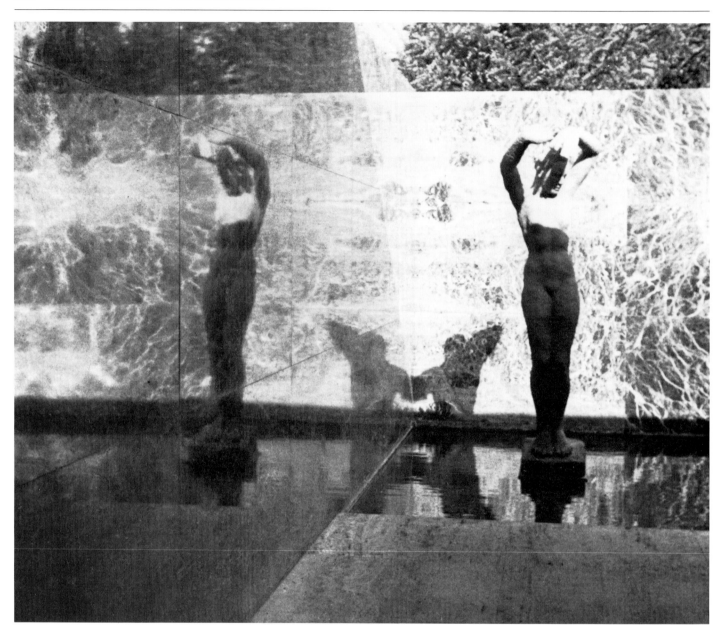

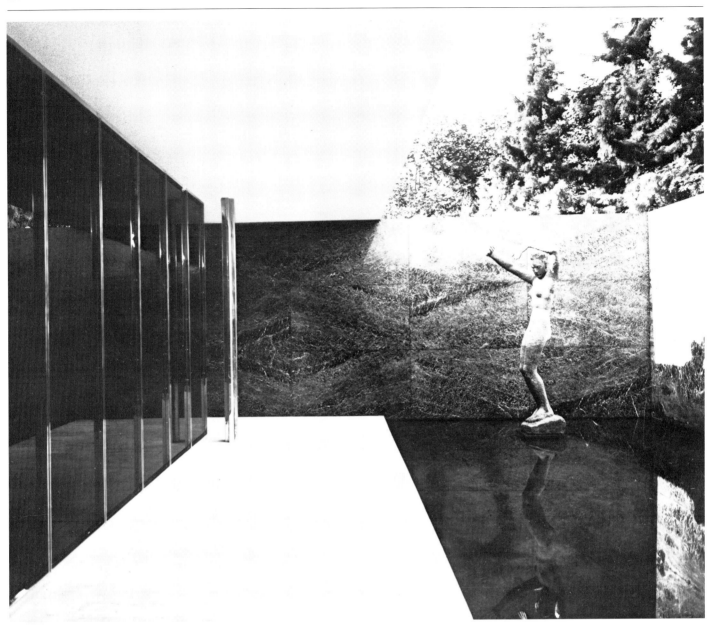

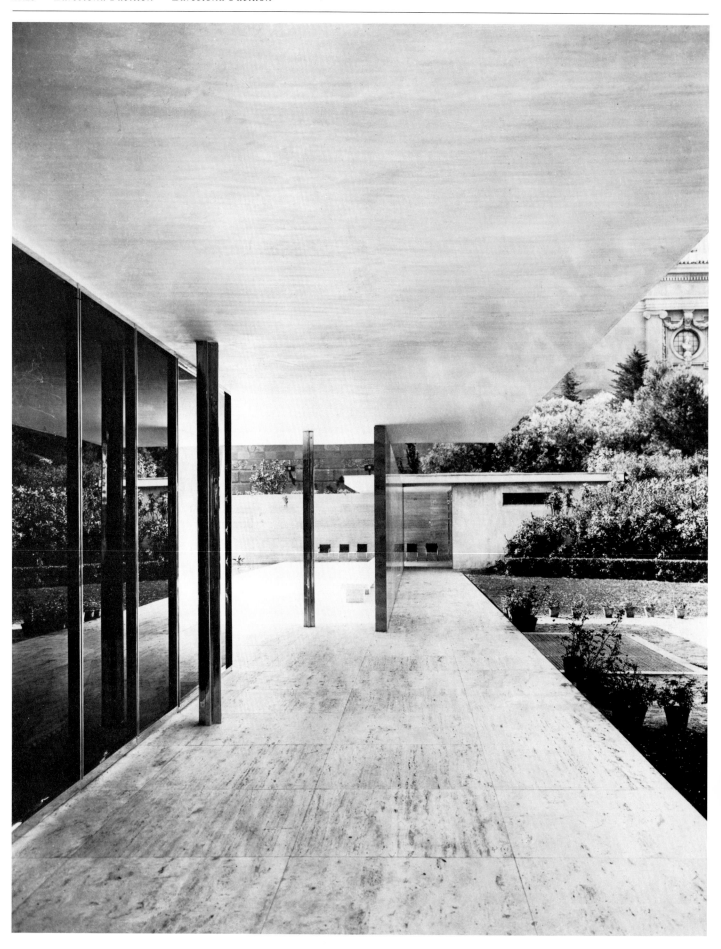

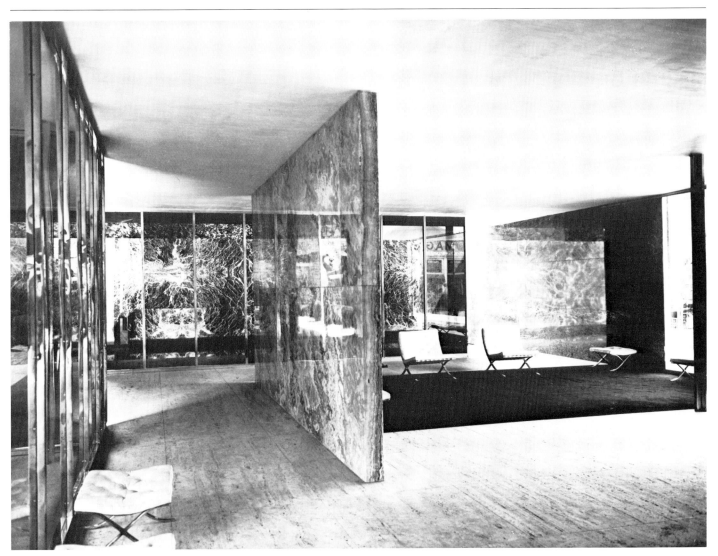

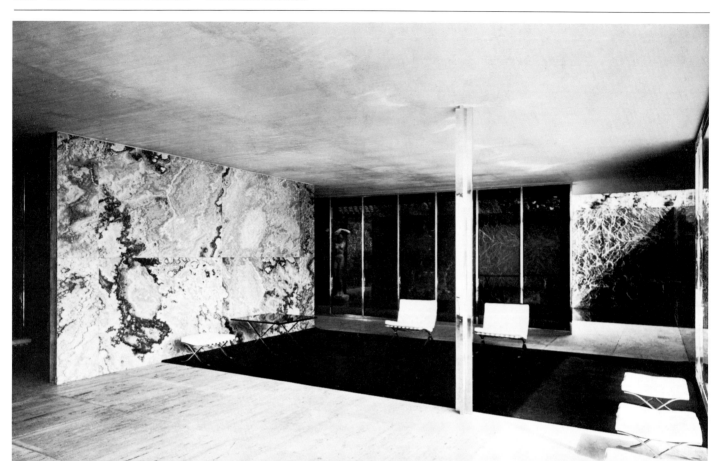

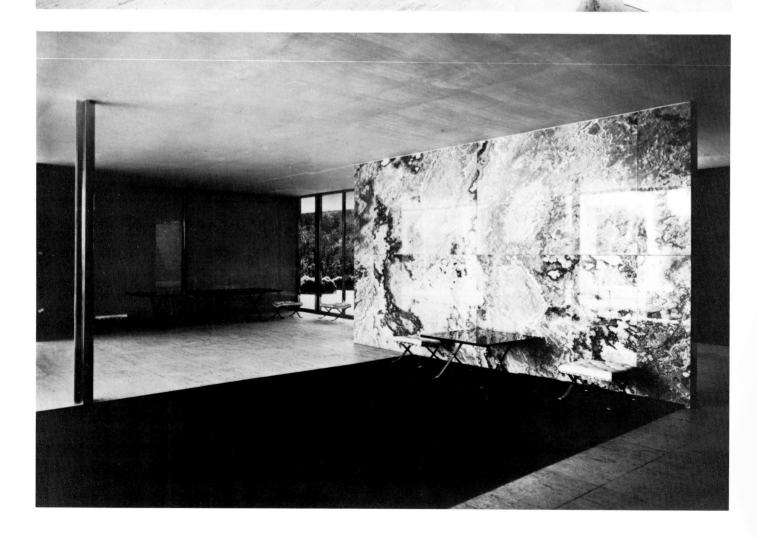

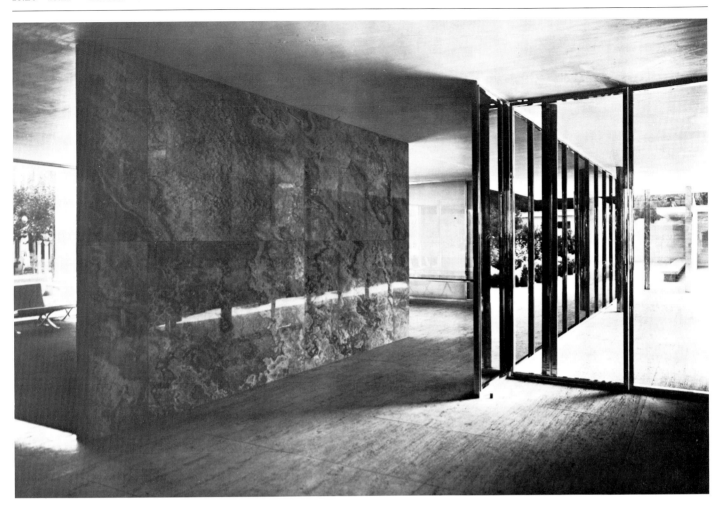

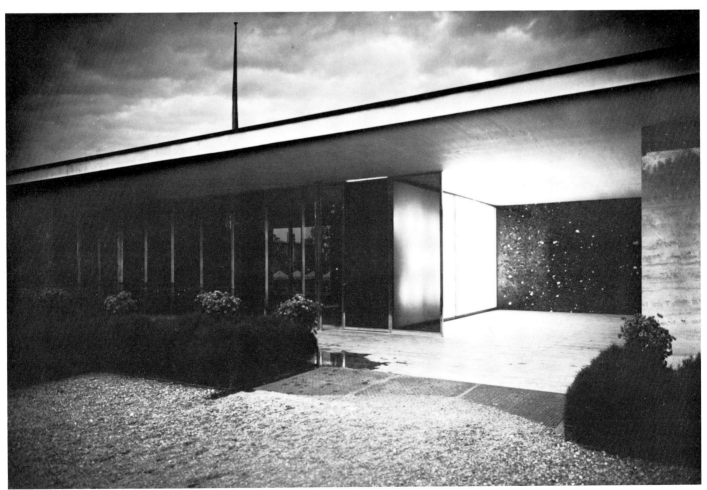

11 Haus Tugendhat

Datierung: 1928–30
Bauherr: Fritz und Grete Tugendhat
Ort: Brno (Brünn), Schwarzfeldgasse 45
Auftragsvergabe: Sommer 1928
Planungsbeginn: Herbst 1928
Baubeginn: Juni 1929
Innenausstattung: 1930
Fertigstellung: November 1930

11 Tugendhat House

Date: 1928–30
Client: Fritz and Grete Tugendhat
Location: Schwarzfeldgasse 45, Brno
(Czechoslovakia)
Date of commission: summer 1928
Project starting: fall 1928
Construction starting: June 1929
Furnishings: 1930
Completion: November 1930

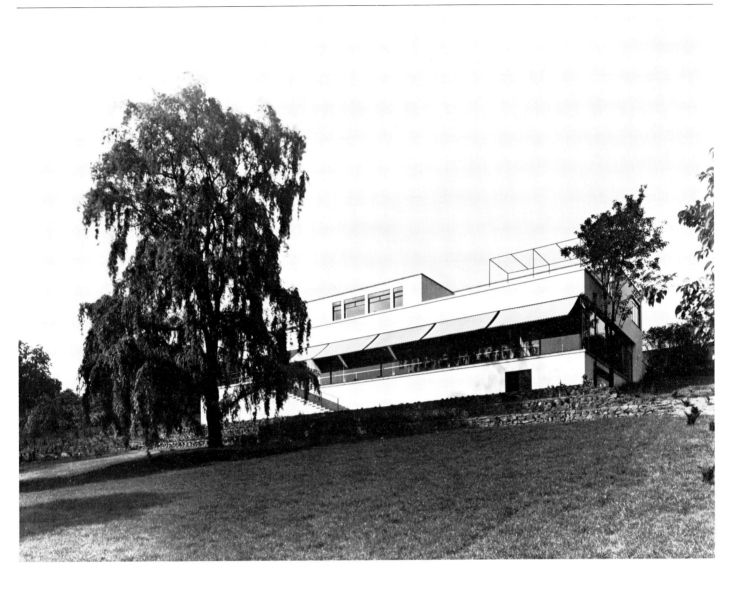

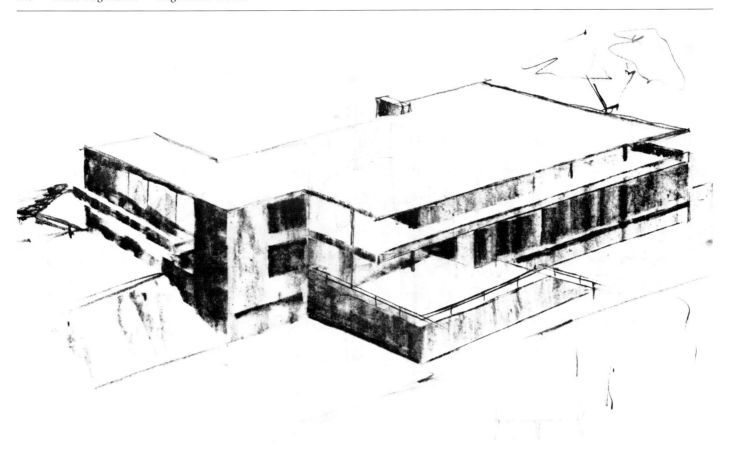

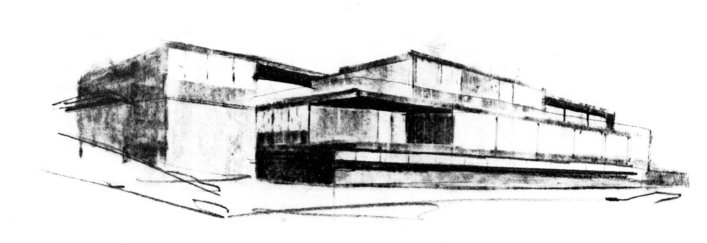

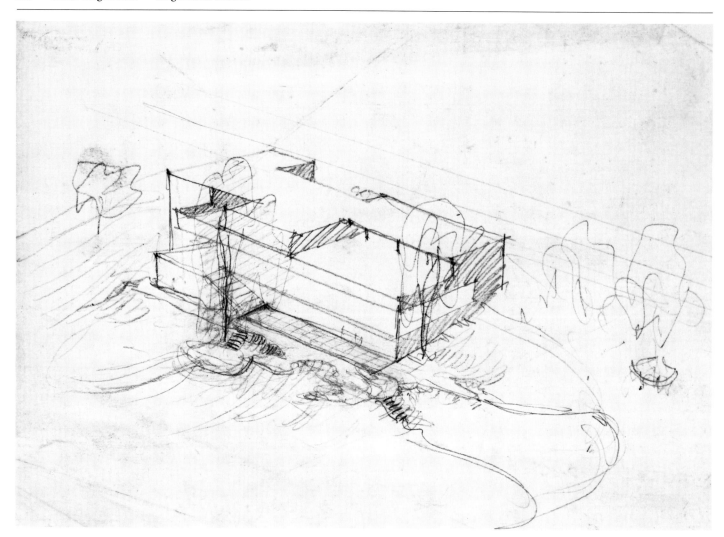

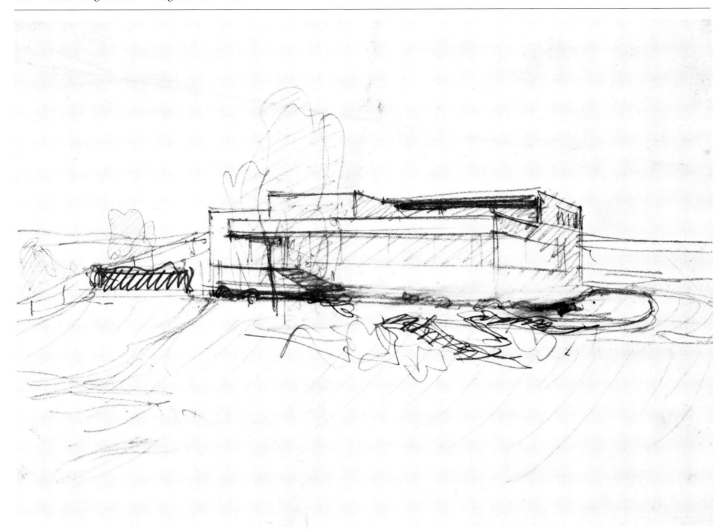

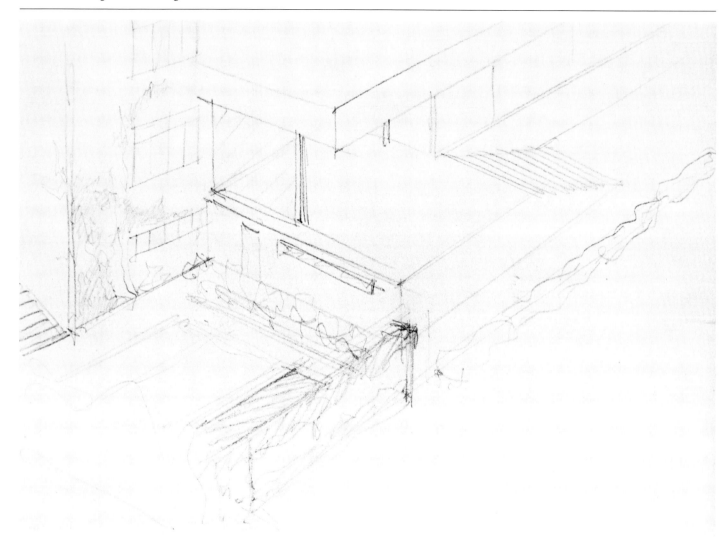

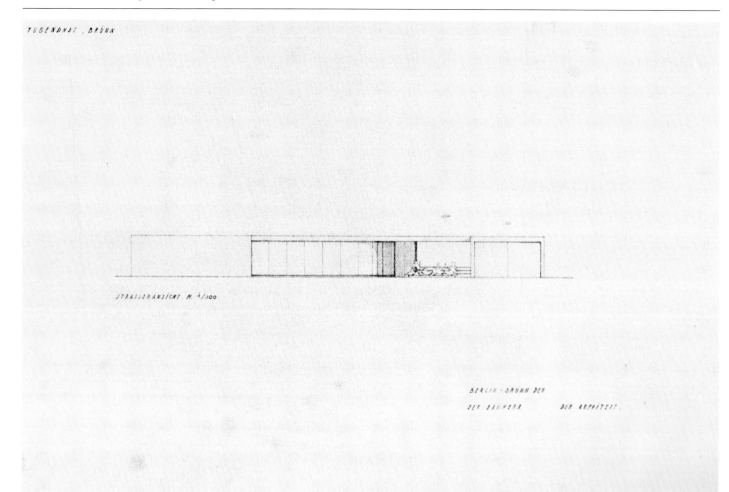

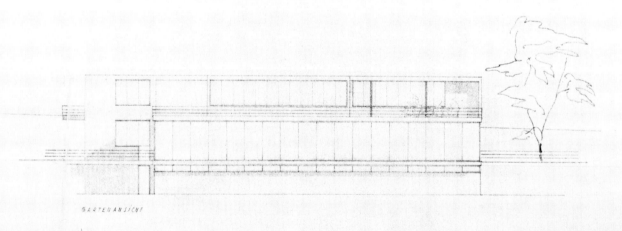

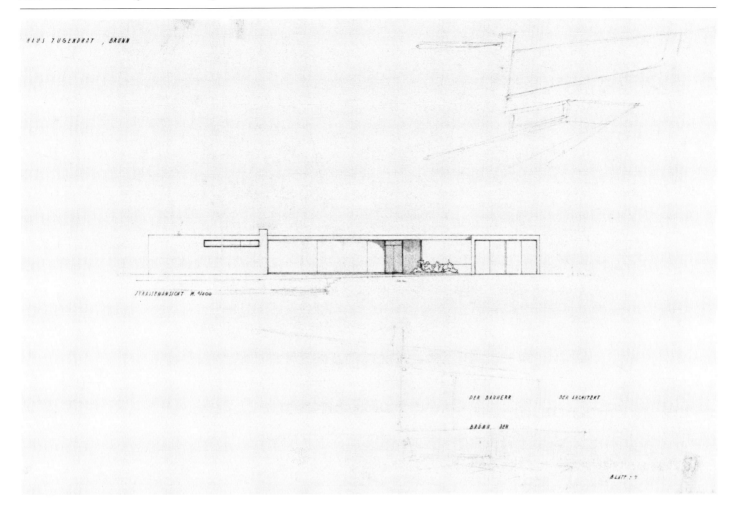

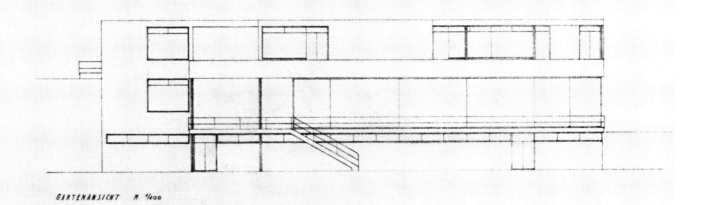

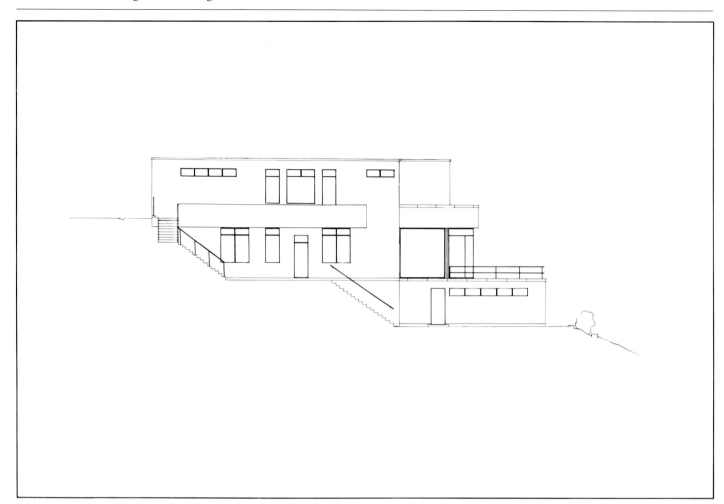

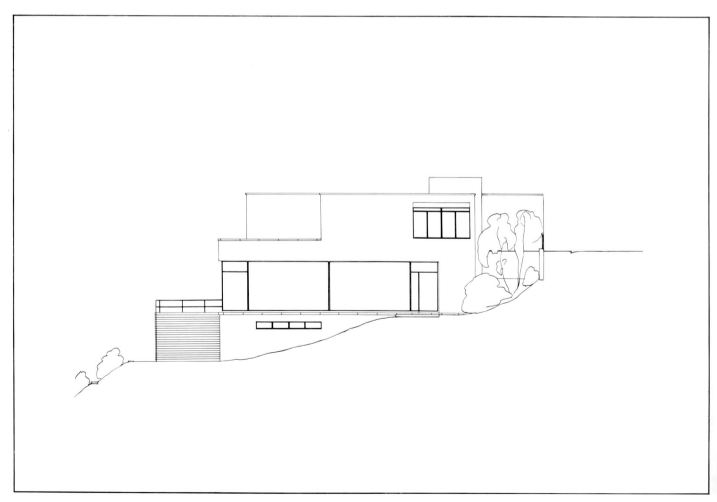

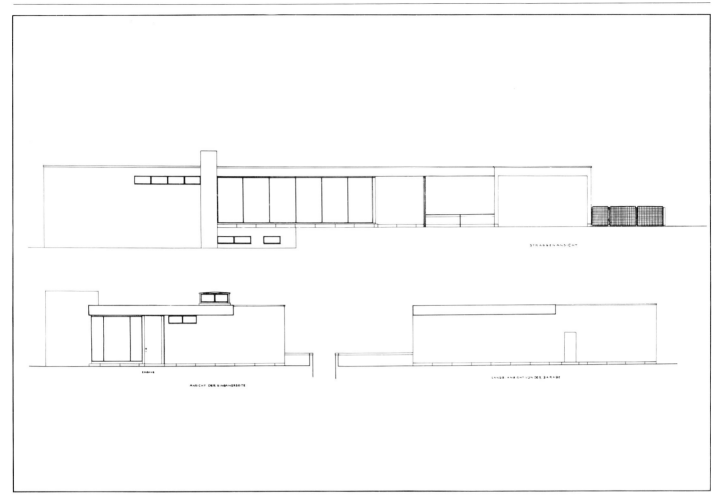

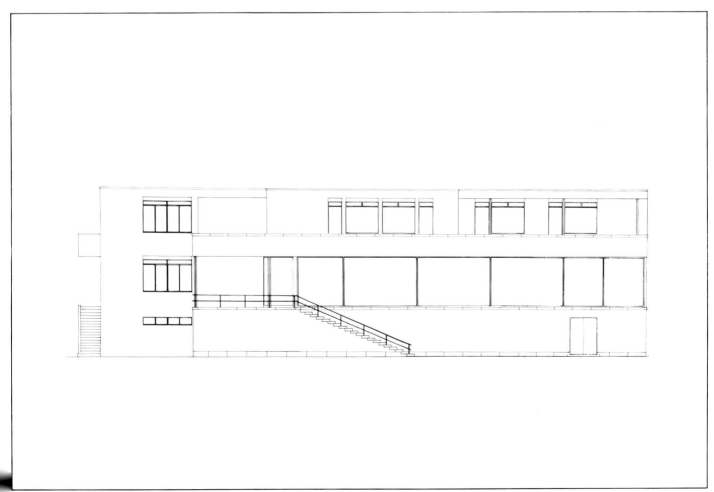

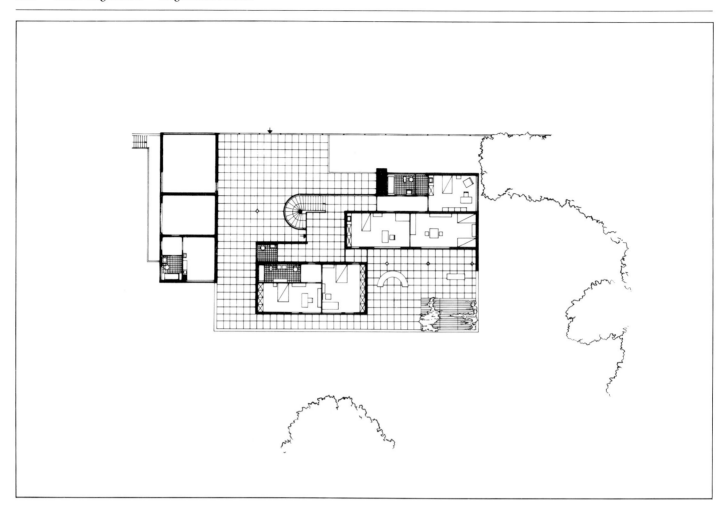

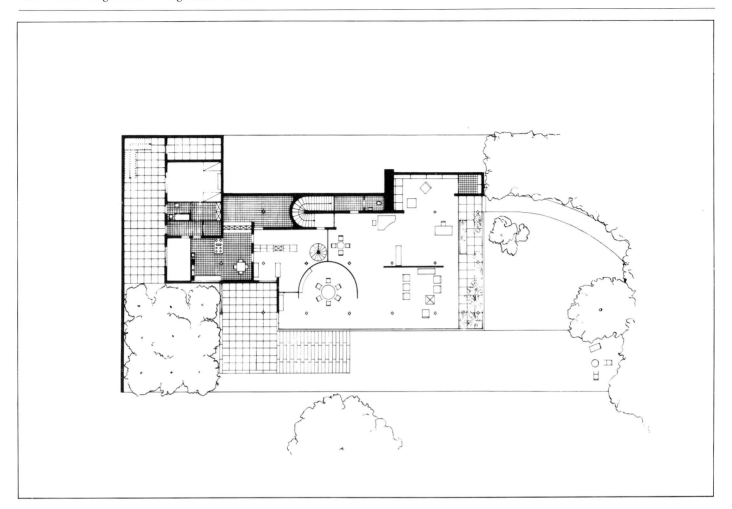

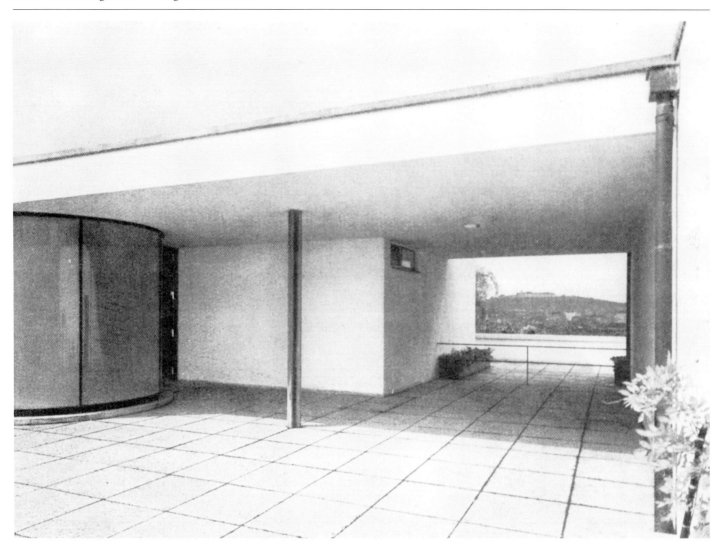

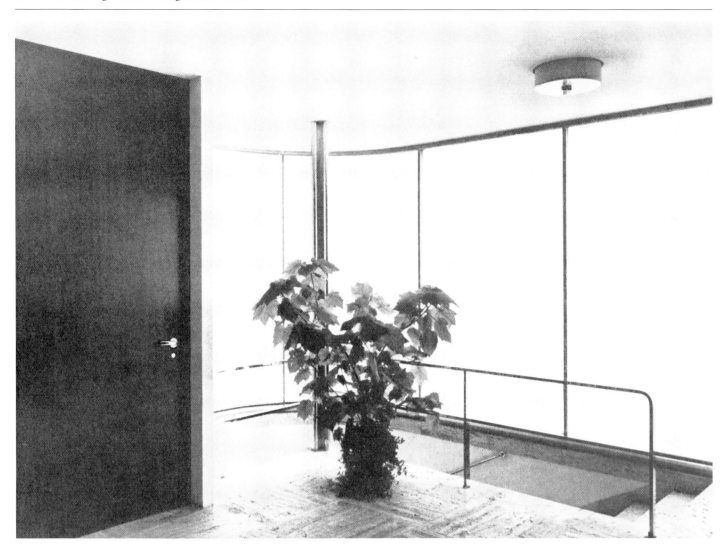

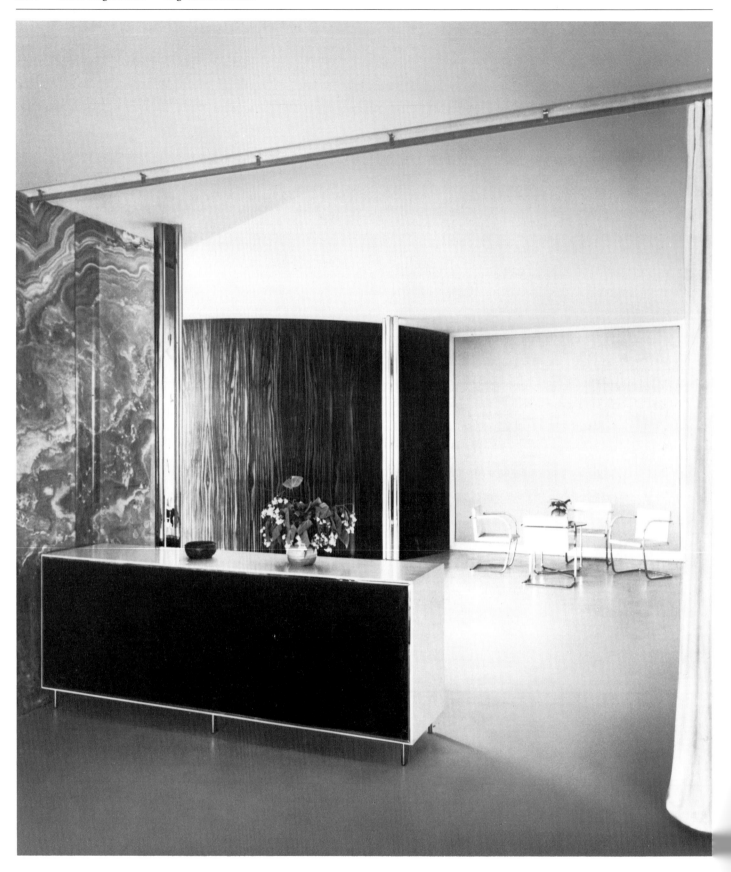

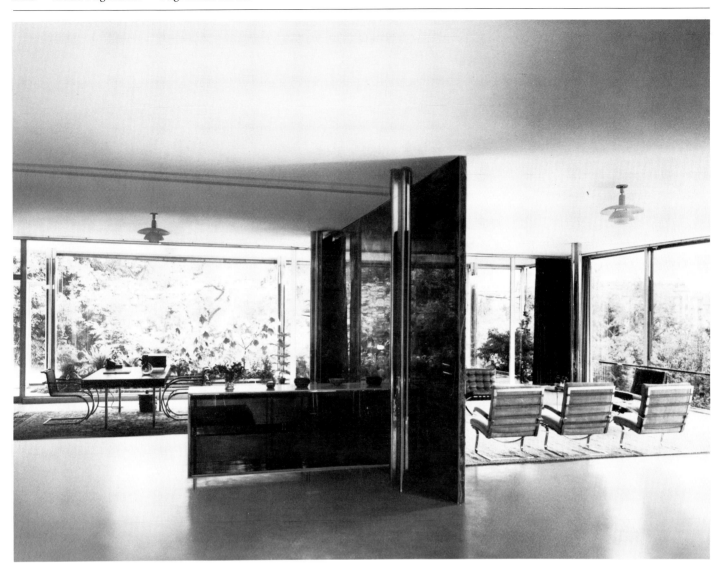

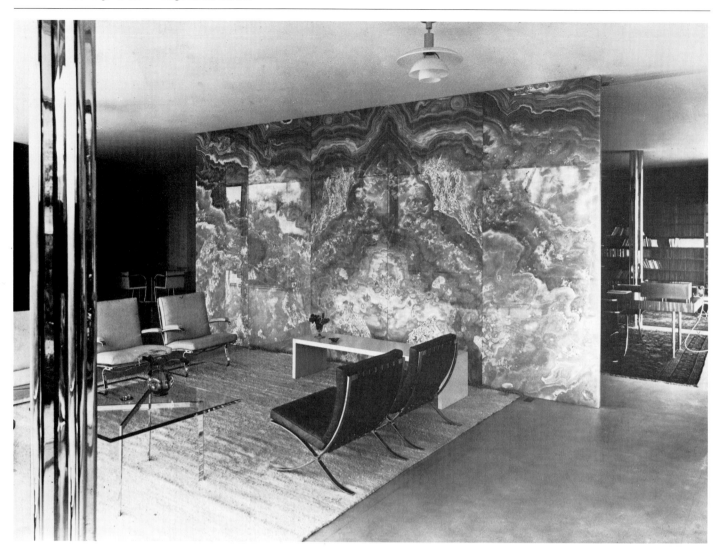

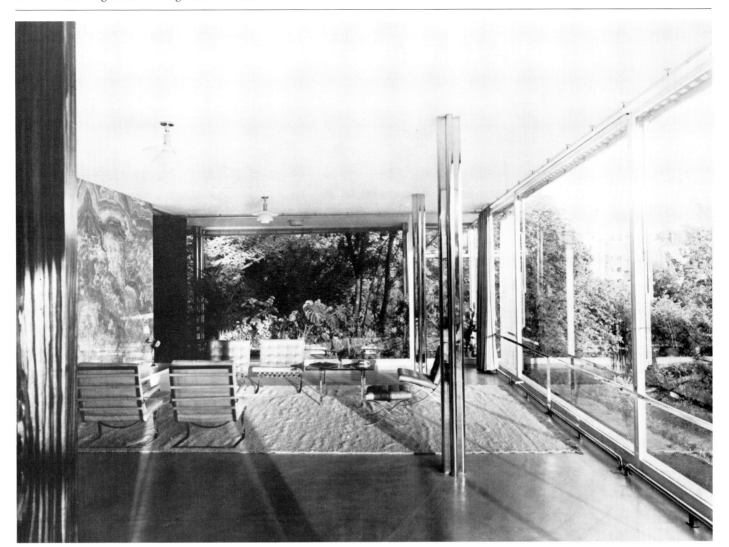

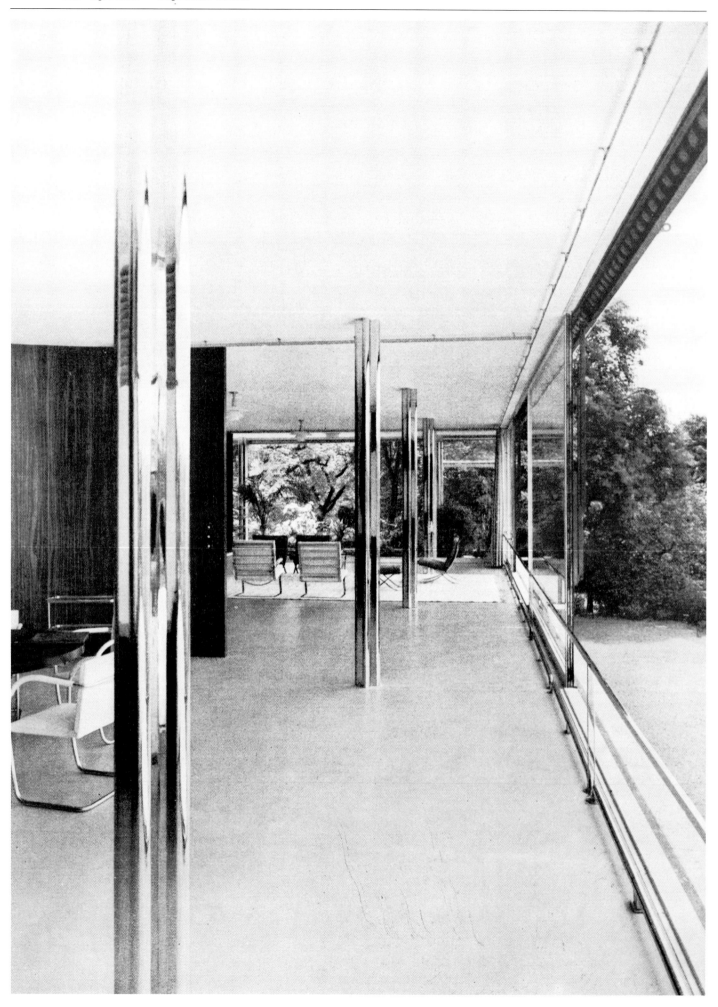

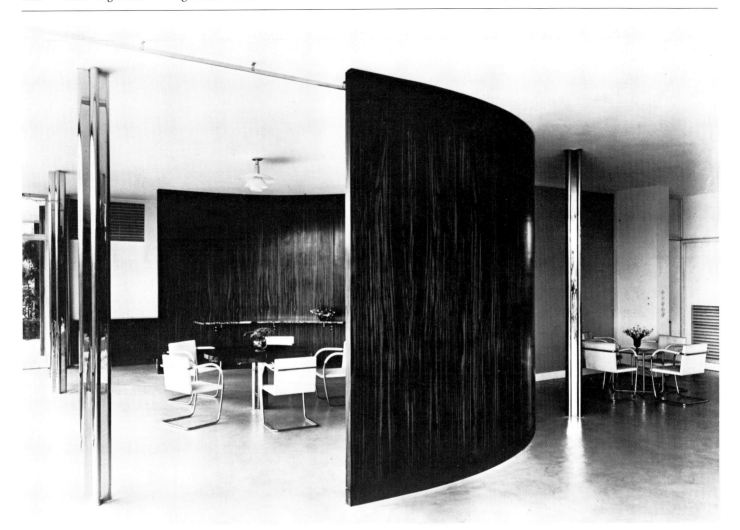

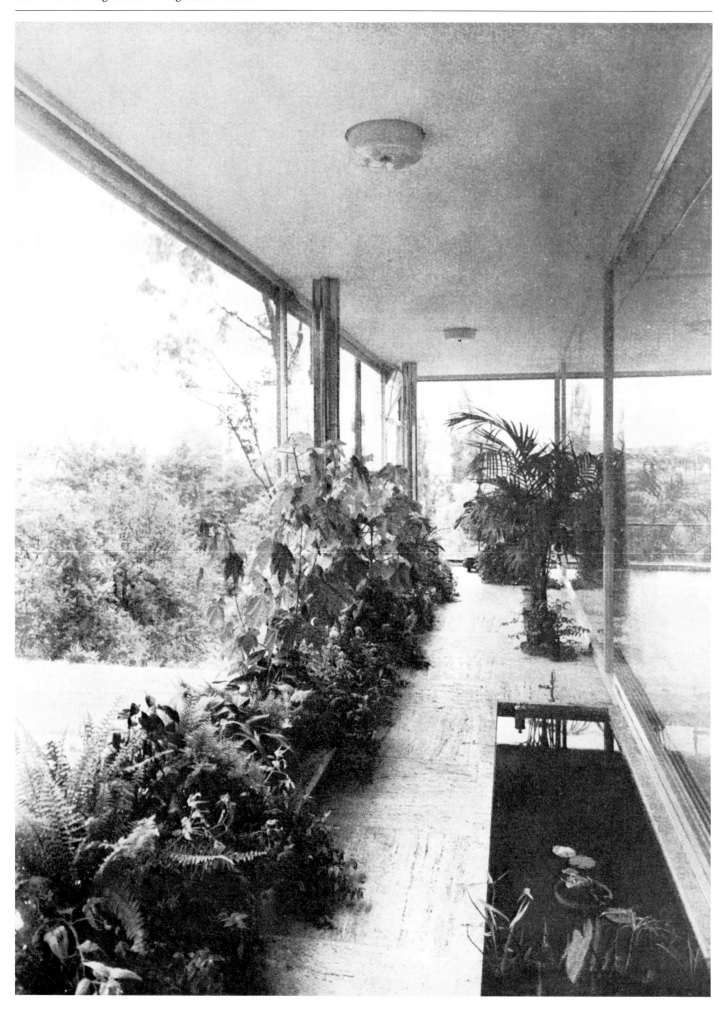

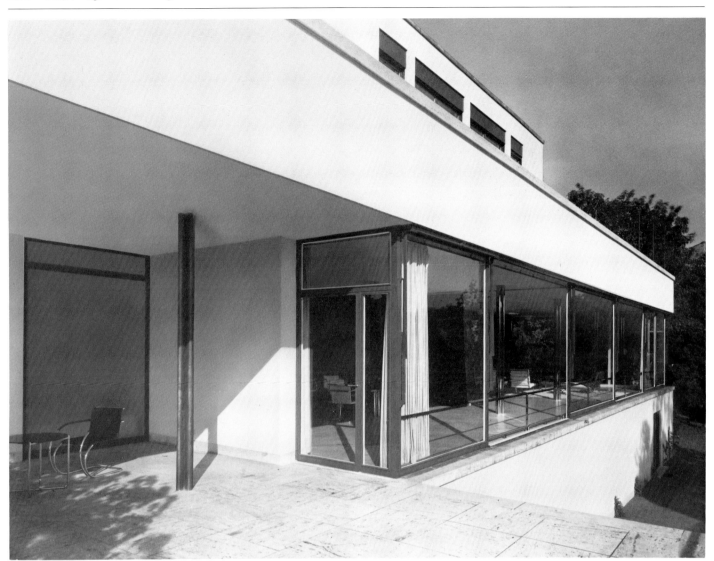

12 Haus Nolde

Datierung: 1929
Auftraggeber: Emil Nolde, Maler
Ort: Berlin-Zehlendorf, Am Erlenbusch
(Ecke Sachsallee)
Auftragsvergabe: vermutlich Januar 1929
Baugesuch: April 1929
Niederschlagung des Projekts: Juni 1929

12.1 Grundriß 1. Fassung
12.2 Grundriß 2. Fassung
12.3 Grundriß endgültige Fassung
12.4 Aufriß Ost- und Westseite
12.5 Aufriß Süd- und Nordseite

12 Nolde House

Date: 1929
Client: Emil Nolde, artist
Location: Am Erlenbusch (corner Sachsallee),
Berlin-Zehlendorf
Date of commission: probably January 1929
Building application: April 1929
Project cancelled: June 1929

12.1 Plan. First version
12.2 Plan. Second version
12.3 Plan. Final version
12.4 East and west elevation
12.5 South and north elevation

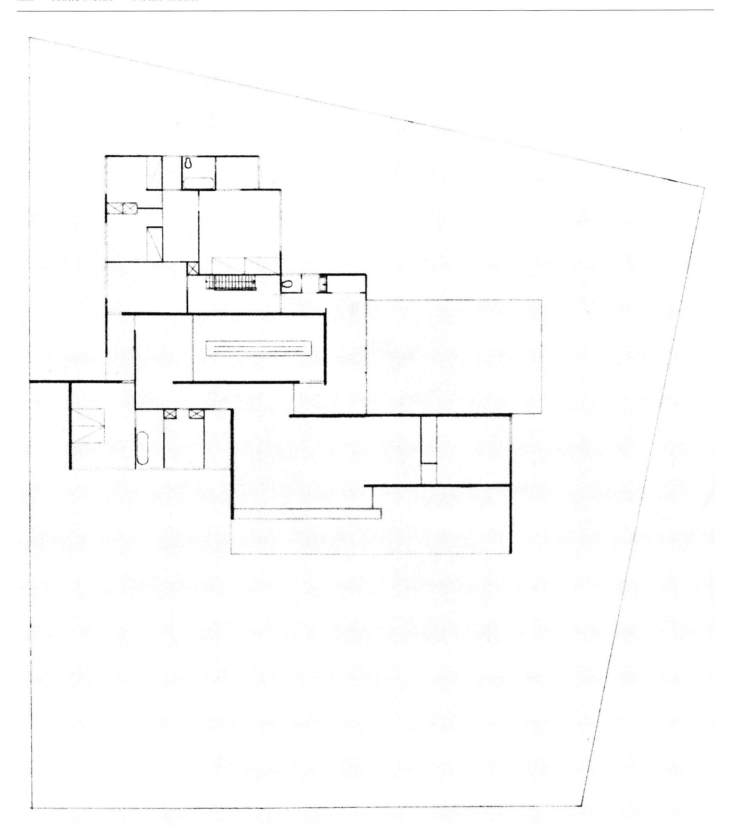

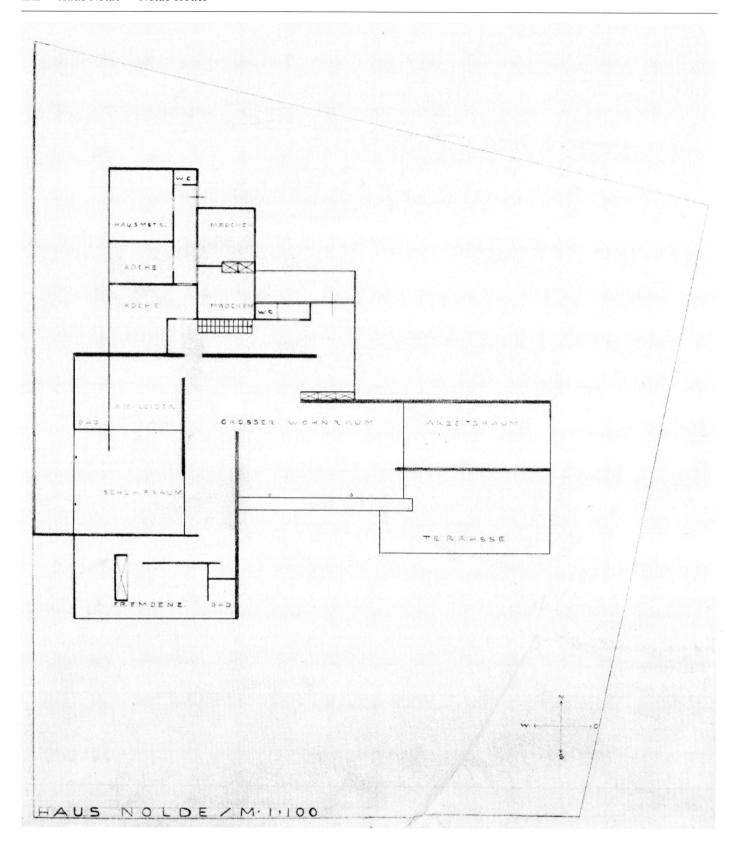

HAUS NOLDE / M·1·100

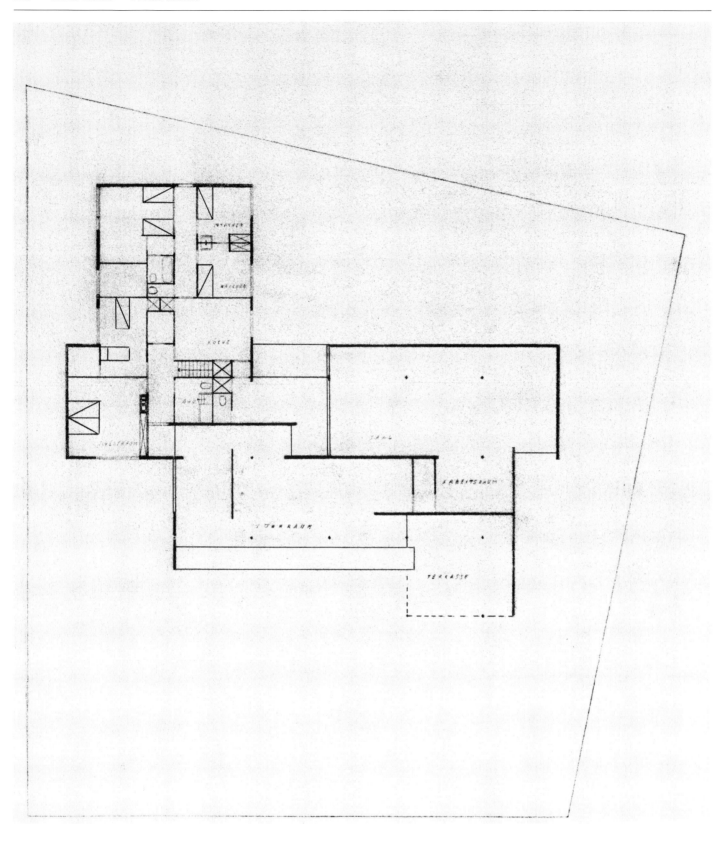

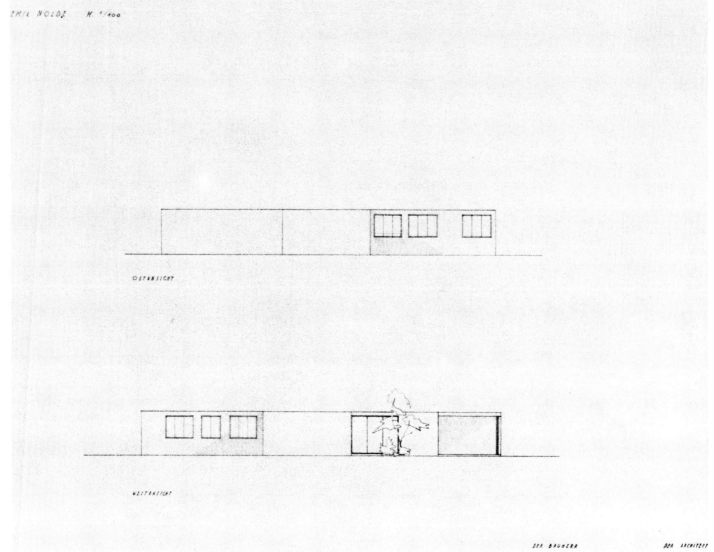

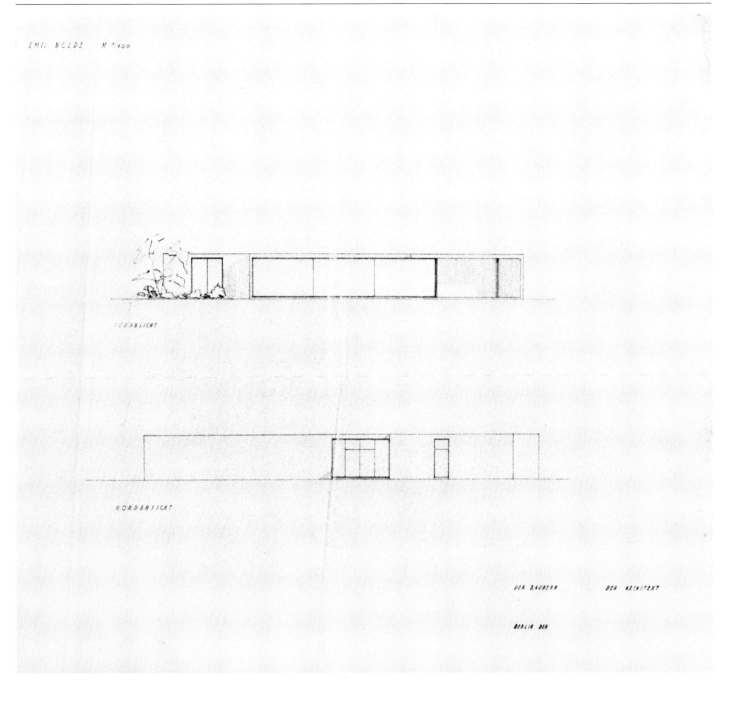

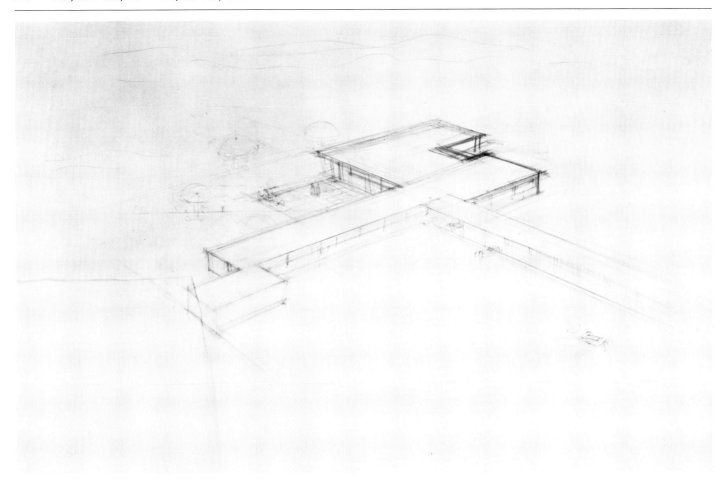

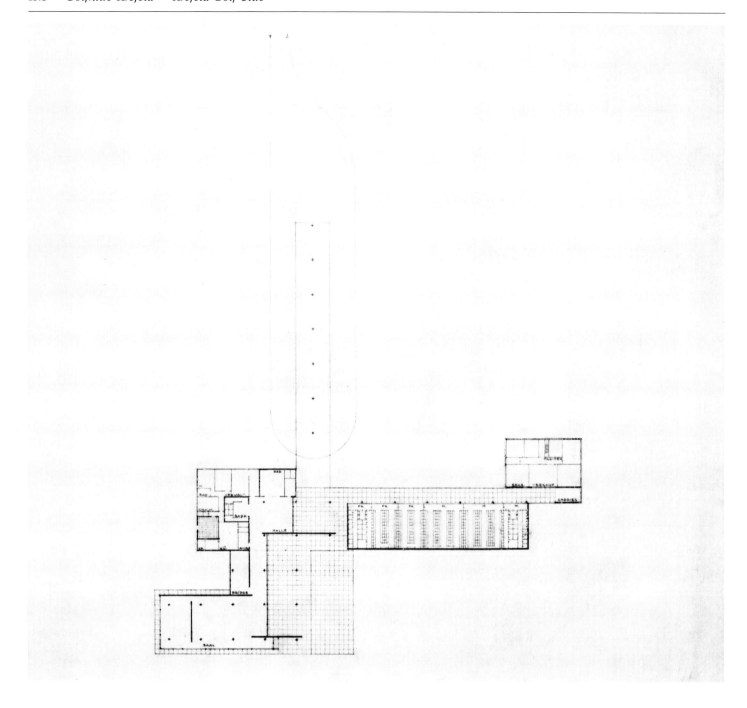

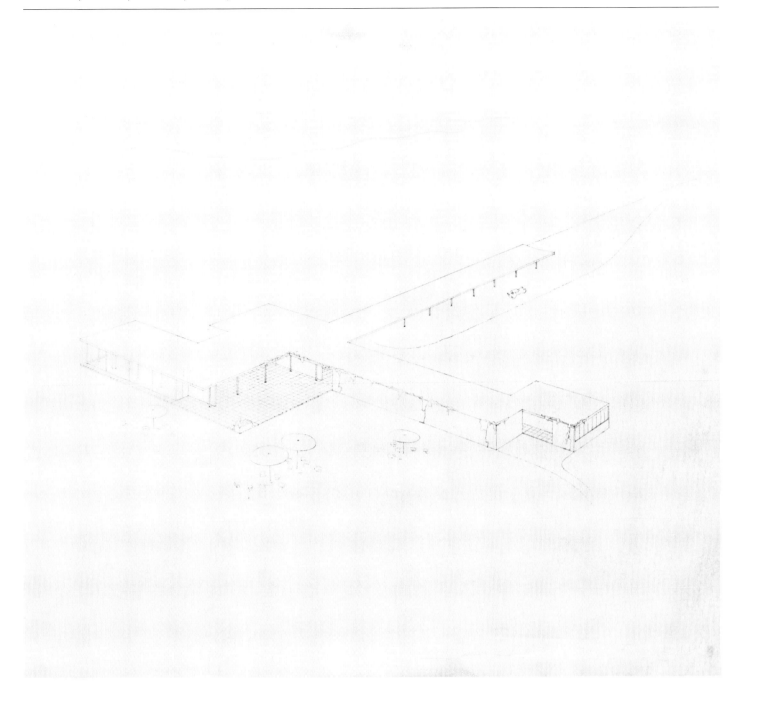

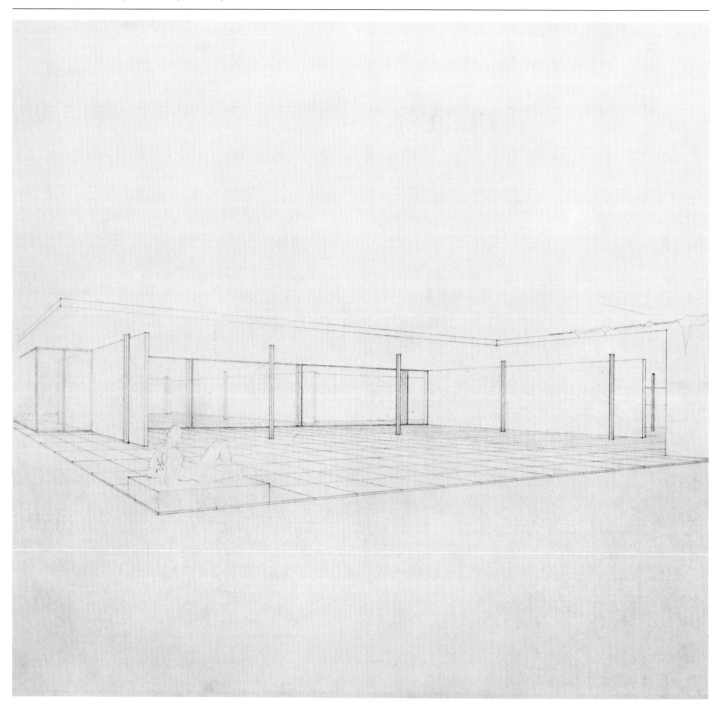

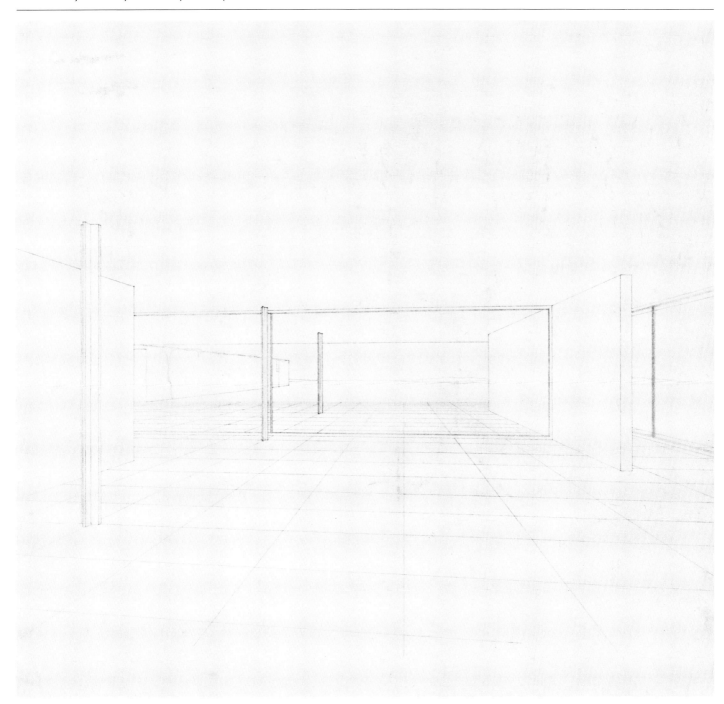

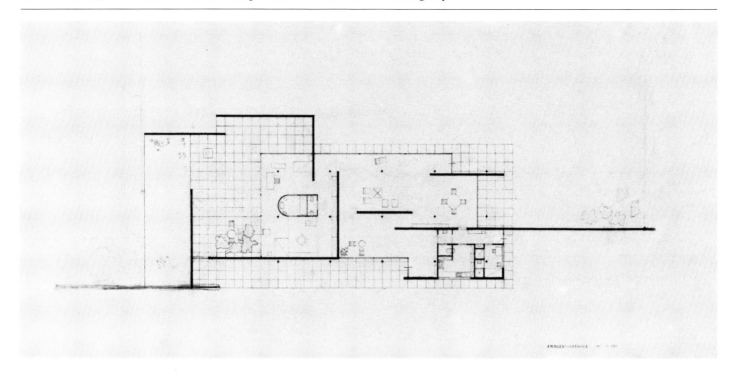

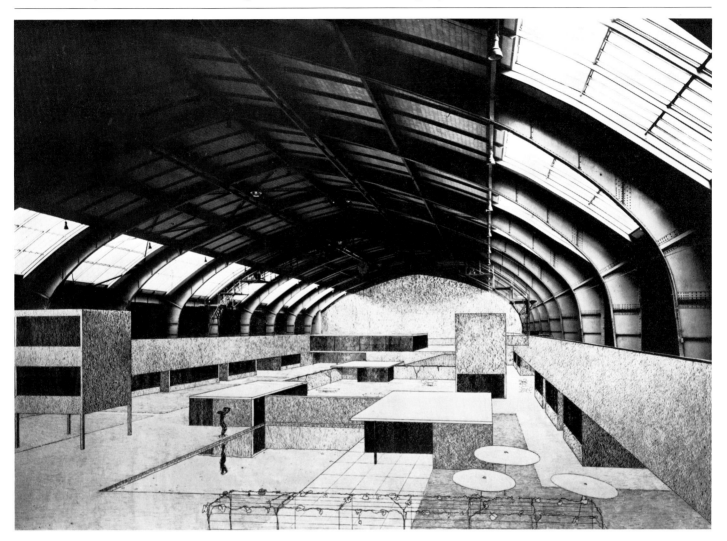

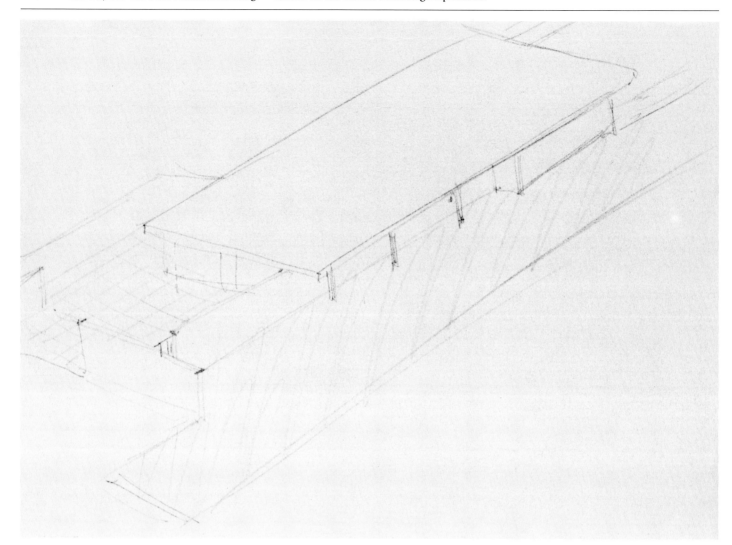

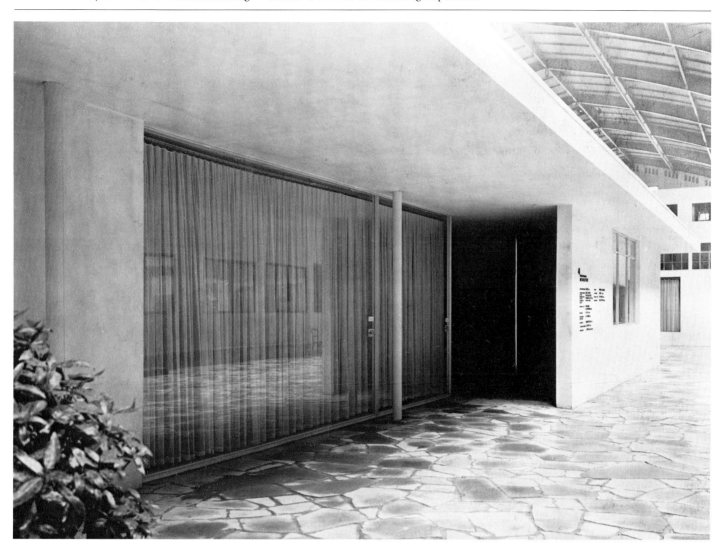

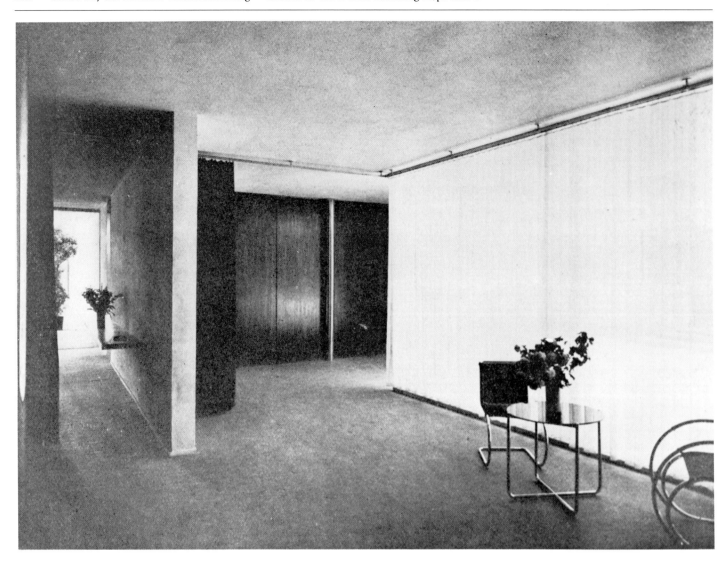

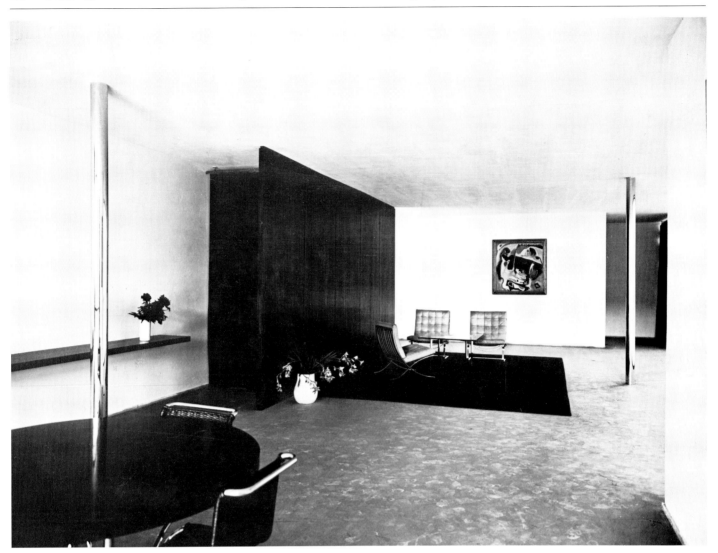

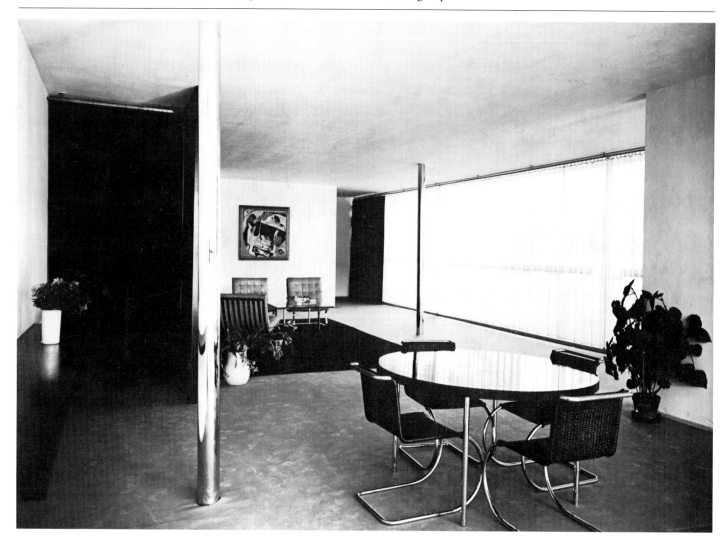

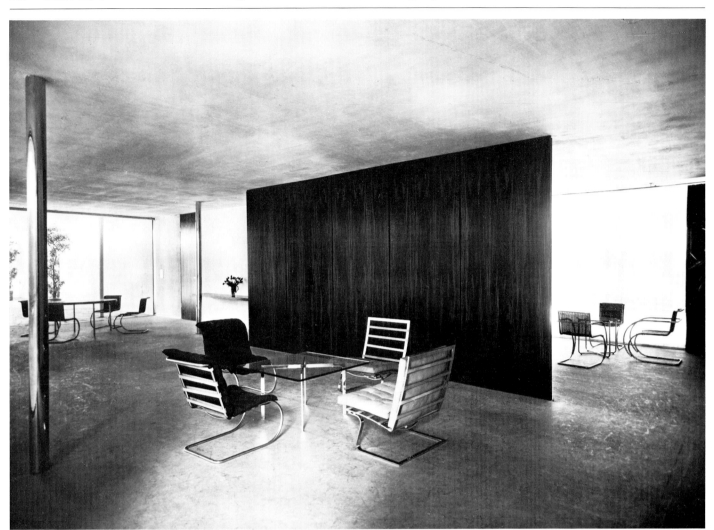

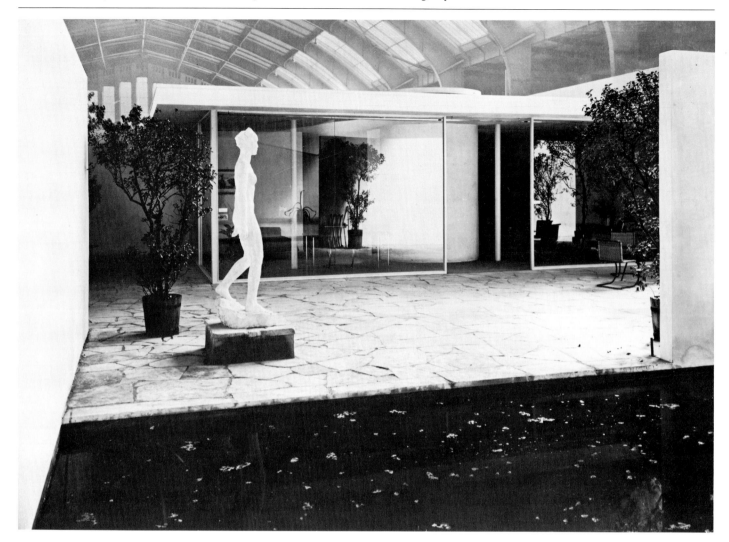

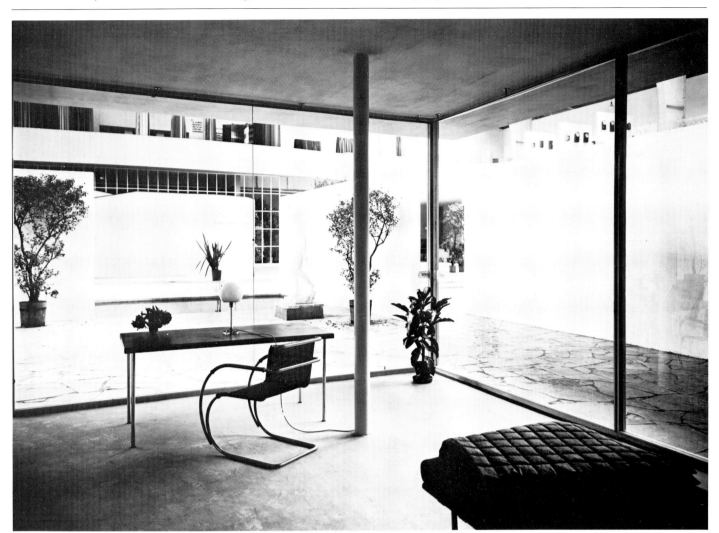

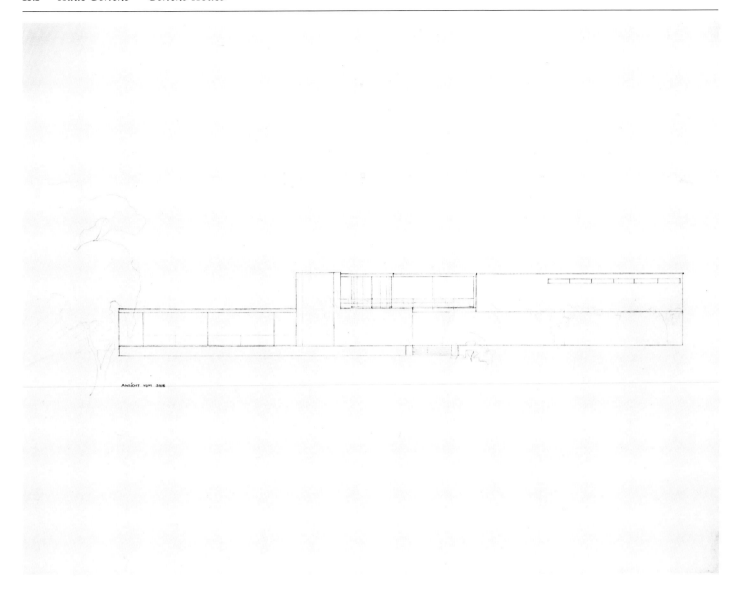

ANSICHT VOM SEE

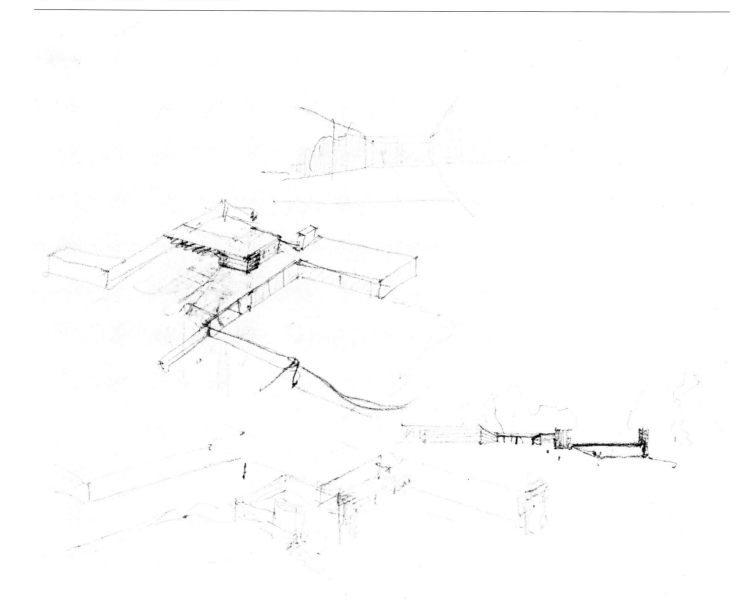

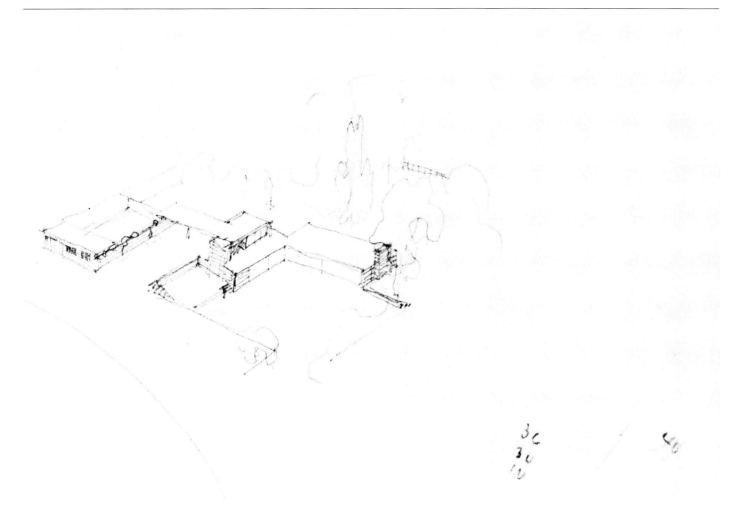

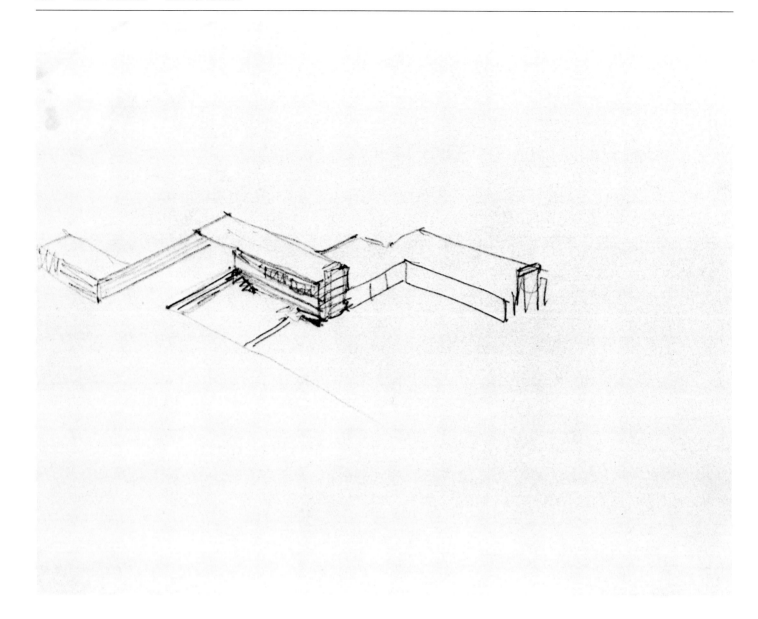

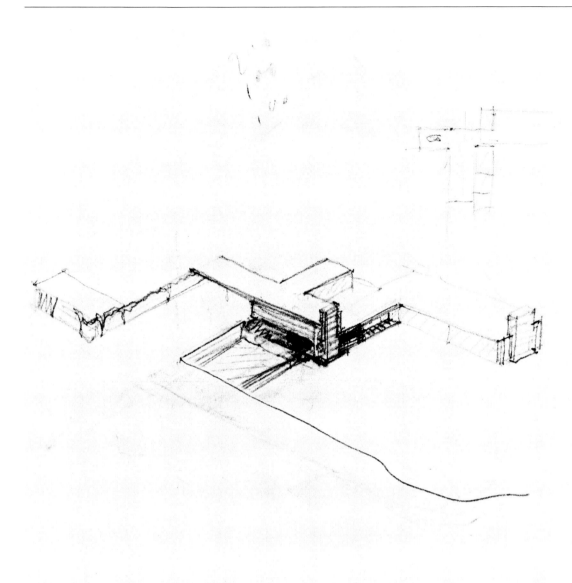

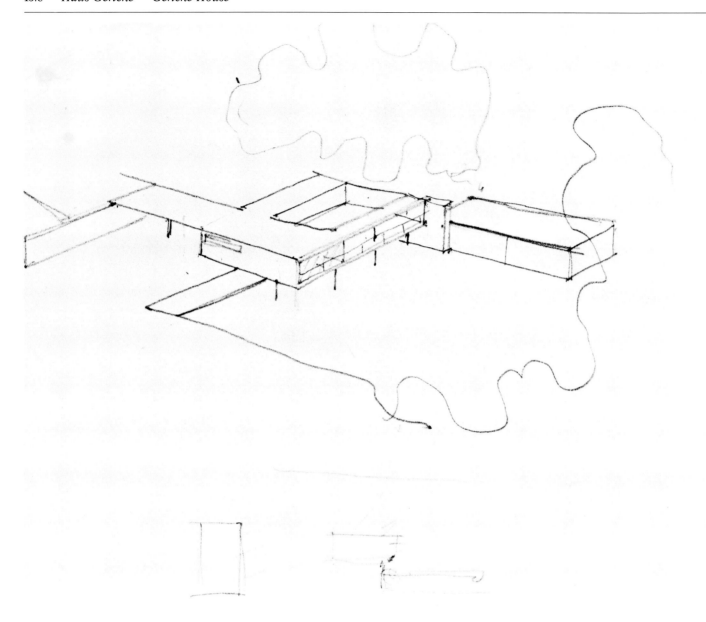

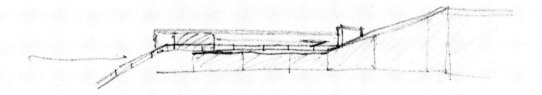

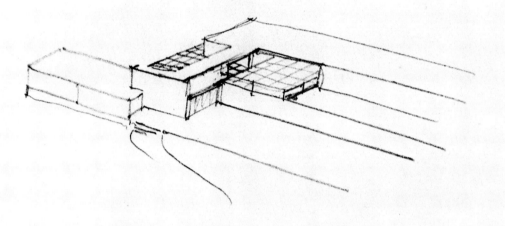

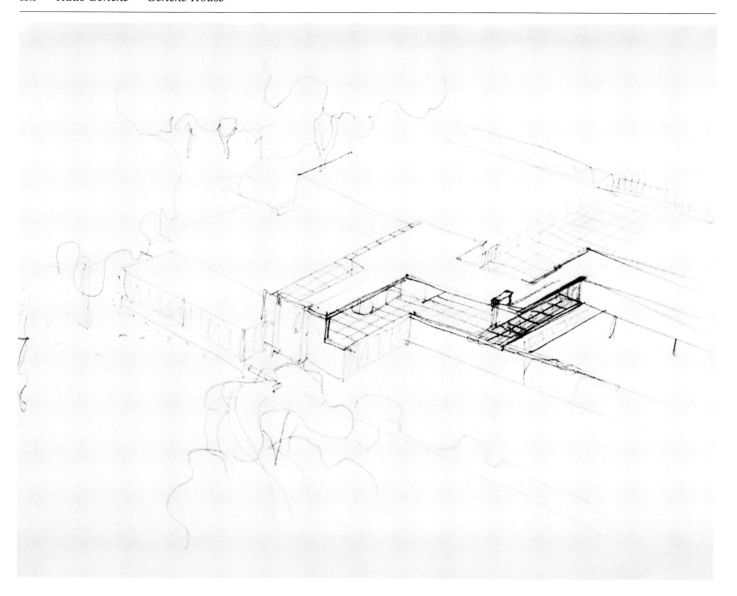

STRASSENFRONT

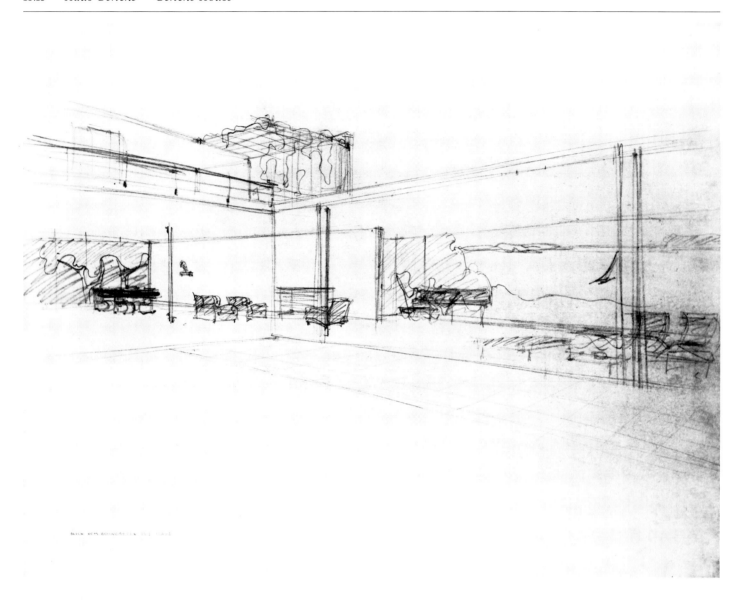

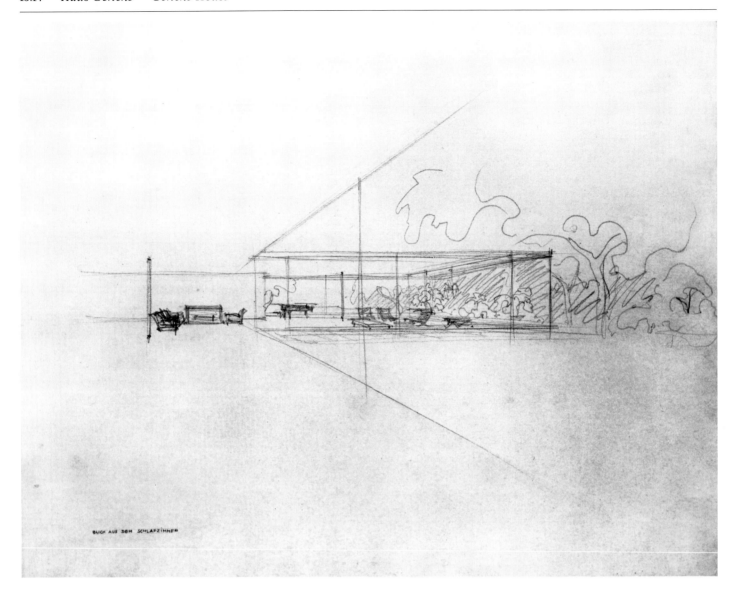

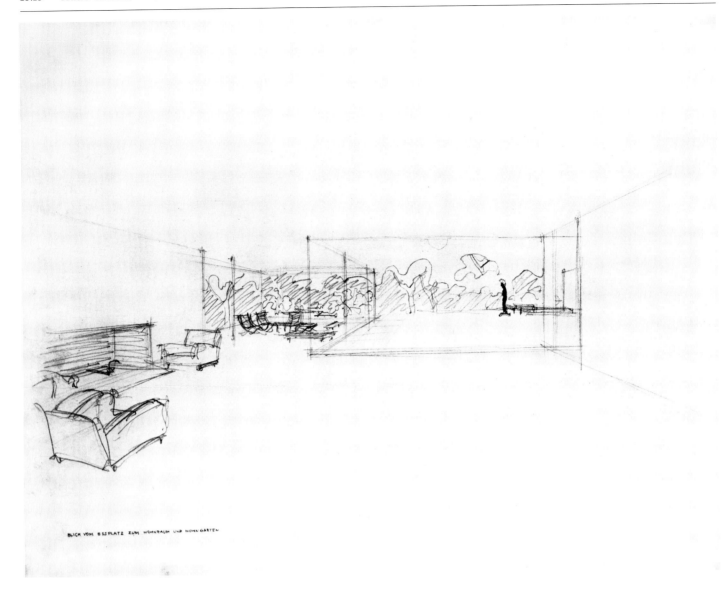

BLICK VOM ESSPLATZ ZUM WOHNRAUM UND WOHNGARTEN

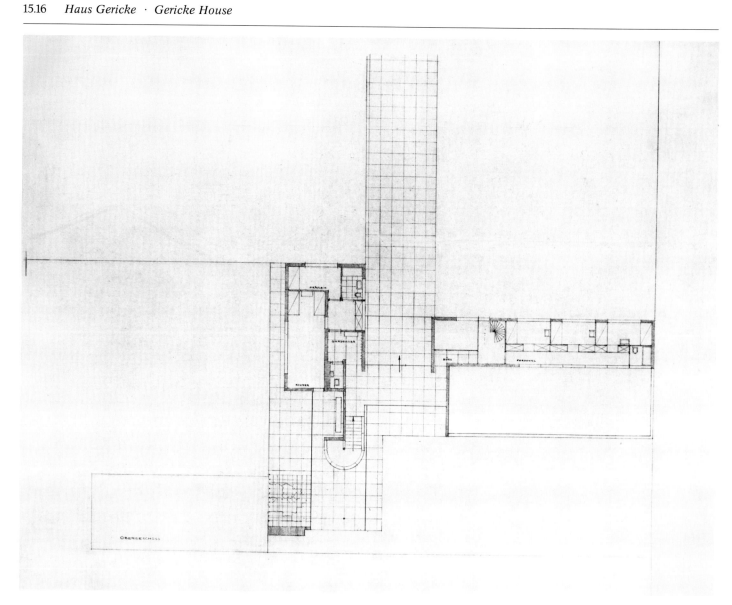

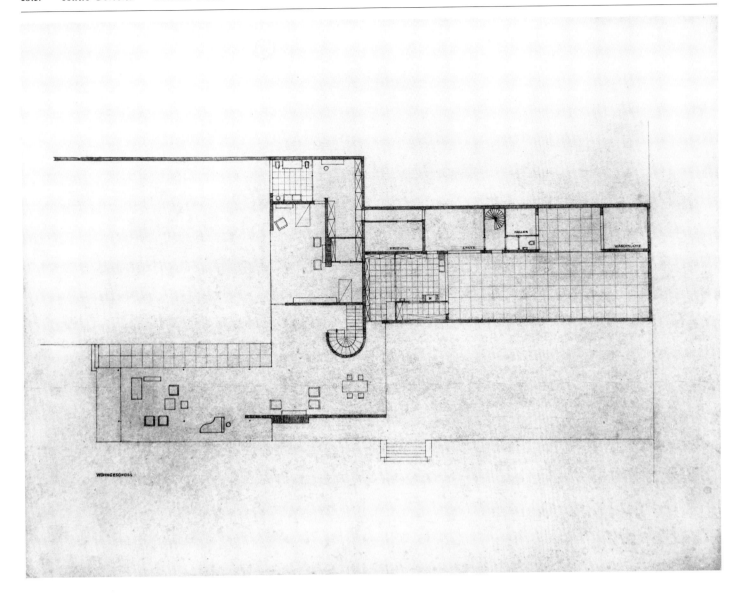

16 Haus in den Bergen

Datierung: 1934
Auftraggeber: Entwurf für ein Haus
des Architekten
Ort: Südtirol, Umgebung von Meran

16.1 Ansicht beider Hauptfassaden
16.2 Seitenansicht
16.3 Blick in den Hof
16.4 Aufsicht
16.5 Ansicht beider Hauptfronten
16.6 Seitenansicht

16 Mountain House

Date: 1934
Client: House for the architect
Location: South Tyrol, near Meran
(Italy)

16.1 Perspective drawing
16.2 Elevation
16.3 Court
16.4 Aerial perspective sketch
16.5 Perspective sketch
16.6 Elevation

16.4 16.5

17 Haus Hubbe

Datierung: 1935
Auftraggeber: Margarete Hubbe
Ort: Magdeburg, Elb-Insel,
Mittelstraße 13 (?)

17.1 Modell, Ansicht vom Fluß
17.2 Modell, Aufsicht
17.3 Lageplan mit Grundriß (Vorprojekt)
17.4 Grundrißvarianten (Planungs-
 stadium)
17.5 Grundriß mit Aufrissen (Planungs-
 stadium)
17.6 Grundriß
17.7 Blick von der Terrasse zum Innenhof
17.8 Blick auf den Wohnraum und zum
 Innenhof
17.9 Ausblick aus dem Wohnraum

17 Hubbe House

Date: 1935
Client: Margarete Hubbe
Location: Elb-Insel, Mittelstrasse 13 (?),
Magdeburg

17.1 Model
17.2 Model
17.3 Site plan. Preliminary scheme
17.4 Sketch with several plan versions
17.5 Plan and elevations. Preliminary version
17.6 Plan
17.7 View from terrace to court
17.8 View towards living room and court
17.9 Perspective view from living room

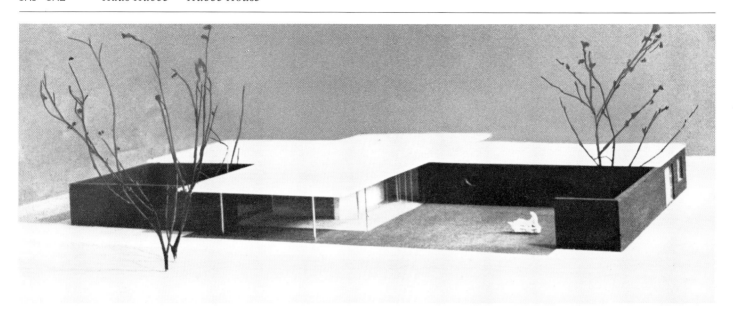

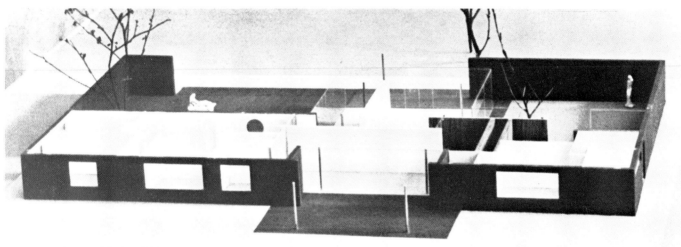

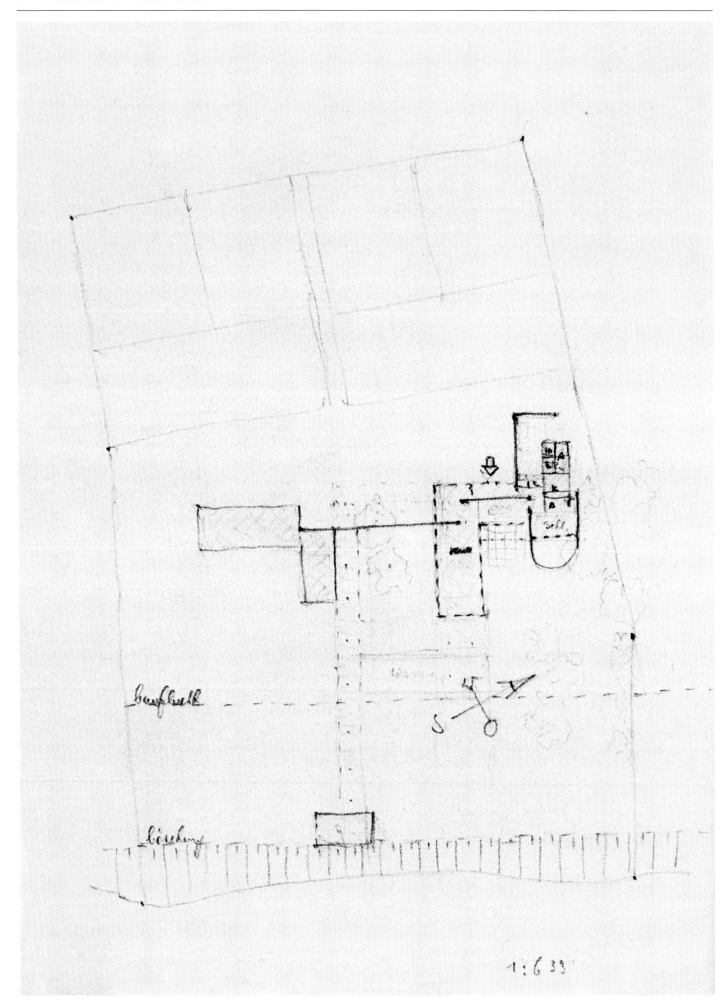

1:633

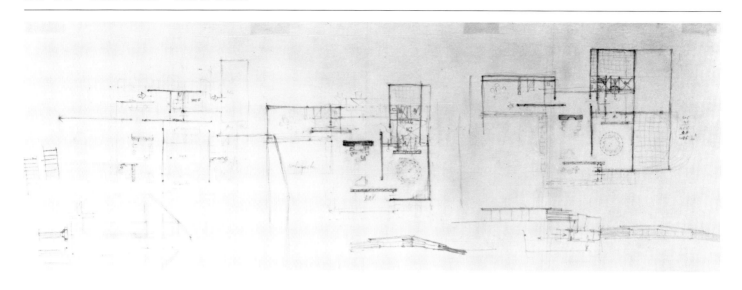

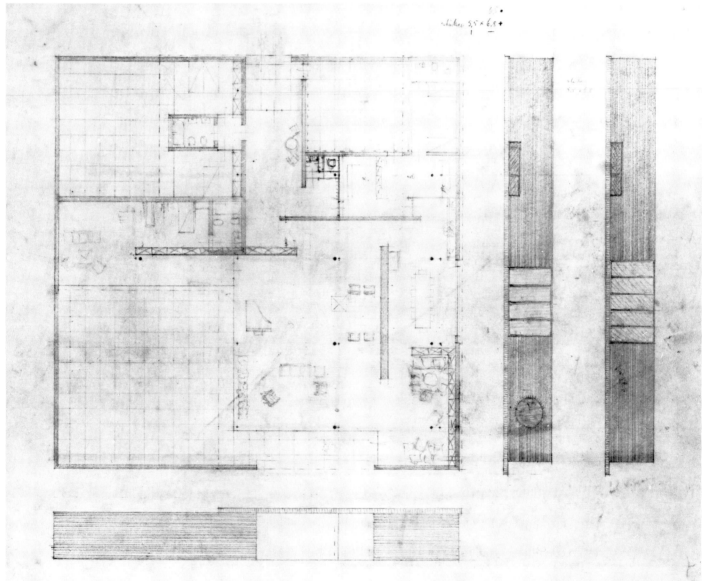

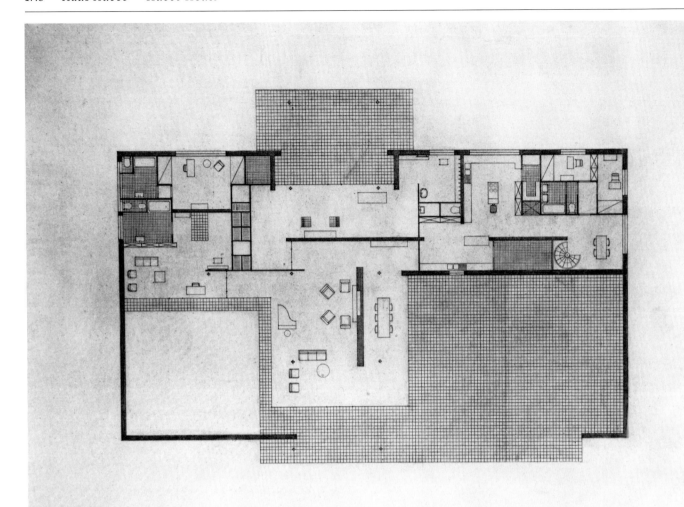

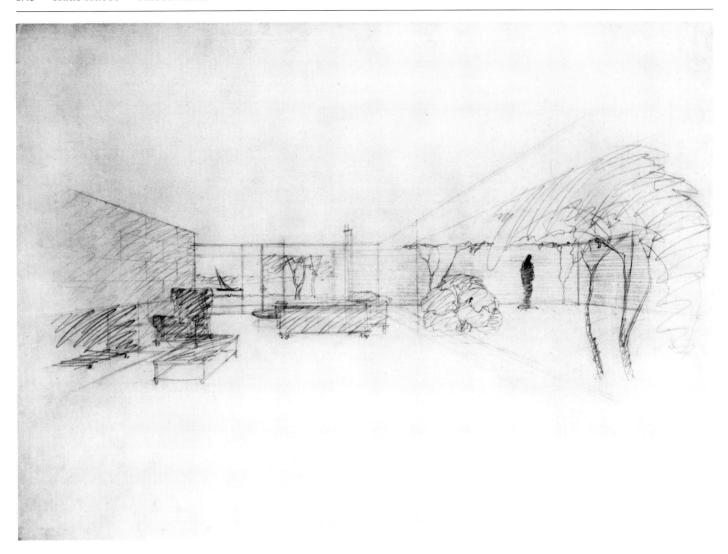

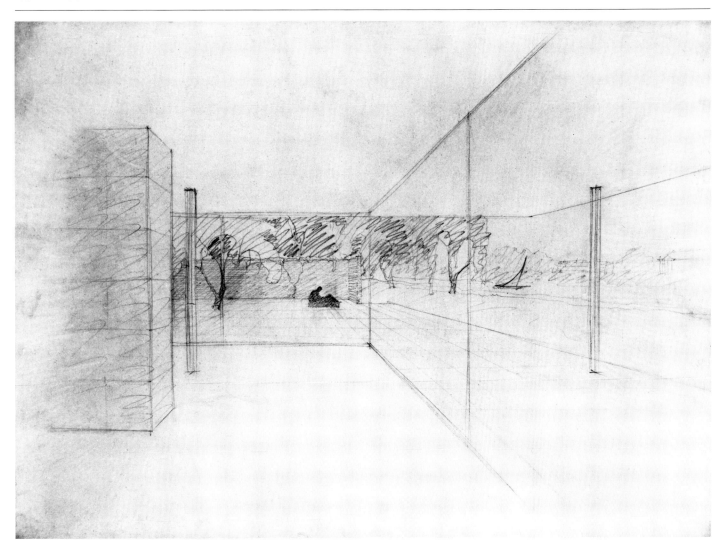

18 Haus Ulrich Lange

Datierung: 1935
Auftraggeber: Ulrich Lange (Sohn von
Hermann Lange)
Ort: Traar (bei Krefeld), Buscher Holzweg
(Ecke Moerser Landstraße)

18.1	Aufriß Hof- und Eingangsseite (Vorprojekt)
18.2	Aufriß Rück- und Vorderfront (Vorprojekt)
18.3	Grundriß (Vorprojekt)
18.4	Blick vom Eingang zum Wohngarten (Planungsstadium)
18.5	Blick von der Terrasse zum Wohnbereich (Planungsstadium)
18.6	Blick aus dem Wohnbereich (Planungsstadium)
18.7	Blick in den Wohnbereich (Planungsstadium)
18.8	Blick von der Terrasse zum Wohnbereich (Planungsstadium)
18.9	Blick in den Hof und Wohnbereich (Planungsstadium)
18.10	Grundriß (Planungsstadium)
18.11	Grundriß, Detail (Planungsstadium)
18.12	Grundriß-Varianten (Planungsstadium)
18.13	Grundriß (Ausführungsprojekt)
18.14	Aufrisse (Ausführungsprojekt)

18 Ulrich Lange House

Date: 1935
Client: Ulrich Lange (son of Hermann
Lange)
Location: Buscher Holzweg (corner
Moerser Landstrasse), Traar (near Krefeld)

18.1	Two elevations. Preliminary scheme
18.2	Two elevations. Preliminary scheme
18.3	Plan. Preliminary scheme
18.4	View from entrance area to court. Preliminary version
18.5	View from terrace to living area. Preliminary version
18.6	View from the living area to court and terrace. Preliminary version
18.7	View towards living area. Preliminary version
18.8	View from terrace to living area. Preliminary version
18.9	View to court and living area. Preliminary version
18.10	Plan. Preliminary version
18.11	Plan. Detail. Preliminary version
18.12	Sketch with several plan versions
18.13	Plan. Final scheme
18.14	Elevations. Final scheme

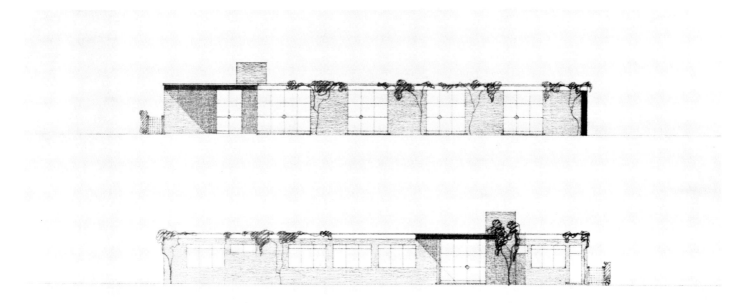

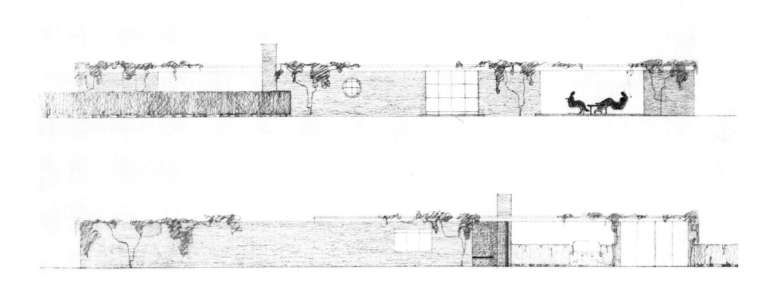

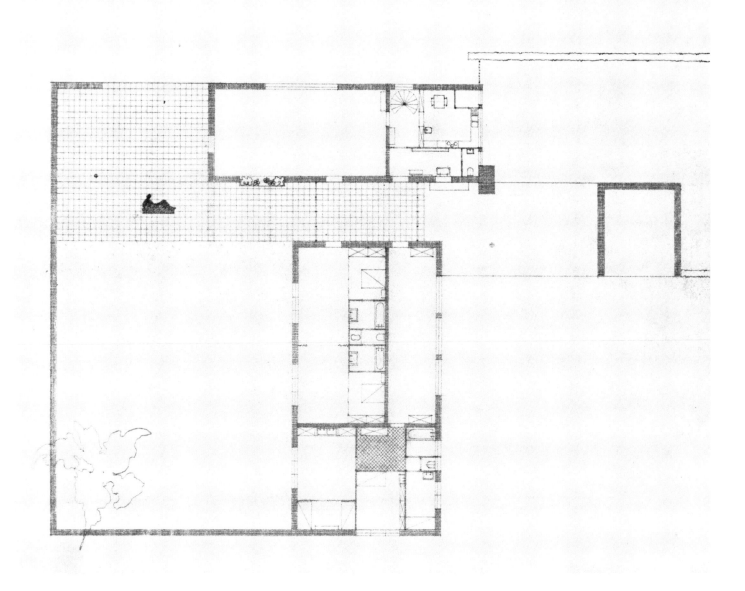

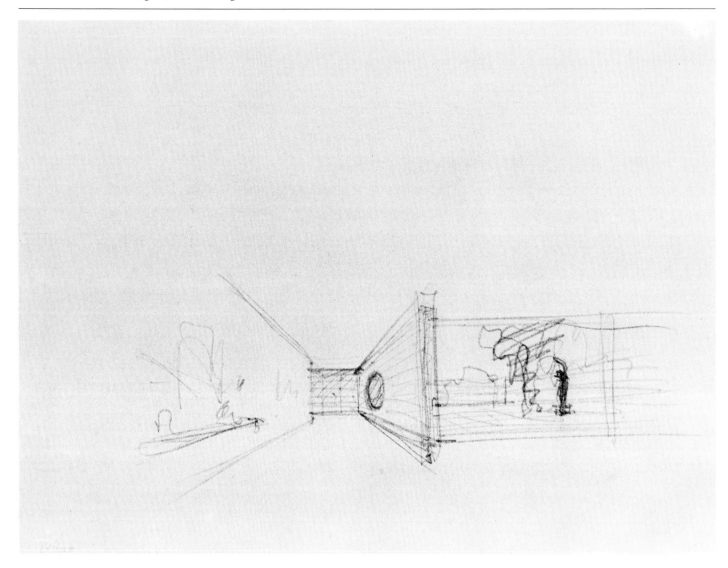

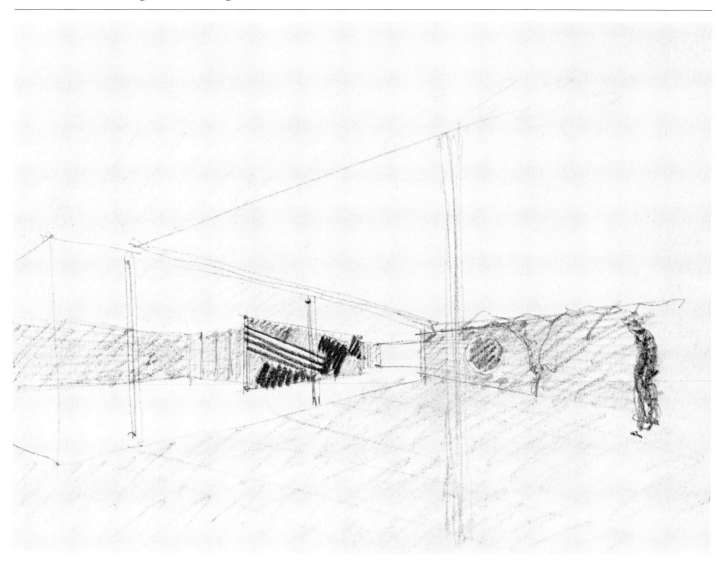

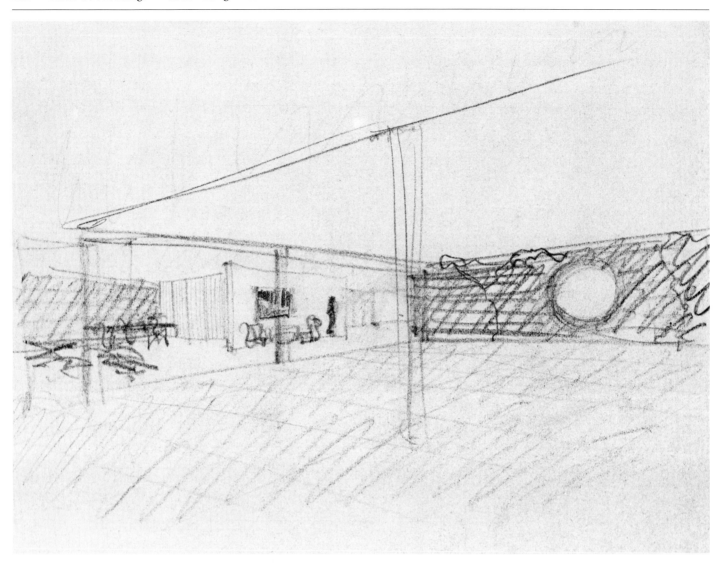

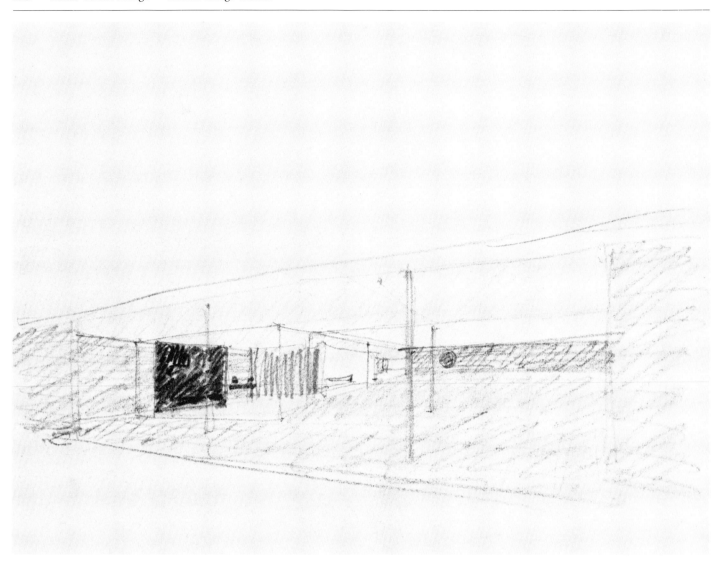

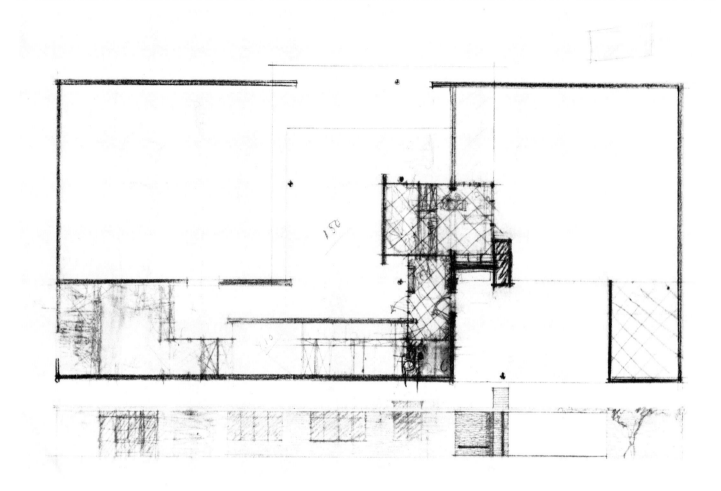

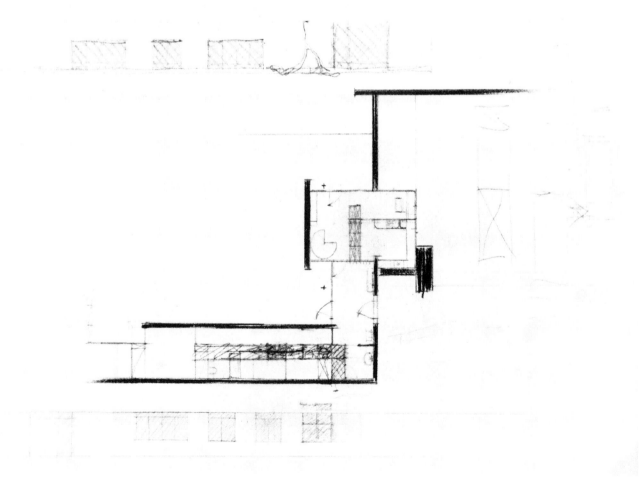

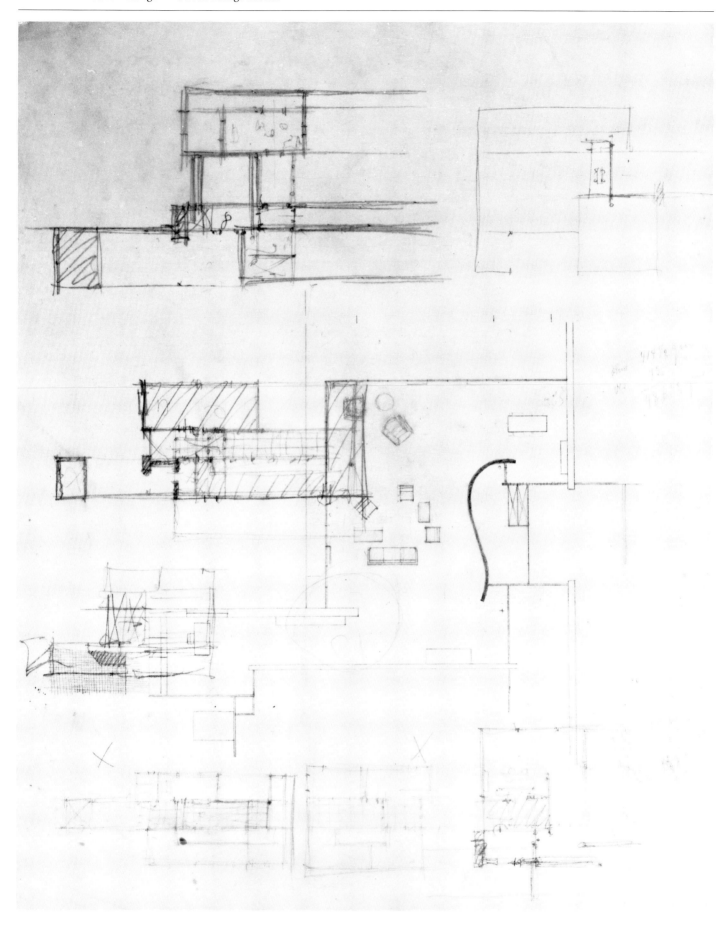

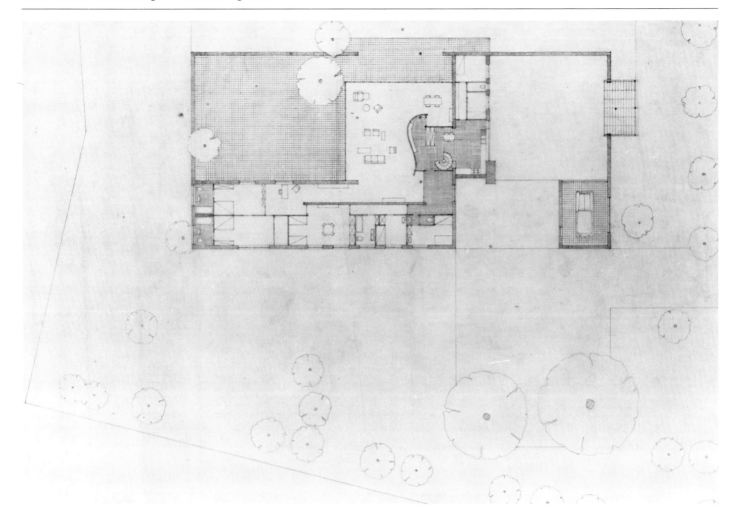

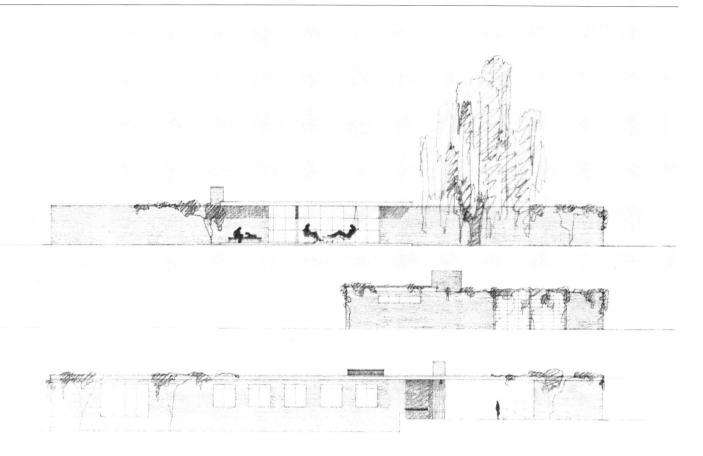

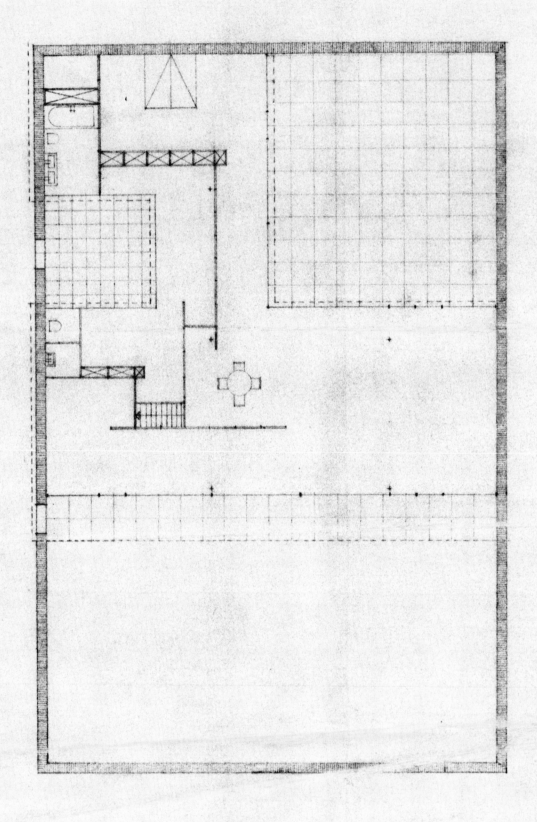

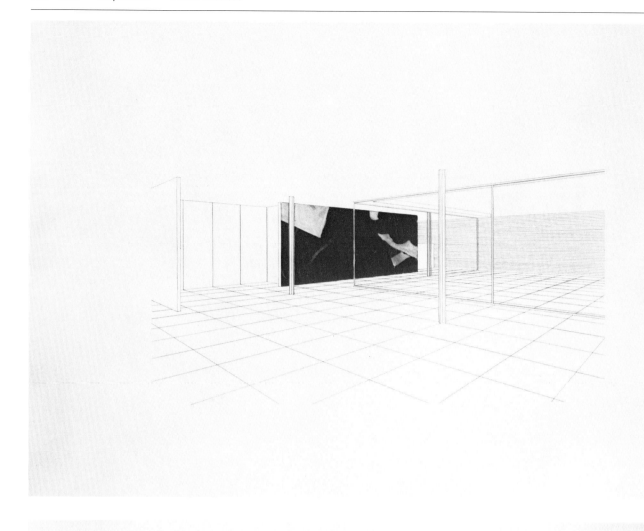

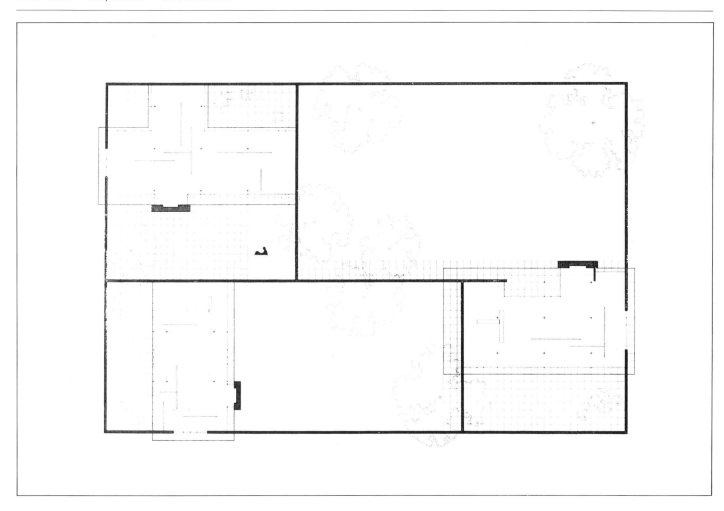

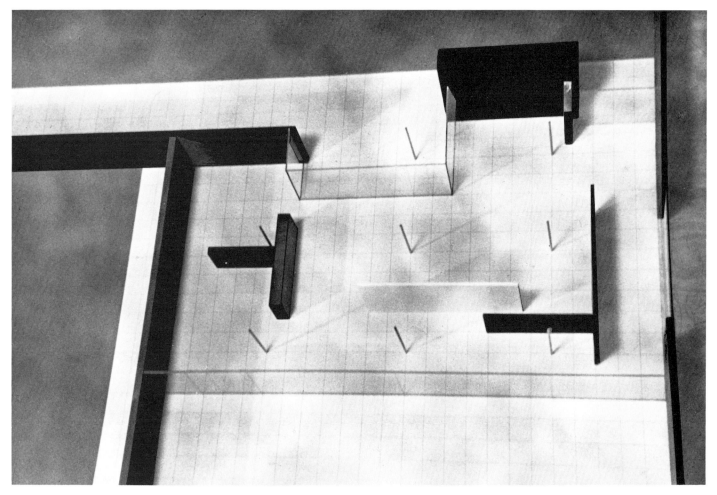

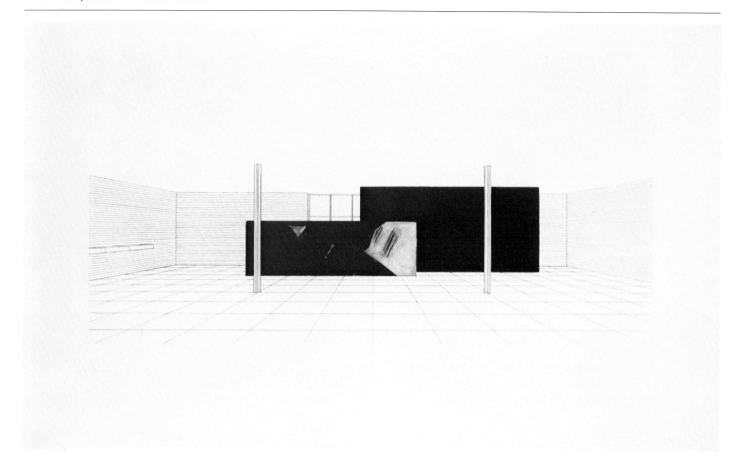

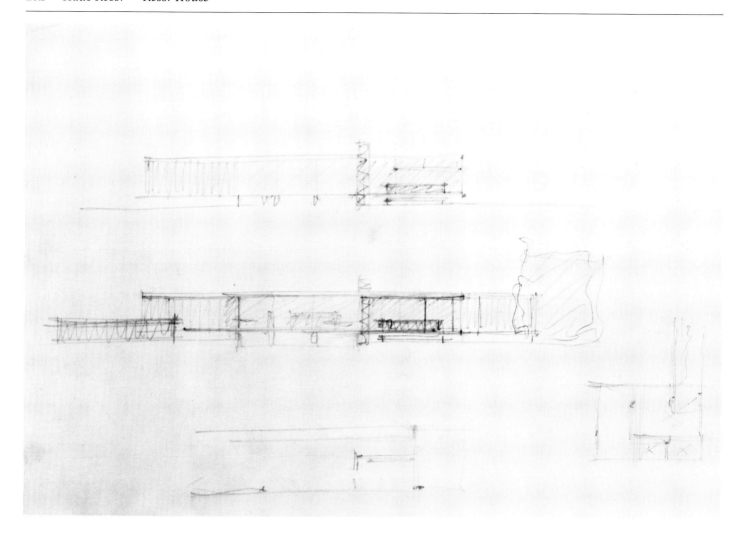

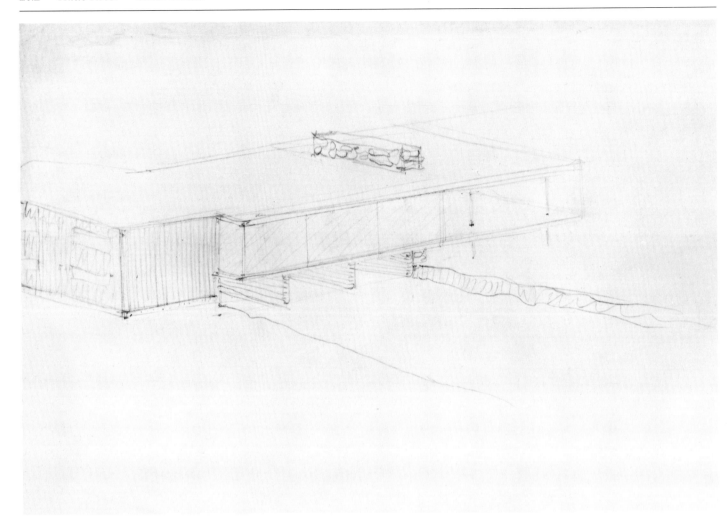

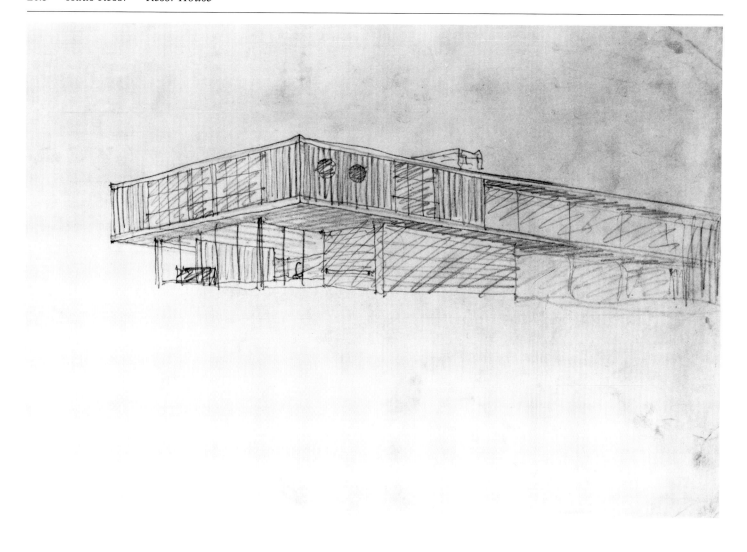

2 losing

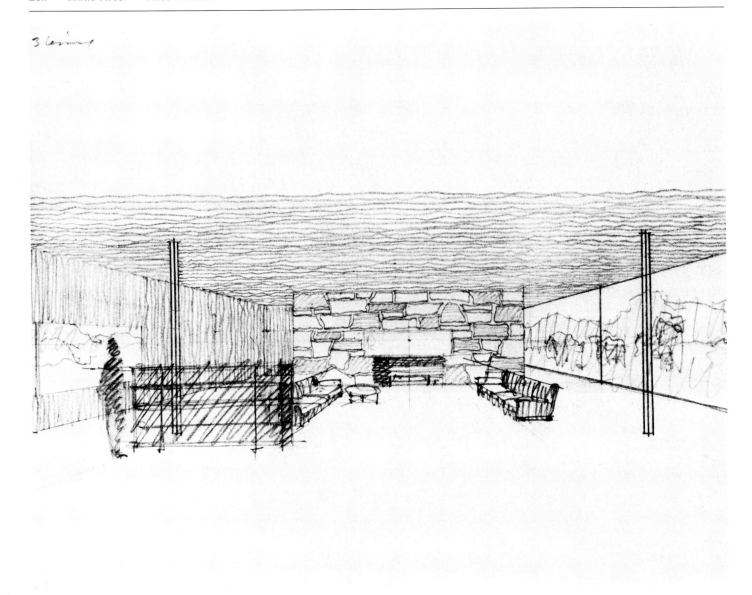

4 lösung

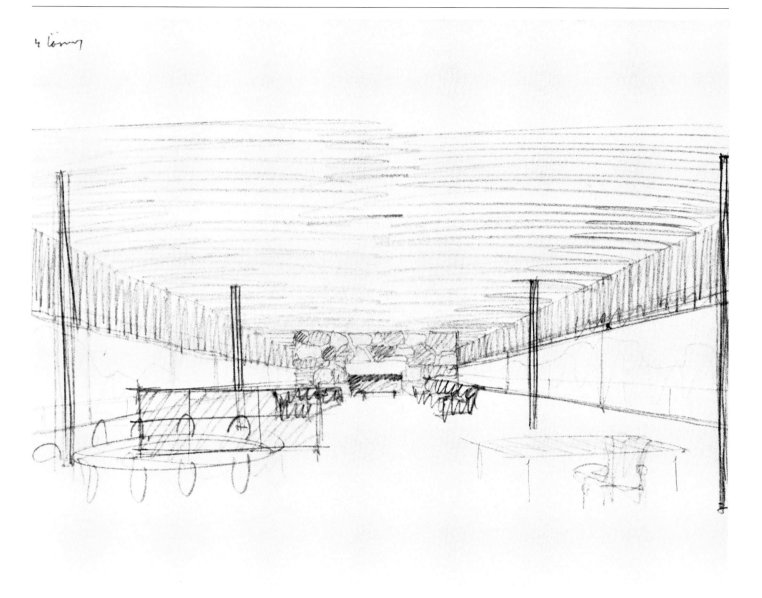

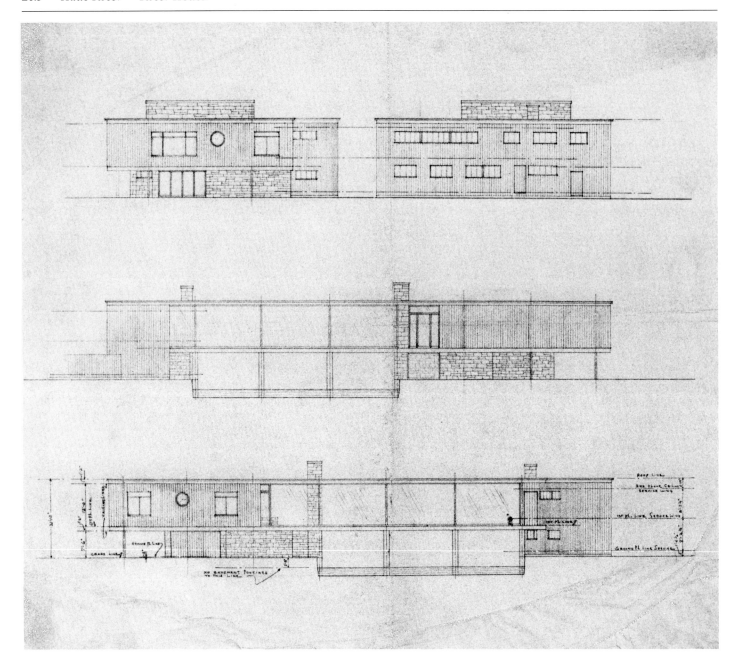

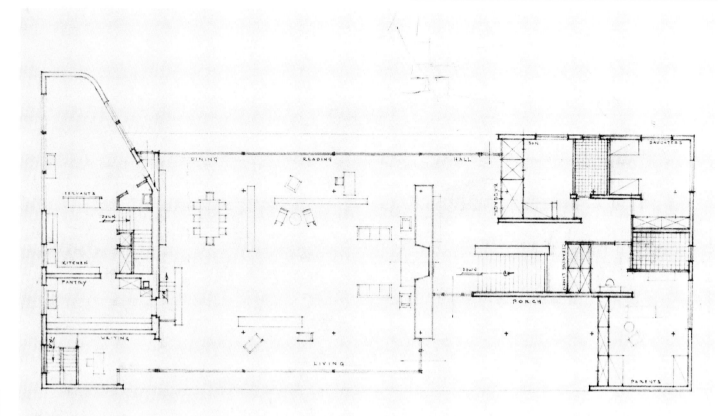

FIRST FLOOR
SCALE 1/8" = 1'-0"

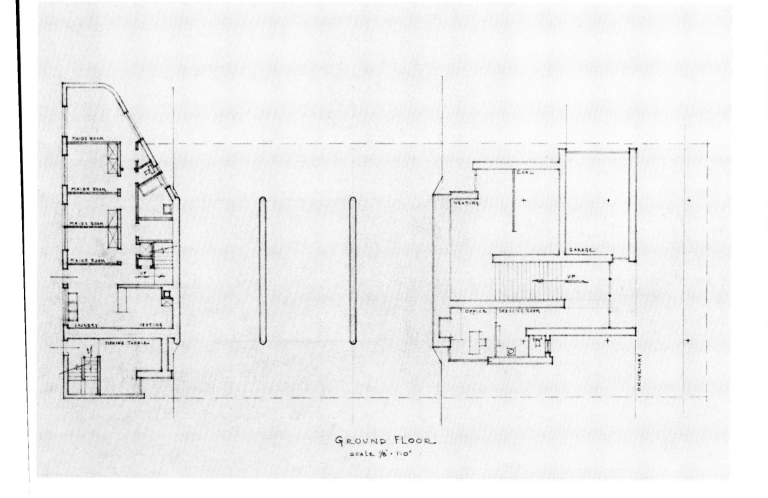

GROUND FLOOR
SCALE 1/8" = 1'-0"

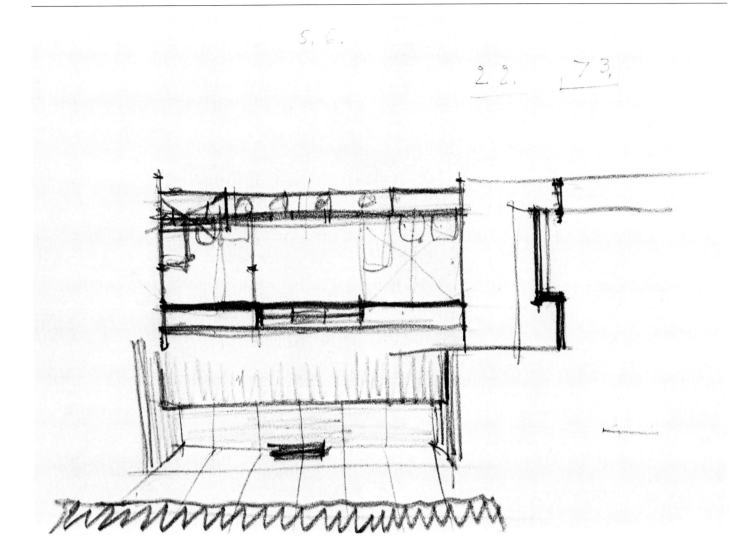

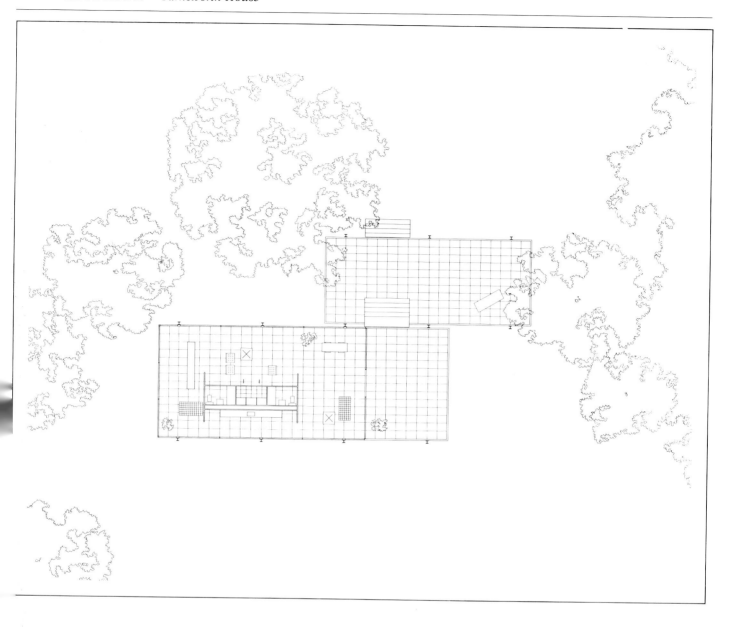

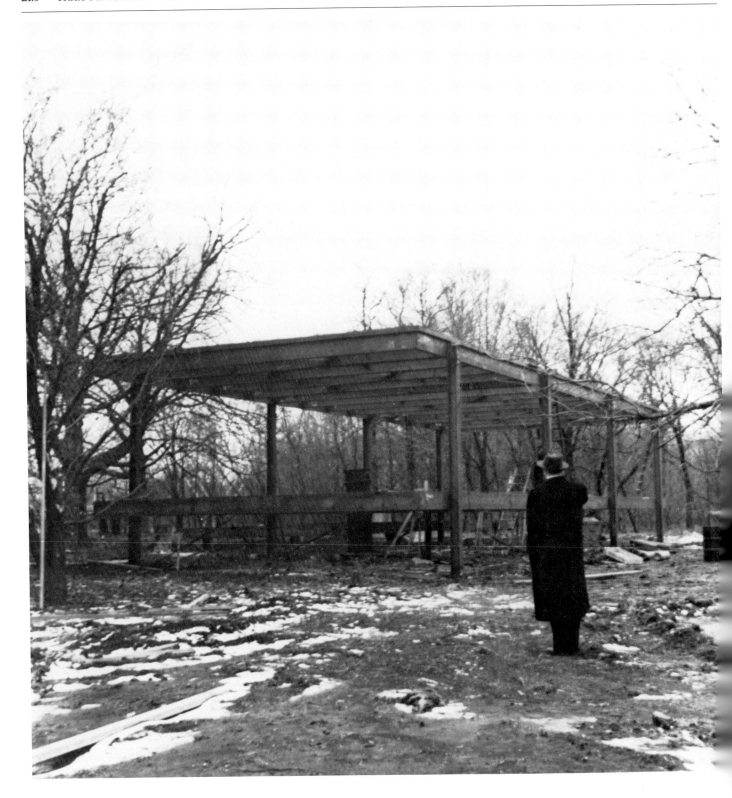

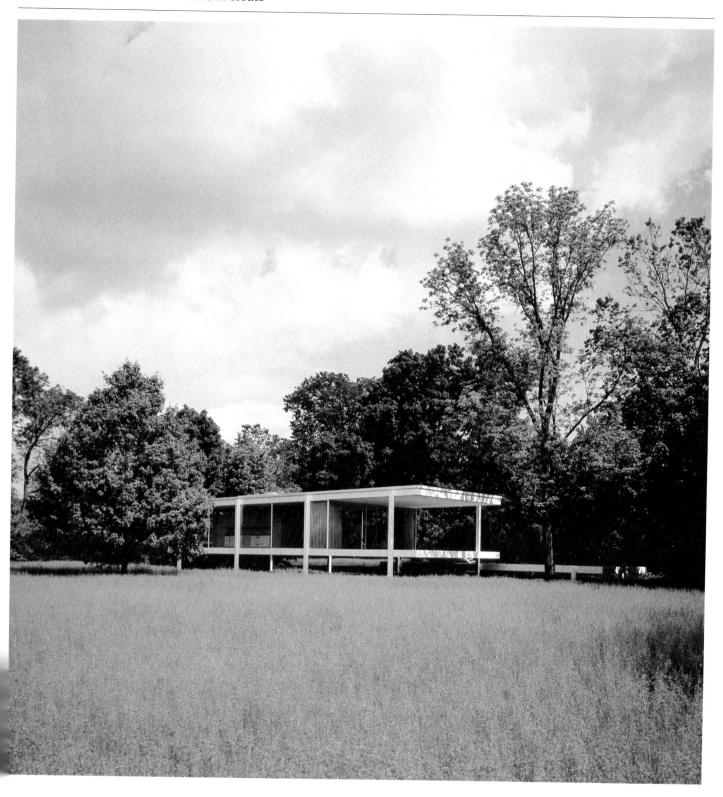

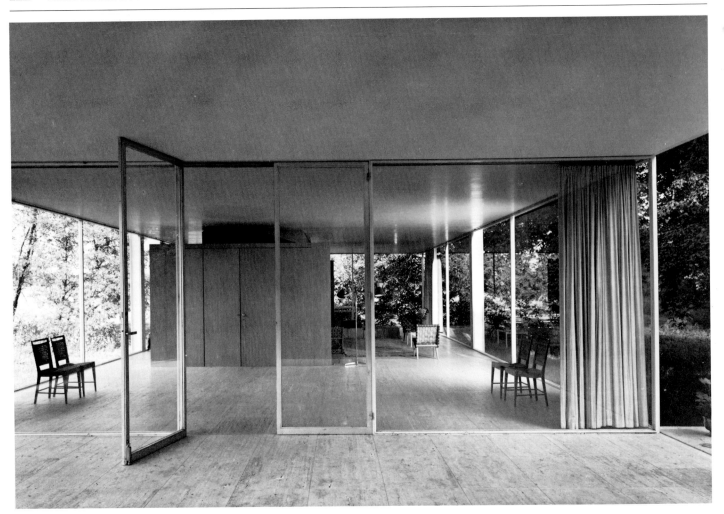

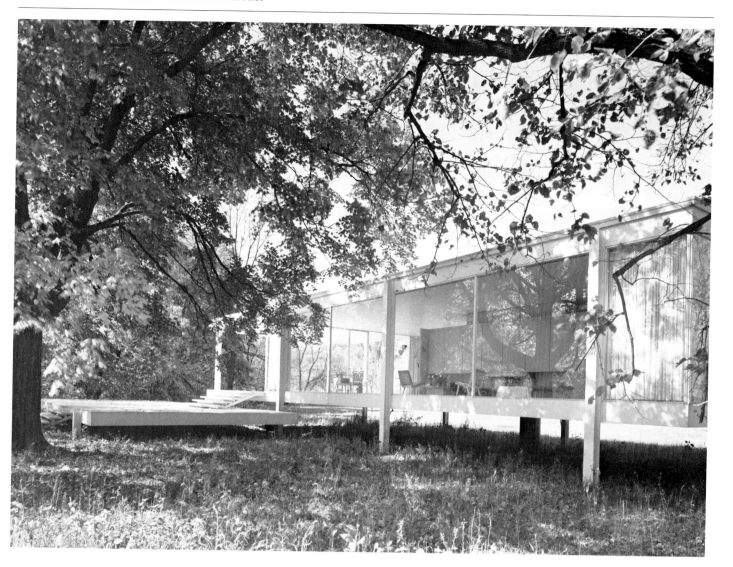

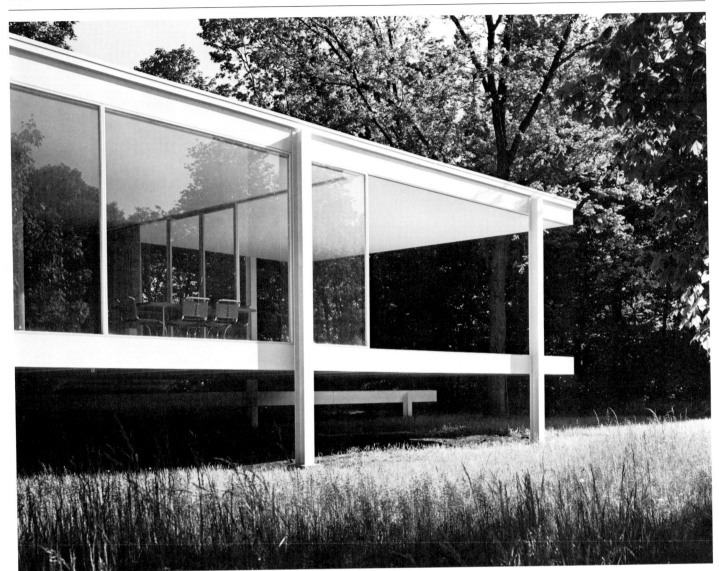

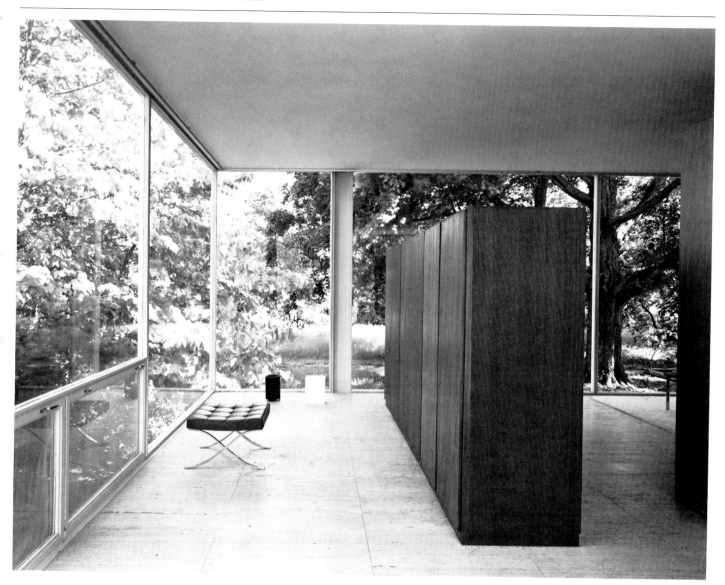

Catalog of the Drawings

With the exception of the nine Dexel House sketches (4.1–4.9) and two sketches of the Barcelona Pavilion (10.3, 10.5), all of the 146 drawings and sketches listed here are in the Mies van der Rohe Archive, The Museum of Modern Art, New York. The catalog numbers correspond to the illustration numbers in the plate section. The number following the abbreviation MoMA is The Museum of Modern Art inventory number. In the dimensions of the drawings, height precedes width.

1 Concrete Country House

1.1
Presentation drawing (white version)
pencil and pastel chalk on drawing paper
85.8 x 228.5 cm
MoMA 12.4

1.4
Presentation drawing (charcoal version)
pencil and charcoal on drawing paper
57.7 x 219.5 cm
MoMA 12.3

4 Dexel House

4.1
Sketches
pencil on drawing paper
21 x 32 cm
Collection Bernhard Dexel, Hamburg

4.2
Sketches
pencil on drawing paper
21 x 32 cm
Collection Bernhard Dexel, Hamburg

4.3
Sketches
pencil on drawing paper
21 x 32 cm
Collection Bernhard Dexel, Hamburg

4.4
Sketches
pencil on drawing paper
21 x 32 cm
Collection Bernhard Dexel, Hamburg

4.5
Sketches
pencil on drawing paper
21 x 32 cm
Collection Bernhard Dexel, Hamburg

4.6
Floor plan (ground floor)
pencil on drawing paper
21 x 32 cm
Collection Bernhard Dexel, Hamburg

4.7
Floor plan (upper floor)
pencil on drawing paper
21 x 32 cm
Collection Bernhard Dexel, Hamburg

4.8
Floor plan (ground floor)
pencil on drawing paper
21 x 32 cm
Collection Bernhard Dexel, Hamburg

4.9
Floor plan (upper floor)
pencil on drawing paper
21 x 32 cm
Collection Bernhard Dexel, Hamburg

5 Eliat House

5.3
Site plan
pencil on transparent paper
55.2 x 100.4 cm
MoMA 28.3

5.4
Floor plan (lower floor) and elevation (garden side), dated 6/17/25
pencil on transparent paper
43.9 x 53.1 cm
MoMA 28.2

5.5
Floor plan (main floor) and elevation (street side), dated 6/17/25
pencil on transparent paper
44.1 x 53.5 cm
MoMA 28.1

6 Wolf House

6.2
Elevation (south side), 12/25/25 version
blueprint with pencil corrections
18.7 x 36.8 cm
MoMA 30.25

6.3
Elevation (north side), 12/25/25 version
blueprint
18.8 x 37 cm
MoMA 30.24

6.4
Elevation (east side), 12/25/25 version
blueprint
18.6 x 36.6 cm
MoMA 30.23

6.5
Floor plan (first floor), 10/19/25 version
blueprint
35.8 x 38.9 cm
MoMA 30.32

6.6
Floor plan (ground floor), 10/19/25 version
blueprint with pencil notation
36.2 x 38.8 cm
MoMA 30.51

6.7
Elevation (south and east sides), final version
blueprint with pencil corrections
41 x 41.4 cm
MoMA 30.38

6.8
Elevation (north and west sides), final version
blueprint with pencil corrections
41.2 x 41.3 cm
MoMA 30.39

6.9
Floor plan (first and second floors), final version
pencil on transparent paper
43.7 x 47.7 cm
MoMA 30.68

6.10
Floor plan (ground floor), final version
blueprint with pencil corrections
41.3 x 41.4 cm
MoMA 30.34

7 Esters House

7.2
Perspective drawing (south side), preliminary version
pencil and pastel on drawing board
36.2 x 60 cm
MoMA 6.150

7.3
Perspective drawing (north side), preliminary version
pencil and pastel chalk on drawing board
41.2 x 60.2 cm
MoMA 6.149

7.4
Floor plan (ground floor), preliminary version
pencil and colored pencil on transparent paper
44.2 x 81 cm
MoMA 3.51

7.5
Floor plan (upper floor), preliminary version
pencil on transparent paper
26.6 x 43.6 cm
MoMA 3.38

7.6
Elevation (north side) and perspective sketch, preliminary version
pencil on transparent paper
39.2 x 94.2 cm
MoMA 3.16

7.7
Plan of garden terrace and elevation of retaining wall (planning stage)
pencil on transparent paper
49.3 x 61.2 cm
MoMA 3.10

7.8
Floor plan (upper floor), as-built plan of 5/28/31
pencil on transparent paper
70.3 x 96.1 cm
MoMA 3.4

7.9
Floor plan (ground floor), as-built plan of 5/28/31
pencil on transparent paper
64.7 x 95.7 cm
MoMA 3.3

8 Lange House

8.2
South elevation (brickwork detail)
pencil on transparent paper
66.2 x 105.9 cm
MoMA 6.102

8.3
Floor plan (upper floor), as-built plan of 5/28/31
pencil on transparent paper
64.7 x 93.3 cm
MoMA 6.153

8.4
Four elevations, as-built plan of 5/28/31
pencil on transparent paper
32.3 x 77.7 cm
MoMA 6.24

8.5
Floor plan (ground floor), as-built plan of 5/28/31
pencil on transparent paper
64.4 x 95.6 cm
MoMA 6.151

9 Glass Room

9.5
Floor plan
pencil and colored pencil on transparent paper
80.5 x 123.9 cm
MoMA 4.95

10 Barcelona Pavilion

10.2
Floor plan, Plan I, 1928
pencil on transparent paper
48.3 x 91.4 cm
MoMA 14.3

10.3
Perspective sketch (street side), preliminary version, 1928
pencil on transparent paper
21 x 28 cm
Collection of Staatliche Museen Preussischer Kulturbesitz, Kunstbibliothek Berlin, Hdz. 7152

10.4
Floor plan, Plan II, 1928
pencil and colored pencil on transparent paper
47.8 x 87.4 cm
MoMA 14.2

10.5
Perspective sketch (garden side), planning stage, 1928
pencil on transparent paper
21 x 28 cm
Collection of Staatliche Museen Preussischer Kulturbesitz, Kunstbibliothek Berlin, Hdz. 7150

10.6
Interior perspective
pencil and conté crayon on drawing board
99.1 x 130.2 cm
MoMA 14.1

11 Tugendhat House

11.2
Elevation (south side, two versions), planning stage, late 1928
charcoal on transparent paper
52.7 x 56.1 cm
MoMA 2.192

11.3
Perspective view (south side), planning stage, late 1928
charcoal on transparent paper
42.2 x 75 cm
MoMA 2.329

11.4
Perspective (south side), planning stage, late 1928
charcoal and pencil on transparent paper
29.6 x 53.6 cm
MoMA 2.328

11.5
Perspective (south side), planning stage, late 1928
charcoal on transparent paper
40.1 x 74.5 cm
MoMA 2.330

11.8
Detail sketch of lower terrace
pencil on tracing paper
20.9 x 29.6 cm
MoMA 2.384

11.9
Sketch of entryway
pencil on tracing paper
21.1 x 33 cm
MoMA 2.385

11.10
Elevation (north side), 4/6/29 version
pencil on transparent paper
40.8 x 65.8 cm
MoMA 2.335

11.11
Elevation (south side), 4/6/29 version
pencil on transparent paper
42.3 x 72.2 cm
MoMA 2.334

11.12
Elevation (north side), 4/16/29 version
pencil on transparent paper
42.8 x 72 cm
MoMA 2.176

11.13
Elevation (south side), planning stage
pencil on transparent paper
38.4 x 51.2 cm
MoMA 2.190

12 Nolde House

12.1
Floor plan, first version
pencil on transparent paper
48.9 x 54.6 cm
MoMA 40.4

12.2
Floor plan, second version
pencil on transparent paper
54 x 54 cm
MoMA 40.2

12.3
Floor plan, final version
pencil on transparent paper
54 x 73.6 cm
MoMA 40.5

12.4
Elevation (east and west sides), final
version, 4/13/29
pencil on transparent paper
56.5 x 72.4 cm
MoMA 40.1

12.5
Elevation (south and north sides), final
version, 4/13/29
pencil on transparent paper
56.5 x 71.8 cm
MoMA 40.3

13 Krefeld Golf Club

13.1
Perspective sketch (view from east),
preliminary version
pencil on tracing paper
20.8 x 29.5 cm
MoMA 19.18

13.2
Perspective sketch (first construction
segment; view from southwest),
preliminary version
pencil on tracing paper
20.8 x 29.5 cm
MoMA 19.16

13.3
Perspective sketch (second construction
segment; view from south), preliminary
version
pencil on tracing paper
20.8 x 29.5 cm
MoMA 19.17

13.4
Perspective sketch (view from southeast),
planning stage
pencil on tracing paper
20.8 x 29.5 cm
MoMA 19.11

13.5
Perspective sketch (view from northwest),
planning stage
pencil on tracing paper
20.8 x 29.5 cm
MoMA 19.14

13.6
Floor plan (freehand drawing with per
spective sketches)
charcoal and pencil on transparent paper
100.4 x 54.5 cm
MoMA 19.53

13.7
Aerial perspective (from southeast)
pencil on transparent paper
54.5 x 93 cm
MoMA 19.41

13.8
Floor plan
pencil on transparent paper
68.4 x 79.3 cm
MoMA 19.31

13.9
Aerial perspective (from southwest)
pencil on transparent paper
72.6 x 100.6 cm
MoMA 19.49

13.10
Perspective view of the club room (from
south)
pencil on transparent paper
72.6 x 100.6 cm
MoMA 19.52

13.11
Interior perspective of the club room
(looking south)
pencil on transparent paper
72.3 x 100.5 cm
MoMA 19.47

14 House at The Berlin Building Exposition

14.1
Floor plan
pencil on transparent paper
38.7 x 83.2 cm
MoMA 25.10

14.2
Perspective view, preliminary version
charcoal and pencil on transparent paper
55 x 86 cm
MoMA 25.47

14.4
Aerial perspective sketch
pencil on tracing paper
21 x 29.7 cm
MoMA 25.3

15 Gericke House

15.1
Elevation (lake side)
pencil on drawing board
48.9 x 63.5 cm
MoMA 700.63

15.2
Perspective sketch (view from south),
planning stage
pencil on tracing paper
21 x 30 cm
MoMA 42.32

15.3
Perspective sketch (view from south),
planning stage
pencil on tracing paper
21 x 30 cm
MoMA 42.27

15.4
Perspective sketch (view from south),
planning stage
pencil on tracing paper
21 x 30 cm
MoMA 42.39

15.5
Perspective sketch (view from south),
planning stage
pencil on tracing paper
21 x 30 cm
MoMA 42.30

15.6
Perspective sketch (view from south),
planning stage
pencil on tracing paper
21 x 30 cm
MoMA 42.26

15.7
Perspective sketch (view from southeast),
planning stage
pencil on tracing paper
21 x 30 cm
MoMA 42.58

15.8
Perspective sketch (view from north),
planning stage
pencil on tracing paper
21 x 30 cm
MoMA 42.62

15.9
Perspective sketch (view from north),
planning stage
pencil on tracing paper
21 x 30 cm
MoMA 42.60

15.10
Perspective view of living area (view from
lake)
pencil on drawing board
49.5 x 64.8 cm
MoMA 701.63

15.11
Perspective view, street front
pencil on drawing board
49.5 x 64.8 cm
MoMA 696.63

15.12
Perspective view of the court (view of the
sleeping and living areas)
pencil on drawing board
49.5 x 64.8 cm
MoMA 697.63

15.13
Interior perspective, dining area (left) and
living area (view from court)
pencil on drawing board
49.5 x 64.8 cm
MoMA 704.63

15.14
Interior perspective, living room (view from
bedroom)
pencil on drawing board
49.5 x 64.8 cm
MoMA 703.63

15.15
Interior perspective, living room and court
(view from dining area)
pencil on drawing board
49.5 x 64.8 cm
MoMA 702.63

15.16
Floor plan (upper floor)
pencil on drawing board
49.5 x 64.8 cm
MoMA 694.63

15.17
Floor plan (main floor)
pencil on drawing board
49.5 x 64.8 cm
MoMA 695.63

16 Mountain House

16.1
Perspective view
charcoal and pencil on transparent paper
55.3 x 101.6 cm
MoMA 706.63

16.2
Elevation
pencil on tracing paper
21.1 x 27.4 cm
MoMA 45.11

16.3
Aerial perspective sketch
pencil on tracing paper
21.1 x 27.4 cm
MoMA 45.13

16.4
Aerial perspective sketch
pencil on tracing paper
21.1 x 27.4 cm
MoMA 45.5

16.5
Perspective sketch
pencil on tracing paper
21.1 x 27.4 cm
MoMA 45.12

16.6
Elevation
pencil on transparent paper
23.9 x 29.2 cm
MoMA 705.63

17 Hubbe House

17.3
Site plan sketch with floor plan,
preliminary version
pencil on tracing paper
29.6 x 21 cm
MoMA 22.48

17.4
Sketch with several plan versions and
perspective illustrations
pencil on transparent paper
24.5 x 72 cm
MoMA 22.47

17.5
Floor plan with three elevations, planning
stage
pencil on transparent paper
45.1 x 54 cm
MoMA 22.22

17.6
Floor plan
pencil on drawing board
48.3 x 67.3 cm
MoMA 708.63

17.7
Perspective view of court (view from
terrace)
pencil on drawing board
48.3 x 67.3 cm
MoMA 710.63

17.8
Perspective view, living room and court
pencil on drawing board
48.3 x 67.3 cm
MoMA 711.63

17.9
Perspective view of terrace (view from
living room)
pencil on drawing board
48.3 x 67.3 cm
MoMA 712.63

18 Ulrich Lange House

18.1
Two elevations (court and entrance side),
preliminary version
pencil on transparent paper
25.6 x 52.3 cm
MoMA 7.2

18.2
Two elevations, preliminary version
pencil on transparent paper
24.7 x 52.1 cm
MoMA 7.1

18.3
Floor plan, preliminary version
pencil on transparent paper
47.1 x 52.3 cm
MoMA 7.3

18.4
Perspective sketch (view from entrance to court), planning stage
pencil on tracing paper
20.9 x 29.3 cm
MoMA 7.9

18.5
Perspective sketch, living area and interior court (view from terrace), planning stage
pencil and red pencil on tracing paper
20.9 x 29.3 cm
MoMA 7.8

18.6
Perspective sketch (view from living area), planning stage
pencil on tracing paper
20.9 x 29.3 cm
MoMA 7.7

18.7
Perspective sketch, living area (view from terrace), planning stage
pencil and red pencil on tracing paper
20.9 x 29.3 cm
MoMA 7.11

18.8
Perspective sketch, living area and interior court (view from terrace), planning stage
pencil and red pencil on tracing paper
20.9 x 29.3 cm
MoMA 7.6

18.9
Perspective sketch, living area and interior court (view from terrace), planning stage
pencil and red pencil on tracing paper
20.9 x 29.3 cm
MoMA 7.10

18.10
Floor plan, planning stage
pencil and colored pencil on transparent paper
38.1 x 54.1 cm
MoMA 7.43

18.11
Floor plan (detail), planning stage
pencil and colored pencil on transparent paper
38.1 x 54.2 cm
MoMA 7.38

18.12
Floor-plan sketches, planning stage
pencil on transparent paper
44.7 x 34.9 cm
MoMA 7.34

18.13
Site plan with floor plan, final version
pencil on transparent paper
55.7 x 96.2 cm
MoMA 7.57

18.14
Three elevations, final version
pencil on transparent paper
41.3 x 60.4 cm
MoMA 7.15

19 Court Houses

19.1
Aerial perspective view, House with Two Courts, c. 1934
ink on transparent paper
20.9 x 29.8 cm
MoMA 689.63.3

19.2
Perspective sketch, Court House (Hubbe House, interior view), 1935
ink on transparent paper
21.3 x 29.8 cm
MoMA 687.63.5

19.3
Floor-plan sketch, House with Three Courts, 1934
pencil on tracing paper
21 x 29.7 cm
MoMA 43.8

19.4
Floor plan sketch, House with Three Courts, 1934
pencil on tracing paper
21 x 29.7 cm
MoMA 43.7

19.5
Floor-plan sketch, House with Three Courts, 1934
pencil on tracing paper
21 x 29.9 cm
MoMA 43.3

19.6
Floor plan, House with Three Courts, c. 1934
pencil on transparent paper
41.5 x 29.7 cm
MoMA 43.11

19.7
Interior perspective, House with Three Courts, c. 1939 (design c. 1934)
studio drawing, pencil, and color reproduction (detail of a Braque painting) on drawing board
76.2 x 101.6 cm
MoMA 686.63

19.8
Floor plan, House with Three Courts, c. 1939
studio drawing, pencil on drawing board
76.2 x 101.6 cm
MoMA 685.63

19.10
Floor plan, group of three Court Houses, c. 1939
studio drawing, ink, and foil screen on drawing board
76.2 x 101.6 cm
MoMA 733.63

19.12
Interior perspective, Court House, c. 1940 (design c. 1934)
studio drawing, pencil, and detail of a black-and-white reproduction on drawing board
76.2 x 101.6 cm
MoMA 994.65

19.13
Interior perspective, Court House, c. 1939 (design c. 1934)
studio drawing, pencil, and color reproduction (detail of a Braque painting) on drawing board
76.2 x 101.6 cm
MoMA 691.63

19.14
Interior perspective, Court House, c. 1939 (design c. 1934)
studio drawing, pencil, and wood veneer on drawing board
76.5 x 101.8 cm
MoMA 43.10

19.15
Interior perspective, Row House with
Court, c. 1940 (design 1931)
studio drawing, pencil, wood veneer, and
color reproduction (detail of a Braque
painting) on drawing board
76.2 x 101.6 cm
MoMA 692.63

20 Resor House

20.1
Two elevation sketches, planning stage
pencil on tracing paper
21.6 x 33 cm
MoMA 3800.260

20.2
Elevation sketch, planning stage
pencil on tracing paper
21.6 x 33 cm
MoMA 3800.259

20.3
Elevation sketch, planning stage
pencil on tracing paper
21.6 x 33 cm
MoMA 3800.264

20.4
Perspective sketch (entrance-hall detail),
planning stage
pencil on tracing paper
21.6 x 33 cm
MoMA 3800.753

20.5
Perspective sketch (entrance-hall detail),
planning stage
pencil on tracing paper
21.6 x 33 cm
MoMA 3800.754

20.6
Perspective sketch, living room (second
version), planning stage
pencil on tracing paper
21.5 x 28 cm
MoMA 3800.750

20.7
Perspective sketch, living room (third
version), planning stage
pencil on tracing paper
21.5 x 28 cm
MoMA 3800.751

20.8
Perspective sketch, living room (fourth
version), planning stage
pencil on tracing paper
21.5 x 28 cm
MoMA 3800.752

20.9
Four elevations, final version
pencil on transparent paper
66 x 67.3 cm
MoMA 100.610

20.10
Floor plan (main floor), final version
pencil and colored pencil on transparent
paper
33 x 51.4 cm
MoMA 100.604

20.11
Floor plan (ground floor), final version
pencil and colored pencil on transparent
paper
45.1 x 53.3 cm
MoMA 100.607

20.12
Perspective of living room (view of land-
scape through northern glass wall)
pencil and photo on drawing board
76.2 x 101.6 cm
MoMA 715.63

20.13
Perspective of living room (view of land-
scape through southern glass wall)
Pencil, wood veneer, detail of a color
reproduction (Paul Klee's *Bunte Mahlzeit),*
and photo on drawing board
76.2 x 101.6 cm
MoMA 716.63

21 Farnsworth House

21.1
Elevation (north side), c. 1946
pencil and watercolor on transparent paper
33 x 63.5 cm
MoMA 1002.65

21.2
Floor-plan sketch, planning stage
pencil on scratch paper
15.2 x 21.5 cm
MoMA 4505.6

21.3
Floor-plan sketch, planning stage
pencil on scratch paper
15.2 x 21.5 cm
MoMA 4505.5

21.4
Floor-plan sketch, planning stage
red pencil on scratch paper
15.2 x 21.5 cm
MoMA 4505.1

21.5
Elevation sketch of fireplace wall and
floor-plan sketch of core area
red pencil on scratch paper
15 x 21.5 cm
MoMA 4505.4

21.6
Perspective sketch of terrace
red pencil on scratch paper
15 x 21.5 cm
MoMA 4505.3

21.7
Perspective sketch (north side)
pencil on scratch paper
15.2 x 21.5 cm
MoMA 4505.2

Photograph Credits

All photographs are from the Ludwig Mies van der Rohe Archive, The Museum of Modern Art, New York, with the exception of the following:

Text Illustrations

Frank Boochs, Rüdiger Mosmann, Bonn: 3.

Carl Friedrich Schinkel, *Sammlung Architektonischer Entwürfe*, 3rd ed., Berlin, 1858, Vol. II, plate 110; Vol. III, plate 169: 6, 7.

Fritz Hoeber, *Peter Behrens*, Munich, 1913, illus. 234, p. 205; illus. 227, p. 198; illus. 222, p. 192: 8, 9, 26.

Sigfried Giedion, *Walter Gropius*, Stuttgart, 1954, illus. 83, p. 124; illus. 87, p. 126; illus. 187, p. 178; illus. 205, p. 186: 10, 11, 29, 66.

Arthur Korn, *Glas im Bau und als Gebrauchsgegenstand*, Berlin, n.d., illus. p. 26; illus. p. 165: 12, 32.

Das Kunstblatt, Vol. 11, No. 2, February 1927, illus. p. 60; illus. p. 61 bottom; illus. p. 61 top: 13, 14, 25.

Sigfried Giedion, *Space, Time and Architecture*, 9th ed., Cambridge, Mass., 1952, illus. 192, p. 340: 17.

Reyner Banham, *Brutalismus in der Architektur*, Stuttgart/Berne, 1966, illus. 222, p. 150: 19.

Wolfgang Pehnt, *Die Architektur des Expressionismus*, Stuttgart, 1973, illus. 82, p. 45: 22.

Bernhard Dexel, Hamburg: 23, 24.

Georgia van der Rohe, New York: 27, 28.

Volker Döhne, Krefeld: 30.

Werkbund-Austellung "Die Wohnung," Stuttgart, 1927, official catalog, illus. p. 81: 31.

Zentralblatt der Bauverwaltung, Vol. 49, No. 34, August 21, 1929, illus. p. 542: 33.

Werner Blaser, *Mies van der Rohe: Die Kunst der Struktur*, Zurich/Stuttgart, 1965, illus. pp. 30–31: 34.

Staatliche Museen Preussischer Kulturbesitz, Kunstbibliothek Berlin: 35.

Exposición Internacional Barcelona MCMXXIX, Barcelona, 1929 (Concesiónes Gráficas; unpaginated): 36, 43, 46.

Arquitectura: Revista Oficial de la Sociedad central de arquitectos (Madrid), Vol. 12, 1930, illus. pp. 98 and 102: 41, 45.

Deutsche Bauzeitung, Vol. 63, No. 77, September 25, 1929, illus. 3, p. 658: 44.

Die Form, Vol. 6, No. 9, September 15, 1931, p. 323, top; No. 6, June 15, 1931, illus. p. 214: 47, 59.

Modern Architecture: International Exhibition, New York (The Museum of Modern Art), 1932, pp. 126-27: 51, 52.

L'Architecture Vivante: Le Corbusier et P. Jeanneret (2nd Series), Spring 1929, plate 16: 54.

Wasmuths Monatshefte für Baukunst und Städtebau, Vol. 15, No. 6, 1931, illus. p. 244 bottom; illus. p. 245 top: 58, 60.

Plates

Bernhard Dexel, Hamburg: 4.1-4.9

Volker Döhne, Krefeld: 7.1, 7.12, 7.13, 8.8, 8.9

Yukio Futagawa, Tokyo: 21.10, 21.13, 21.14

Hedrich/Blessing, Chicago: 11.6, 11.7, 21.11, 21.12

Staatliche Museen Preussischer Kulturbesitz, Kunstbibliothek, Berlin: 10.3, 10.5

Berliner Bildbericht: 10.8-10.21, 11.1, 11.20-11.31, 14.5-14.11

Das Kunstblatt, 1927, p. 59: 2.1, 5.1

Die Form, 1928, No. 1: 9.1-9.3

Die Schildgenossen, Vol. 14, No. 6: 17.1, 17.2

Kunst und Künstler, Vol. XXVI, p. 424: 6.1